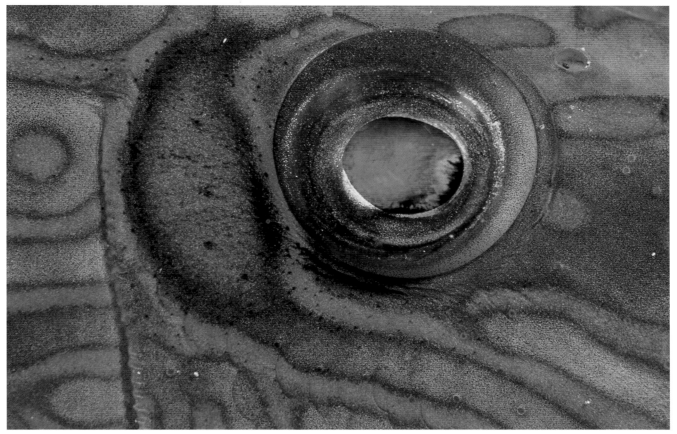

Wrasse eye, by Jose Luis Gonzalez, Spain 2000

LIGHT *on the* EARTH

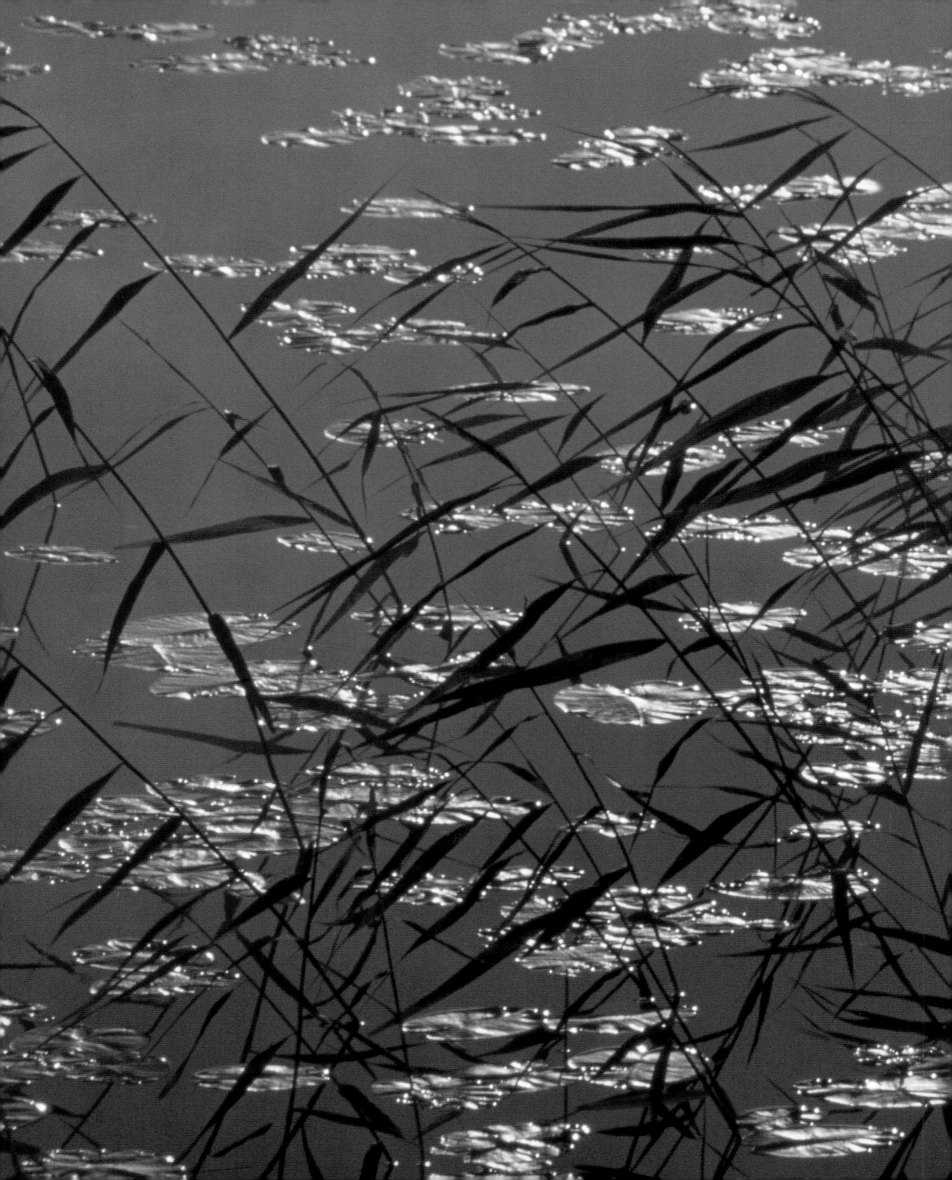

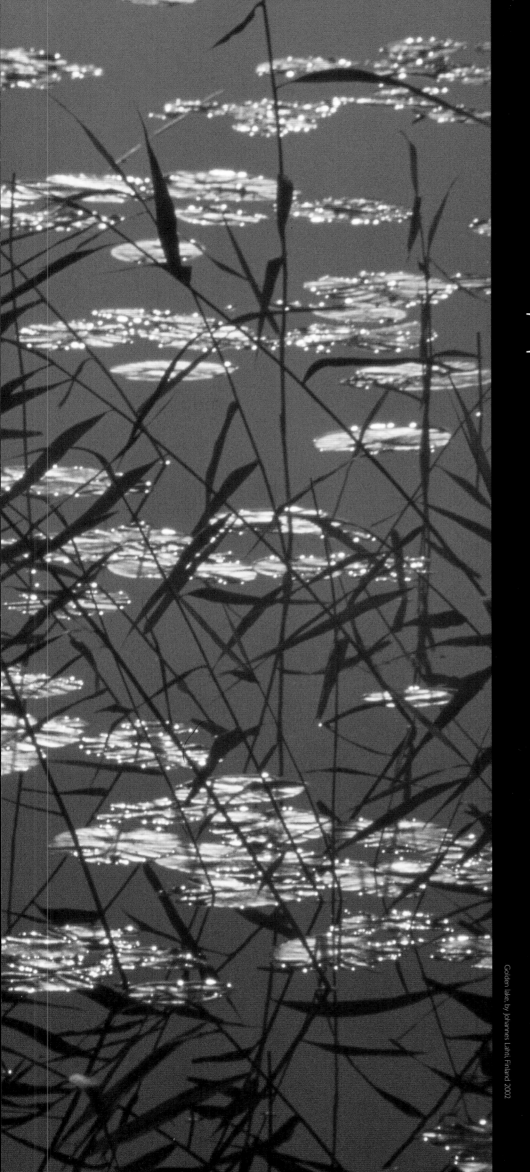

LIGHT *on the* EARTH

BBC
BOOKS

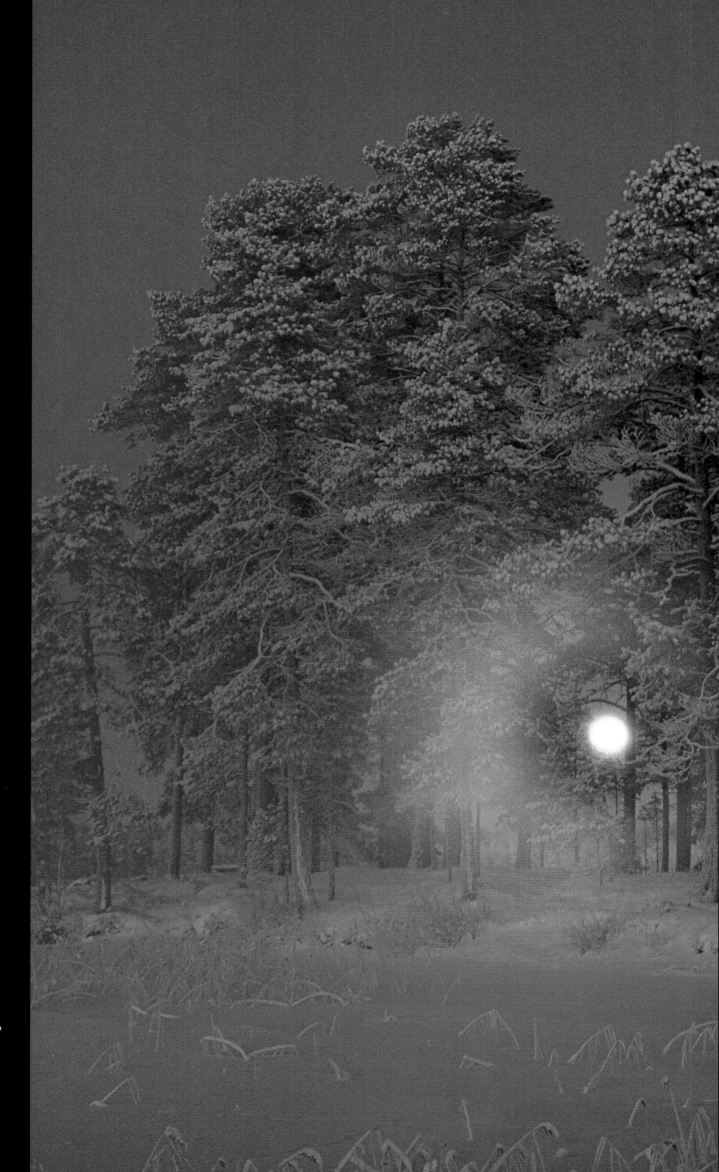

Published in 2005 by BBC Books,
an imprint of Ebury Publishing
Ebury Publishing is A Random
House Group Company
Addresses for companies within the
Random House Group can be found
at www.randomhouse.co.uk
The Random House Group Limited
Reg. No. 954009
First published 2005
Reprinted 2006, 2007
Compilation and text
© BBC Worldwide 2005
Photographs © the individual
photographers

Managing editor
Rosamund Kidman Cox

Commissioning editors
Shirley Patton and Stuart Cooper

Art director
Simon Bishop

Designer
Traci Rochester

Caption text
Rosamund Kidman Cox

Production controller
David Brimble

Editorial assistance
Wendy Smith
Gemma Webster

ISBN 978 0 563 52260 7

Colour separations by
Butler & Tanner Origination
Printed and bound in
Great Britain by
Butler & Tanner Limited

Moonwood

Winter in Finland is very dark and
very cold. But the light can also be
very beautiful. On the afternoon of
a full moon, the photographer
positioned himself at the edge of the
frozen lake and waited for the moon to
rise, knowing exactly where it would
be at 4pm. The special ingredient was
the freezing mist, which transformed
the moonshine into a golden halo.

Hannu Kivelä *Finland 2003*

Contents

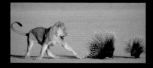

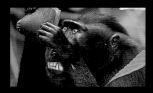
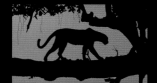

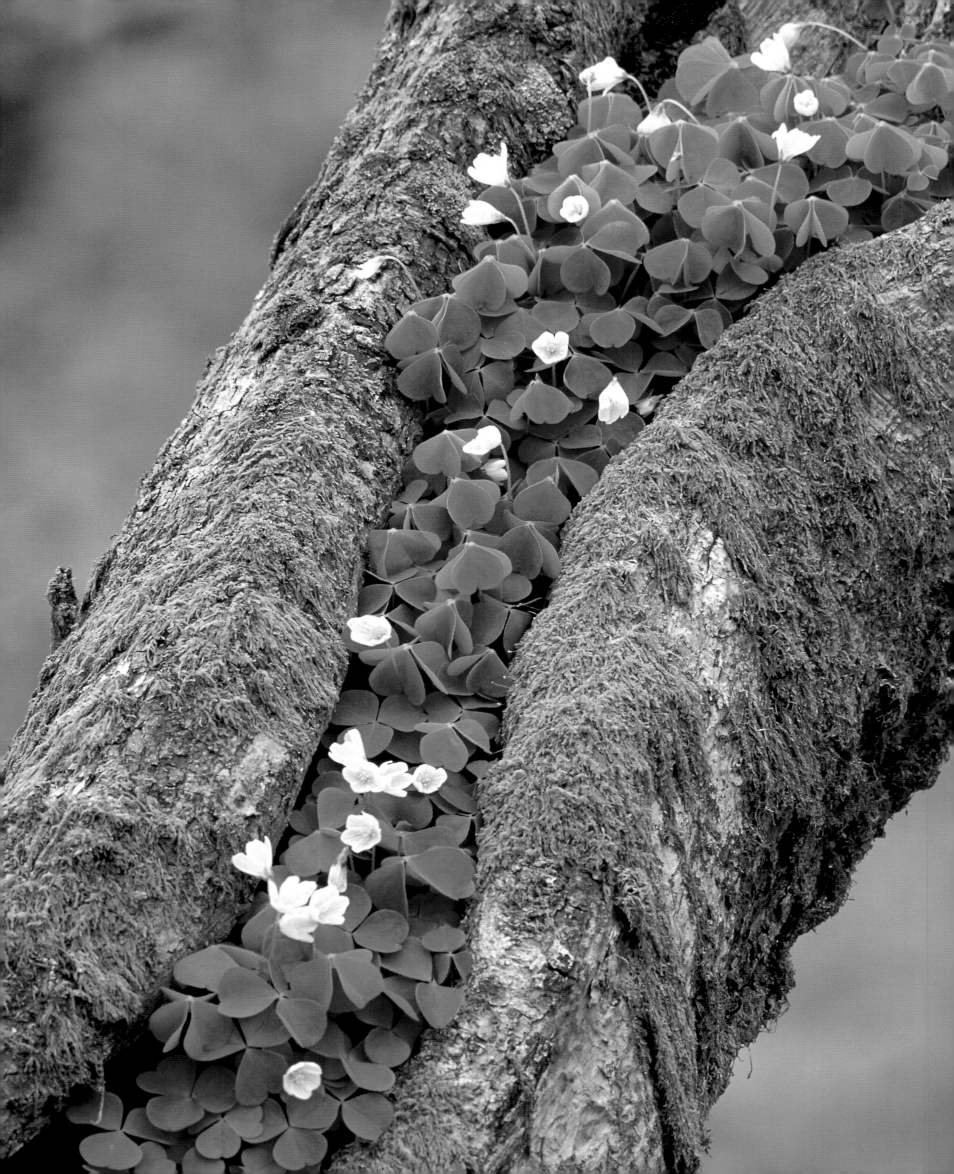

Foreword

DAVID ATTENBOROUGH

Twenty years of competition, more than a quarter of a million images submitted, more than two thousand selected – how can you choose 'the best' from such numbers? Of course you can't. Even in a single year, in a single category, the task is close to impossible. There are too many occasions on which a jury of talented and experienced people with real vision will disagree on which are the most deserving of the pictures submitted to them and the order in which they should be placed. That is the danger of competitions. They inevitably become rankings, whereas their true function should be straightforward celebration.

On the other hand, some pictures are unquestionably 'great'. Sometimes one can be given that name because it is a stunning image that few have ever seen before – a vortex of tiny fish through which a shark plunges. Sometimes it is a picture that has been so carefully composed and framed, the moment of its taking so perfectly timed and the manner of its printing so subtle, that it transforms the most familiar subject, such as a bird singing in the light of dawn, into an image of which the eye never tires. Sometimes greatness depends on the presence of a tiny detail, easily missed at a casual glance because it is so small – a tiny speck that is an eagle in the swirling mists of a northern forest – that reveals the character of its surroundings in an almost mystical way.

Great nature pictures, however, do have one thing in common. They remind us that the world that lies outside us but of which we are assuredly a part is the most profound source of beauty, wonder and joy. And of the select group of pictures that do that, a few have one further quality. They imprint themselves on the mind. They are unforgettable. That is the rarest and most precious category. All those gathered here belong to it. They are simply great pictures.

Wood sorrel

The photographer believes that near-perfect natural compositions are all around – that you merely need to learn how to see them. This means being intimate with an environment, though. The detail is from a Scottish woodland near the photographer's home. An overcast day provided just the soft light needed to bring out the subtle colours of the wood sorrel cupped in the branch of an ancient oak and the patterns of the moss and lichens encrusting the bark.

Laurie Campbell *UK 1999*

Wildlife Photographer of the Year

competition

This annual event is a lot more than just a competition. Over the years, it has become a showcase and a forum for wildlife photographers all over the world.

It started in the UK with small beginnings, back in 1964, as a competition in *Animals* magazine, the forerunner of *BBC Wildlife Magazine*, which organises it in conjunction with the Natural History Museum in London. Even in those days, when the entries were in the hundreds rather than the thousands as they are today, photographers took great pride in receiving a placing, as there were few other ways to get their images seen by a wide audience. But it really took off as an international event the competition got its first sponsor and *BBC Wildlife Magazine* joined forces with the Natural History Museum.

The result was a big exhibition at the museum, a special supplement in the magazine. Then followed a book of the hundred or so chosen images and an international touring exhibition. Today, this combination means that millions of people around the world can see and marvel at the images.

For a struggling photographer – and most wildlife photographers do struggle to make a living – this can make a huge difference. And the fact that the mix of photographers is international, with different styles and different ways of seeing nature, has resulted in cross-fertilisation of ideas and techniques.

Most of the biggest names in wildlife photography have entered over the years, and their work has inspired upcoming photographers. For those in countries without a tradition of wildlife photography, winning an international prize and being publicised at home can be both a validation and an inspiration. For others, it has enabled them to publicise the stories behind the pictures.

The international attention given to the picture by Chinese photographer Xi Zhinong of the endangered snub-nosed monkeys has helped him in his fight to prevent their forests being logged. For conservationist Karl Ammann, the showcasing of his pictures of deforestation and great apes caught up in the bush-meat and pet trade has helped his campaign against logging in Africa and South-east Asia.

One very important element of the competition is the special section for young photographers, which aims to encourage new talent. What the judges look for, as they do in the rest of the competition, are shots that show imagination, an eye for composition and a feel for nature. Of those who win, there are always some who are inspired enough to go on to become professional photographers or film-makers.

One thing to keep in mind as you turn the pages of this book is that there are literally thousands of other photographers who have featured in the Wildlife Photographer of the Year competition over the years and whose images could equally have been selected. This collection is merely a taste of some of the wonderful and varied pictures that the world's wildlife photographers have produced. That some have won prizes and others were commended is irrelevant, as all are special in one way or another, and the choice of favourites is for you to make.

For the judges of the competition, the task is an onerous one, and when it comes to the final selection, the choice can only ever be personal. The essays in each chapter, by contemplative photographers who have either been judges or won prizes in past competitions, are there to give a flavour of the passion and dedication that are common to all wildlife photographers and to tell us what they think it is that transforms records of nature into art. As most of them say, all images are illusions, but the greatest are those that reach the heart and stay with you.

Like all the past supporters of the competition, who have included the late Sir Peter Scott, Eric Hosking and Gerald Durrell, they believe that still images of nature have the power to affect how we think and feel about the splendour, drama and variety of life on Earth and so care about its future.

Touching

For nearly an hour the photographer watched this mother and calf playing gently in shallow water off Grand Bahama. Gradually play turned into synchronous circling, each nuzzling the other in an obvious display of affection and pleasure. The spotted mother appeared almost to be calming her boisterous adolescent. Eventually, they rejoined their group, leaving the photographer alone and far from his boat – in his absorption, he had drifted nearly a kilometre (half a mile) away.

Kelvin Aitken *Australia 1994*

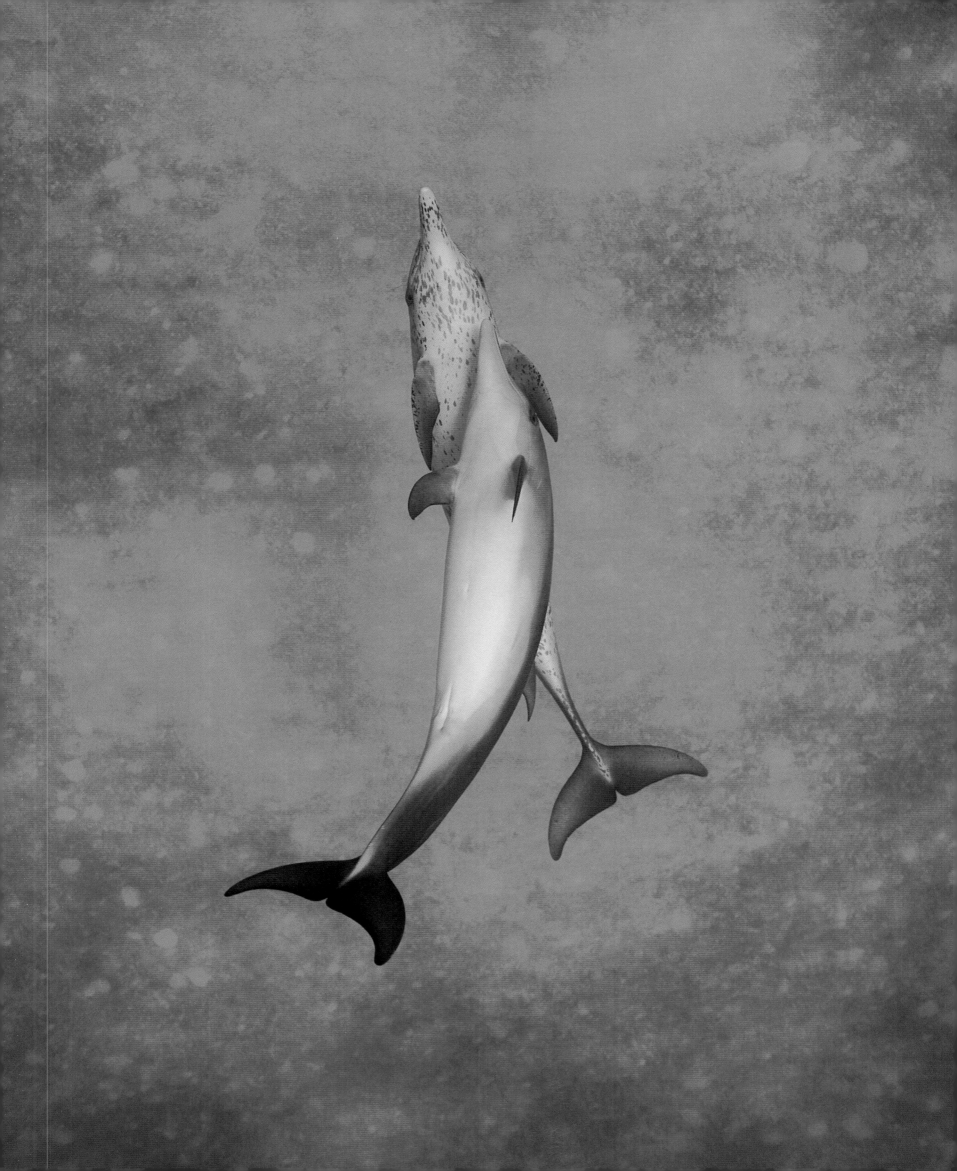

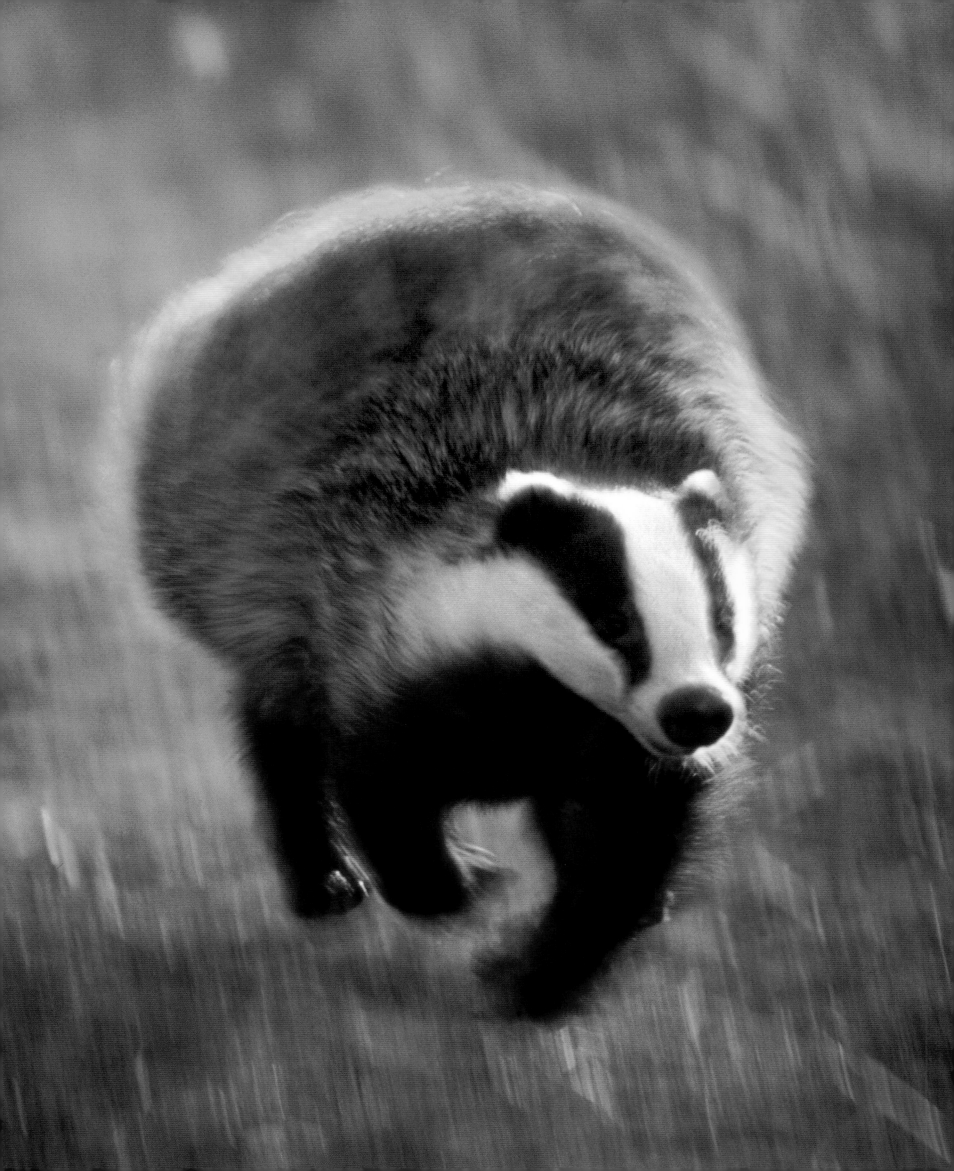

Illuminations

YANN ARTHUS-BERTRAND

When I think back after all these years, the time I spent with animals is definitely when I was most happy and at one with my work. There are few jobs where you can get close to life in the wild, and this is the biggest motivating factor for many wildlife photographers. They have respect for nature and see it in a positive light. There is a kind of naivety in the way they see the world. It's a job that encourages you to dream . . .

Evening run

This is a picture of youth and energy – no chance shot but one carefully planned with knowledge of the area (a Somerset wood bounded by fields) and the subject's day-to-day behaviour. The youngster is bounding in its badger-like way across an open space down a path leading from its sett to a regular feeding area. Using backlighting from the late-summer evening sun, the photographer has transformed the moment into an icon of badgerness.

Jason Venus *UK 1996*

Illuminations

Photographing wild animals taught me about light. When you watch the light moving over the same landscape through the day, colouring it and shaping it, you realise how much it creates the shot.

. . . I had been managing a reserve in central France in the department of the Allier for several years. It was a time when the first safari parks were appearing, and the Thoiry safari park near Paris had just opened. To prevent its lion population growing too big, it would sometimes have to cull newborn cubs. I would rescue them, take them over to my reserve and hand-rear them. But I longed to see them in the wild. I imagined myself in Kenya, sitting in my Land Rover in khaki shorts and hat, following the lions in their own environment. Diane Fossey, Jane Goodall and George and Joy Adamson were my heroes.

My wife and I spent three years living in the Masai Mara in Kenya. They were probably the best years of my life. We were there to write a thesis on the behaviour of a pride of lions. We counted their whiskers and plotted them on index cards so we could recognise individuals. My wife did the writing, and I started taking pictures, realising that photography could provide vital information and in a very different way from words. I would follow the animals with my telephoto lens, staying for hours in one place to watch them. I knew then that I wanted to be a photographer.

I enjoyed a way of life where you could follow the reactions of the animals really closely, get to know them, understand them and anticipate their behaviour. But you're always on the outside looking in. To them, you don't exist. There is always a certain distance, but it allows you to stand back and think, take a step back from your life and discover what you want to do.

I go mad in a traffic jam, but I could watch a lion sleeping for days. You can't cheat with wildlife photography and say to the animal "put yourself over there". You can't organise anything – you just have to wait for the photo to happen. And, if you are determined enough, something usually does happen.

Over the days spent waiting and observing, you develop a different view of living things – one that is much more real and true. It's very far from the calendar presentation of wildlife – cute, idealised lion cubs, for example. You soon discover that death is ever-present in the wild. Animals are often under stress, trying to find food or a mate or to flee from danger, and young ones frequently die. You see the violence that is a natural part of life – kill or be killed. This attitude to life becomes ingrained in you. But there are moments that transcend this.

One day, when I was at Diane Fossey's place to photograph the mountain gorillas, the massive dominant male fell asleep with his head on my foot. I cried with emotion. I was astonished to be accepted like that. It was the most beautiful moment of my life

as a photographer – no, of my entire life.

Photographing wild animals taught me about light. When you watch the light moving over the same landscape through the day, colouring it and shaping it, you realise how much it creates the shot. The magical hours are at the beginning and end of the day – the rising and setting sun beautifying everything.

When I returned to France, it was clear that I still had that same sense of light, and so I didn't need to spend any more time learning about it. When I took pictures of the tennis at Roland Garros or the Tour de France, I captured the movement, just as I had learned to do with the lions. I also used a telephoto lens, which was still quite new in sports photography at the time.

Today, my photography has once again more commitment to it, in tune with my convictions. After all those hours of aerial photography for *Earth From Above*, rising high above the land of men, far from the sweet smell of the magnificent dry savannah grasslands, I realise how much I owe to the lions of the Masai Mara, for it was they who taught me how to take pictures.

Mist and the mountain raven

Huge pine trees flank the steep sides of the Vosges Mountains in eastern France – a wild and, in places, inaccessible region with unpredictable weather, but also a refuge for wildlife, from capercaillies to chamois. It's the photographer's favourite haunt and a place that he passionately believes should be protected. In this picture, he used the early morning light of a misty autumn day and a wind-buffeted raven to emphasise the wildness and mystery of the place.

Vincent Munier *France 2001*

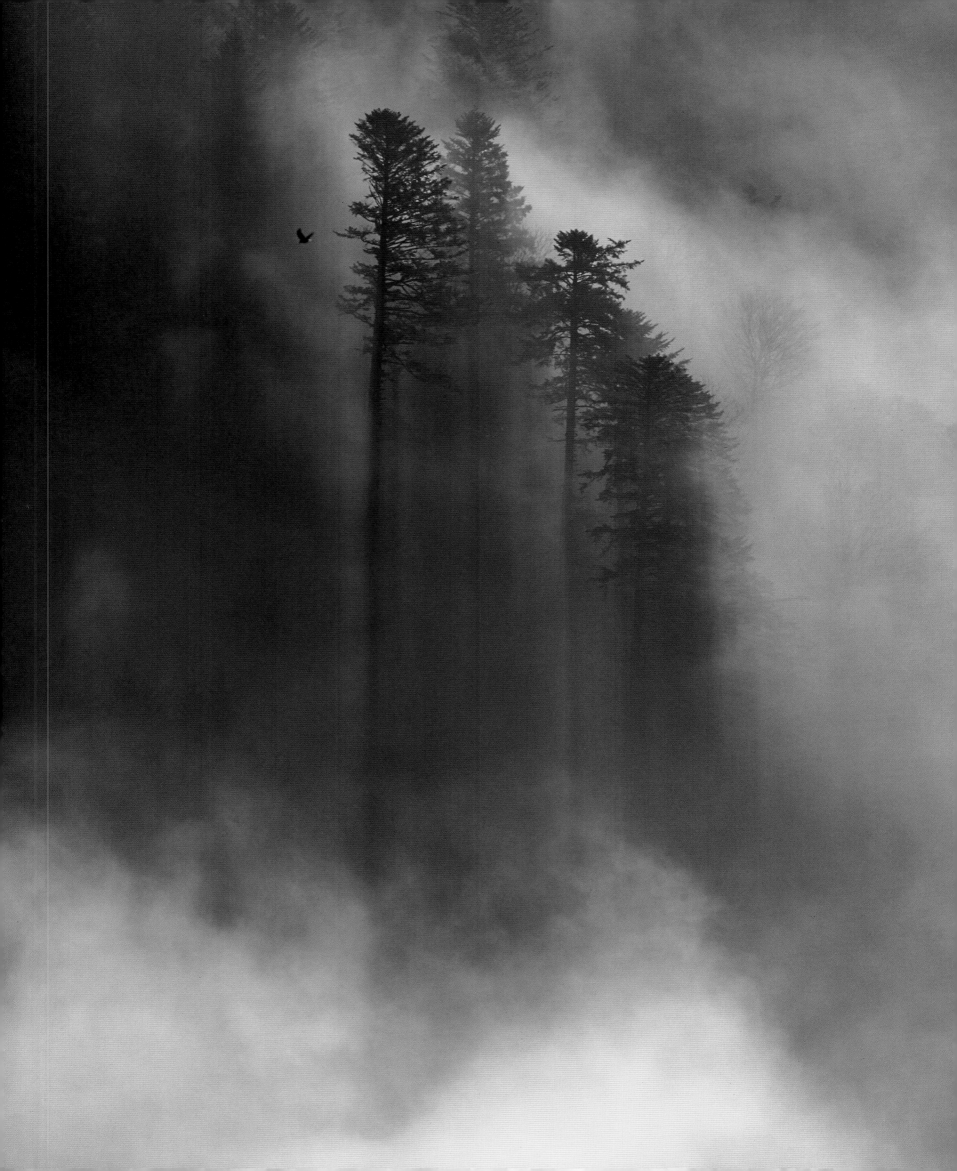

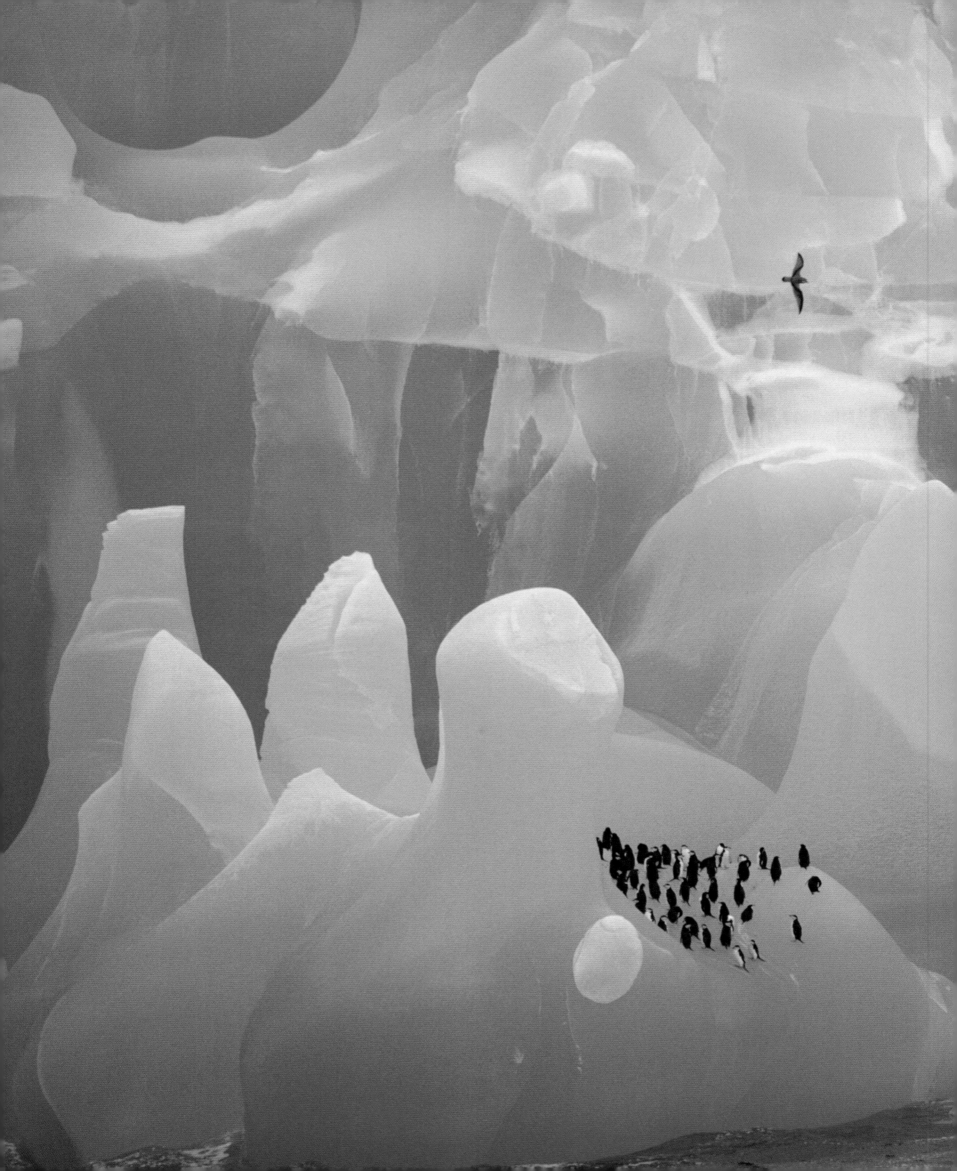

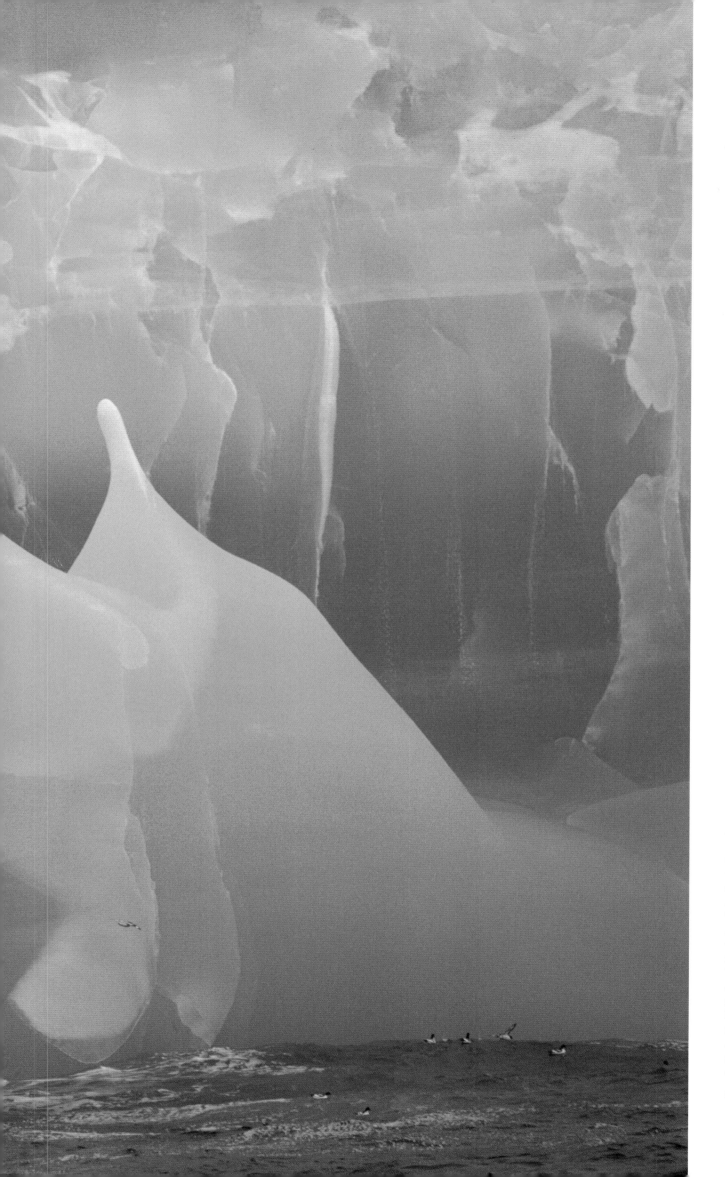

Blue ice and penguins

Constantly changing light, reflected from ice, snow and sea through clean, cold air creates the atmosphere that's unique to Antarctica. Some of the ice that breaks off from the base of ancient glaciers and crashes into the sea is so compressed that it absorbs most of the light, reflecting only the blue end of the spectrum. Over time, these rare blue icebergs are sculpted by the elements and transformed into floating cathedrals of light. What makes this shot so perfect are the extra touches: the huddle of Adélie penguins contrasting black against the blue, and the perfectly positioned Antarctic prion flying high above, emphasising the vastness of the ice creation.

Cherry Alexander *UK 1995*

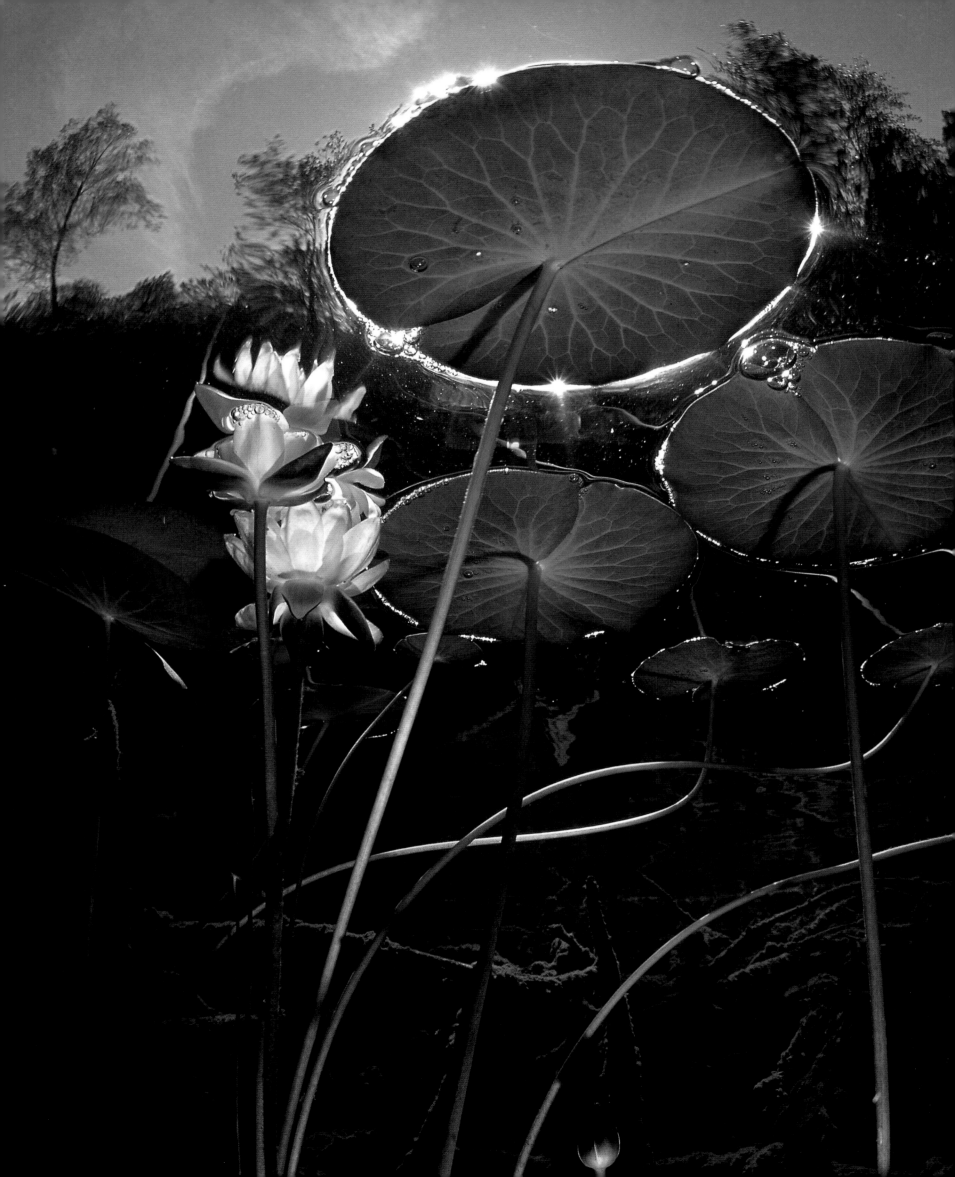

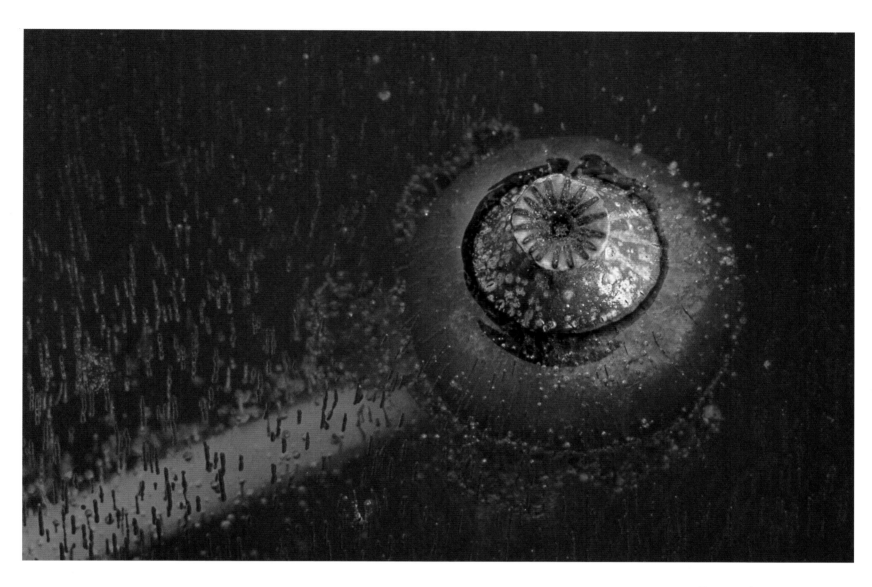

Ice pod

This is an artist's view of something very simple: a water lily seedpod frozen into the ice. It is also a product of the photographer's intimate knowledge of his home environment in Finland. He knew the pond, looked into it most days, knew what would happen to the seedpod as the autumn nights turned freezing and when the sun would be out but not warm enough to melt the ice creation.

Paavo Hamunen
Finland 1997

Acid-water lilies

To take such a perfect picture from under the water without rippling the mirror of the surface requires both diving and photographic skills. The white water lilies are illuminated with an ethereal light, but there is something sinister about the picture, hinted at by the clarity of the water. It's a fish-eye view, but there are few fish in this and many other of the Swedish lakes that the photographer swims in. Acid rain – rain polluted with particles blown north from factories in Europe – has killed much of the plankton in the lake water, and so hardly any animals remain, mainly dragonfly nymphs, leaving plants such as these water lilies as the survivors.

Fredrik Ehrenström *Sweden 1998*

Illuminations

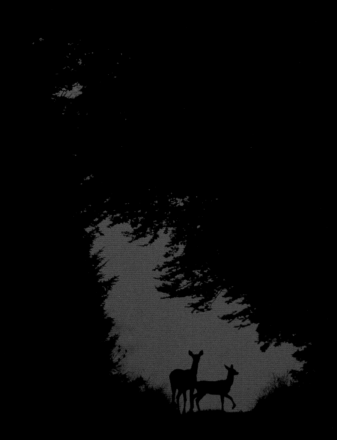

Doe and fawn
at dusk

The dark tunnel of trees
creates the drama of this picture:
two prey animals and the hidden
approach of a predator.
The doe strains to see what is
moving in the forest. Her
nervousness, ears forward and
body taut, and that of her fawn,
its leg poised for flight, are
obvious from just their
silhouettes. The encounter, in
the Côte-d'Or region of France,
was a chance one, but the
photographer saw the potential
and stalked the red deer until he
had framed the perfect picture.

Daniel Magnin *France 2002*

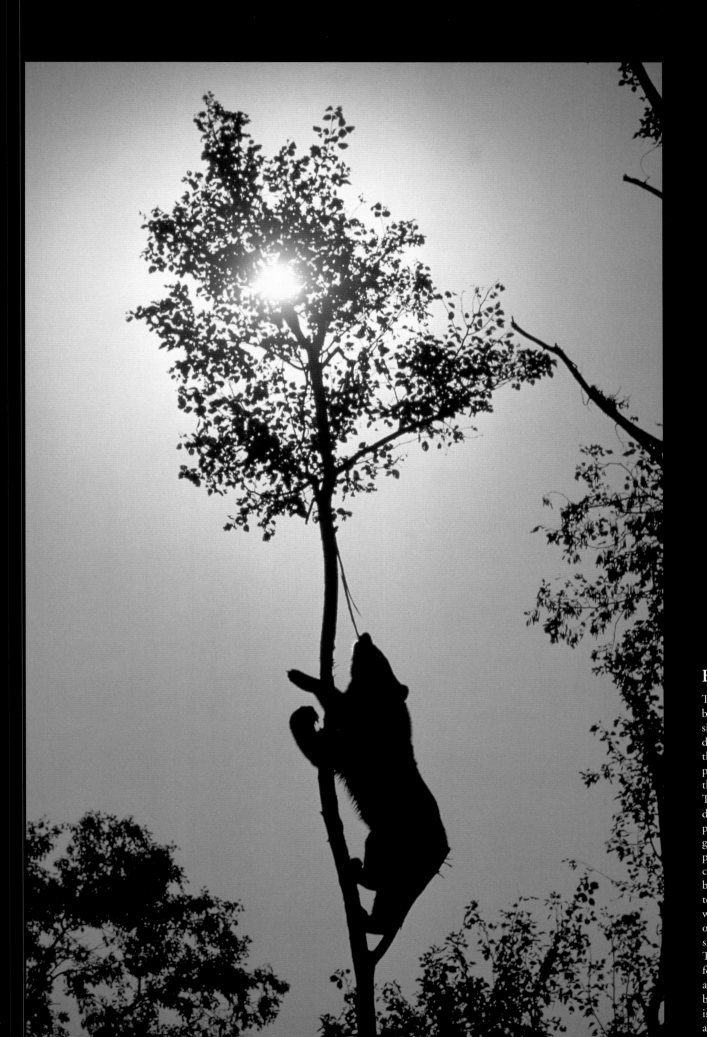

Balancing act

This is a picture of contrasts, between the light and the dark silhouettes and between the delicacy of the young tree and the heaviness of the bear perched precariously – at exactly the right angle to strip the bark. The bear was so intent that it didn't notice the approach of the photographer, who had time to get into just the right position to place the sun behind the tree and create a sunburst. The Himalayan black bear was probably after the termites and other insects that would have been under the bark or being a young animal, it may simply have been having fun. This dawn encounter in the foothills of the Himalayas was a chance one, but made possible because of the photographer's intimate knowledge of the area and his seasoned fieldcraft.

Bison aurora

The low-angle viewpoint, upward sloping ridge, illuminating backlighting, freezing temperature and defrosting warmth of the early-morning sun together create a picture of mystical proportions. The setting is Yellowstone National Park in Wyoming after a night when the temperature had fallen to -26°C (-15°F), coating the bison in hoar frost. The photographer knew when and where to be in position and braved the cold to catch the moment when the sun was at precisely the right angle and the steam rising from the bison's coat had formed an aurora of refracted light.

Mervin D Coleman

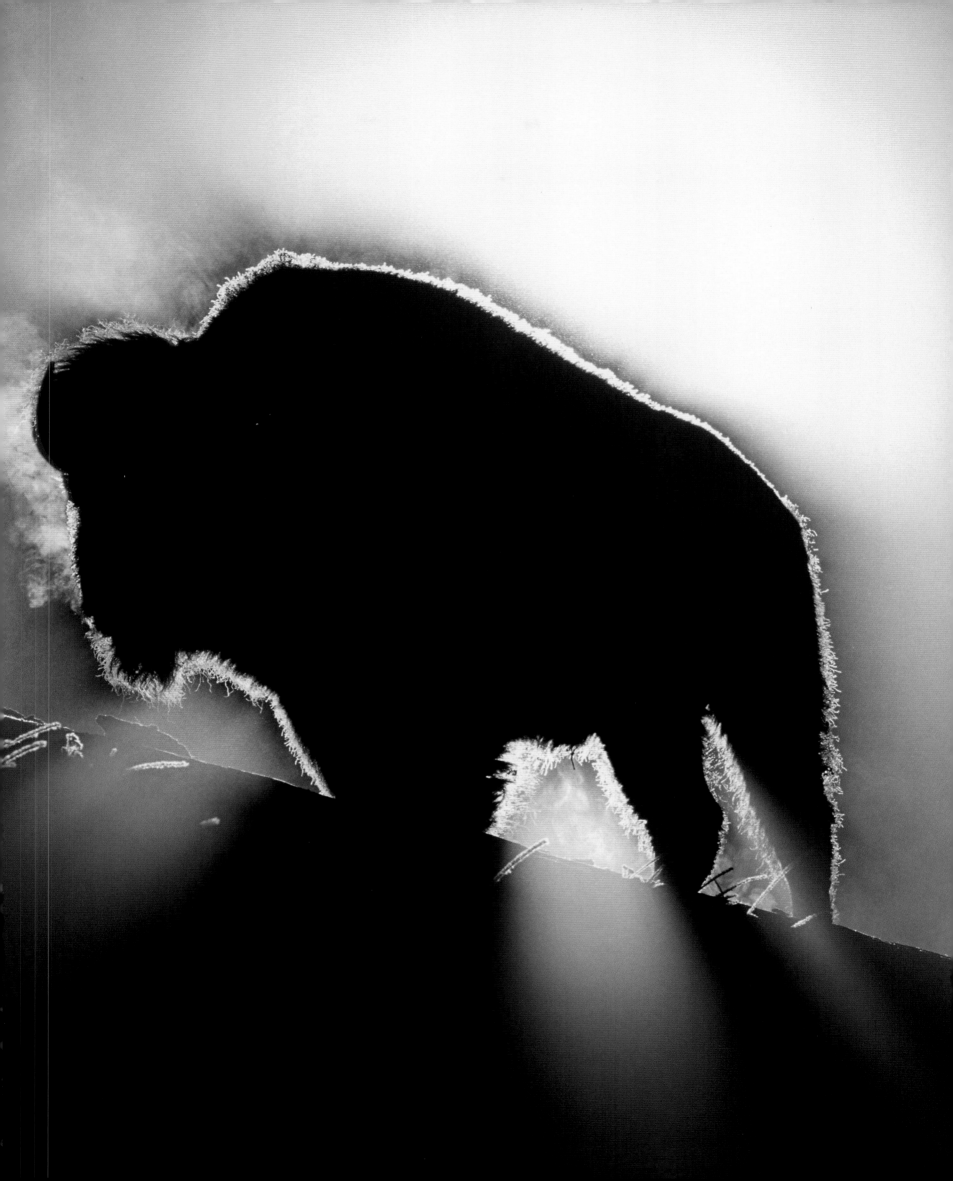

Illuminations

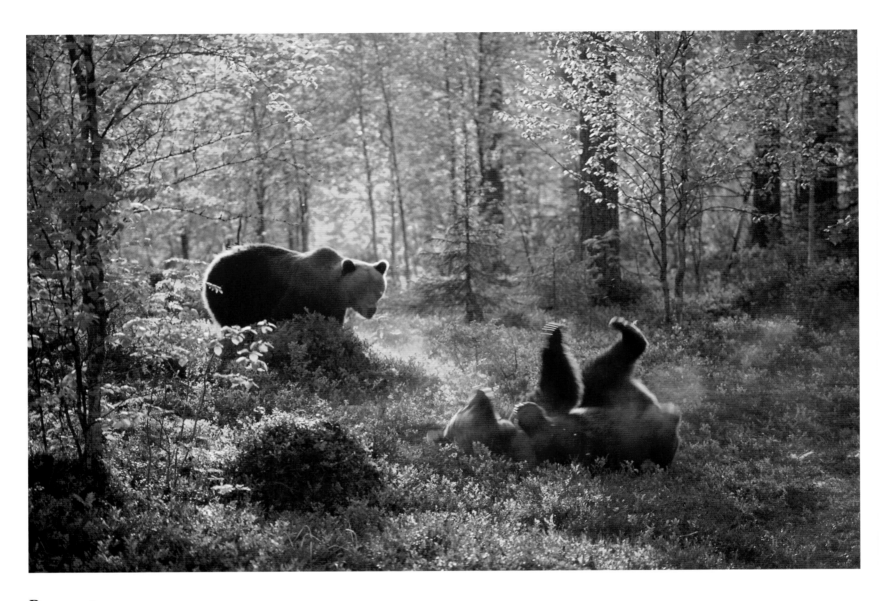

Bear ecstasy

Ecstasy is what a male bear feels
when rolling on something
exceedingly smelly, such as
carrion, in front of a receptive
female in a peaceful forest glade
(oblivious, of course, of the
photographer in his hide).
It's an intimate shot, taken at
the height of spring by someone
who knows and loves brown
bears and spends much of his
time camped out in the forests
of Finland. It's made all
the more perfect by the
early-morning sun highlighting
the mosaic of fresh leaves and
irradiating the moving scene.

Eero Kemilä *Finland 1997*

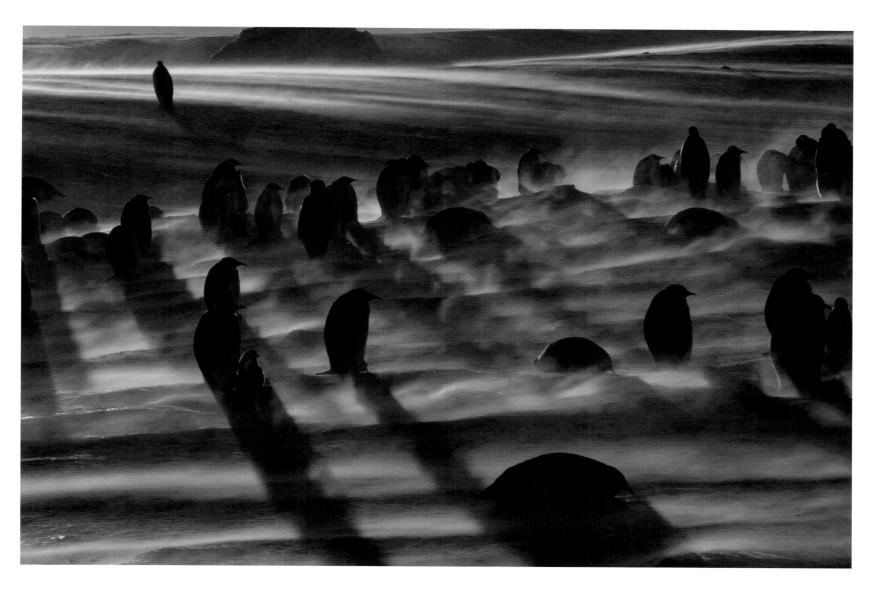

Emperors at sunset

It's an otherworldly scene: penguins basking in desert sunlight. In reality, the emperors and their chicks are huddled on snow-covered ice, backs to a bitter Antarctic wind, one brave individual marching into the sunset. Criss-crossing shadows and the low sun of late winter give this remarkable picture its painterly feel. To get such a shot took a month living on the ice in snowstorms and gales at the edge of the Weddell Sea. The penguins, though, had to endure such conditions far longer before they could escape back to sea.

Frans Lanting *USA 1996*

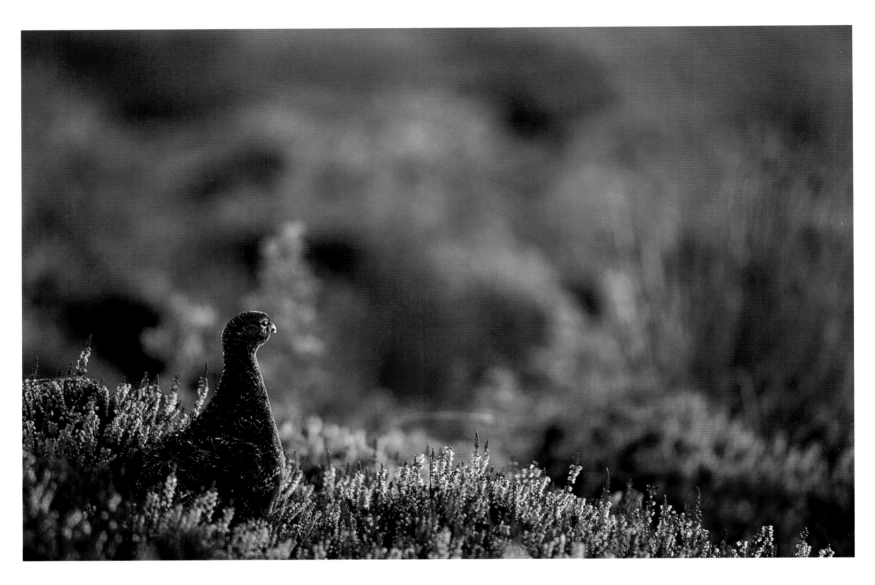

Grouse in heather

There is subtlety to this picture: subtle light, just illuminating the breast of the grouse and the heather around its breast; subtle blending of colours, the feathers matching the pattern of the heather; subtle focus on just the head of the bird throwing the background into a blur of pink and green. The framing has made the grouse the subject but used its gaze to make us, too, look out over the heather. It encapsulates the essence of summer on the North York Moors, captured by a photographer with an eye for simple beauty.

Roy Glen *UK 1998*

Seahorse in kelp

Under water, artificial lighting is necessary to overcome the water's blue-green filter and bring colour to a picture, but the way the lights are used is all important. Here the Tasmanian pot-bellied seahorse is illuminated as if posing in a studio, against the frond of a giant kelp more beautiful than the creation of any human artist. Though the seahorse's face is sharp, its eye trained on the photographer, there is also a sense of the movement of the water, created by its rippling fin and the curves of the seaweed fronds. From a fish's point of view, though, the real scene would be very different: it would be a study in yellow and green, the seahorse perfectly camouflaged among the seaweed.

David Hall *USA 2000*

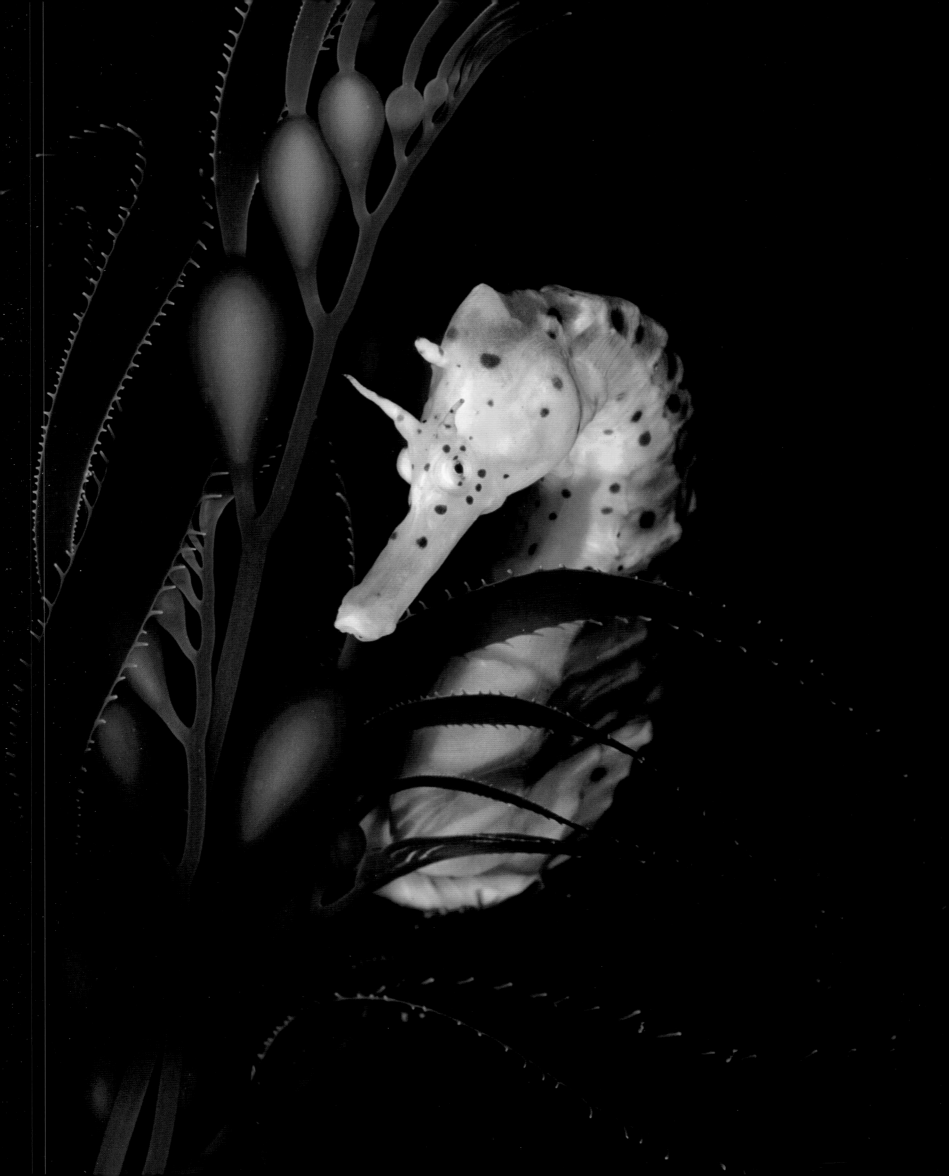

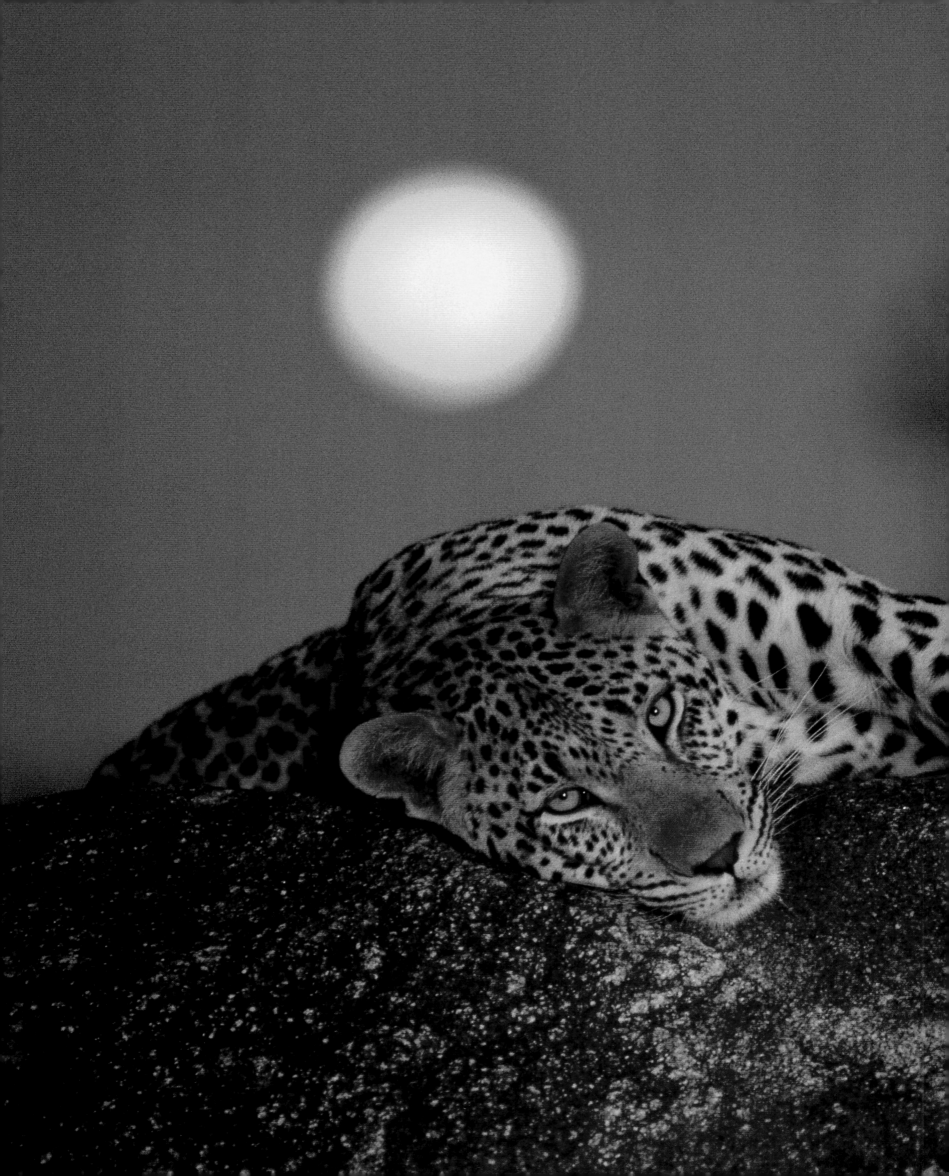

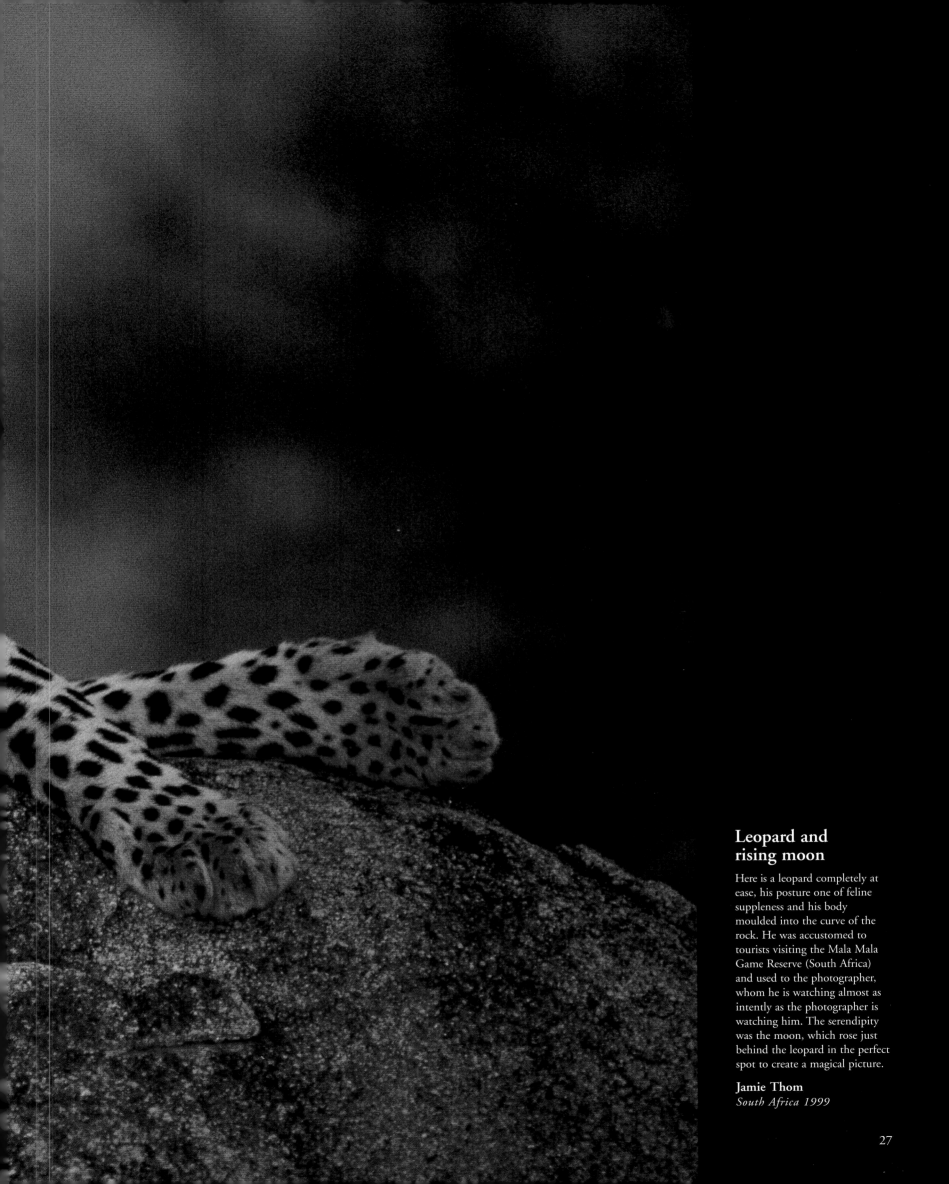

Leopard and rising moon

Here is a leopard completely at ease, his posture one of feline suppleness and his body moulded into the curve of the rock. He was accustomed to tourists visiting the Mala Mala Game Reserve (South Africa) and used to the photographer, whom he is watching almost as intently as the photographer is watching him. The serendipity was the moon, which rose just behind the leopard in the perfect spot to create a magical picture.

Jamie Thom
South Africa 1999

27

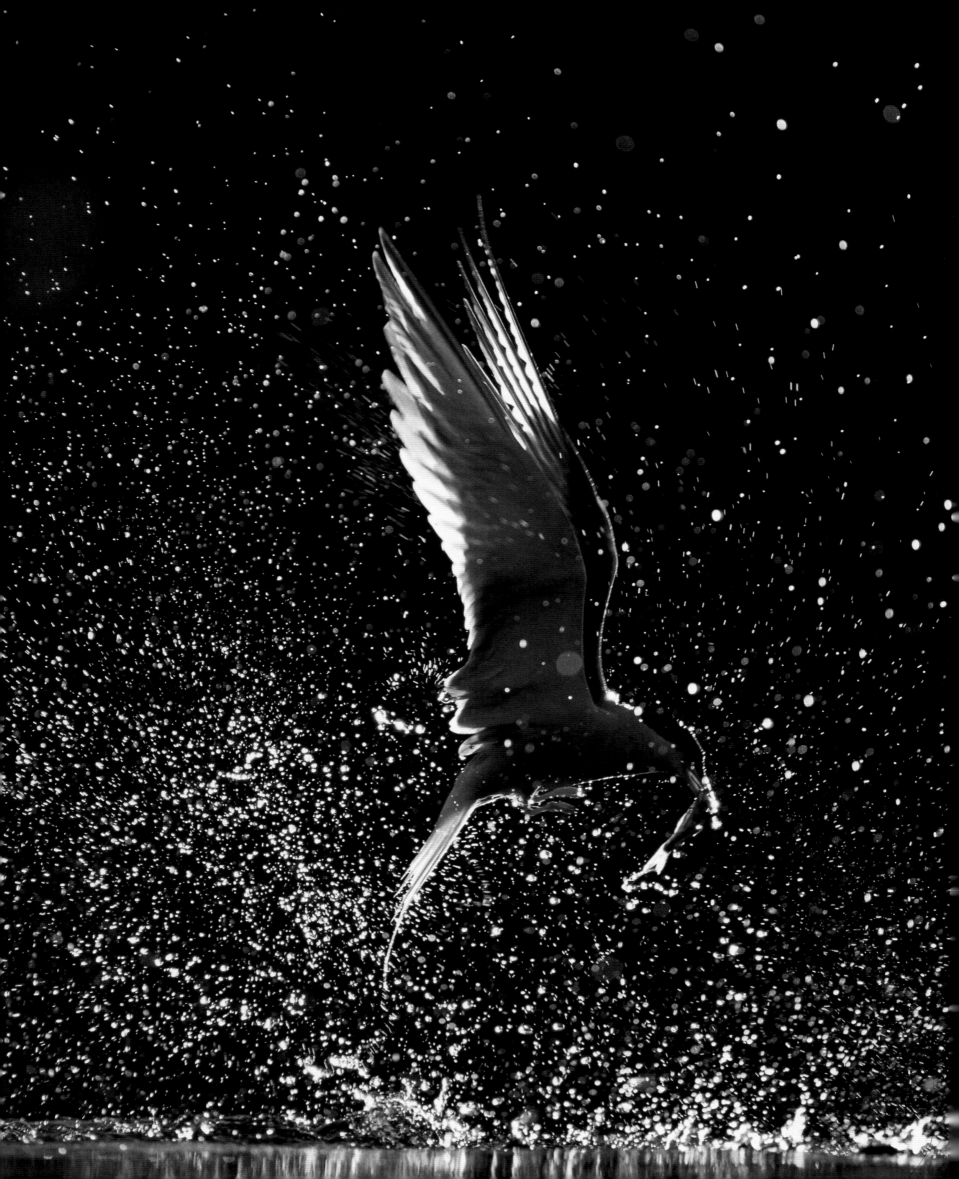

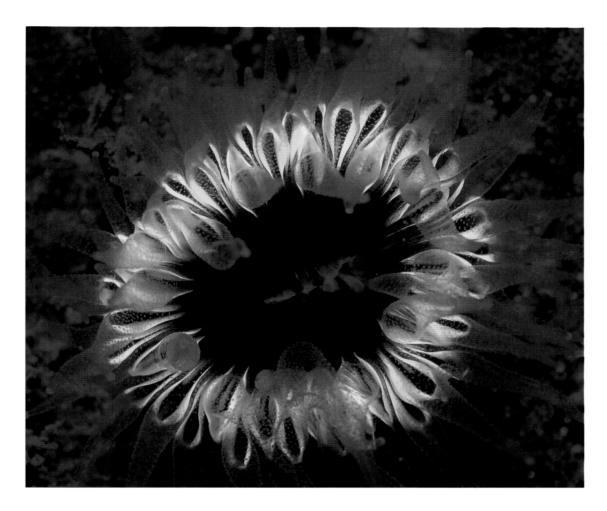

Light of the sea

Only people who dive experience
the true richness of the colours of the sea,
and it's only relatively recently that anyone
has captured the magical colours of
animals that fluoresce. Using special
lighting techniques, the photographer has
managed to illuminate the beauty of
a fluorescing brown cup coral set against
the rich blue of its non-fluorescing parts.
Different individuals have different
strengths of colour, and this one, in
Monterey Bay, California, is particularly
bright. The reason for the fluorescence
and exactly how it is achieved remain
a mystery, but the light may be protective
in some way, either physiologically or by
warning away potential predators.

Dan Welsh-Bon *USA 1998*

Heavenly splash

This extraordinary portrait of a common tern has been caught at
the precise moment of ascent, the delicacy of the detail illuminated.
The golden evening sun is reflected in its wings and off the shower of
sparkling water droplets. The slither of glowing, reflective water below
acts as a foil to the drama of the frozen action. The picture is the
product of years of watching and photographing the wildlife around
a lake close to the artist's home in southern Finland.

Tapani Räsänen *Finland 1997*

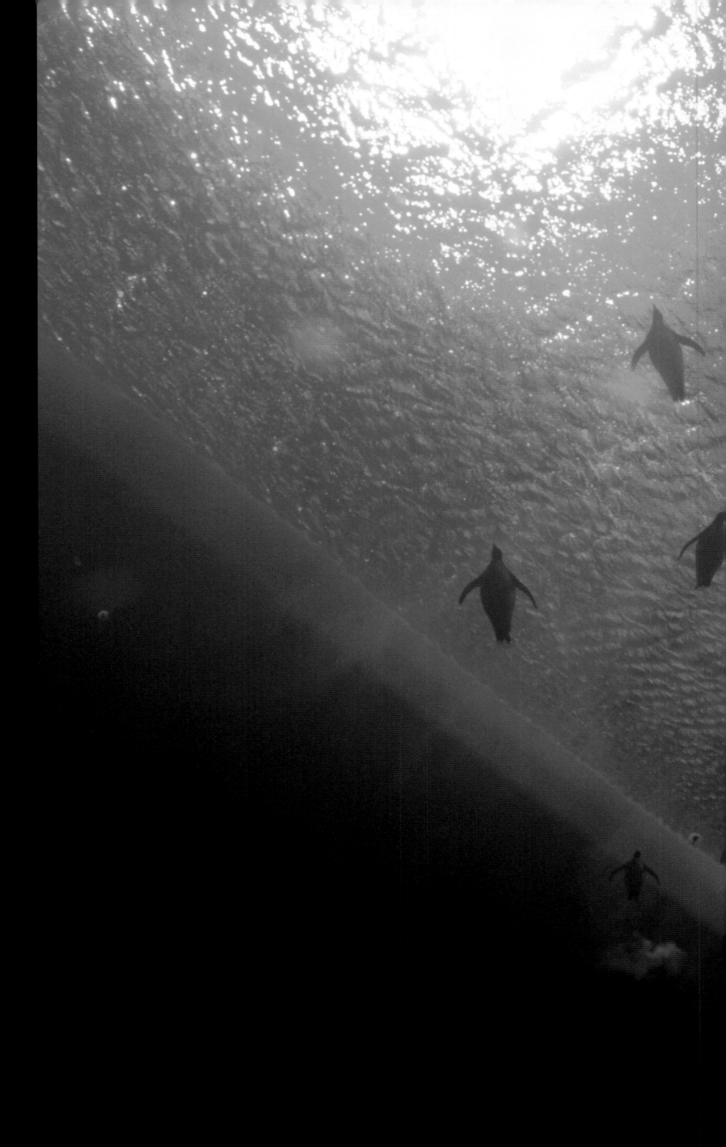

Emperors in their element

A break in the ice provides the dramatic frame for this shot of emperor penguins flying through the clear Antarctic water, backlit against the sky. Such an unusual perspective helps convey a sense of their supreme swimming skills. These streamlined aquabats hunt in groups, partly as a way of minimising the individual risk of being caught by their arch-enemies, leopard seals, and are capable of diving to more than 500 metres (1,640 feet) and holding their breath for nearly half an hour. Very few photographers witness their behaviour under water, as diving below the ice in freezing Antarctic water requires considerable back-up. But for those determined enough, the rewards are great.

Norbert Wu *USA 2001*

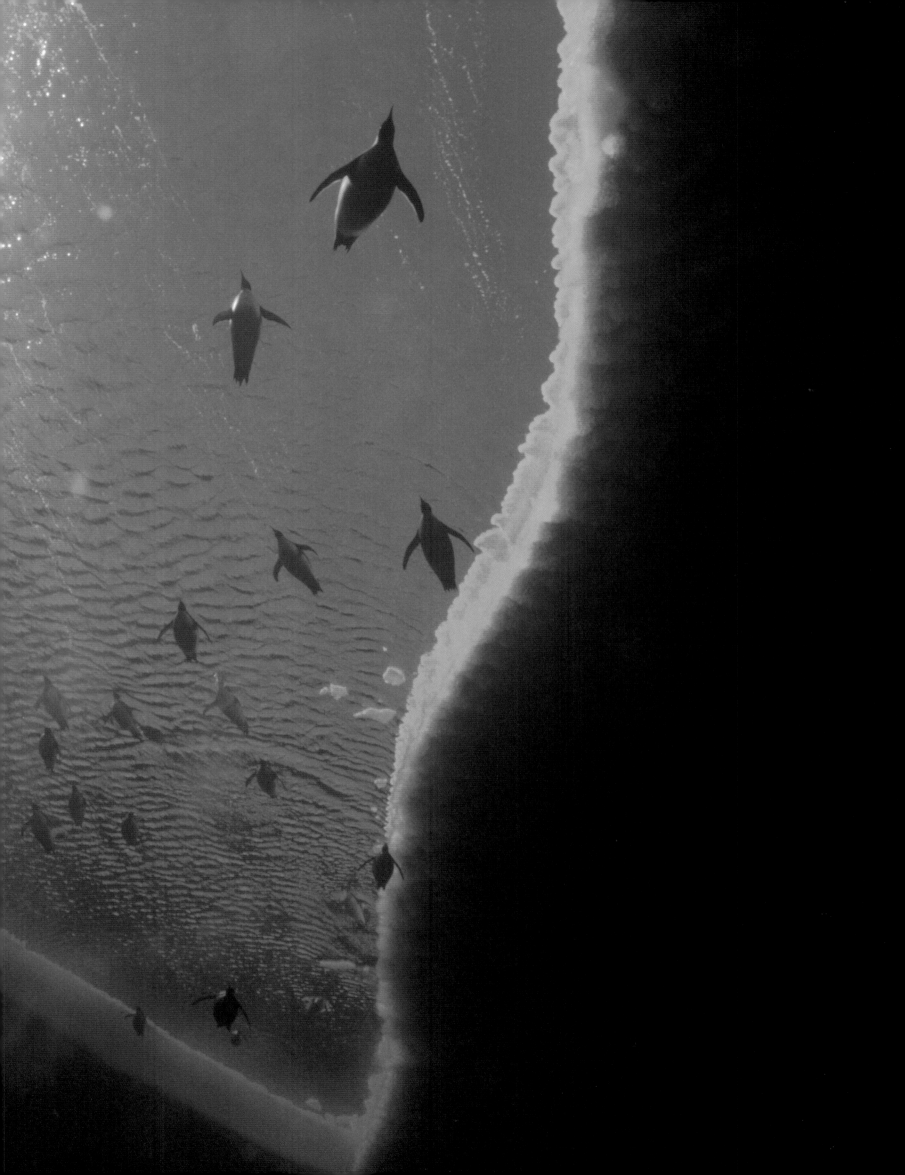

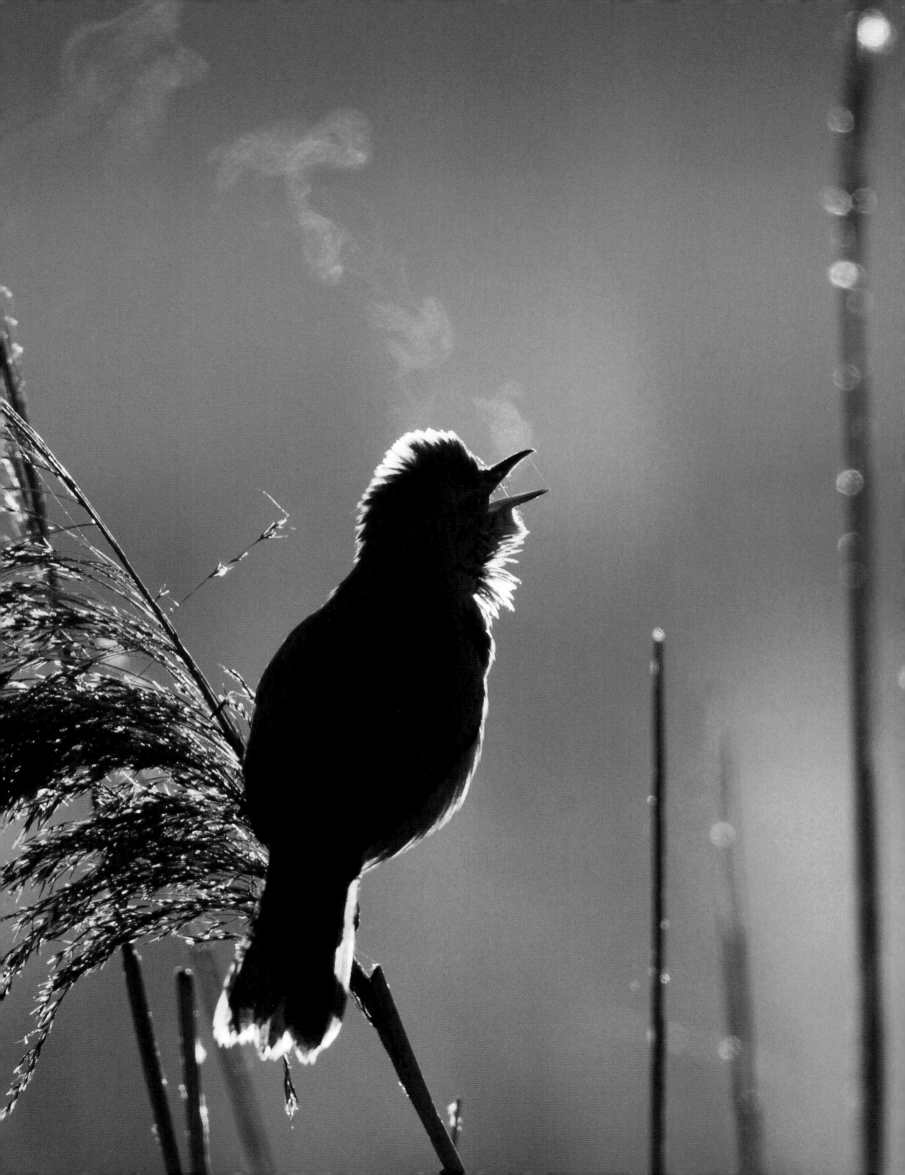

Rainbow shell

This is a simple, playful picture, composed on a day when the photographer was confined to his studio. It began as contemplation of a shaft of light passing through bevelled glass in the studio window and casting a rainbow on the floor. He placed a favourite shell in the spotlight, played around with the resulting colours and textures and chose this as his painting in light.

Kevin Schafer *USA 2002*

Song breath

To see a great reed warbler among a forest of reeds is difficult enough, but to photograph one requires planning and great patience, even though the strident song of a male trying to attract a mate is hard to miss. In this picture, taken in the swamps of Kiskuunsagi, in Hungary, the photographer has managed to capture not only a male on his song post, high up on the top of a reed, but also the signature of the song itself, illuminated in his breath in the cold morning air. The backdrop of early-morning sunlight is the gilding on this glorious shot.

Jan Vermeer *The Netherlands 2004*

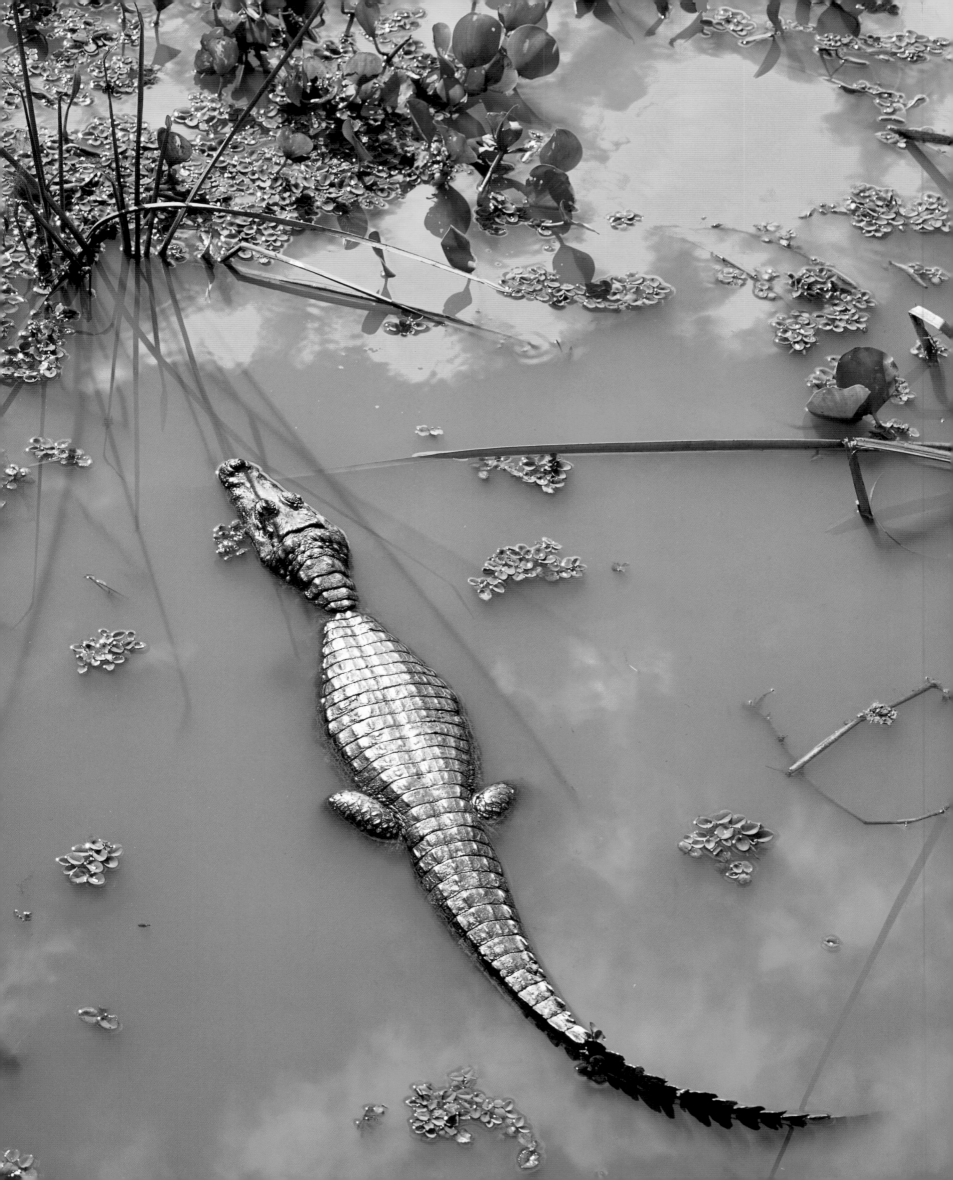

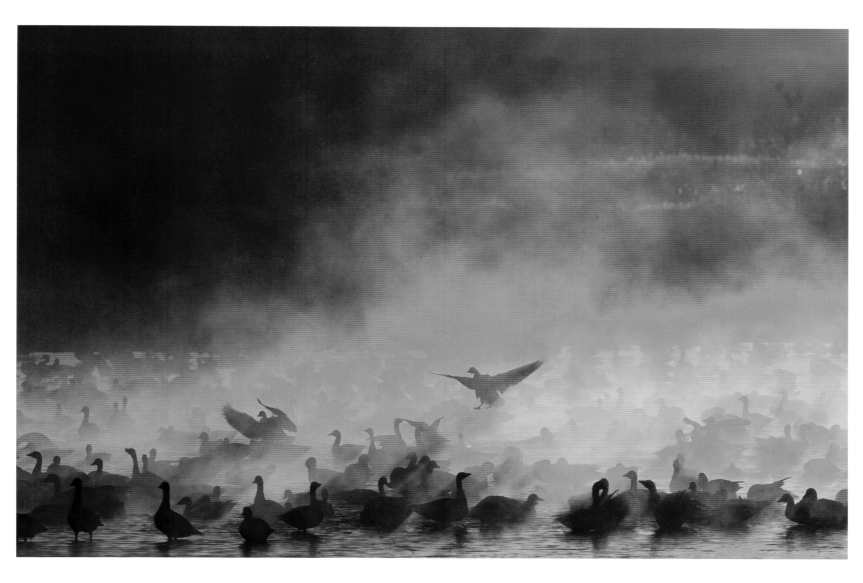

Golden caiman

Sometimes the best pictures are the simplest. What's required is
the vision to see them. This Yacare caiman, in the Pantanal wetlands of
Brazil, was lying motionless in a pool below an elevated road that
provided an ideal viewing platform. The photographer saw the picture,
waited for the light to be at the right angle as the sun started to go down
and used a polarising filter to enhance the golden glow.

Howie Garber *USA 2004*

Burning of the mist

To get such a picture took more
than 200 days of photography
over eight winters in Bosque del
Apache National Wildlife Refuge
in New Mexico – the famous
wintering site for 30,000 or
more snow geese. In all that time,
the photographer only twice
witnessed a scene like this, when
heavy mist rising from the water
was irradiated by the early-
morning sun, enveloping the
waking geese in a celestial glow.

Arthur Morris *USA 2001*

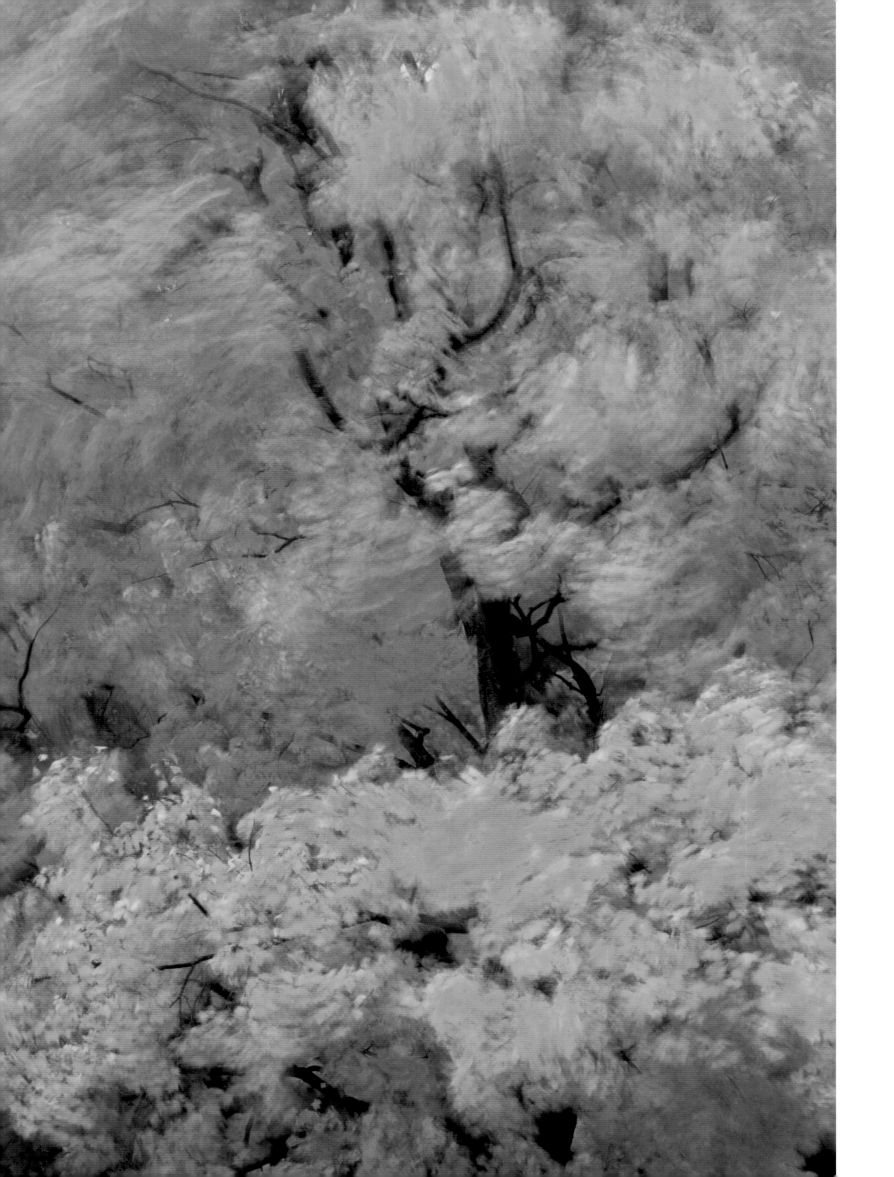

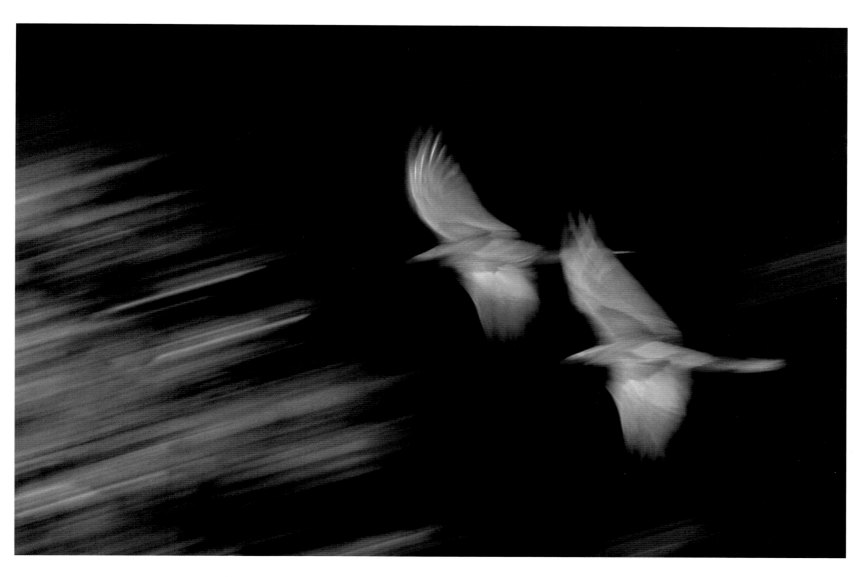

Maple in the wind

Here the photographer set out to let the wind be the brush and to paint an abstract of movement with the autumn leaves of a sugar maple near his Wisconsin home. It took just two seconds for the picture to be created once the subject had been found and the frame decided on, transforming the tree into swirling masses of colour.

Larry Michael *USA 2004*

Military fly-past

The photographer set out to capture the essence of these spectacular macaws. He was in the Cuicatlan Biosphere Reserve in Mexico, where a colony of military macaws survives, using his photography to raise awareness of the reserve and the plight of these endangered parrots. He was therefore familiar with a canyon used by the macaws when commuting between their breeding ledges and the forest. Slowing the shutter speed and panning the camera to create a sense of speed, he took the shot just as the macaws entered the frame so that the blur of sunlit cliff ahead would add to the forward-flowing movement.

Claudio Contreras Koob
Mexico 2002

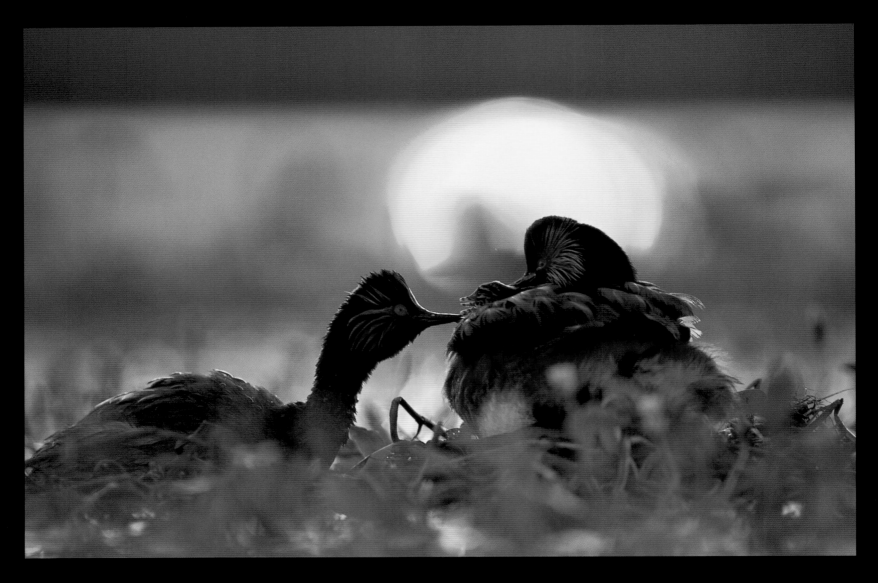

First feed, setting sun

A parent offers one of its two newly hatched chicks a tiny insect – an intimate act seen by few people, as black-necked grebes are secretive and rare in Britain. To get close enough to their open-water nests requires both a licence and great determination. Unfortunately, egg-collectors are also determined, and every season, the photographer has to guard this Northumberland colony. He uses a camouflaged, floating hide and stands sentinel chest-deep in the water. When he witnessed this scene, it was 11pm, and the only way to take a picture was to get down to nest level and line up the reflection of the setting sun behind the birds. The soft glow proved the perfect illumination for such a delicate interaction.

Rob Jordan *UK 2002*

Rosebay summer, dancing midges

The gentle, warm light, the golden hovering midges and the soft-focus flowers conjure up the essence of a delicious summer evening. Rosebay willowherb blooms in late summer in Sweden and covers fields, woodland edges and clearings in great swathes of vibrant pink. For the photographer, it's the flower that symbolises the exuberance of wildness.

Peter Lilja *Sweden 2002*

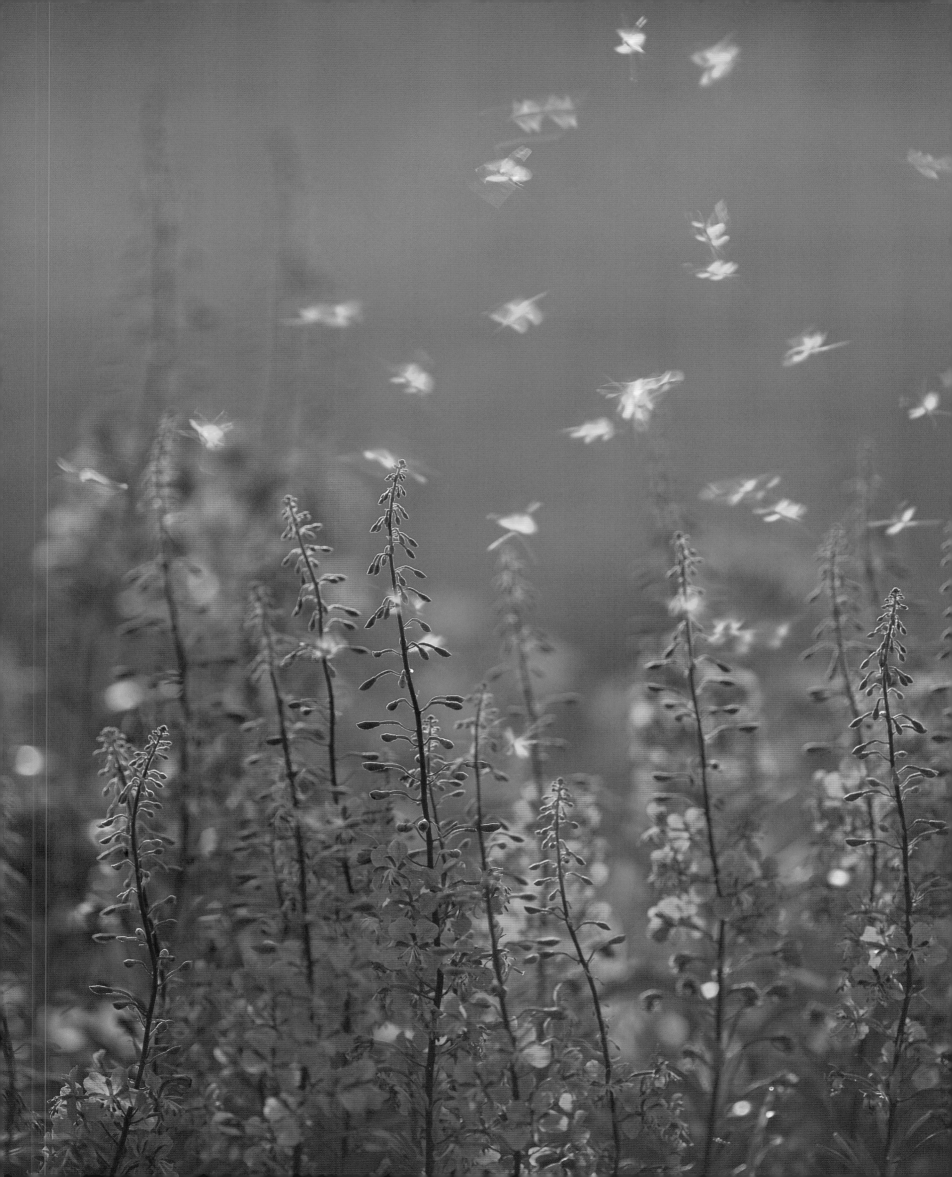

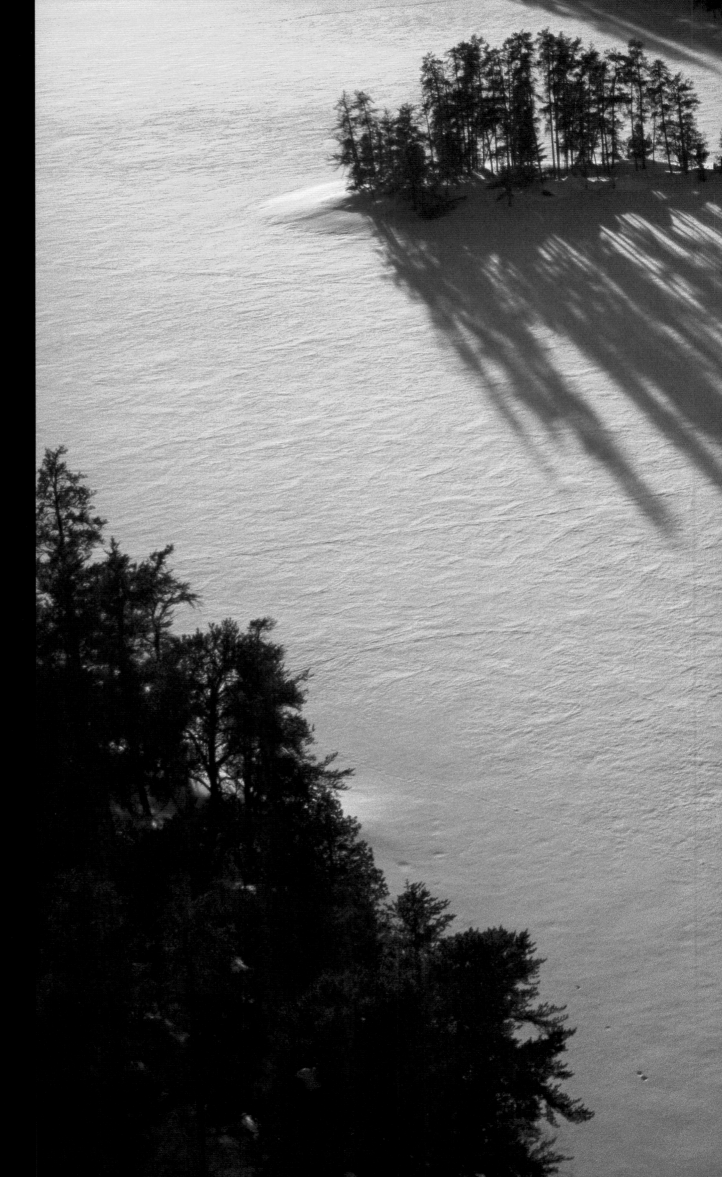

Illuminations

Wolf highway

A frozen lake in Minnesota provides the ideal highway for these wolves, enabling them to travel 80 kilometres (50 miles) or more on a night's hunting trip. The aerial view not only creates a sense of the vastness of the wilderness but also allows an intimate glimpse of a pack in its element. The wolves were used to being tracked by plane as part of a study. Low winter light has created long shadows that sweep across the ice and create a feeling of forward movement as the evening hunt begins.

Joel Sartore *USA 2001*

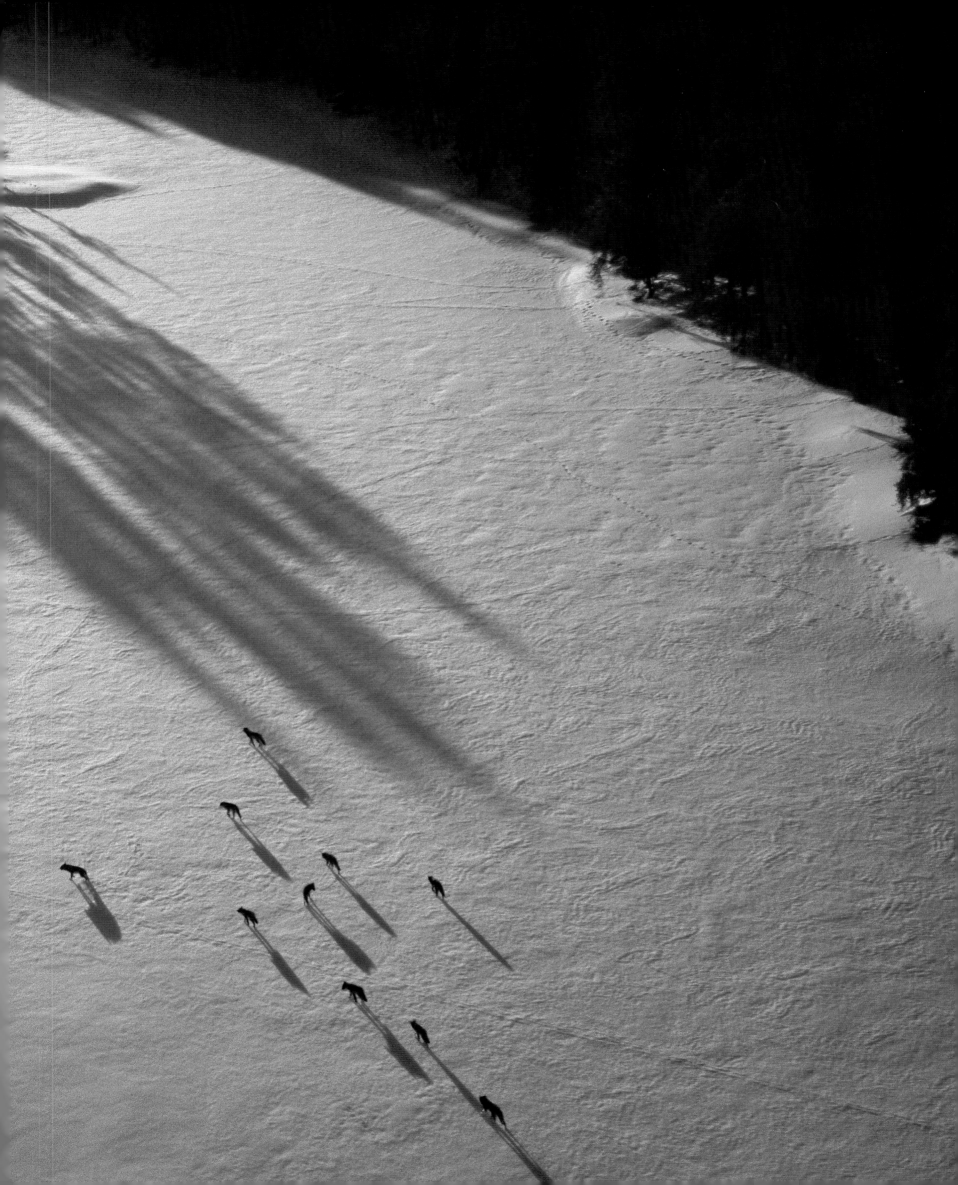

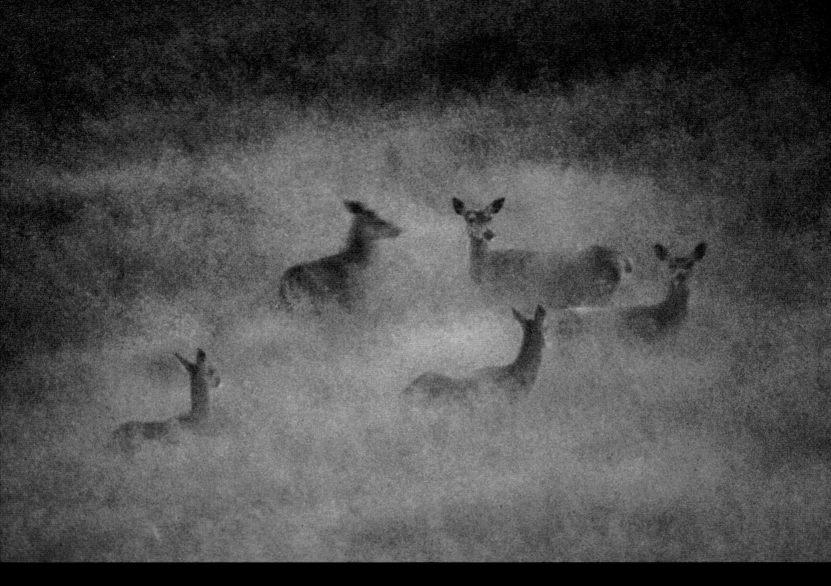

Deer at midnight

Here is a portrayal of deer as few
see them, resting at night in
a field of long grass but alert for
the danger they can't see.
The photographer deliberately
chose a night when the mist was
thick and used very fast film to
create the grainy image he
wanted of animals just glimpsed.

Pål Hermansen *Norway 1994*

Beluga watch

Belugas can't resist coming up for a look at a singing, snorkelling
human. Here they circle gracefully under the spreadeagled photographer,
who is singing softly into his mask. Tilting their heads upwards to
scrutinise him, they click, squeak and twitter to each other. Light from
above illuminates their white bodies against the gloom they have
emerged from – deep water in the Canadian Arctic.

Doug Allan *UK 2002*

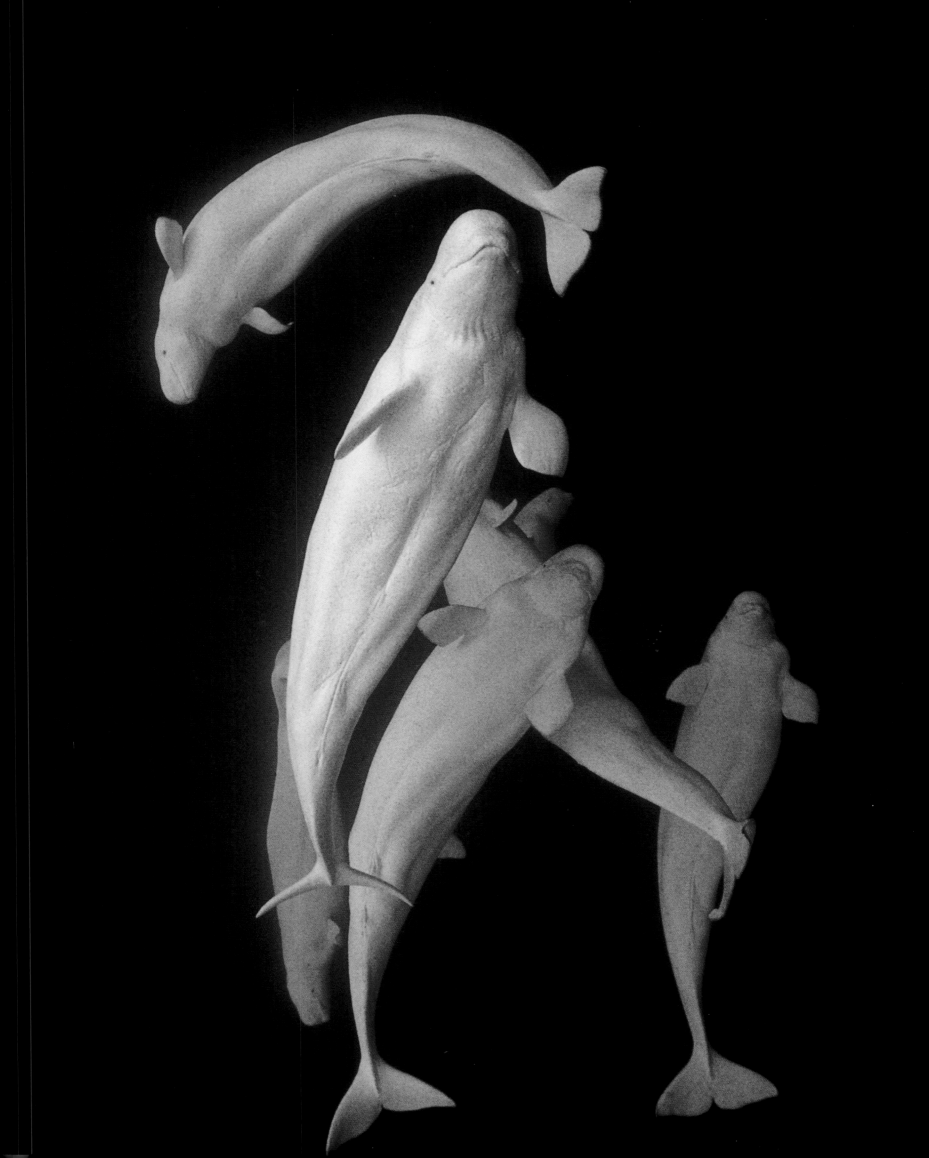

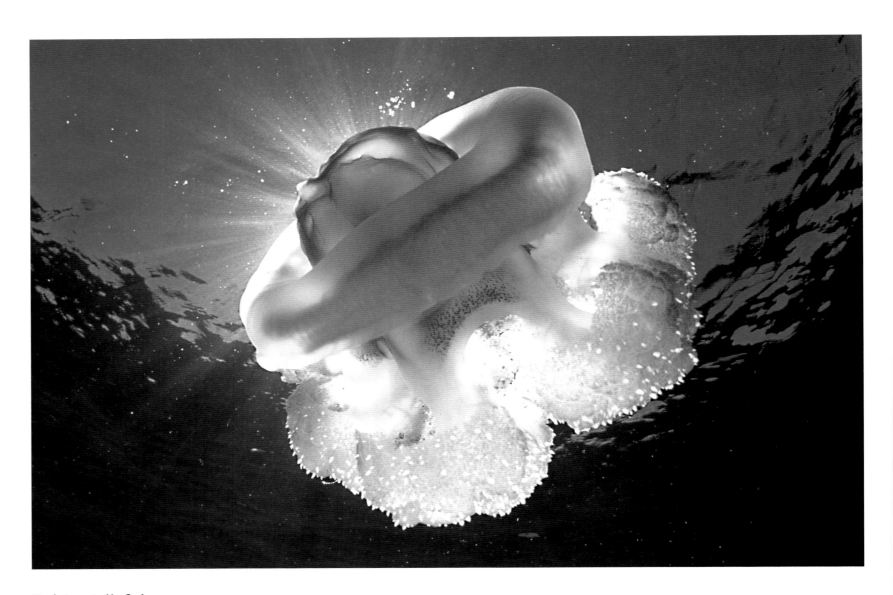

Pulsing jellyfish

Mesmerised by the slowly pulsing crown jellyfish he saw drifting past his dinghy, the photographer slipped into the water off the South Pacific island of Niue and drifted with it. The jellyfish was as wide as the length of his forearm and was glowing in the light filtering down. To capture in a photograph something of the ethereal nature of the strange animal, he dived under it, underexposed the image to place the surroundings in darkness – allowing the sky to glow through – and used flash to bring out the colour and detail. The only thing he failed to do was notice just how long he had been in the water and that he had drifted far from his dinghy.

Pete Atkinson *UK 2003*

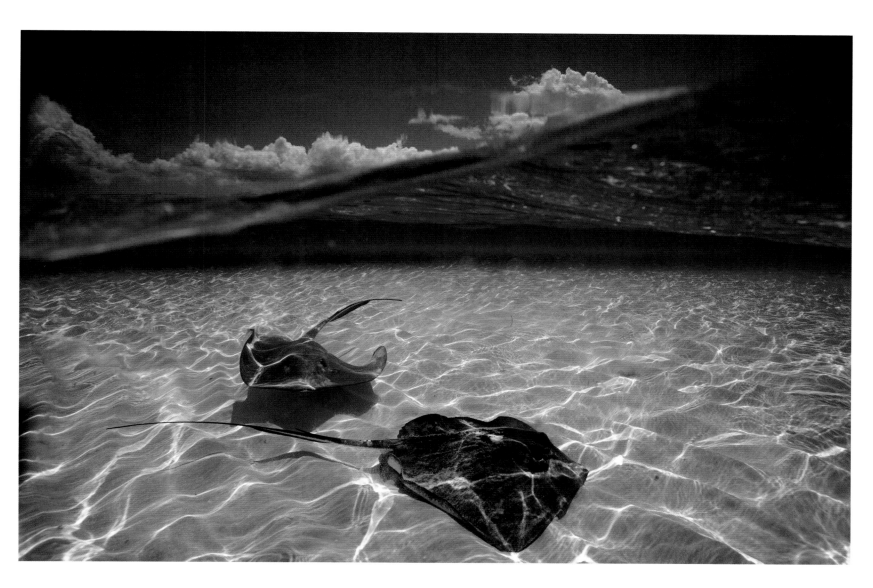

Stingray elegance

This is one of the most famous pictures of the world's most famous stingrays. The innovative photograph brought to international fame a group of about 30 southern stingrays that live on a sandbank off Grand Cayman and are unafraid of humans, approaching divers and snorkellers to be hand-fed. The use of a split-diopter lens created the split view: the skies of the aerial world and the shallows of the underwater one. Light reflected at the interface onto the sand creates a sense of the rippling movement of both the water and these graceful winged creatures as they glide towards the photographer, giving them an almost bird-like appearance.

David Doubilet *USA 1989*

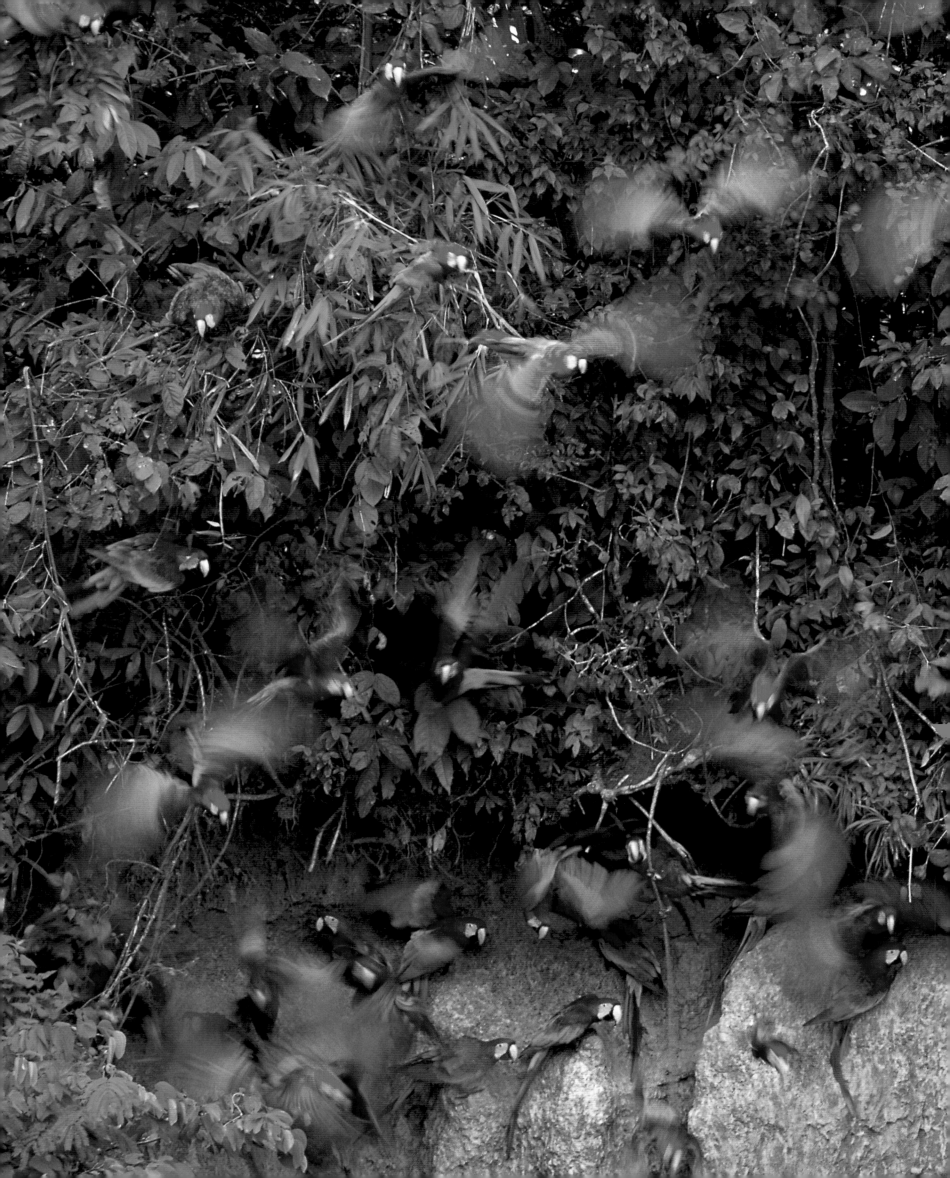

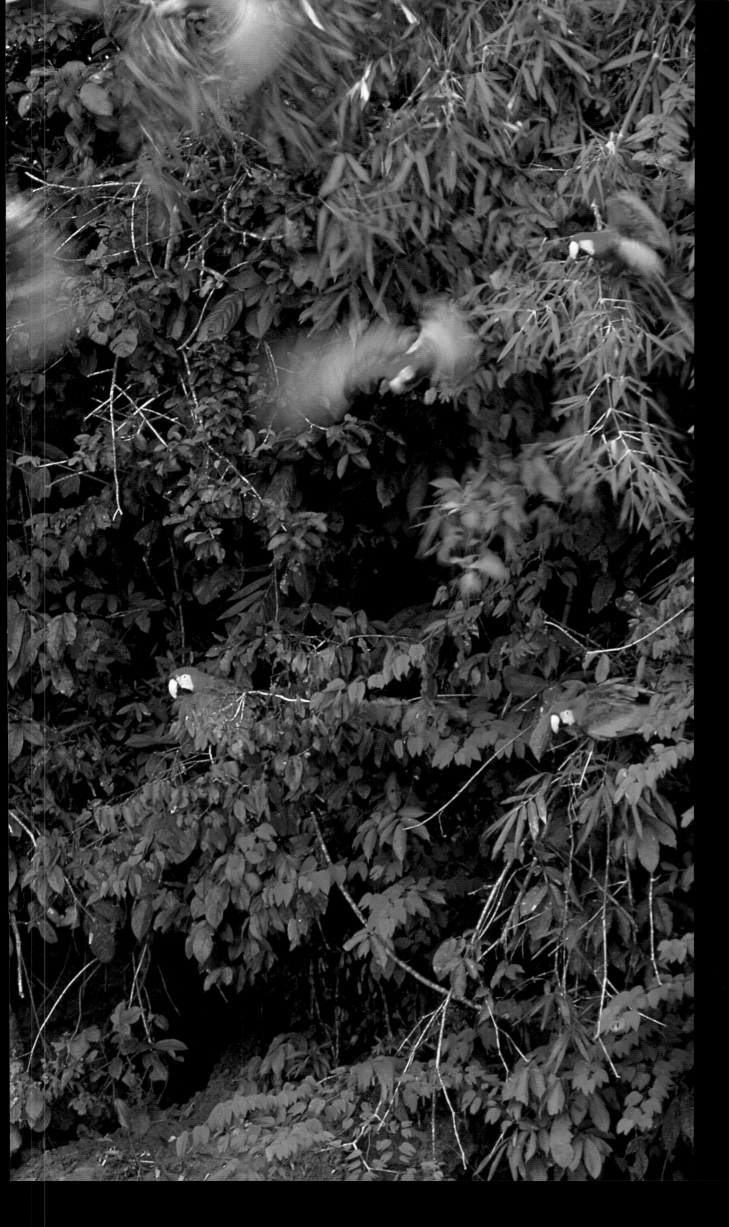

Mining macaws

The beauty of this picture is in the movement – the blurs of colour against the lush green background and the whirling of the birds around the focus, an area of exposed clay on the riverbank. The scene was enlivened by a continuous, raucous chatter between the red-and-green and scarlet macaws, which took turns to fly down and grab beakfuls of clay. They need the clay to neutralise the toxins they ingest with the seeds they eat in Peru's Manu National Park. The macaws arrive every morning at the clay mine, but to photograph the scene required many hours waiting in a hot and humid hide on the opposite bank and arriving before sunrise to avoid spooking the ever-watchful, highly intelligent birds.

André Bärtschi
Liechtenstein 1992

47

Illuminations

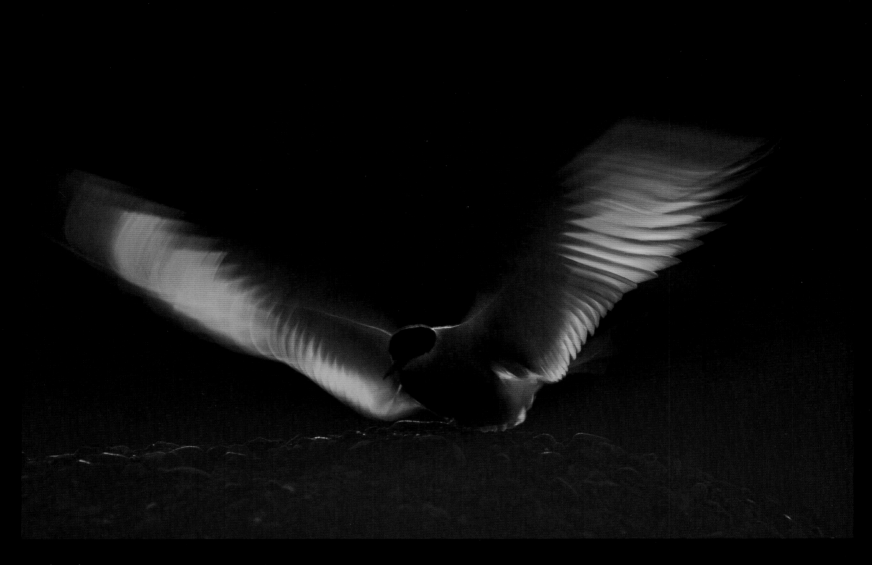

Midnight tern

The photographer had dreamed
of taking such a picture. But to
get it took four trips to Iceland
in summer, when the Arctic terns
arrive to breed and the sun never
sets. The backdrop was a sand
dune in deep shadow, caused by
the midnight sun just touching
the horizon. The timing had to
be precise – the moment when
the tern touched down – and the
positioning exact, so that the sun
was directly behind its wings.
A slow shutter speed created the
final effect, capturing the
movement of the sunlit wings
like a series of brush strokes.

Anders Geidemark
Sweden 1998

Sunbeam on a toadstool

Here is a magic stage – a mysterious forest floor, littered with strange
mounds and covered with a carpet of moss. Dark tree trunks create
a sinister backdrop. But the focus is the tiny destroying angel toadstool,
spotlit by a sunbeam. The picture was a matter of luck and foresight.
The photographer had planned an image that would reflect the
atmosphere of the forest, a Swedish nature reserve, and had framed the
shot he wanted when a beam of sun broke through the clouds and hit
the forest floor. The shaft gradually moved across until, miraculously, it
touched the toadstool – a celestial light on an angel.

Per-Olov Eriksson *Sweden 2002*

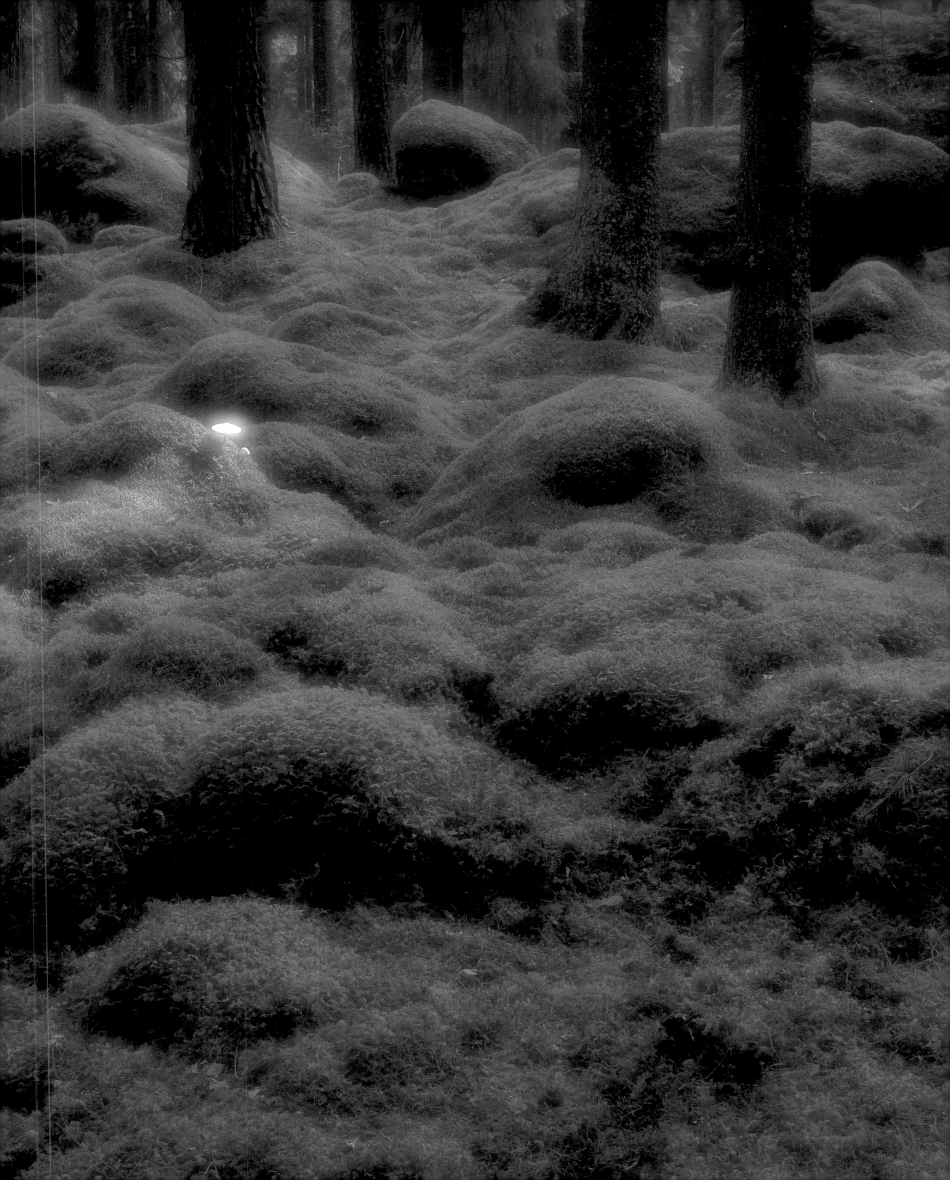

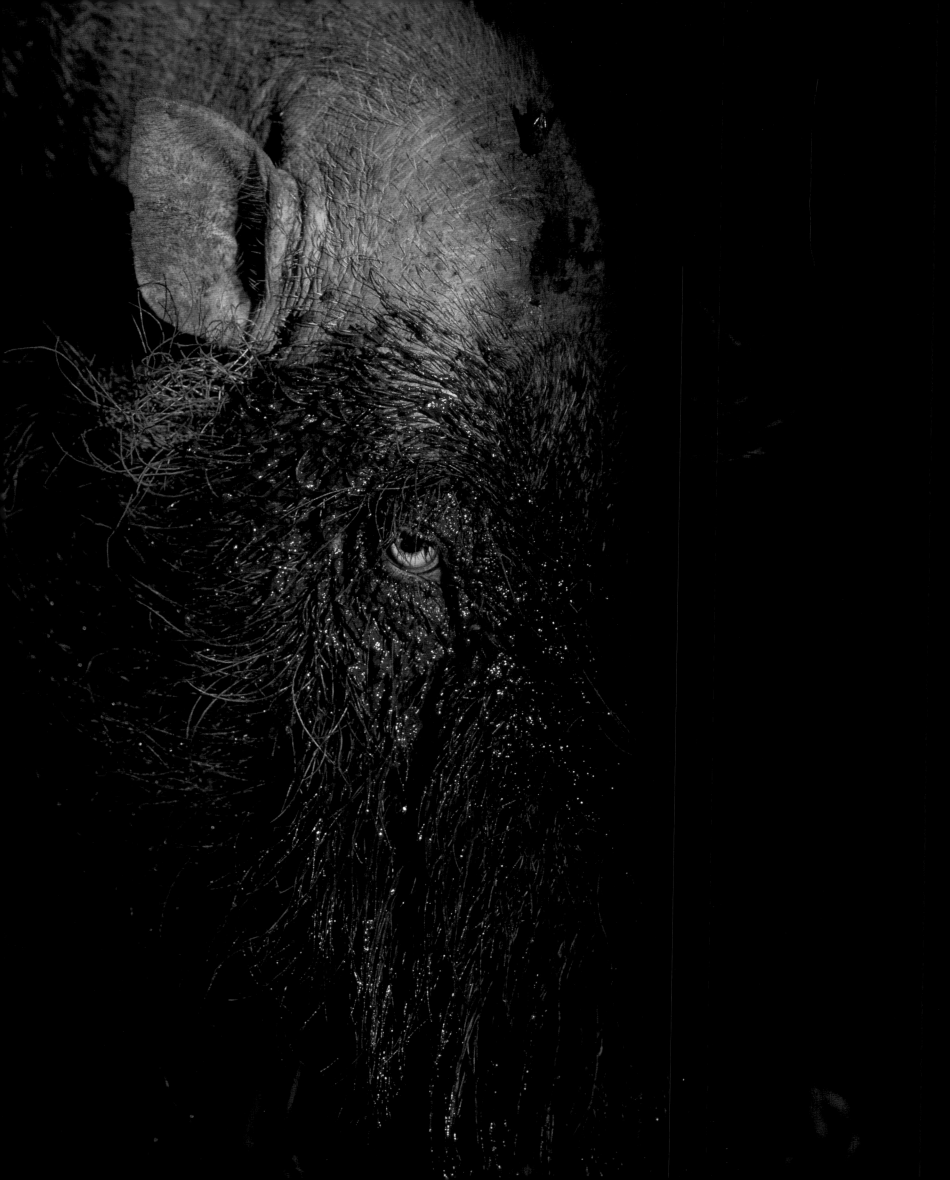

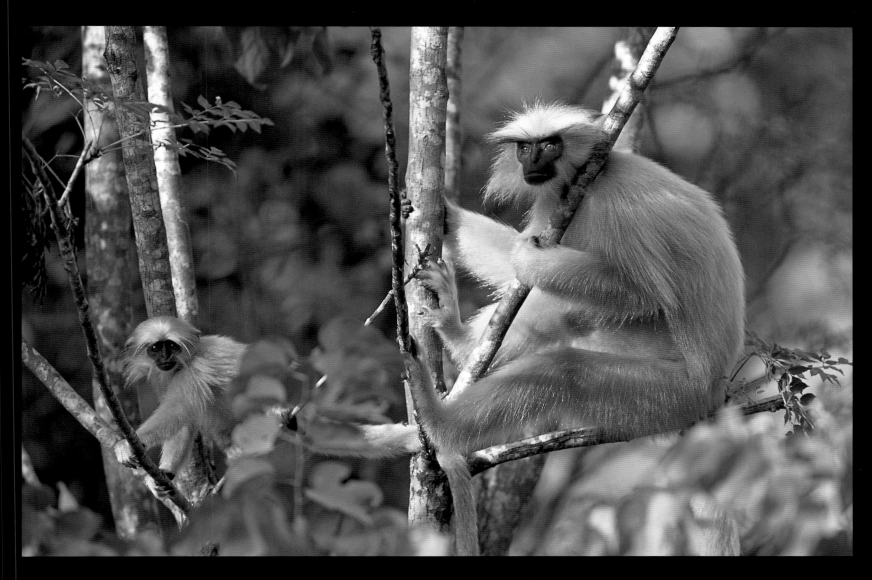

Golden leaf monkeys

This male, the leader of his troop, is completely at ease, basking in the sun filtering through the forest canopy. The adolescent by comparison is nervous, having just been usurped from the same seat. To get such an intimate view involved weeks following the troop in a forest in Assam, northern India, for up to 12 hours a day – the actual shot being taken from an overlooking rock. It's a rare picture in more than one way. These endangered monkeys now number fewer than 2,000 and are confined to forest remnants in Assam and Bhutan – much of which is being logged.

Elio Della Ferrera *Italy 2004*

Bearded pig

Late-afternoon sun filtering down through the rainforest canopy has cast a golden glow over the mud-coated head of this boar returning along a forest path from a wallow. It's a dramatic shot, created by the fieldcraft and artistic eye of the photographer, who used the contrast of light and shadow to conjure up the power of the animal. Hunted throughout their range, bearded pigs are extremely wary, and Bako National Park in Sarawak is one of the few places left in South-east Asia where it is possible to observe them. Once a year, they gather in great herds, each led by an old boar, migrating at night on traditional paths to new feeding grounds.

Stefano Unterthiner *Italy 2004*

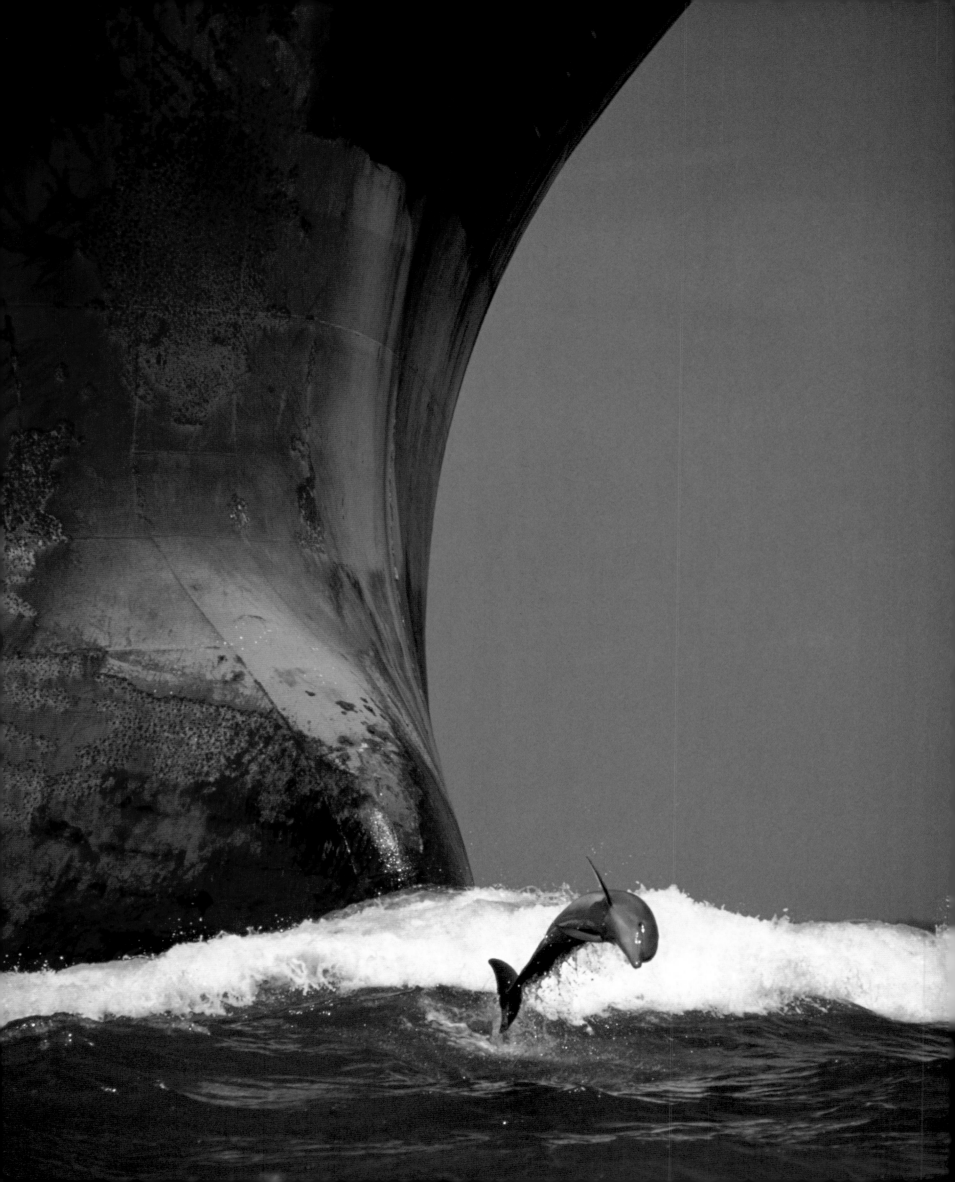

Moments

CHRIS PACKHAM

Infrequently and quite unpredictably, life deals us perfect moments.

These deeply personal events sparkle so brightly that our hearts flutter, we

draw breath, our eyes widen, and we are engulfed by a surge of awe.

They can be ignited by a smell, a touch, sounds such as words or music,

or by the sight of something beyond the vision of our everyday lives . . .

Dolphin in its element

This is a moment of pure simplicity. For sheer pleasure, a bottlenose dolphin surfs the huge bow-wave of an oil tanker. The curve of its seemingly tiny, streamlined body contrasts hugely with the sweep of the rusting iron bow ploughing through the water off an oil terminal at Port Aransas, Texas. It's a juxtaposition that makes you think.

Michel Denis-Huot *France 1997*

> *The paradox is that, while photographers repeatedly fail to see that perfection themselves, they pass it on to us to marvel at. And this book is testament to the fact, because here is a remarkable collection of perfect moments.*

. . . Occasionally it is a blend of these sensual responses that carries the moment to our hearts, but most often it is our vision. What adds to the beauty of these rare and precious events is that they cannot be created.

Even with all your desired components assembled and choreographed in a determined space and time, you cannot fabricate perfection. Favourite song, partner, perfume, place, in sunshine, rain or rainbow . . . it just won't work. Not without the ingredient of surprise to fire the magic that catches us off guard and crashes us into an instant where we can believe in perfection.

There are parallels between this phenomenon and truly great photography. And a paradox, too.

Photographers crave perfection. They engage in a lifelong, lens-led struggle to arrange moments where all the technical and creative skills they have learned coincide with a series of events to produce a record of these unique split seconds. Unless you have pursued such a quest, you cannot imagine the pain of its failure.

At the end of wet, cold, tiring and utterly fruitless days, naturalists are often infuriatingly chided by the old maxim, 'You should have been here yesterday'. But for photographers who do arrive at the right time, it can be worse. They do see what happened just before or immediately after their point of exposure, those lost instants when the sun, the scene or their subject was better, and the agony of knowing that 'you should have pushed the shutter 1/125 of a second ago' leaves a diabolical legacy. It fuels a dissatisfaction that has them out again, refuting their success to chase another collision of their chosen elements.

The paradox is that, while they repeatedly fail to see the perfection themselves, they pass it on to us to marvel at. And this book is testament to the fact, because here is a remarkable collection of perfect moments.

Distilled from a rich lode, recorded by the world's most diligent, determined, self-critical photographers, here is an extraordinary catalogue of tiny fractions of time on our beautiful planet.

Flicking through these pages of images, I wonder how many seconds would pass if we summed all of the exposures, all the 1/1000ths, 1/500ths, all the 1/125ths, 1/60ths and so on. What do you think? Fewer than 1,000, 500, 100 seconds? Consider this as you examine these pictures that command so much attention, that generate so much emotion, so much wonder: that they are all that remain of less than 100 seconds of light reflected from subjects from all corners of our Earth. All of this in so little time, all those things, living things, in all those places, doing so much.

Imagine then all the time it took to learn the skills, acquire the equipment, travel to and from and back again, all the hours, the lifetimes spent focused on the convergence between photographer and these places, so that when it got close to that moment, the eye did not wander, the finger did not falter, the shutter did not shiver and the artist was able to burn an image onto a frame of chemical-covered plastic.

Of course, they have been rewarded, in cash, in kudos, with kind words, flattery, praise and respect and by having their work included in this pantheon of photography. OK, some have inflated egos, a few are smug, but most wildlife photographers are driven, not by the trappings of applied success but by the brutal task of trying to capture nature's beauty in perfect pictures.

How cruel it is then that the very thing that energises this special clan is so necessarily denied them forever, and how fortunate we are that they allow us to relish their perfect failures.

Snake surprise

To photograph any small animal in truly wild and free conditions requires technical know-how, detailed field knowledge, great patience and luck. Here the photographer has captured a moment few witness – a snake swallowing spawn. The focus is sharp enough and the lighting strong but natural enough to see the eyes of the wriggling red-eyed treefrog tadpoles prematurely exiting their jelly homes to escape the cat-eyed snake by sliding into the water below. The shot is the photographer's reward for many months' work in the rainforest of Panama, a love of the subject and an eye for a perfect composition.

Christian Ziegler *Germany 2004*

Deadly touch

What you see is a moment in a drama played out for hours between two adolescent lions and a mother porcupine and her youngster.

The brothers circled and circled the South African porcupines, trying to flip them, but the porcupines also circled and circled, presenting a combined defence of erect spines. Should one of their spines have pierced a lion, the result could have been not only painful but also deadly, as septicaemia is often the outcome of an embedded spine.

The panorama for the drama was the Kalahari Desert, providing strong light and golden sand. The outcome was a draw, with the inexperienced lions giving up and the porcupines retreating to safety.

Barrie Wilkins *South Africa 1993*

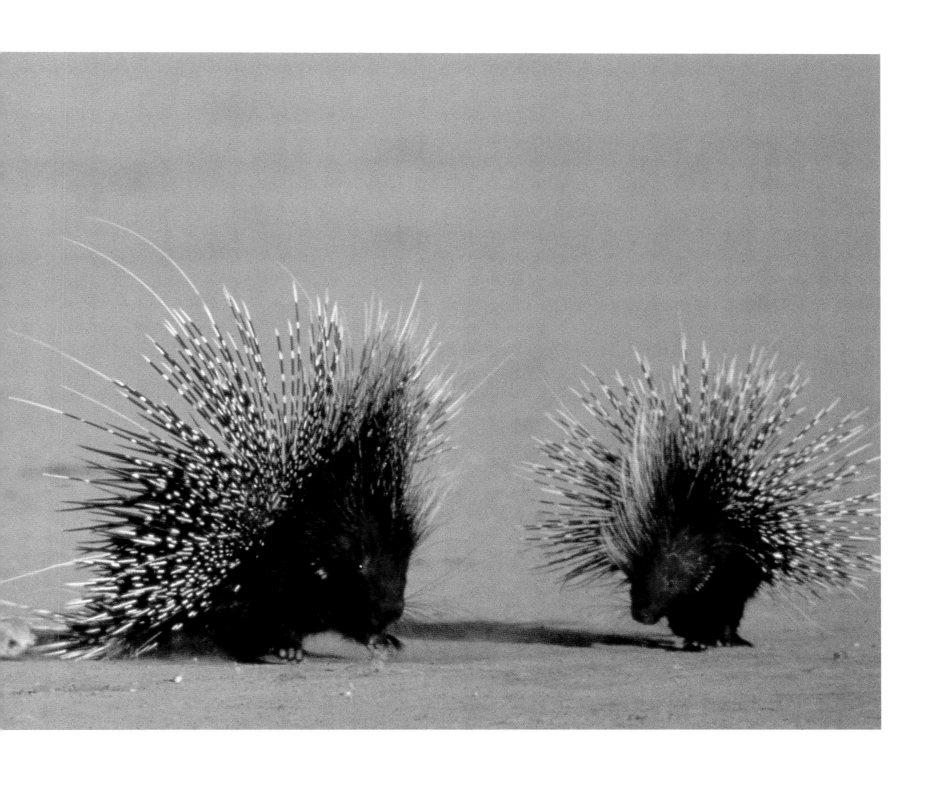

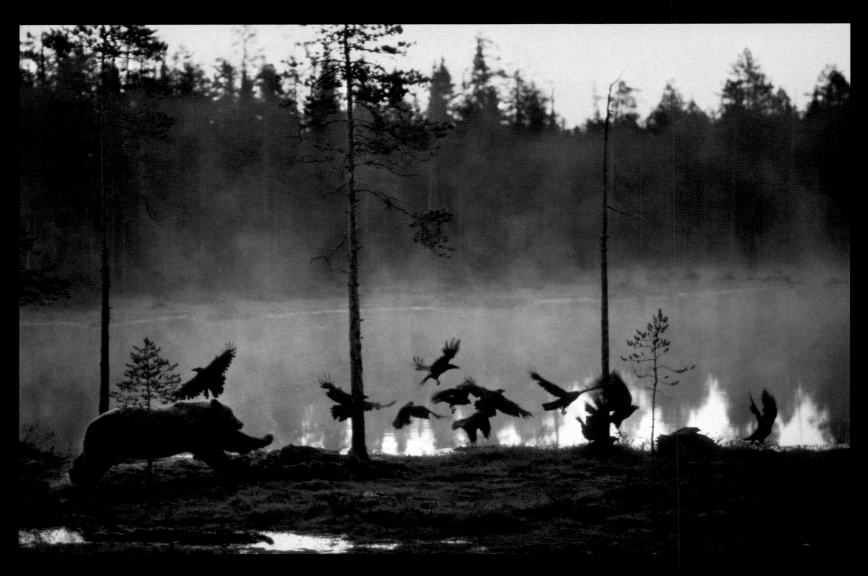

Chasing the ravens

Only those who live in the forest
and are intimate with its
inhabitants will ever see such a
magical scene. Mist rising from
the lake provides the ghostly
backdrop, and dawn light
illuminates the stage.
The brown bear had risen at
4am to find ravens already
feeding on its carrion prize and
is attempting to chase them off.
The photographer, who rose
even earlier, was in his hide to
capture the moment.

Antti Leinonen *Finland 1989*

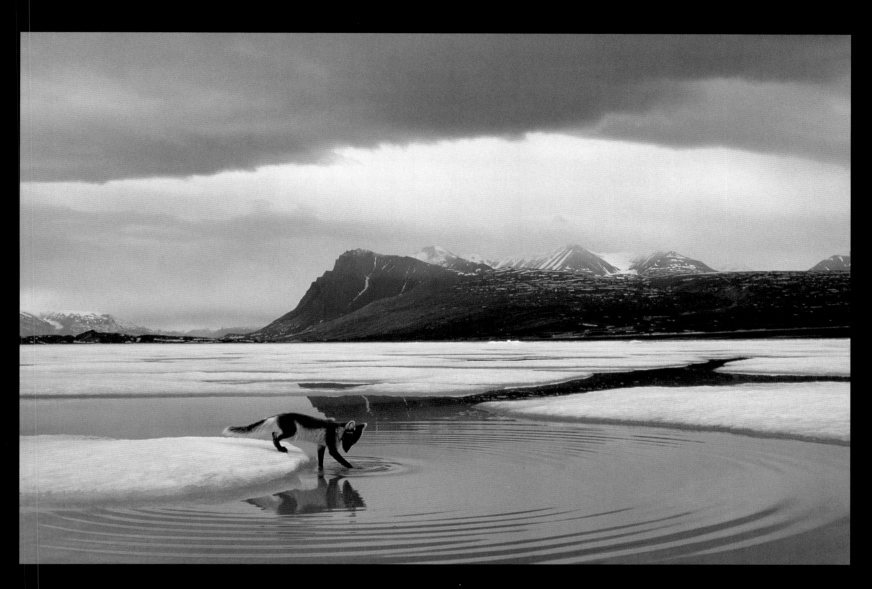

Testing the water

Circling ripples on the icy, grey water focus attention on the moment of concentration as the Arctic fox delicately tests the water's depth. Intent on crossing the fast-melting ice in search of the nests of Arctic terns, it ignored the photographers, having become accustomed to their presence in this remote area of Greenland. Such trust allowed them to compose the precise picture they had planned.

Jean-Louis Klein and Marie-Luce Hubert
France 1994

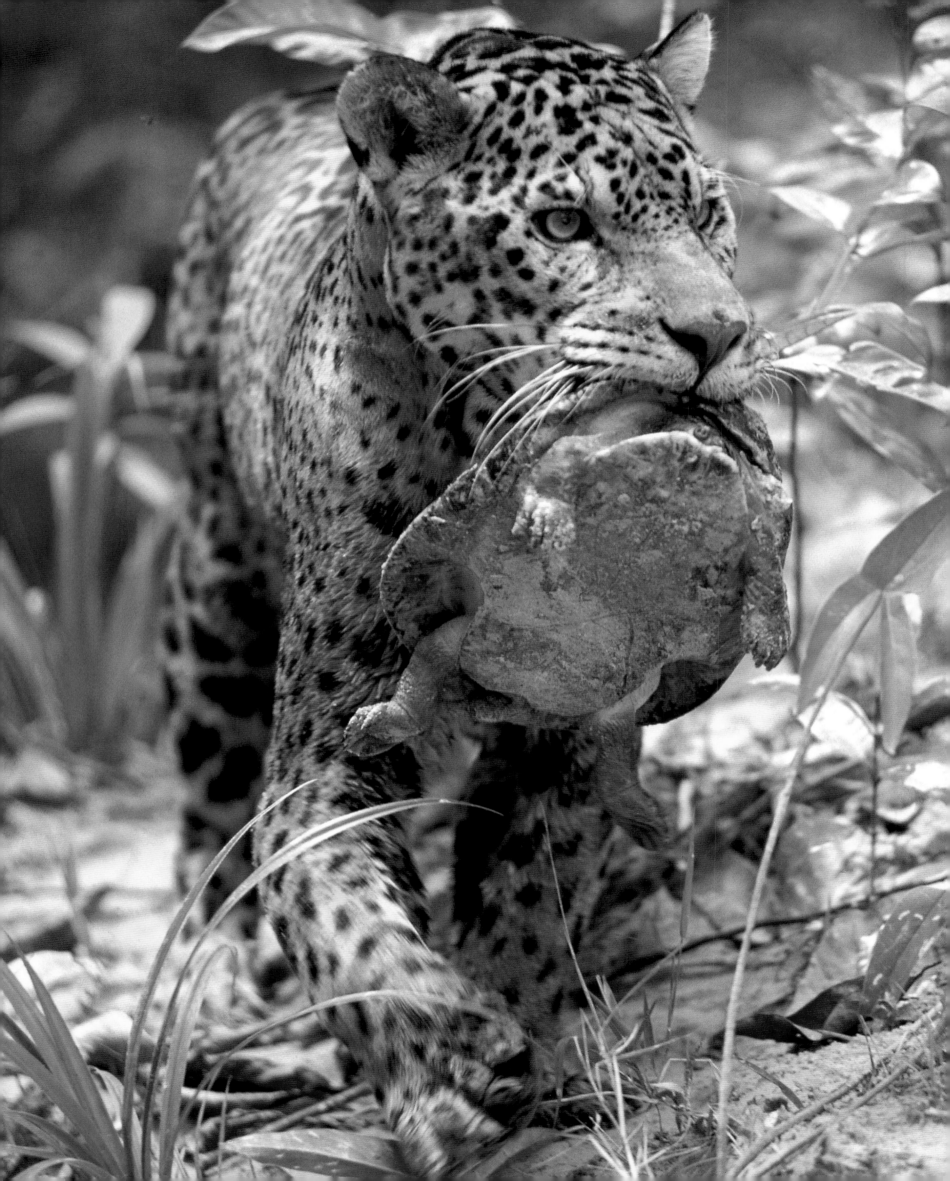

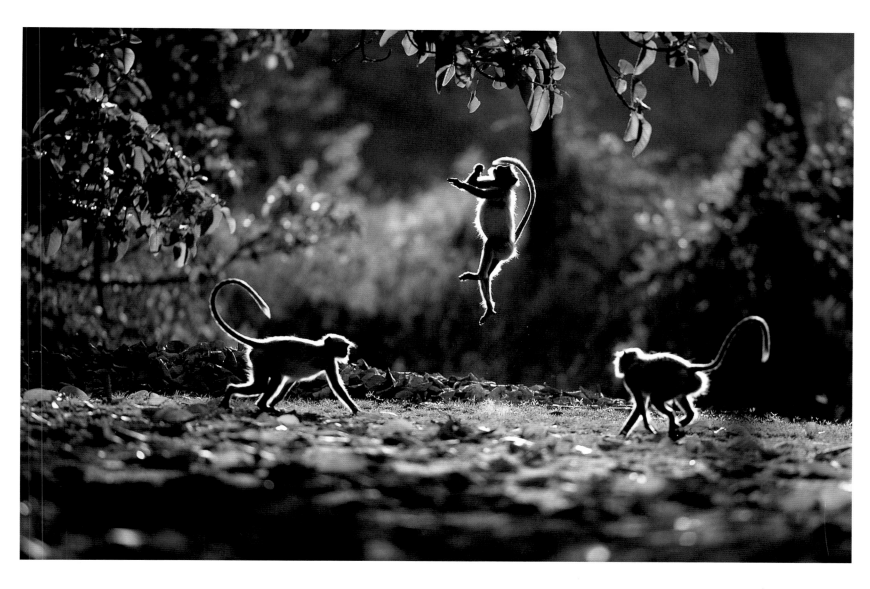

Leaping langurs

This is a picture of pure fun. The adolescent Hanuman langurs are letting off steam, paying a game of 'touch the leaves', while the adults in the troop are resting or feeding. Their playground in India's Ranthambore National Park is under a huge banyan tree. Backlighting adds sparkle to the bounce of the central performer, his two companions providing the perfect balance for the composition.

Anup Shah *UK 1997*

Prize catch

There are very few pictures of truly wild jaguars, and this is one of them. Such a portrait was the result of months of tracking and waiting, learning the animal's habits and locating regularly used paths and lying-up spots, while making a film on jaguars in the Amazon – a seven-year labour of love. Jaguars are strong swimmers and often frequent riverbanks on the look-out for fish and other river creatures such as this side-neck turtle, or just to lounge in the sun. This shot was taken from a hide erected near one of the male's favourite fishing spots.

Nick Gordon *UK 1993*

Moments

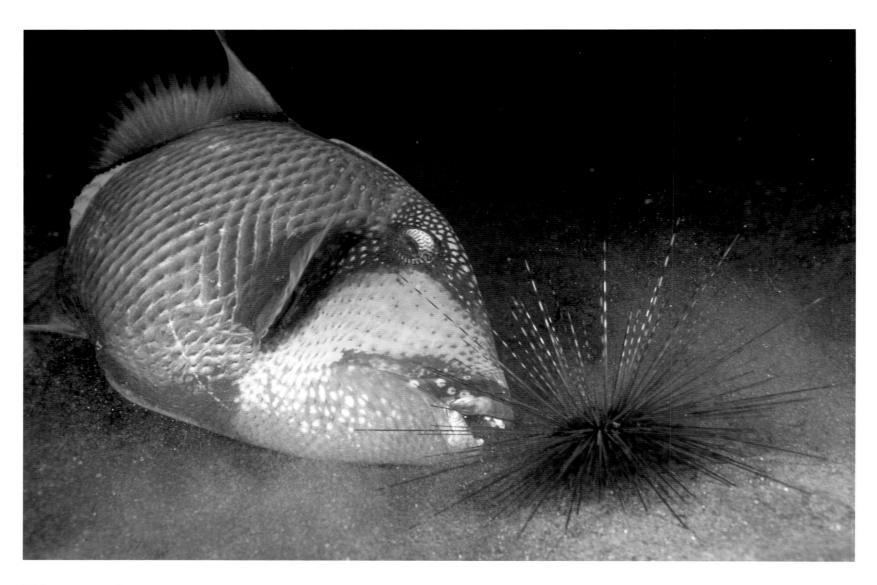

Trigger attack

The surprise of this action comes not
only because the triggerfish has
a mouthful of incisors that look as if
they've come out of a dentist's display
case but also because it's attacking
a ball of fearsome spines. One spine is
perilously close to the fish's eye, and
in fact several became impaled in its
face, despite its armour of scales,
before the fish managed to up-turn
the sea urchin and crunch out its
insides. The photographer excels in
taking dynamic but beautiful pictures
of underwater behaviour. Here, in the
sea off Bali, skilful lighting highlights
the drama while throwing the
background into shadow and creating
a golden foreground of disturbed sand.

Fred Bavendam *USA 1998*

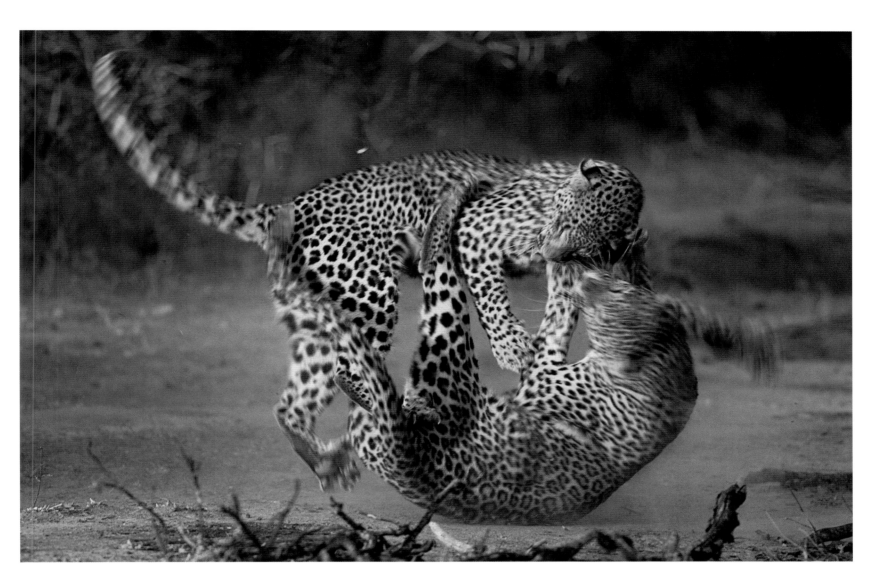

Leopard fight

As the eye travels around the whirling bodies, it is the feet that become the frozen focus of the drama, powerful claws extended as the attacker rakes her opponent, sending fur flying, and the defender tries to kick her off. The territorial fight between the two females (in Mala Mala Game, South Africa) was furious but fast, lasting just a few seconds. The photographer managed to capture the moment of attack because he had been following the older female, knew something might happen and was ready the moment it did. The victor moved off triumphant, leaving the territorial transgressor to slink away.

Richard du Toit
South Africa 1995

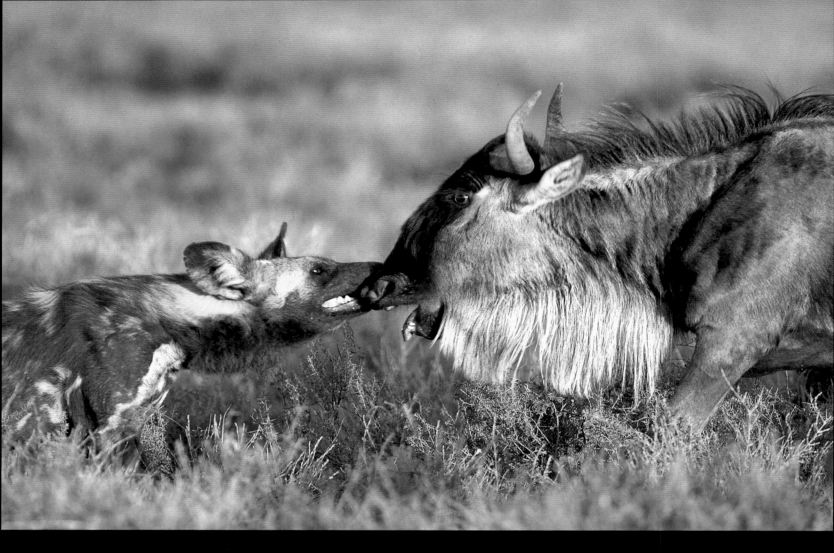

Final struggle

The last moment of the chase
came at the end of the day.
The pack of hunting dogs, in
Tanzania's Serengeti National
Park, had singled out and run
down a wildebeest, and in an
effort to immobilise it, a male had
grasped it by the upper lip.
The photographer knew the
picture he wanted, with the heads
centre-frame to enhance the
drama. But the light was fading
fast, and he was using a telephoto
lens, and so take a sharp image
required precise timing.
The result, though, was a
hauntingly memorable shot of
a life-and-death struggle.

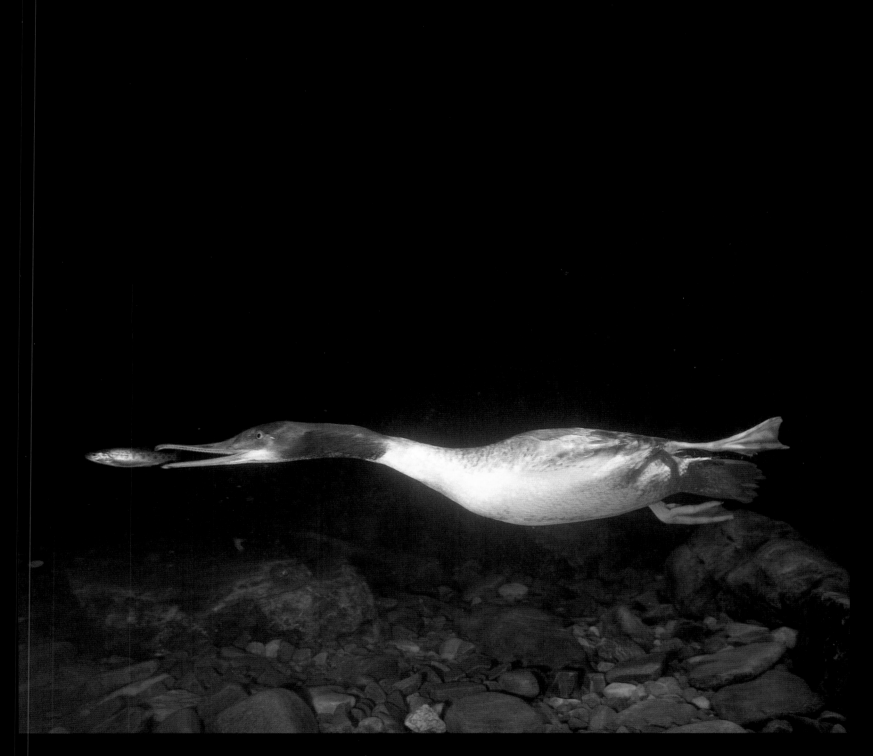

The catch

This is an instant that took a month to capture. The goosander was hand-reared but wild, living on a small Scottish river, on the bank of which the photographers had built a special hide with a glass viewing panel below water level. The daily vigil would begin at dawn, with Richard in the hide and Julia on the bank ready to signal when the goosander dived. But the action was always so fast that it took many weeks and many rolls of film to get the picture of the precise second when the bird caught its fish.

Richard & Julia Kemp
UK 1984

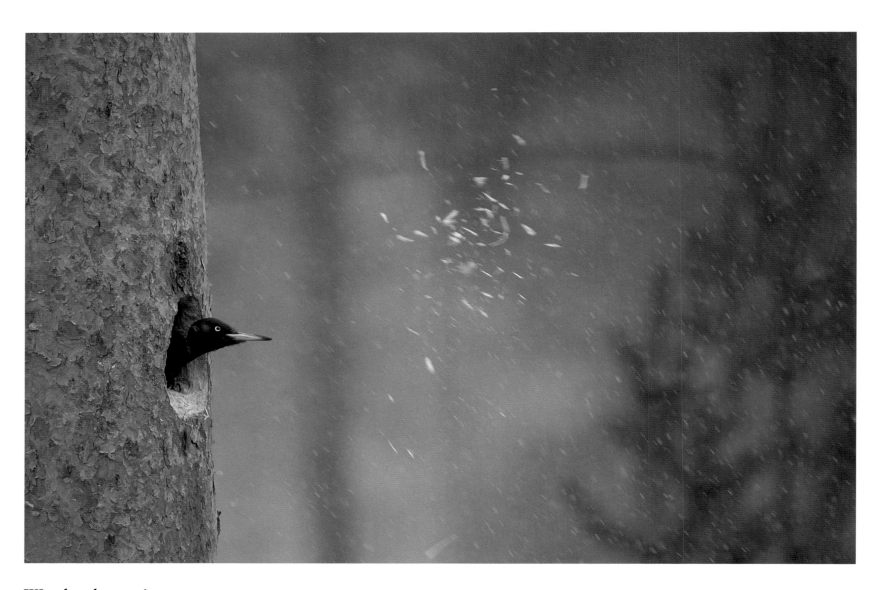

Woodpecker action

Force and determination are the ingredients of this shot. A woodpecker's brain is tightly packed into dense, spongy skull bones that, along with other buffering mechanisms, prevent the whiplash and battering that would otherwise result from the manic pecking necessary to excavate a new nesthole. Here a black woodpecker, on the last day of a two-week drilling marathon, has spat out a mouthful of chips as a blast of snow swirls around the tree. The photographer, too, endured a two-week marathon to get his shot, perched for hours every day 7 metres (23 feet) up a ladder leaning against a spruce tree opposite the nesthole in a remote forest in Finland.

Benjam Pöntinen *Finland 1991*

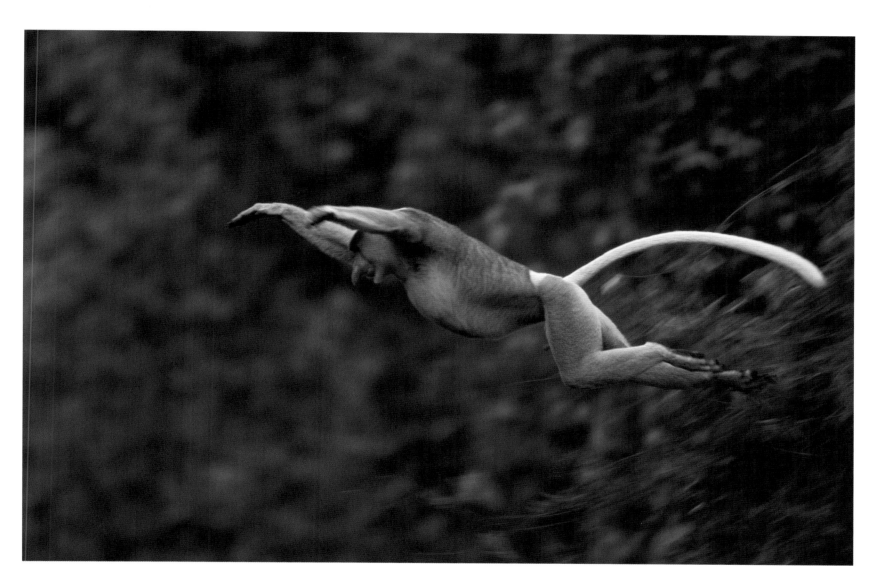

Proboscis leap

Stationed on the river in a small boat, the photographer managed to anticipate the exact second that this lead male proboscis monkey would make his giant leap and caught the moment mid-flow, with the monkey's hands curved forward ready to grasp the branch he'd set his eyes on. The rest of the troop then followed suit. Proboscis monkeys live in the mangrove forests along the waterways of Borneo and so must make frequent river crossings, in this case, across the Mananggol River in Sabah. They can cover up to 10 metres (33 feet) in a leap, and if the river is wide, they just plunge into the middle and swim the rest of the way, making full use of their webbed feet.

Nick Garbutt *UK 2003*

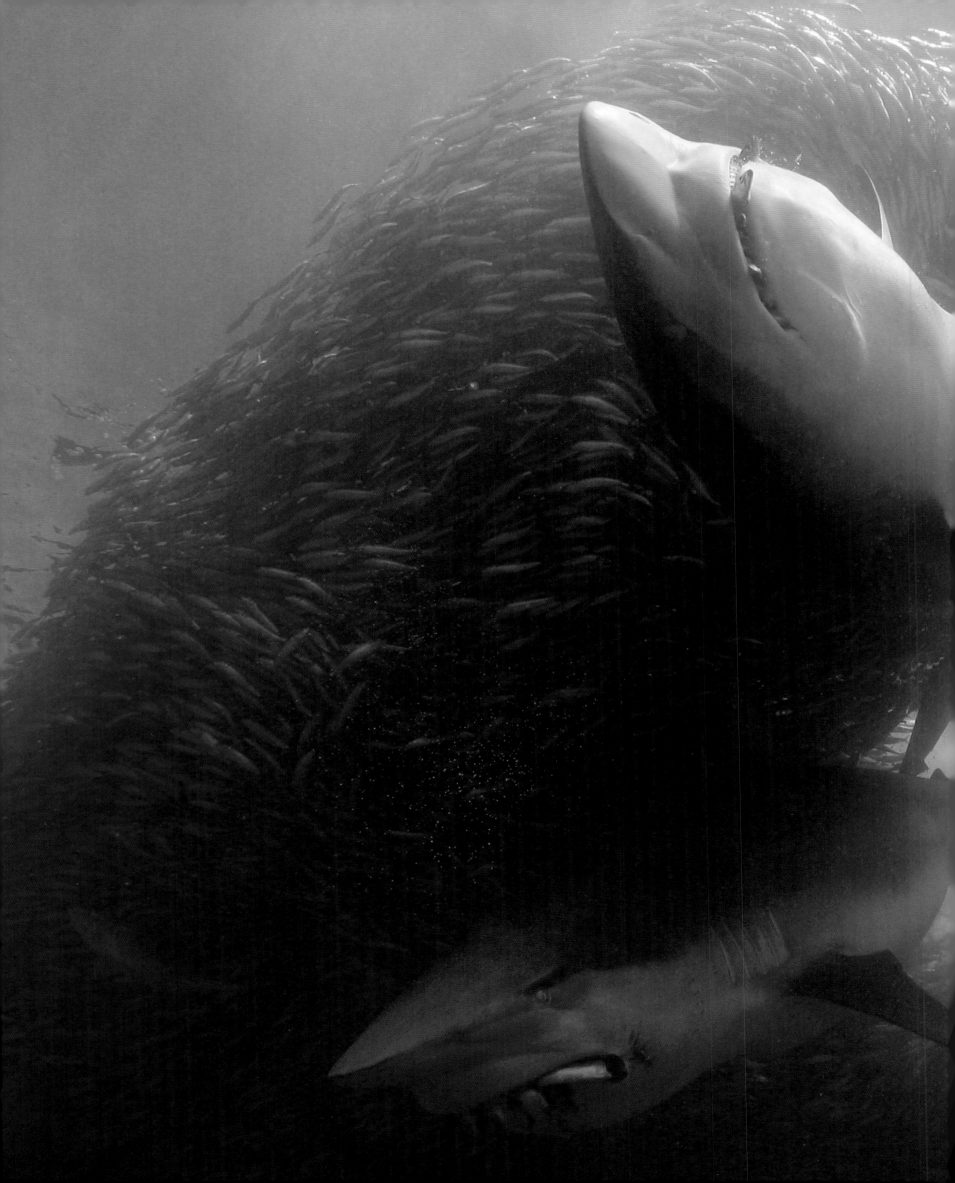

Charging sharks, swirling baitball

The photographer describes the taking of this shot as the most exhilarating and terrifying experience of his life. The shot itself is pure drama. At the centre of the action is a ball of sardines that began as a vast shoal and ended as a shimmer of scales. Attacked from every side by dolphins and sharks and from the surface by gannets, the fish twisted and turned as one in a fruitless effort to confuse their predators. Here two bronze whalers take great mouthfuls of fish as they charge through the swirling mass of quicksilver, twisting and turning at speed. Pulled into the action, the photographer had to grab shots in between being whacked by the highly charged sharks, either testing him as possible food or investigating the electrical discharges from his flashes.

Doug Perrine *USA 2004*

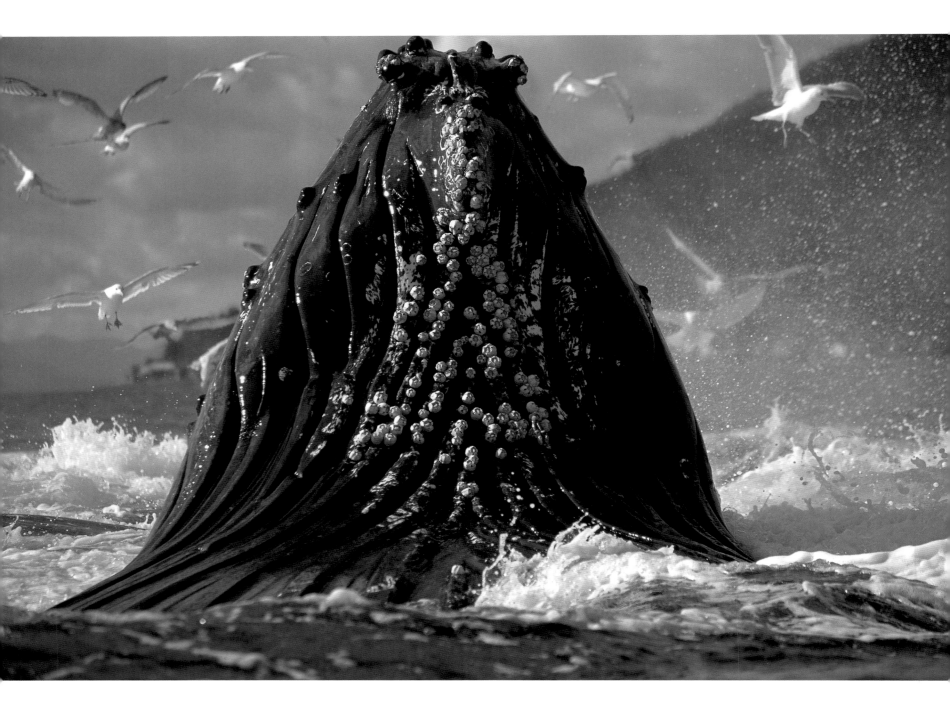

Emergence

The power of a huge humpback lunging
up out of the water is truly awe-inspiring,
especially if you are beside it in a small
kayak, as the photographer was.
To be in the right position and press
the trigger at the exact second for such
a shot requires nerve and precise timing.
The picture is framed so that the whale's
enormous head is almost pushing out of
the frame, its gulletful of fish bulging
just below the water. It's a unique
image – the outcome of more than
20 years of kayaking with humpbacks in
Southeast Alaskan waters.

Duncan Murrell *UK 2002*

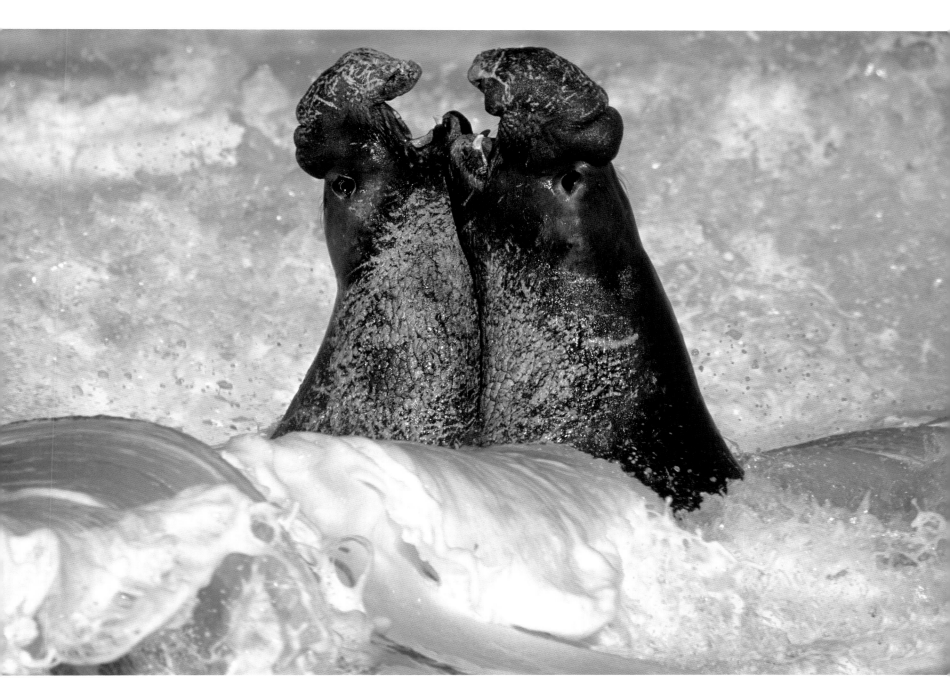

Clashing bulls

This is the moment of truth for one of
these huge northern elephant seals,
battling on a California beach over access
to females. The image of their titanic
struggle is heightened by the spume and
crashing waves behind and the great roll
of water in front, their chests red with
blood and scar-tissue. It's an almost
sculptural image made beautiful by
the perfect lighting and contrast of
colours. The photographer spent hours
watching the bulls interact, anticipated
the moment and positioned himself in
the exact spot to capture the finale.

Tim Fitzharris *USA 2001*

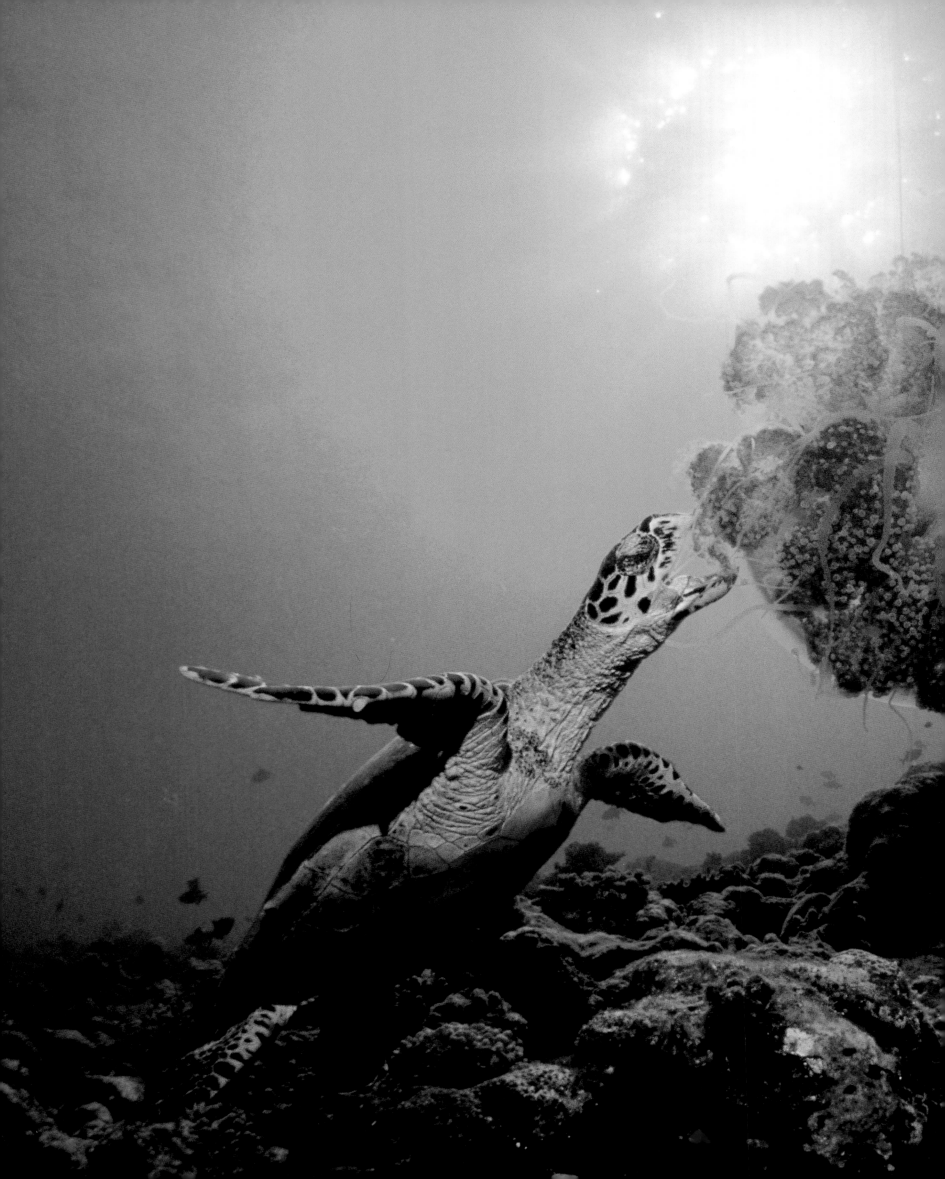

Hawksbill beakful

On the few occasions when turtles beach to lay their eggs, their movements appear laboured and almost painful. This shot, though, shows that a turtle in its element is truly elegant. There is delicacy in this moment as the hawksbill opens its powerful beak (capable of biting off chunks of coral) to pluck a piece from the jellyfish. The photographer, diving over coral in the Maldives, moved with the turtle as it circled the jellyfish until the light above was in the right position and pressed the trigger just as its beak opened.

Reinhard Dirscherl
Germany 1997

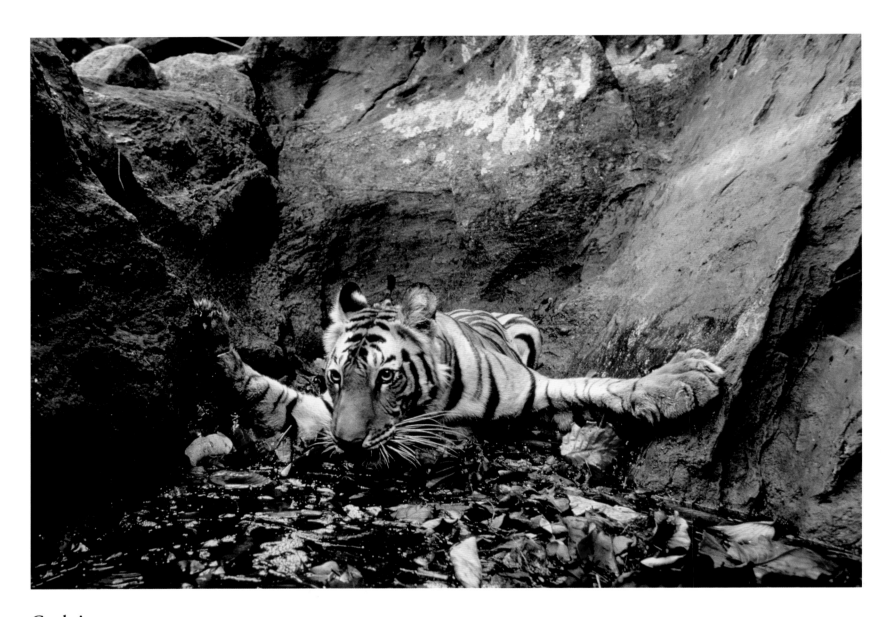

Cool tigress

Planning was key to this powerful
composition, taken in Bandhavgarh
National Park, India. To get the shot he
had in his mind's eye, the photographer
employed perseverance, wizardry
(a specially made remote set-up triggered
by an infrared beam) and knowledge of
the animal's routine. The rock-cleft pool
was somewhere cool where the young
tigress went in the heat of the day to
relax unseen – except, of course, for
the remote camera. The picture she took
of herself shows her framed by rock,
her great paws and the strange angle of
her body, emphasising her strength
and athleticism.

Michael Nichols *USA 1998*

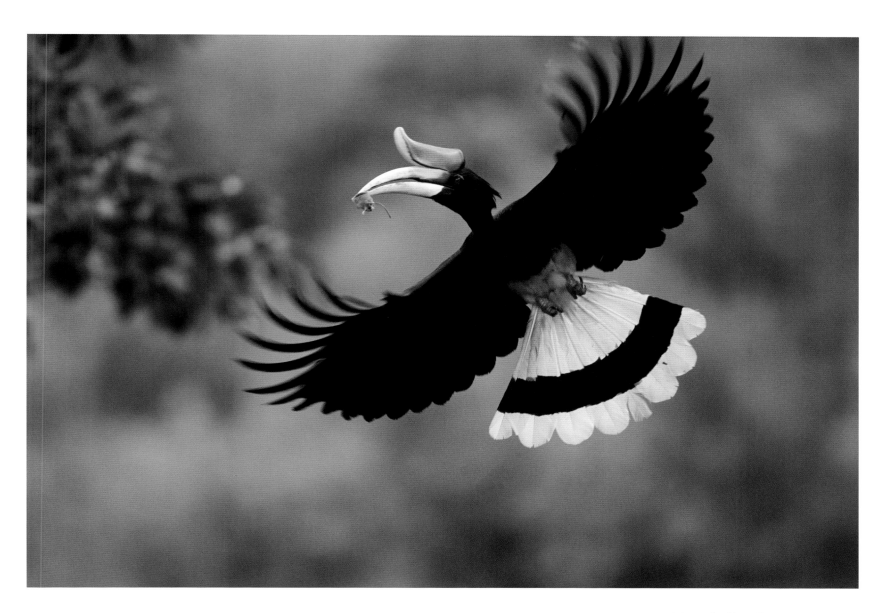

Hornbill gift

Here is a wonderfully exuberant shot of an extravagant bird, his impressive red and yellow casque set off by his black plumage and his glorious fan of feathers displayed to perfection by the rich green, out-of-focus rainforest background. The tiny mouse at the end of the rhinoceros hornbill's huge, curved beak is an offering for his mate, whom he has incarcerated in a tree-trunk nesthole with just a beak-sized feeding hole. The photographer knew the male's flight routine and planned the shot, pre-focusing at the spot where he would have to bank and so expose his wingspan on the final turn to the nesthole.

Tim Laman *USA 2002*

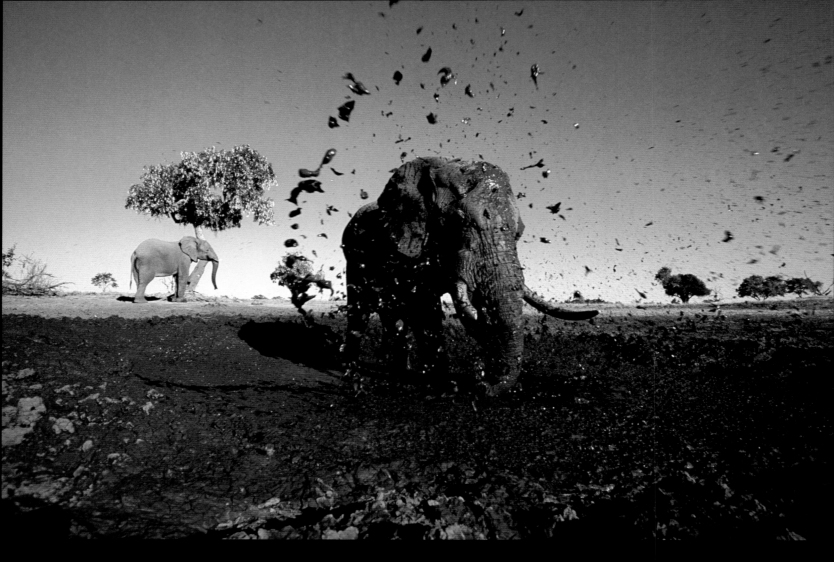

Elephant mud shower

This is an action-planned shot,
complete with a giant swirl of
serendipity. The photographer lay
in the wallow, composed the shot –
tree off centre, horizon down from
centre – left the camera (attached
to a shutter-release cable) in
the mud and retreated. The first
elephant to arrive fell asleep in
position by the tree. The next went
straight for the wallow – and
the camera – showering its disgust
at the intrusion. The repair bill
was worth it, though.

Andy Rouse *UK 1998*

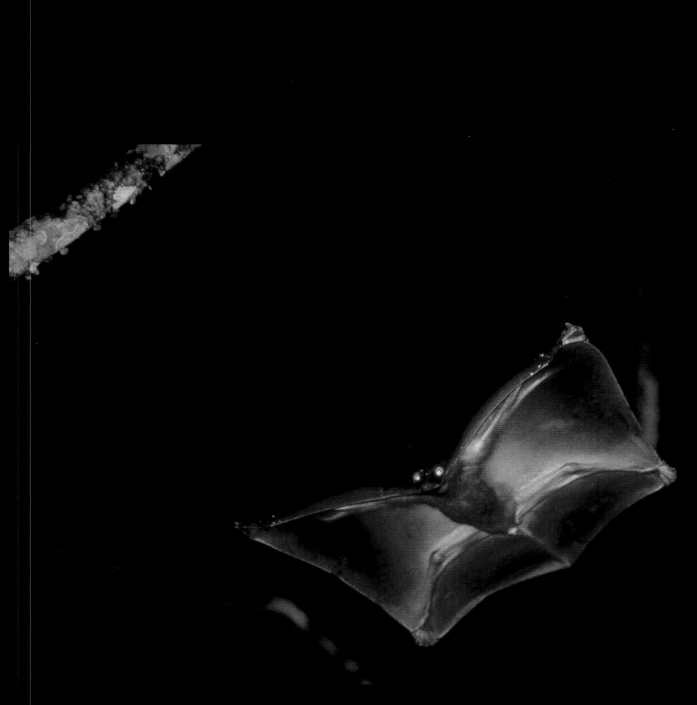

Night glider

To see a colugo is rare enough, but to photograph one in mid-glide requires fieldcraft and forethought. It took two weeks of daylight searching in the Borneo rainforest for resting colugos camouflaged against tree trunks to find the right one, and then nights of frustration and painful stumbling through the forest to catch the full-stretch performance and illuminate the colugo's bat-like physique – limbs and digits all enclosed in one huge membrane.

Tim Laman *USA 2001*

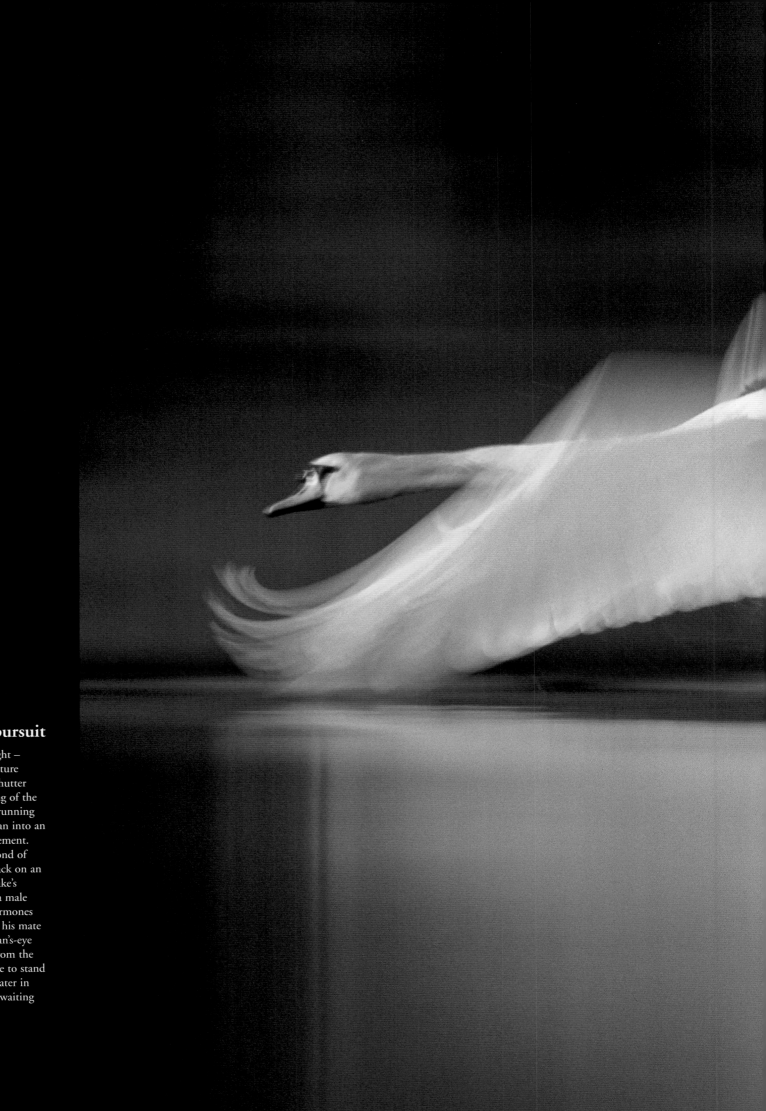

Swan in swift pursuit

Low, glowing evening light –
the perfect light for a nature
photographer – a slow shutter
speed and steady panning of the
camera have frozen the running
take-off of this mute swan into an
image of form and movement.
The action is a split second of
a successful running attack on an
intruding swan by the lake's
largest territory holder, a male
pumped up with the hormones
of spring and defending his mate
and nest site. Such a swan's-eye
view required stamina from the
photographer, who chose to stand
chest-deep in freezing water in
a Northumberland lake waiting
for the moment.

Rob Jordan *UK 2003*

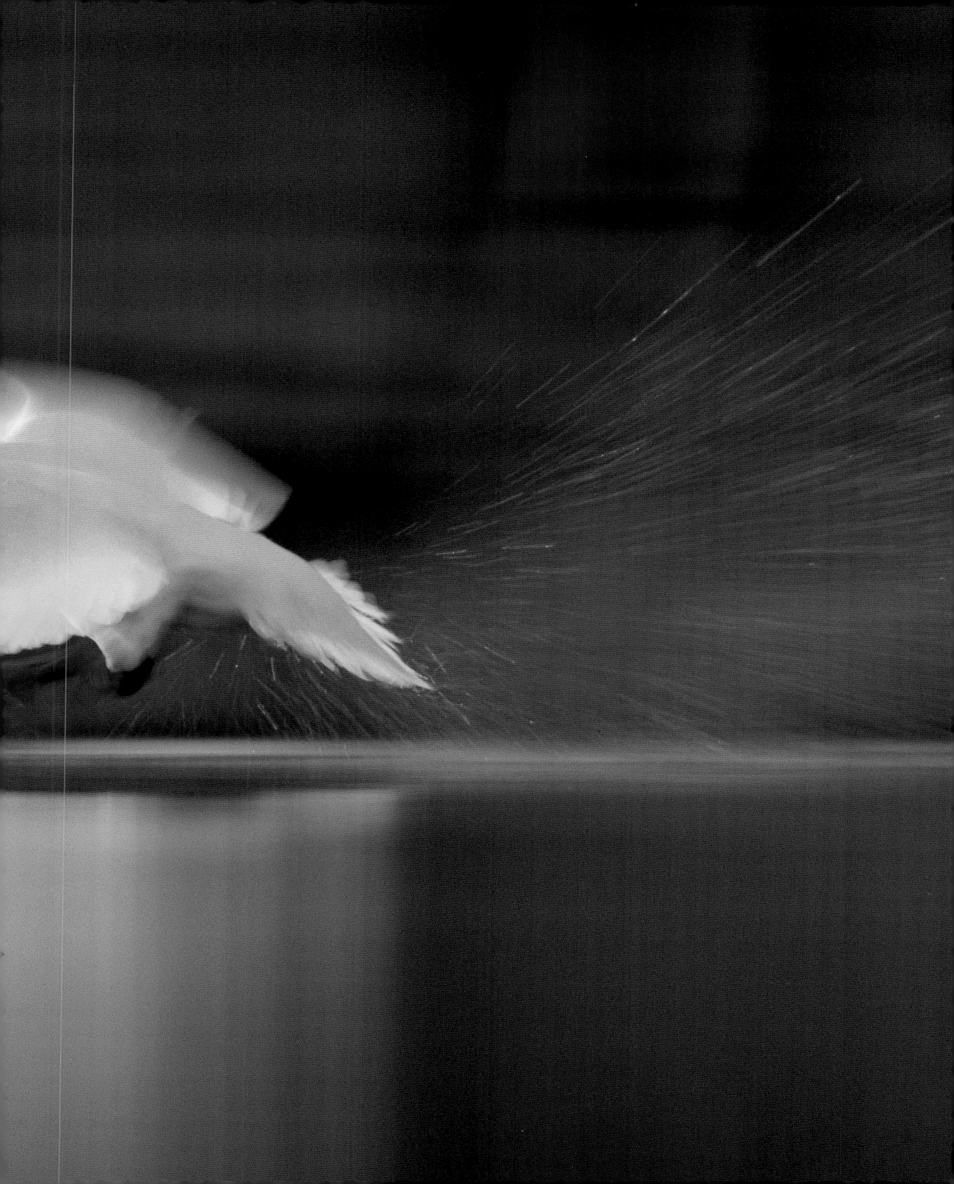

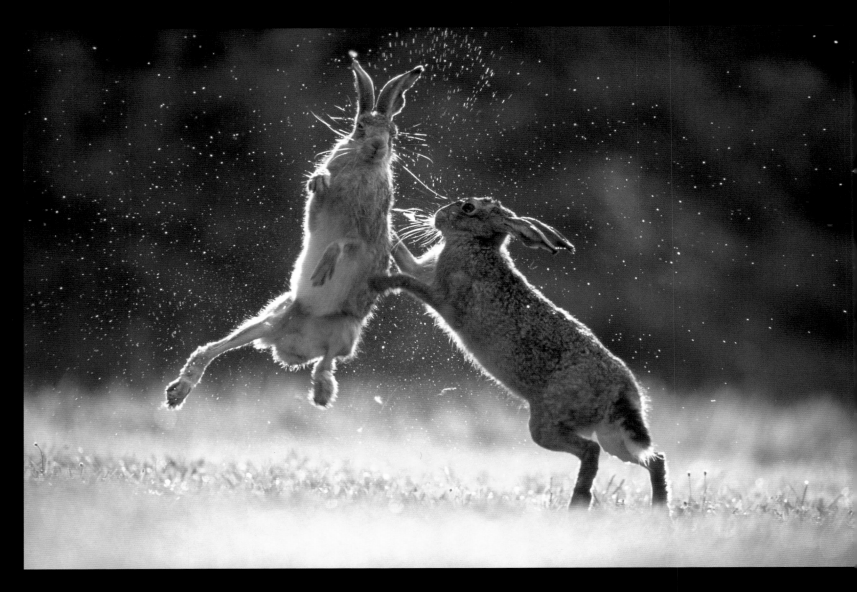

Hare rebuttal

The fur that's flying is the male's, who is being boxed away by a female not in the mood for mating. To capture such a moment requires perseverance, as hares are extremely shy – being the prey of many animals, including humans. The photographer, though, has spent nearly 30 years watching hares, knowing exactly where and when to take a picture and how to use the early-morning light to add that extra, illuminating touch.

Manfred Danegger
Germany 1998

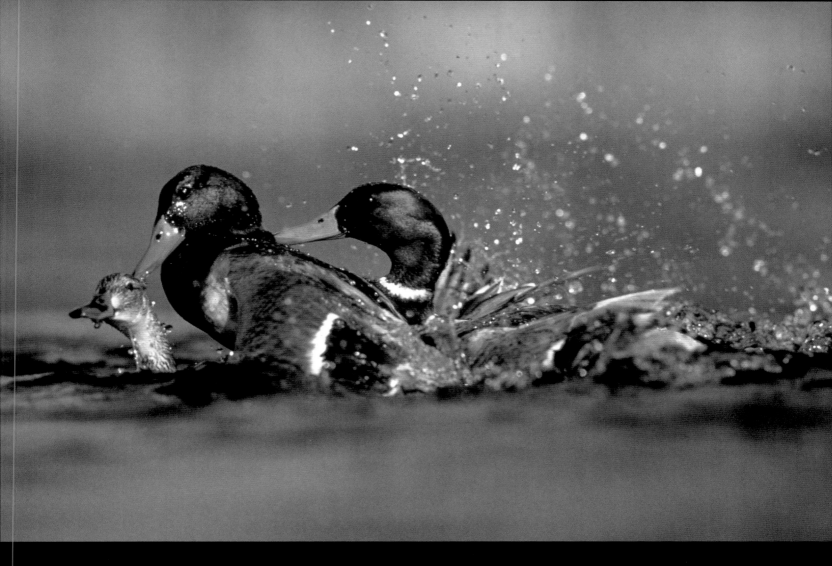

Drake rape

It's traumatic (for the viewer as
much as the ducks), but it's not
abnormal behaviour, occurring
in the breeding season when
unpaired male mallards are
chasing the remaining unpaired
females. The photographer is in
a floating hide in a lake, his
camera on a tripod but angled at
water level – his favourite
position for a bird's-eye, intimate
view. Despite the speed of the
action, he has managed to
emphasise the drama by closing
in on the scene and pressing

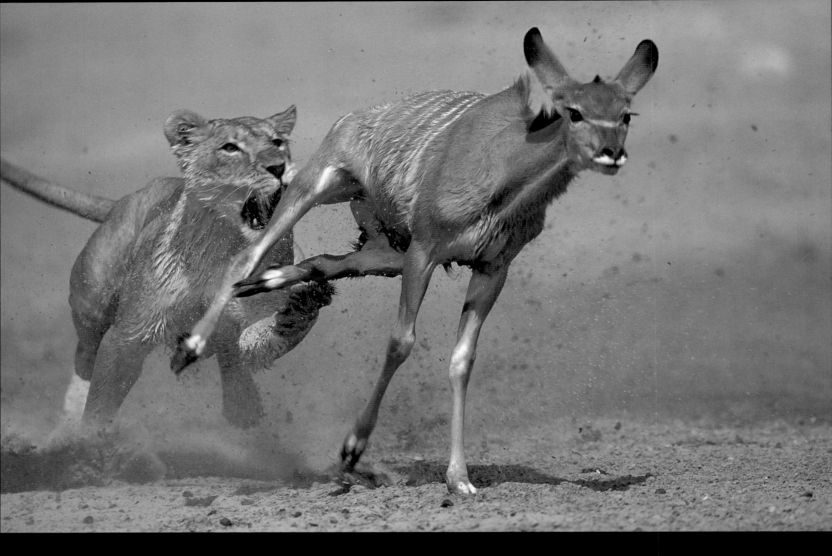

The final trip

The movement of the lioness's
paw is almost delicate as it flips
the leg of the kudu – and so
precise you can see the claw just
catching – a quintessential
moment of action. The outcome
is all in the movement,
the power and precision of the
lioness and the wrong-footed tilt
of the nimble greater kudu as it
starts to topple, its ears rotated
back towards its nemesis.
An impression of the speed of
the action – the lioness has
burst out of cover beside
a waterhole – is enhanced by
the eruption of dirt and spray as
they skid to the final end.

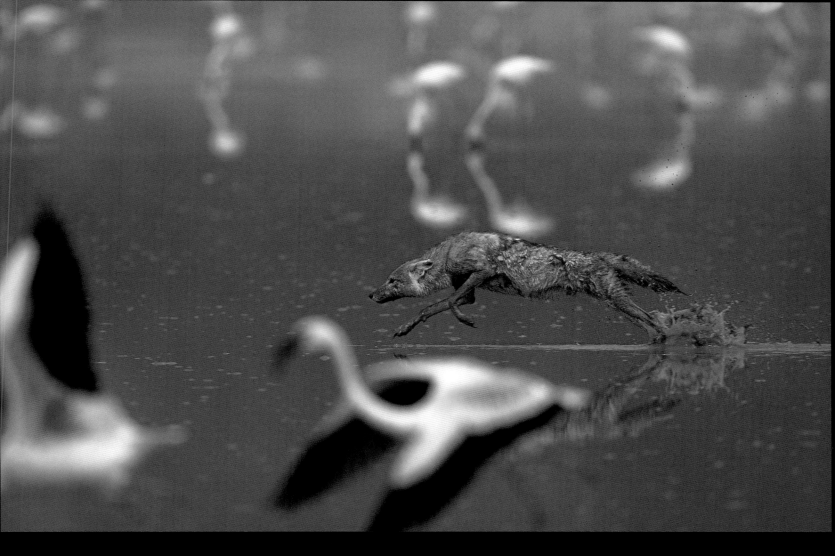

Flamingo run

This was no chance shot, rather a story composed with perfect timing, focus and framing. Caught in mid-sprint across the shallow water of the soda lake, the jackal is fully stretched, its head all doggedness in pursuit of its flamingo target. Its surprise entrance is revealed by the calm of the as-yet-unaware flamingos in the background and the pink blur of panic in the foreground. Golden jackals usually scavenge or hunt small animals, including insects, but on Lake Makat, in Tanzania's Ngorongoro Crater, where thousands of lesser flamingos gather, their food is large and plentiful.

Anup Shah *UK 2004*

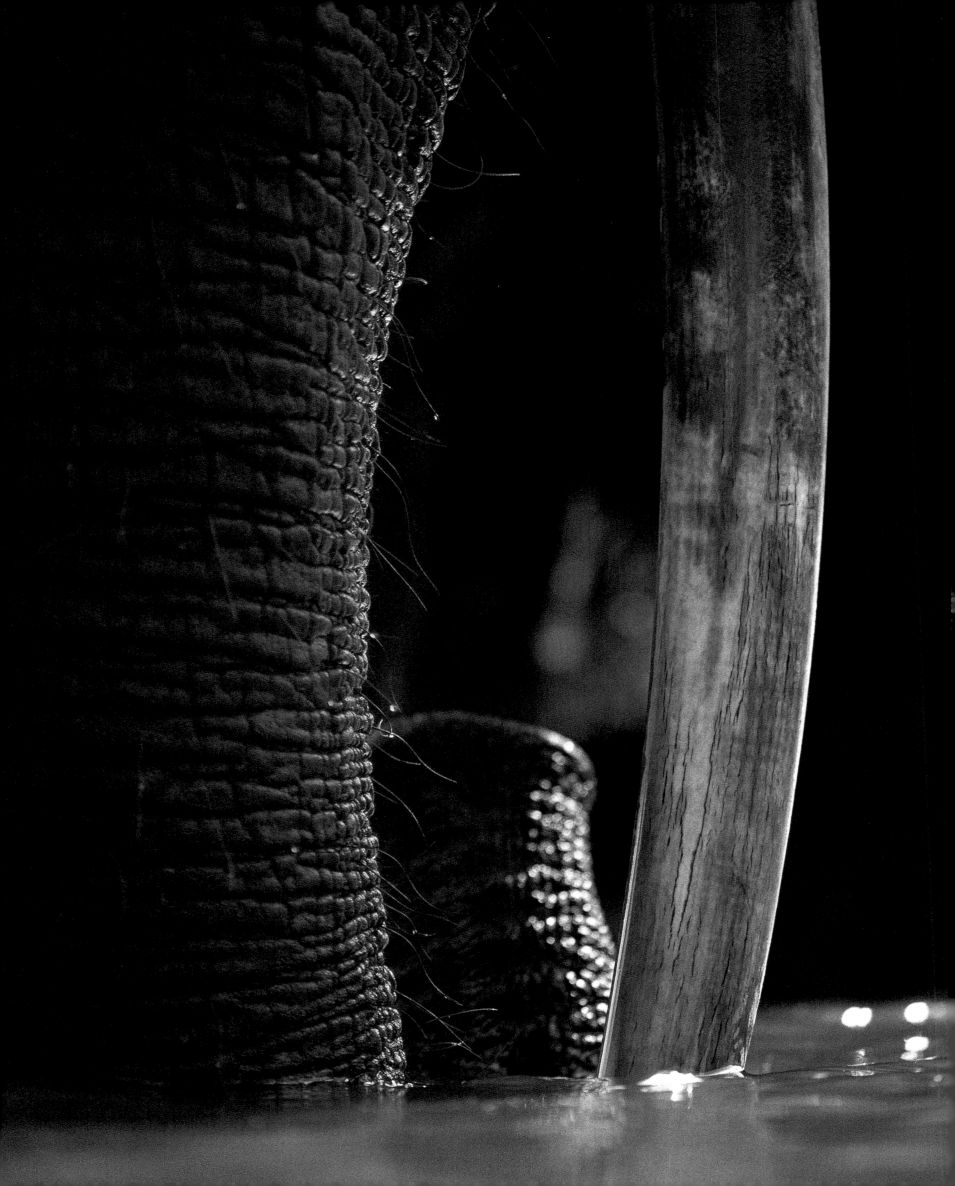

Formations

SIMON KING

Everything in our world is beautiful. Everything. It is possible to look beyond the surface of any phenomenon, and find in it grace, find in it an angel. A rusting oil tanker may, if seen in a certain light, be spellbinding with its hues of red, brown and orange. A plastic bag caught in an alleyway becomes a living thing, tossed and turned in a ballet by the wind . . .

Tusk and trunk

The simple act of drinking has been transformed into a sculptural composition of form and function. Light reflected off the water has thrown the curve of the trunk into wrinkled relief, its texture contrasting with the smoothness of the tusk. The ivory is cracked and stained from digging and from immersion in the peaty water of forest pools. Today there is a poignancy about the picture – the elephant was photographed in the Virunga National Park, then Zaire, now war-torn Congo, where poaching has decimated the elephant population.

Bruce Davidson *Kenya 1994*

Formations

It is sometimes difficult to divorce ourselves from that which we expect to see and allow ourselves to see freely. An avocet may be photographed a thousand times, but only one image in a thousand will reach out and move us.

. . . How then does this relate to the natural world, where beauty is conventionally perceived as innate, inherent? Because the greatest skill is in the eyes of those who see more than the obvious, deeper than the surface, who find in the abstract details of life on Earth a subtext that moves them and somehow manages to convey that passion and emotion through an image.

We are each of us moved by different things in everyday life. Increasingly, it seems, we crave large signposts. Laugh now; cry now; be angry now; be afraid now. But despite becoming lazy, we are essentially creatures of subtlety. Our senses are designed to pick up the slightest nuances of sight, scent and sound.

There is nothing new in pursuing a pure route to these senses and so to the emotions they trigger. The minimalist hues and juxtaposition of a Rothko may have started life as decoration for a restaurant, but they have moved many (including me) to tears. We are vulnerable, exposed (or at least we should be) to fundamental stimuli that hold mnemonics to past experience or perhaps awake in us feelings that we simply do not understand but experience anyway.

For many years, the photographic competition that has encouraged this collective of greats has been a distillery of abstract images from nature. Some are easy to interpret, others less so. But almost without exception, they have the capacity to move the observer.

They are not intended as cryptograms, however tempting it may be to try to 'work out' what they are (I have always wanted to remain ignorant of the source of those which are entirely dominated by colour and form). In fact, it is as well not to know the source of the beauty.

Oh, we say, it's just a fish. Or, oh, so it's just the grain of wood. But if we feel the image is diminished by the familiarity of its source, we are missing the point. One could just as easily argue: oh, it's simply pigment taken from a variety of minerals – and in so doing, disregard every great painting ever created.

Photography of the natural world often suffers from this handicap of having its raw materials blatantly on display. We want to experience something unique and special, but we also want our wildlife pure. When we know that the beauty beheld is simply the surface of a pond reflecting autumn colours, we may feel cheated. It's perfectly natural. The 'I could have done that' jibe which follows in the wake of a great deal of contemporary art can also be applied to a great deal of abstract and form-dominated nature photography. But, by and large, you didn't do that, someone else did, and it is that vision we are celebrating here.

The same notion applies to more figurative imagery. When we are familiar with a subject, it is sometimes difficult to divorce ourselves from that which we expect to see and allow ourselves to see freely. An avocet may be photographed a thousand times, but only one image in a thousand will reach out and move us. Just how and why that happens is elusive.

The ephemeral equations that conspire to make a great image, constantly pondered by photographers trying to harness the solution, remain unsolved. I venture that this is because they are as complex and as varied as the human brain itself. Indeed, they are the human brain. After all, it is how we interpret the result that matters in the end. But in the field of nature photography, the fact is some people have a capacity to respond to the moment with innovation, clarity and sensitivity in a way that translates to the image – and, more importantly, to the observer of that image – and some do not. Furthermore, there are some, a very few, who see the picture long before it exists and go in search of it.

Sometimes conditions conspire through serendipity to produce a fluke, a glorious accident. But more often than not, the photographer has built the image through a combination of technical skill, natural history know-how, and artistic integrity. The great names in the field are great by virtue of continuity. The lucky snapper comes and goes with the wind.

Our brains are wired, to a greater or lesser extent, to both predict and to receive, to expect and to be 'open minded'. The images in this collection will appeal to both hemispheres, but I implore you to allow the bigger picture to dominate – to be taken on a journey rather than guess the destination – and be the richer for it.

Great tree buttresses

A picture of form and function: the great buttress roots of a huge reseco tree in Costa Rica, banking out at least four metres to stabilise the trunk on the thin rainforest soil. Their brown and gold forms, like ancient sleeping animals, are patterned with bark-lines of growth and coloured with moss and algae.

Gary Braasch *USA 1995*

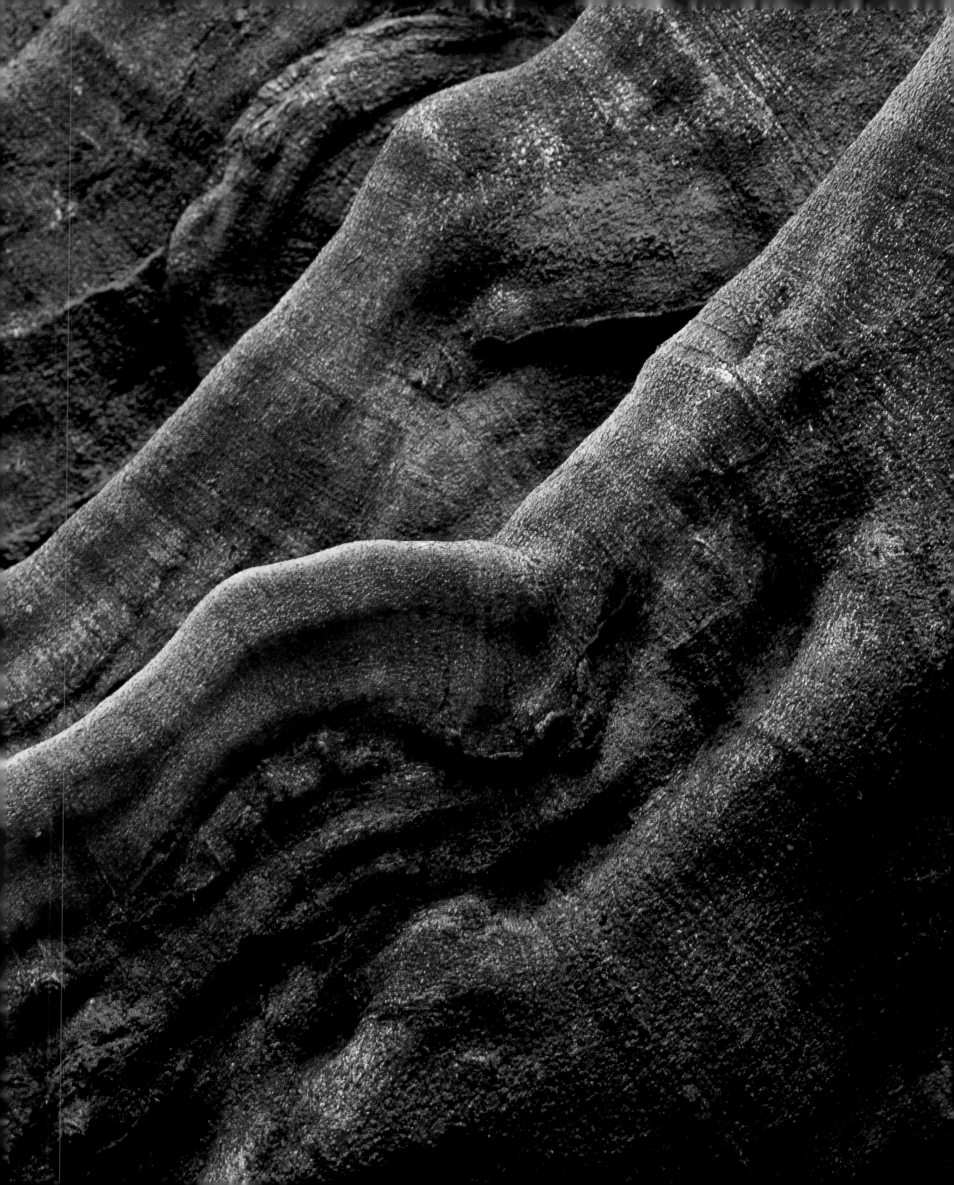

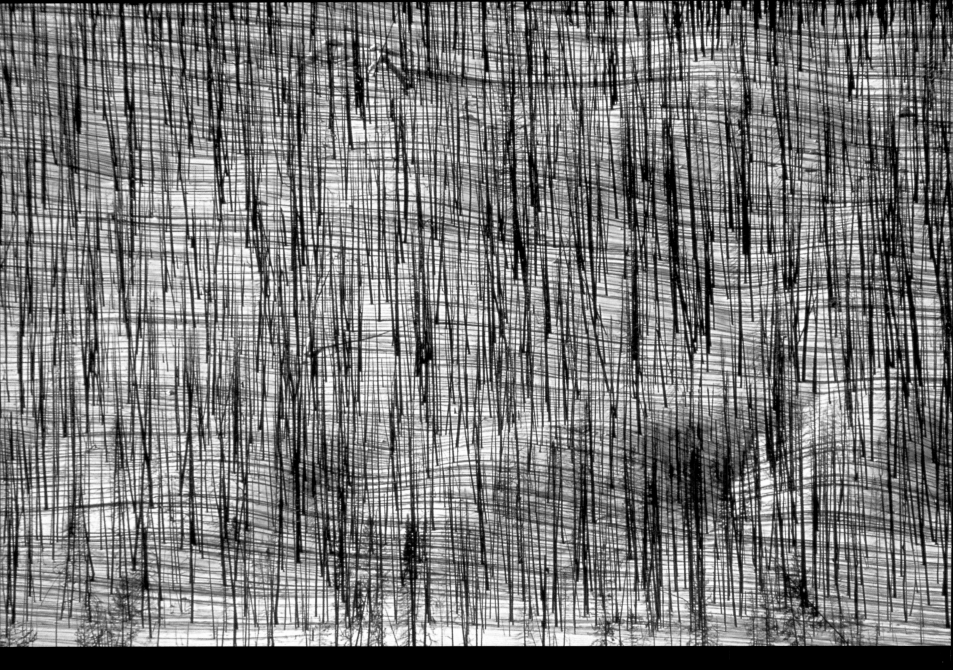

Snowscape

Only when you see the curve of
a valley or a fallen tree does the
real picture materialise: naked
trunks, their shadows undulating

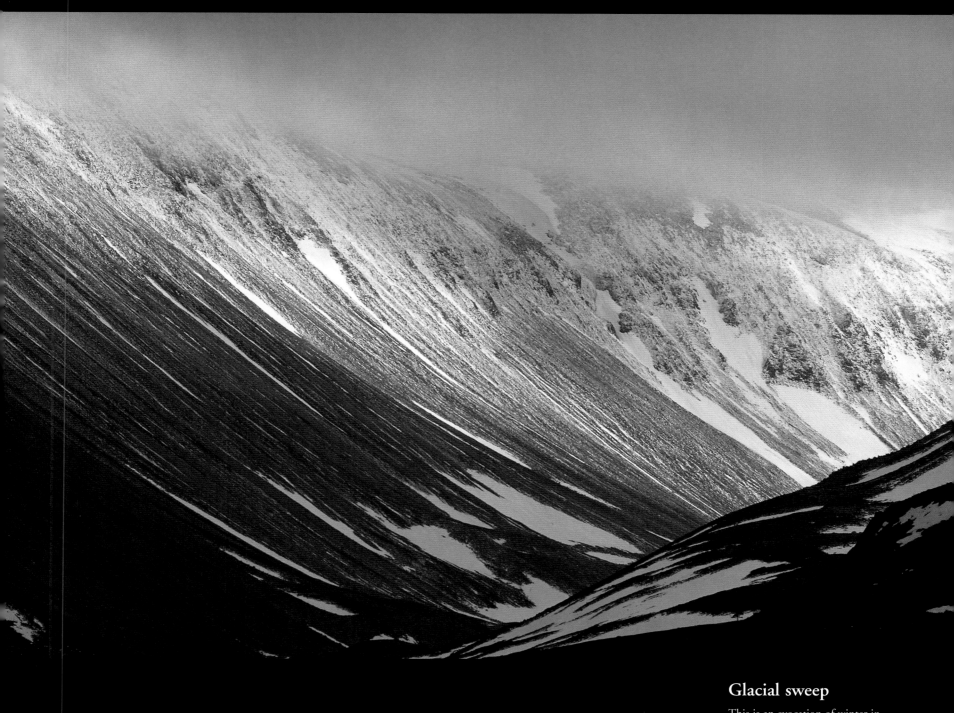

Glacial sweep

This is an evocation of winter in
the Cairngorms, the sides of
the Lairig Ghr valley swept bare
by the wind, a snowstorm
rolling over the high tops of
the mountains, the deep basin
left in cold shadow as the
fleeting light moves fast down
the valley away from it. But it's
also a black and white abstract of
texture, light and shadow.

Laurie Campbell *UK 1991*

Formations

Bloodwood rock

The sheer-sided Uluru (Ayers
Rock) is sacred to the Aboriginal
people of central Australia.
As the sun sets, the rock glows
blood red against the desert sky,
its eastern side pitched into deep
shadow. Rather than show the
vastness of the spectacle, the
photographer chose a struggling
bloodwood tree as the focus, its
trunk transformed into a crack in
the rock, its upward stretching
branches contrasting against the
V of the cleft – a symbolic image
of life and death in one of the
harshest places on Earth.

Andy Townsend
Australia 2003

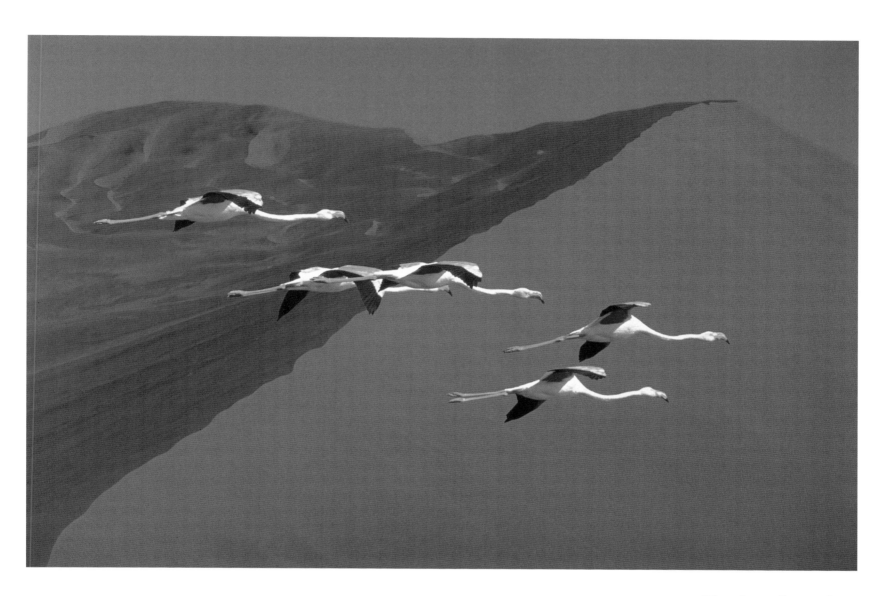

Flamingo formation

To see a flock of greater flamingos flying almost at eye level, their wings outstretched in horizontal synchrony, is almost unbelievable, and to have one of the world's most impressive dune systems, in Namibia's Sossusvlei National Park, as the backdrop is the making of a classic shot. The position of the sun, creating angles of shadow and flattening the facing side of the dune, is the final stroke of luck. But the steady hand and eye of the photographer is what made a picture that few others would have seen or managed to create.

Marcello Calandrini
Italy 1998

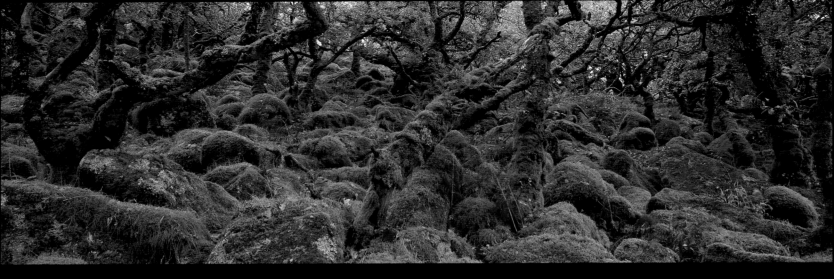

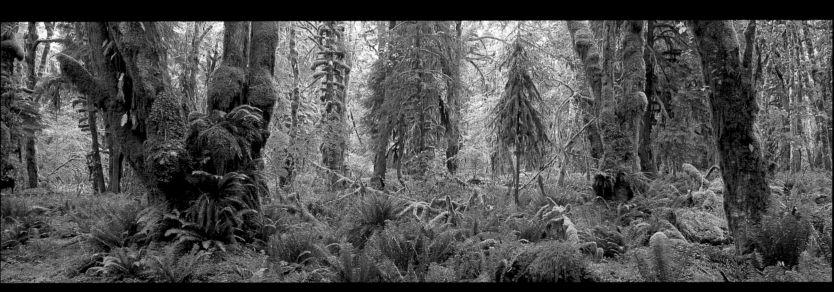

Wistman's Wood

A panorama is perfect for a view
into this prehistoric miniature
oakwood on Dartmoor in
South-west England.
The photographer chose
a stormy morning in early
winter, when an overcast sky
would bring out the diversity of
greens and russet browns and
the dark forms of the sinister,
twisted trunks of sessile oaks.

Rainforest glade

Above is a picture for the eye to
wander into, among the
hummocks and tussocks and
through the jumble of maple,
spruce and hemlock. The use of
low light from an overcast sky
muted by drizzle conjures up
the cool, wet nature of the place,
every surface lush with plants,
sword ferns bursting out of
a carpet of moss and hanging

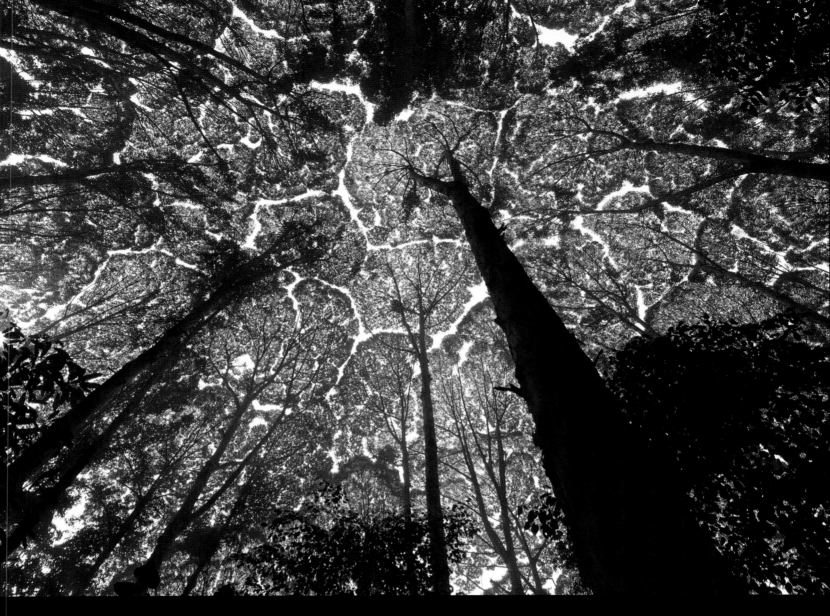

Forest cathedral

Wide-angle-lens views of forest canopies are an established way of depicting the magnificence of trees, but here the photographer has achieved something more with this Malaysian rainforest view. Shooting at dawn, he has created a subtly tinted image, emphasising the delicate tracery of the crowns, while leaving the huge, 80-metre (33-foot) trunks and lower leaves in deep shadow.

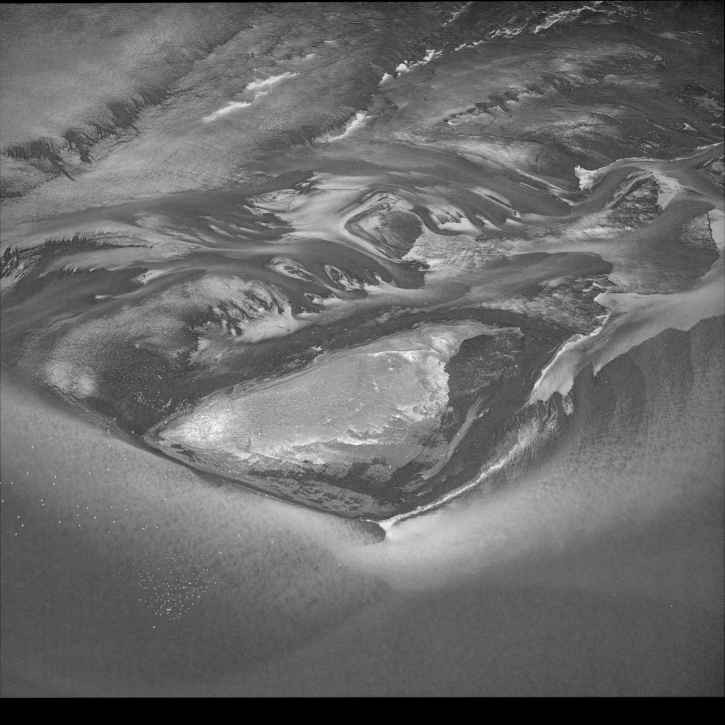

Delta illusion

This picture has many forms. Sometimes it's a swirl of paint, sometimes islands and rivers, sometimes rockforms in strange relief. Turned around, it transforms into sand dunes and great waves. This was the effect that the photographer wanted, taking his shot with the sun overhead on a clear day flying high up in a light plane over the vast River Rangá delta at the foot of Iceland's most active volcano. The orange and yellow tones are the product of iron-oxide-rich water washing off the lava, staining the mud and the great sandbanks. The sprinkling of tiny pinpricks of white in the foreground are hundreds of kittiwakes feeding in the estuary.

Hans Strand *Sweden 2001*

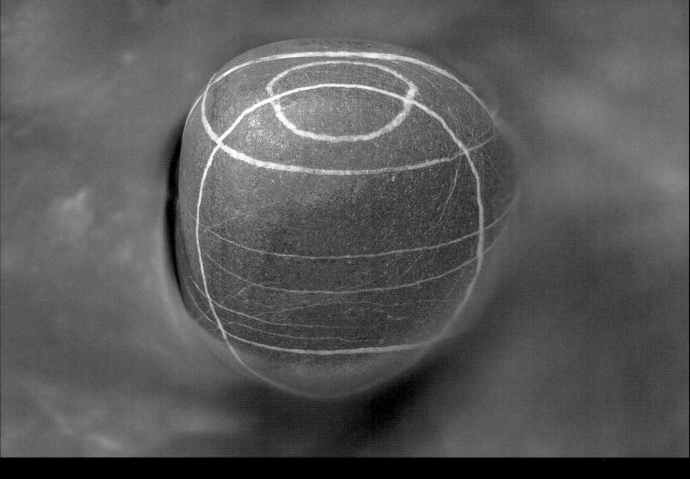

Circles of stone

It's a tiny stone of many layers, a thing of beauty that the photographer found on a beach on a Greek Island and fell in love with. He photographed it exactly where it lay, in shallow water reflecting the blue sky and clouds above. Using a long exposure, he transformed the water into a mystical surround that perfectly matches the extraordinary nature of this cosmological geological creation.

Adriano Turcatti *Italy 1998*

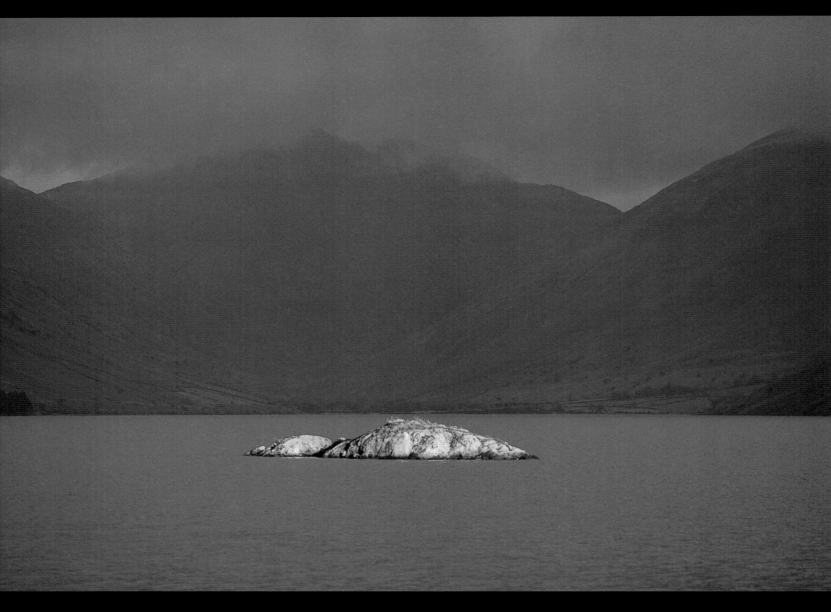

Lake magic

Winter in Britain is a time for creating atmospheric and imaginative pictures for photographers fascinated by the trickeries of light. The start of this grey December day in the Lake District appeared unpromising, but what the overcast sky melding with the cloud-covered hills behind Wast Water created was a dramatic backdrop for the picture the photographer had visualised. He had to wait six hours, much of it in the rain, before the heavens brought him his reward – a ray of sun breaking through the clouds and gilding the tiny island.

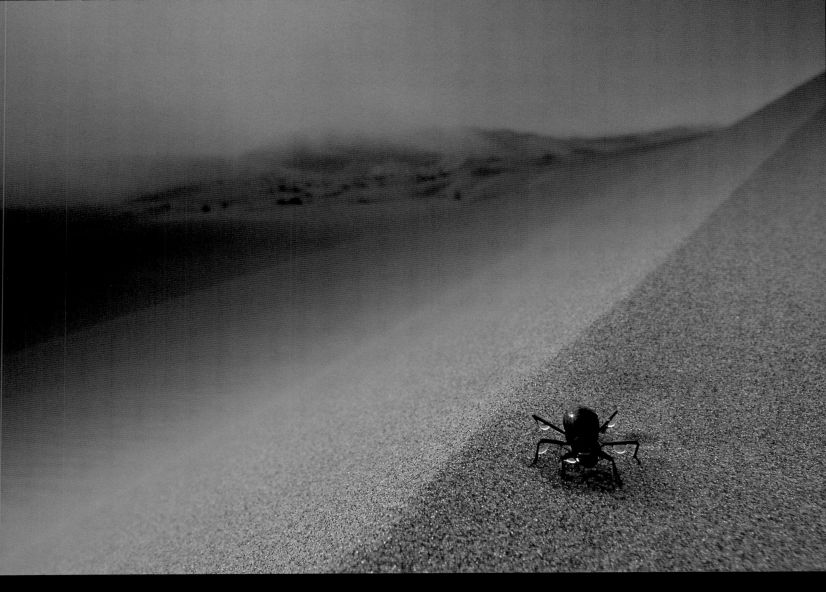

Dune beetle at dawn

Cold, foggy nights are what feed
the dunes of the Namib Desert.
Every plant and animal there –
in this case, a tenebrionid beetle –
has a special way of collecting
the moisture. The photographer
wanted both to tell the story and
to reveal the drama of the place.
Here he has used the structure of
the dune to create diagonal
divisions: the ghostly mist rolling
over the sandhills, a great sweep
of sand in the middleground and
a triangular pattern of sand in
the foreground, on which the
beetle is about to do a headstand
and drink the moisture running
down its legs and back.

Olivier Grunewald

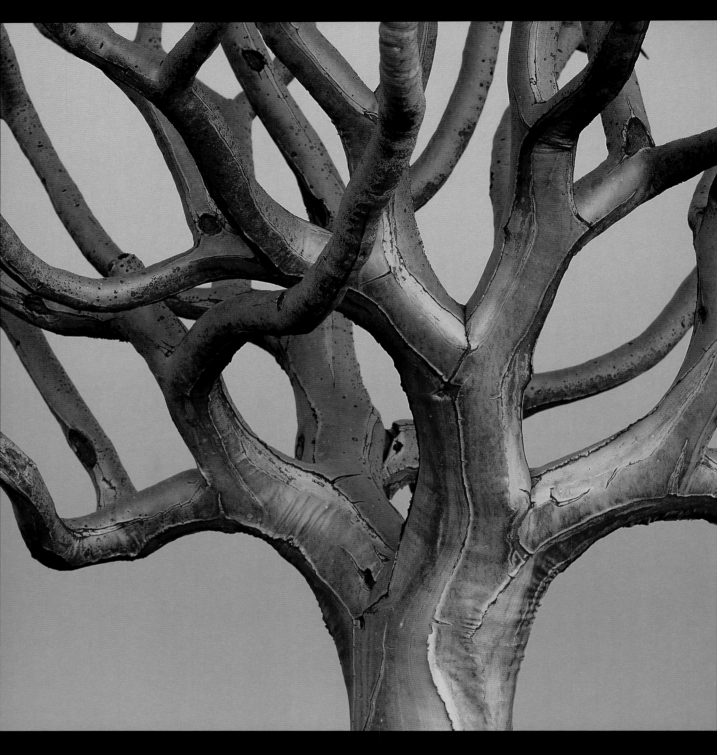

Tree of life

The photographer has used the afterglow of the
setting sun to portray the strange branching of this
giant aloe as a golden sculpture. The thick bark of
the kokerboom, or quiver tree, helps it conserve
water and protects it against the heat of its extreme
environment – semi-desert areas of Namibia and
the northern Cape in South Africa. In the past,
the Bushmen would drink the water stored in
the leaves of the tree-like succulent and hollow out
its branches to use as quivers for their arrows.

Tore Hagman *Sweden* 2002

Woman of the woods

In Scandinavia, woods are places of inspiration fo
and writers. And one of the most symbolic trees i
northern mythology is the birch – a pioneer color
symbol of renewal, strongly associated with fertility
When the photographer saw this huge silver birch
exactly the picture he wanted. It's a creation of fra
timing, using a sunny day at the point when snow
transformed the twigs into silver tracery but had
enough to give the outspread branches an etherea

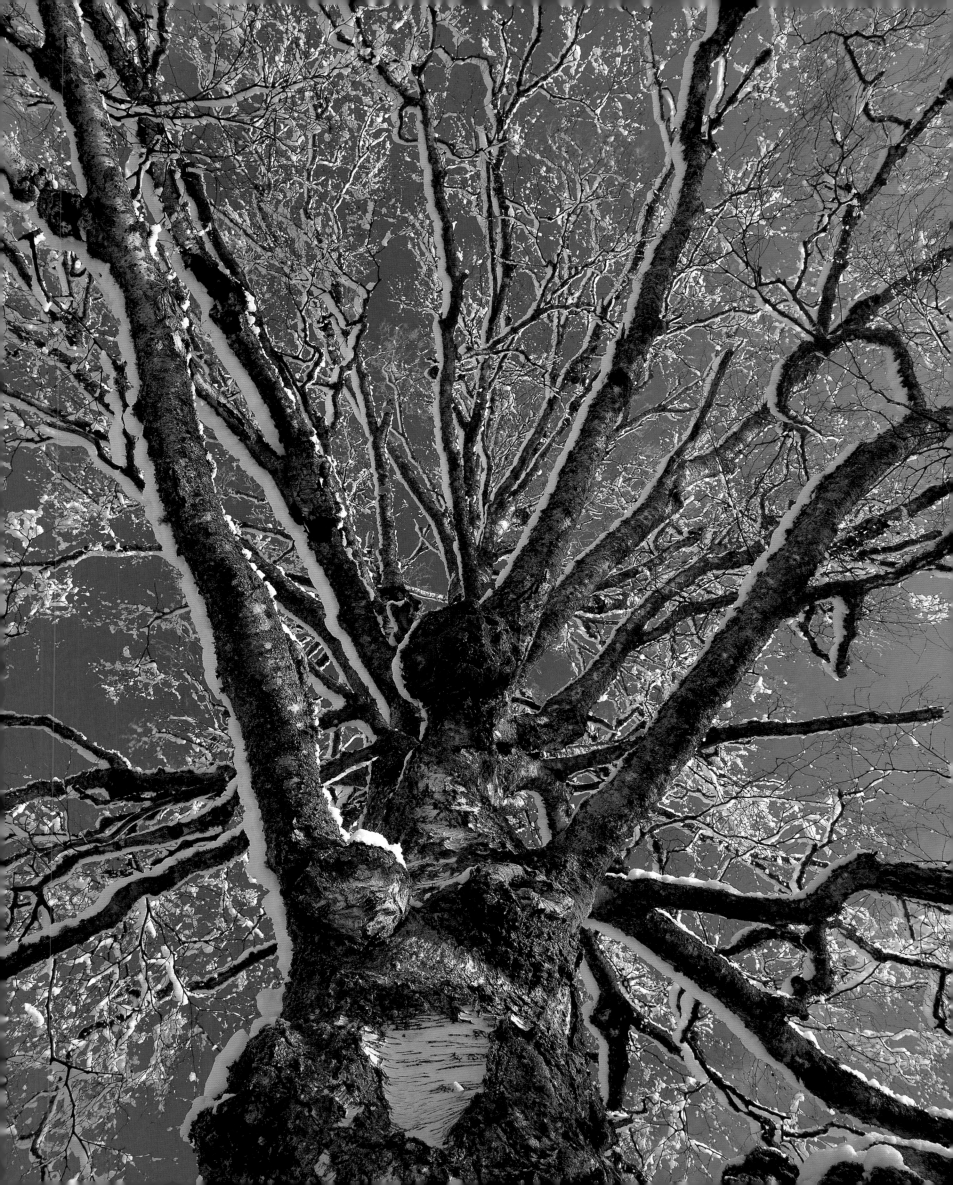

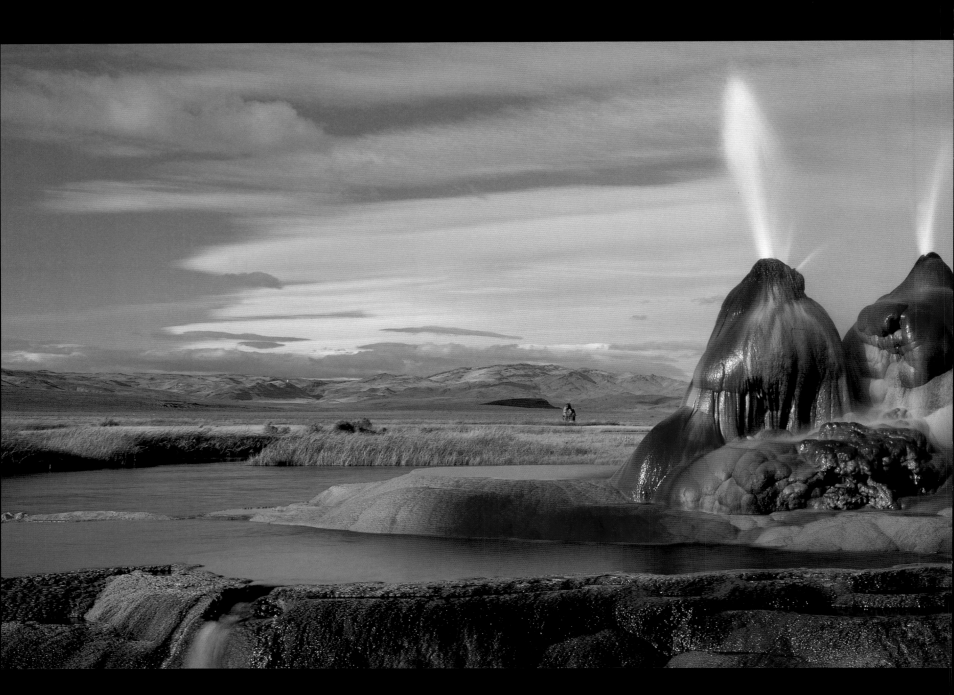

Desert geyser

These extraordinary formations
have been created from minerals
deposited over years by the three
high-pressure spouts of a geyser,
the site of an old bore hole in
Black Rock Desert, northern
Nevada. What makes the image
so powerful is both its panoramic
frame and the timing: wind
has covered one half of the

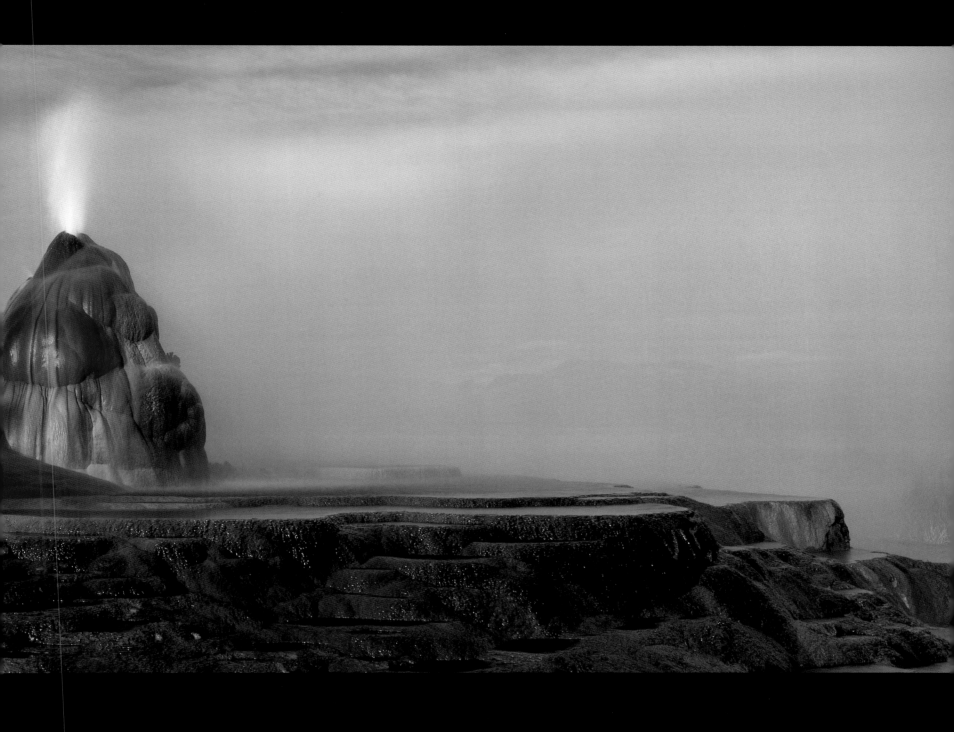

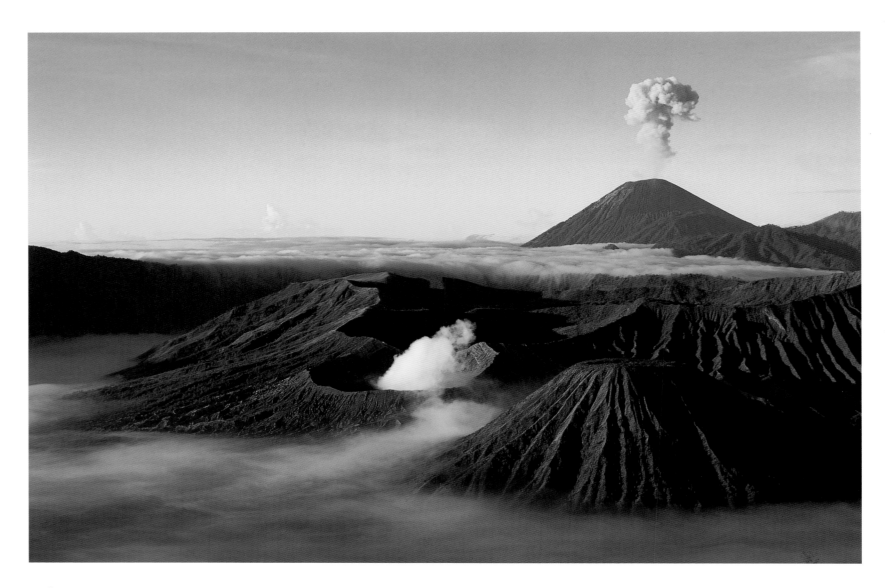

Volcanic sunrise

The photographer has used the glow of sunrise to light a mystical scene of volcanic power, golden seas of mist surrounding the lava cones and their plumes of smoke. It's a symbolic portrayal of a landscape sacred to the Tengger people, who live in the shadow of the Tengger volcanic massif of eastern Java. In the foreground is the cone of Mount Kursi, central is the caldera of Mount Bromo, and in the background is the smoking Mount Semeru, the island's highest mountain. Tengger religion involves reverence of the power of the smouldering volcanoes and an annual sunrise offering into the depths of Mount Bromo.

Dan Bool *UK 1998*

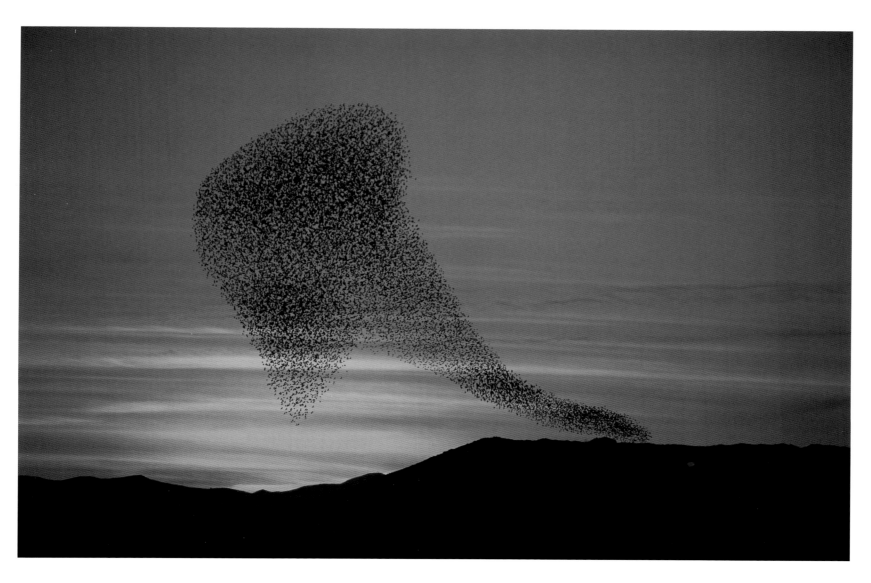

Starling sunset

It took days to get just the right picture of this extraordinary phenomenon – thousands of starlings in an enormous plume, like one huge organism, pouring down into a reedbed roost against the orange light of a setting sun. Starlings probably gather in such huge numbers for the same reason that fish shoal, to confuse predators by sheer numbers and also to exchange information about good feeding places for the following morning. But this northern wonder of the natural world is fast becoming a phenomenon of the past as starling numbers continue to fall. This particular Spanish lakeside roost no longer exists.

José L Gómez de Francisco
Spain 2001

Formations

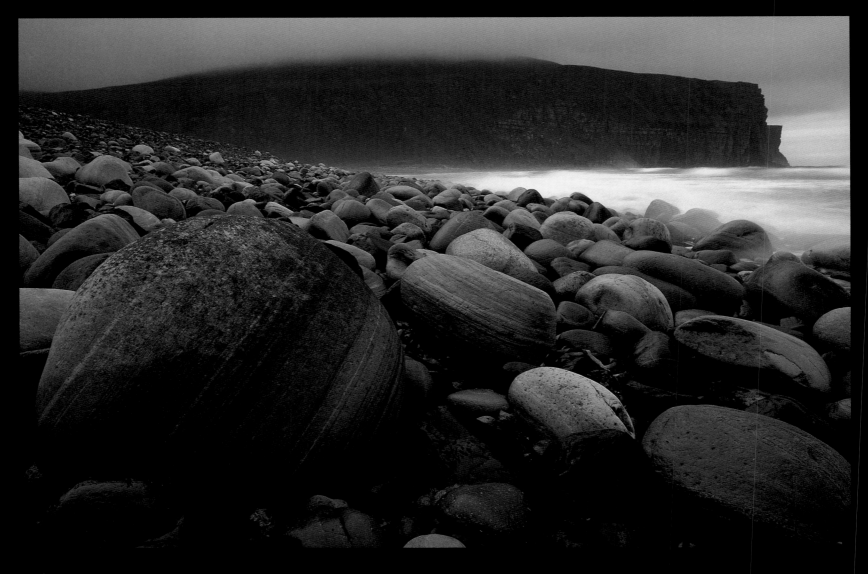

Orkney stones

Time and time again, the photographer returns to Orkney, attracted by its elemental nature and the way the landscape never appears the same – the way it can change even in a matter of hours. This beach is one of his favourite spots, especially in the soft light of a long summer evening, when the subtle colours of the stones emerge. Shooting in a raging late-evening storm in driving rain and seaspray provided him with a new experience of the place and a unique light. To make an image like this, he says, doesn't require skill, just the ability to see and respond.

Mark Mattock *UK 1990*

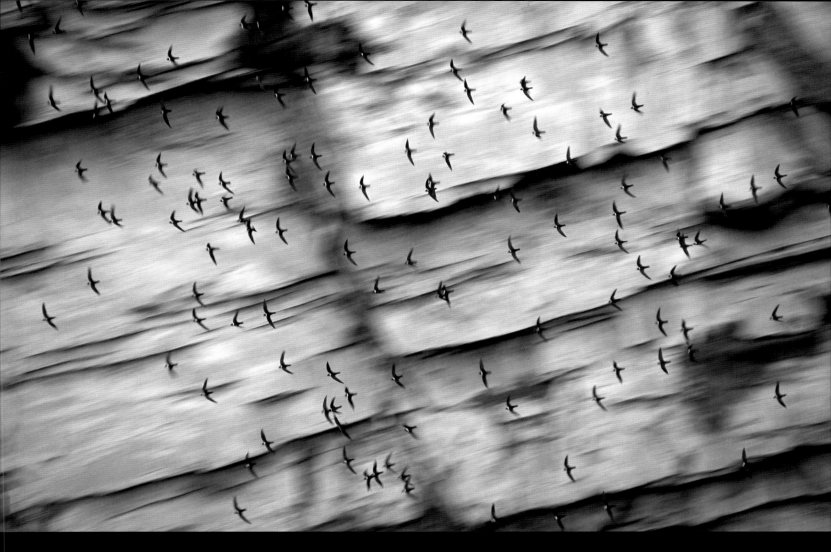

Swift exit

The essence of a swift is in its name. Here the photographer has caught the exit at speed of a formation of Mexican white-collared swifts from their strange nesting colony – an immensely deep limestone sink hole. Hundreds and thousands of the swifts poured out of the comparatively narrow opening, the noise of their wings like rushing wind. Panning the camera and so transforming the rock-face into a pattern of striations, he has emphasised the movement and trajectory of their frantic flight.

Formations

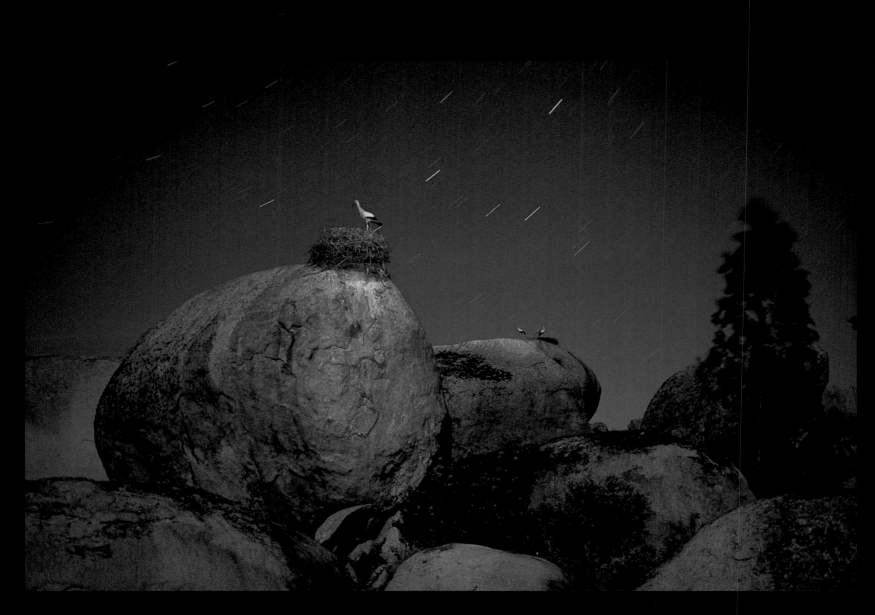

Starlit roost

Here is a picture of impressive
proportions. A striking daytime
scene becomes truly dramatic at
night. But it is a drama of the
photographer's creation, which
took months of preparation.
There was time, as the storks in
Barruecos Natural Park, Spain,
use their nests as safe roosts once
breeding has finished. But many
calculations had to be made: the
right nest, the right composition,
the right camera angle, the moon
phase and distance, the exposure
length. And a prayer had to be
said for the storks not to move
during the six-minute exposure
necessary for the Earth to rotate
and leave star trails on the film.

José B Ruiz *Spain 2003*

110

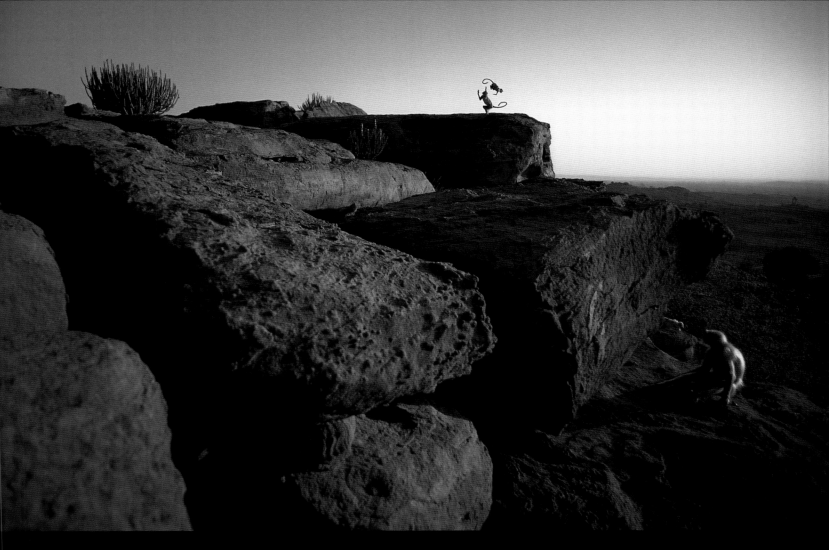

Langur high-jump

This was a picture visualised and planned many sunsets before it was actually taken. Over three years, the photographer visited the Thar Desert of Rajasthan, in India, to watch the same troop of Hanuman langurs at their favourite playground high up on a spectacular ridge. His vision was to show the rocks bathed in early-morning light, at an angle wide enough to reveal their height above the forest below, and with monkeys cavorting at their edge. But though young langurs are tremendously playful, they don't perform on cue, and so it was serendipity that clinched the shot.

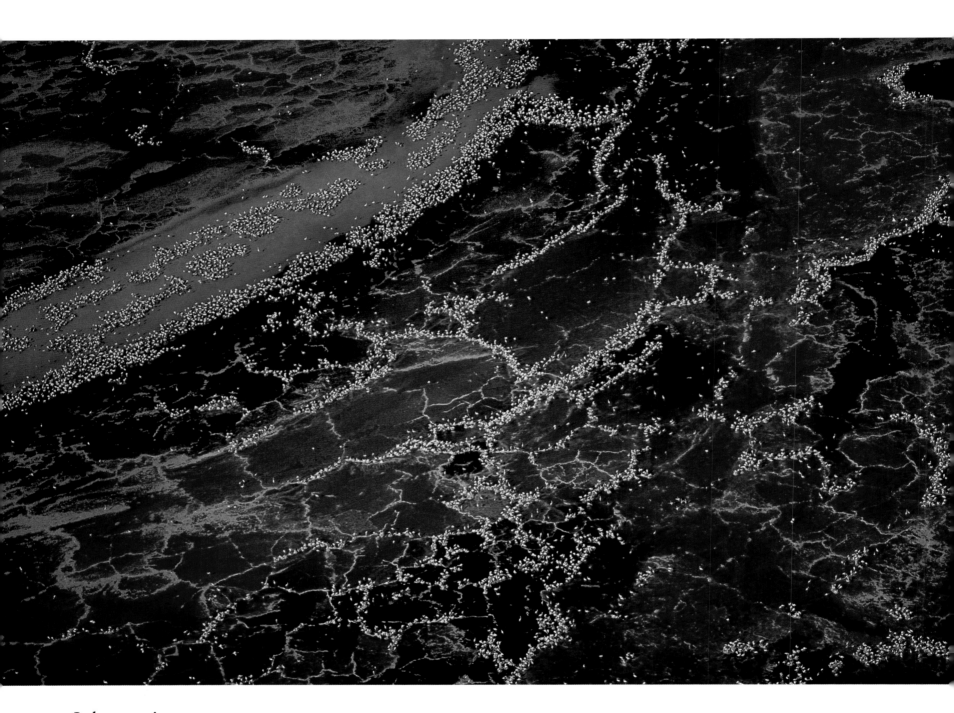

Lake mosaic

You are looking at a scene unique on Earth: a huge soda lake, fringed by caustic mudflats stained red by spirulina algae and patterned with crystallised salt from hotsprings. But what makes Tanzania's Lake Natron special are the hundreds of thousands of lesser flamingos that feed on the algae – the source of pink in their feathers. The photographer knew the aerial view he wanted, and got it, showing meandering groups of nesting and feeding flamingos as ribbons of pink snaking over the otherworldly surface of this Rift Valley lake.

Anup Shah *UK 2004*

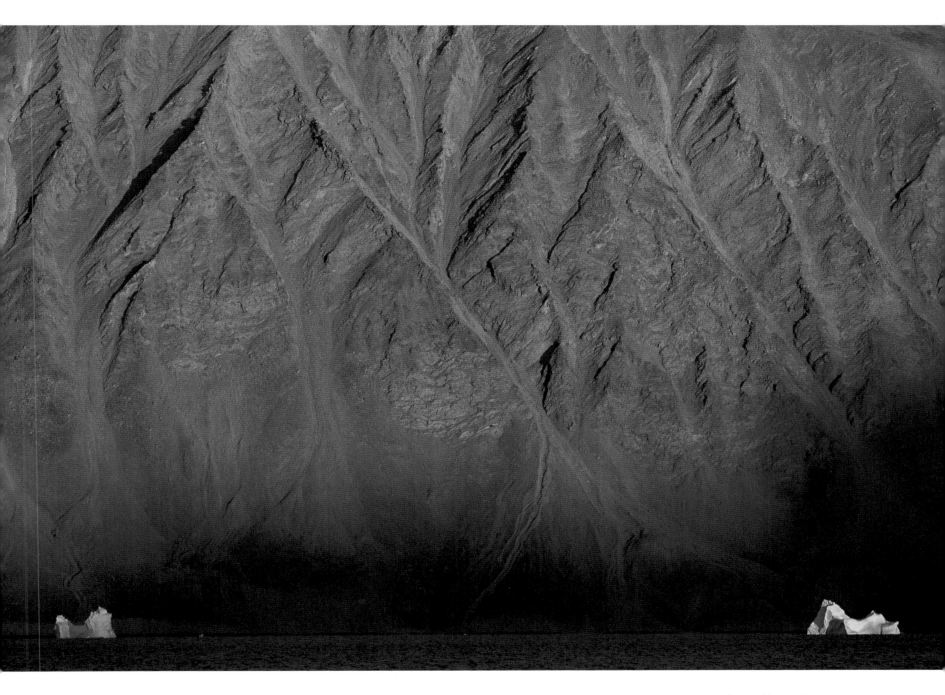

Rock wall and ice

Such a breathtaking vista is one few have seen. The immense rockface is the edge of an island in one of the least visited places on Earth – Northeast Greenland National Park. It's so huge that the four-storey-tall icebergs below are dwarfed. The photographer wanted to create an image that would convey the overwhelming immensity and strangeness of this polar desert, and chose the low light of the midnight sun (the picture was taken from his expedition ship at 3am) to cast a glow over the sheer wall and to spotlight the ice.

Staffan Widstrand *Sweden 2004*

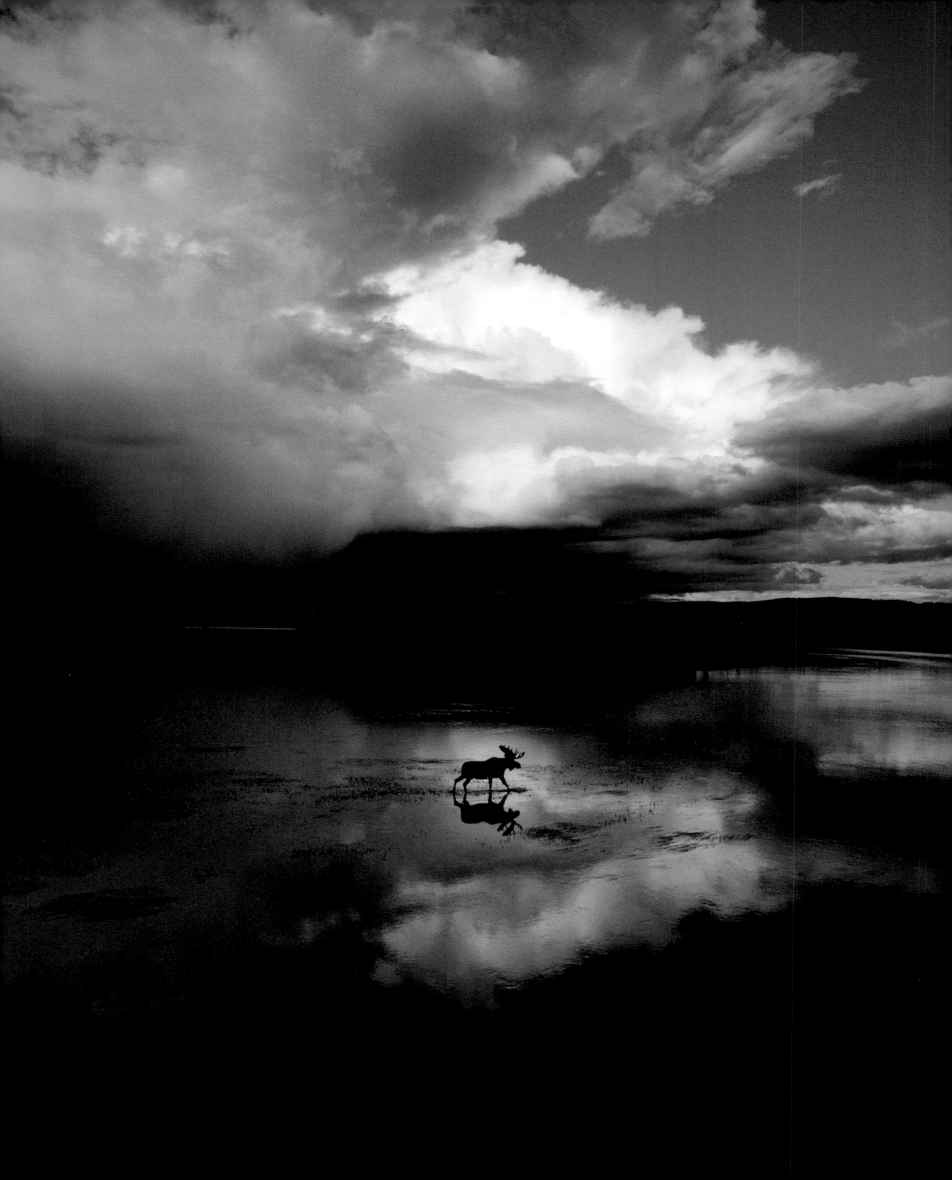

Reflections

Elio Della Ferrera

Can wildlife photography be regarded as an art form?

Or will it always be seen as just a way of documenting nature?

The wondrous ability of the camera to reproduce reality instantly clouds

the issue. The camera is merely a tool, adding to a repertoire of artists' tools.

If Leonardo da Vinci had used a camera to capture the Mona Lisa on film,

would he have paid any less attention to the depth of her expression? . . .

Moose at sunset

Here is a picture that has resulted from an intimate knowledge of
a place. The photographer has lived in Yellowstone National Park
for more than 30 years, and this is one of his favourite spots.
After a heavy summer storm, he chose to wait beside the river,
which was at its lowest, knowing what was likely to happen.
As the sun set behind the storm clouds, a moose came down to feed
on the exposed aquatic vegetation. The shot was taken as it lifted
its head to listen to the noise of a car in the distance – a reminder
that there are few truly wild areas left on Earth.

Steven Fuller *USA 1984*

Reflections

Photographing nature eventually becomes a mission to capture more deep and meaningful shots and to tell the sad stories of the fate of animals and environments from forgotten corners of our planet.

. . . The reality portrayed on film can never be as it is in nature. It is a reflection of how photographers see things, what they know and feel about their subjects, and how they capture unique moments, blending light, shades of colour and composition.

The wildlife photographer, though, is devoted to the essential truths of nature and therefore doesn't manipulate the medium to the extent that a photographer from another genre or a painter might, or manipulate the subject – ethical considerations that may mask individuality.

Notwithstanding such limitations (or maybe even because of them), wildlife photographers still manage to create pictures never seen before – as this book reveals. *Light on the Earth* is a synthesis of two decades of wildlife photography from the farthest corners of the Earth – images chosen for their artistic value as well as their content.

Of course, not every wildlife photograph is as an artistic creation. More often than not, wildlife photography is simple documentation. It's the photographer who decides whether to use the camera like a painter's brush or simply as a tool to take a frame from a scene. And if the photograph is published, it's the editor who decides whether to dedicate more space to the artistic aspect or to the descriptive part and whether to frame it in an artistic way.

There is also another aspect to wildlife photography that influences the outcome. Photographing nature is a real adventure. The setting is unpredictable. The weather and the light can change rapidly. The subjects move, appear and disappear. Rarely can one speak about a comfortable job – on the contrary, it's frequently very hard work. Sleeping in a small tent on the snow of the Alps to photograph mountain hares or ermines is no holiday. Yet for a wildlife photographer, it can be an extremely satisfying experience. It is in situations like this that it is possible to capitalise on the fleeting moment and capture that unique image in an ever-changing natural scene.

Every photographer has his or her own favourite subjects, and such emotional attachment can add another element to the final creation. For me, an animal or a landscape can arouse my interest to the same degree, and I am prepared to dedicate the same amount of time and passion to both. But if time forces me to choose, primates – monkeys and apes – have been the reason I've uprooted time and time again from the quiet, alpine valley where I live to remote, barren and at times hazardous lands.

Geladas – those magnificent baboon-like creatures – were the reason that, 10 years ago, I camped out for almost a month on the spurs of the Simien mountain range in the Ethiopian highlands.

From then on, I've always included monkeys among the subjects of my travels. I've always been fascinated by their appearance, their variety, their behaviour and expressiveness. If you stay with them long enough, it is even possible to distinguish their personalities. Normally, however, they are extremely shy creatures. And watching a group of these mischievous sprites is not made easier by turning into a filling station for bloodsucking mosquitoes, leeches and ticks. The determination to stick it out and the necessary intense concentration comes from passion – passion to be in the midst of nature, to explore and observe, to really get to know all its wondrous forms.

Photographing nature eventually becomes a mission to capture more deep and meaningful shots and to tell the sad stories of the fate of animals and environments from forgotten corners of our planet. And getting the result you want is a matter of pride and another reason to keep going despite the difficulties. Used with care, a camera has the power to capture the emotion of the moment, to educate and, above all, to make us contemplate. Add to that experience, sensitivity and the artist's eye, and you have the perfect medium for expressing the wonder of nature.

Golden diver

A picture like this is the product of devotion, in this case, more than 20 years of devotion to red-throated divers in the remote regions of Finland – watching, photographing and writing about them.
This was one very special evening. It was almost dark, storm clouds were gathering, and the shady forest surrounding the pool had cast a strong shadow on the murky water. For just a minute the sun came out and hit the breast of the sleek bird – perfection.

Jouni Ruuskanen *Finland 1989*

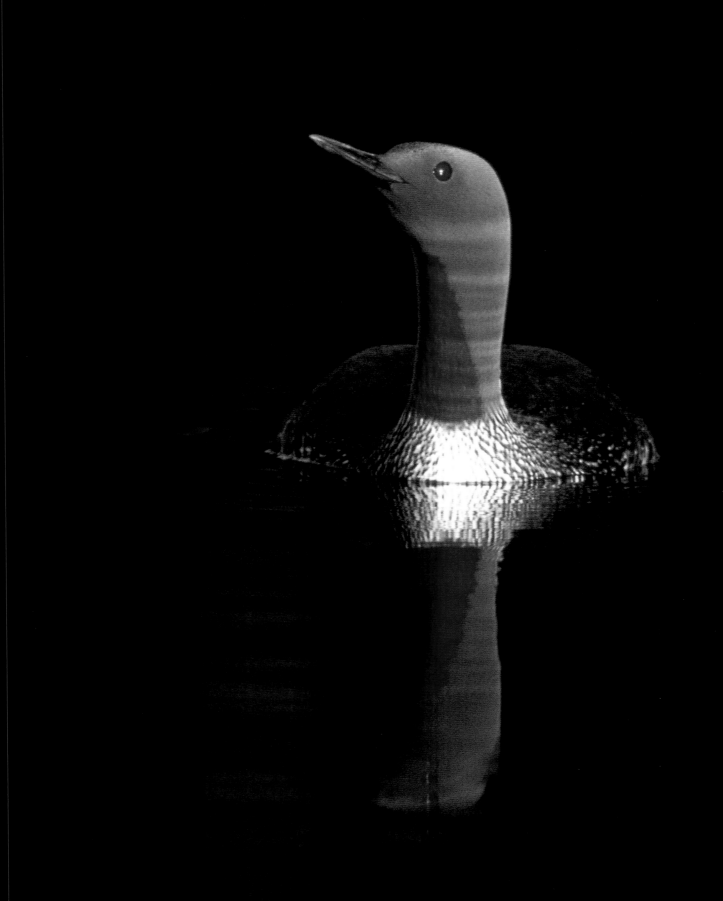

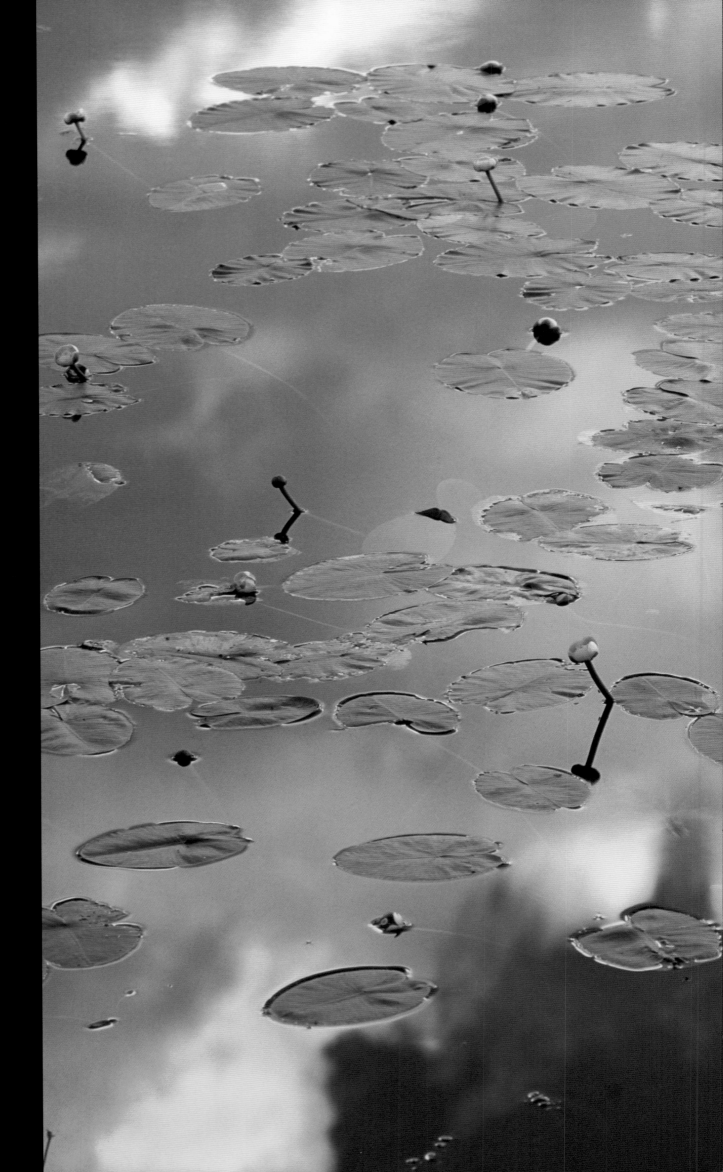

Reflections

Sky lilies

Tinted clouds and a palate of blues are the canvas for this reflective composition, taken in the early evening on a summer day. The photographer portrays the leaves of the wild yellow water lilies floating on the sky and the emerging flowers like strange buoys attached to the roots in the mud below the tranquil surface of the lake.

Jan Töve *Sweden 1992*

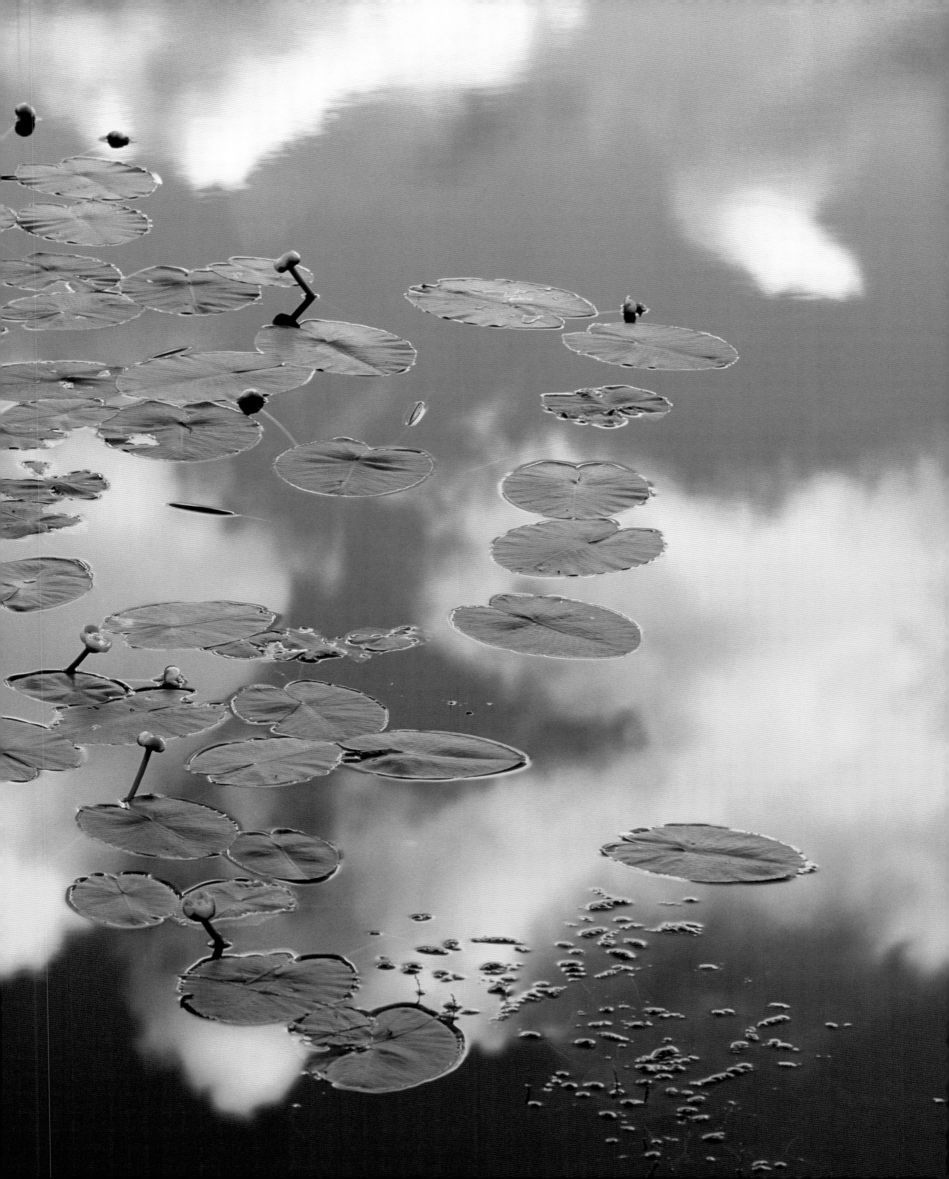

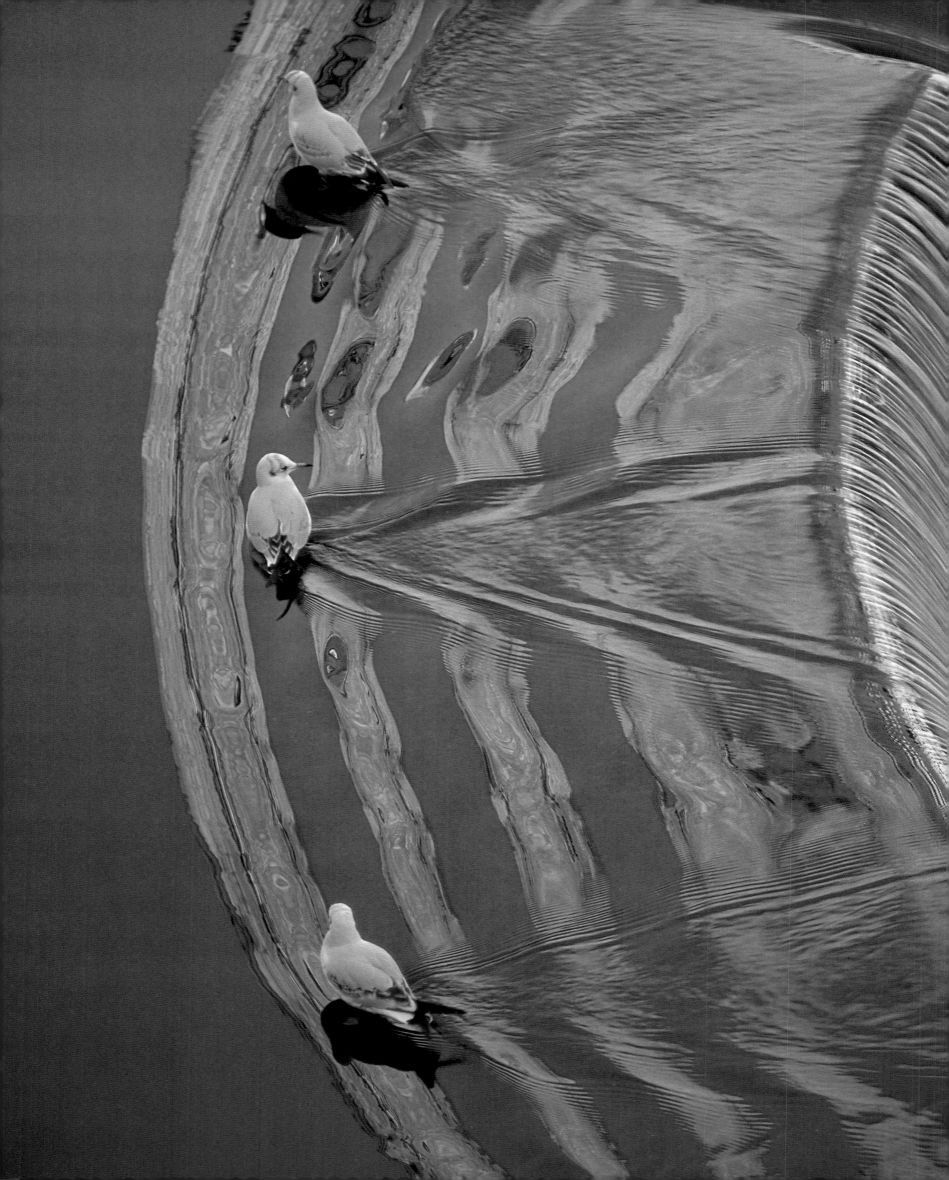

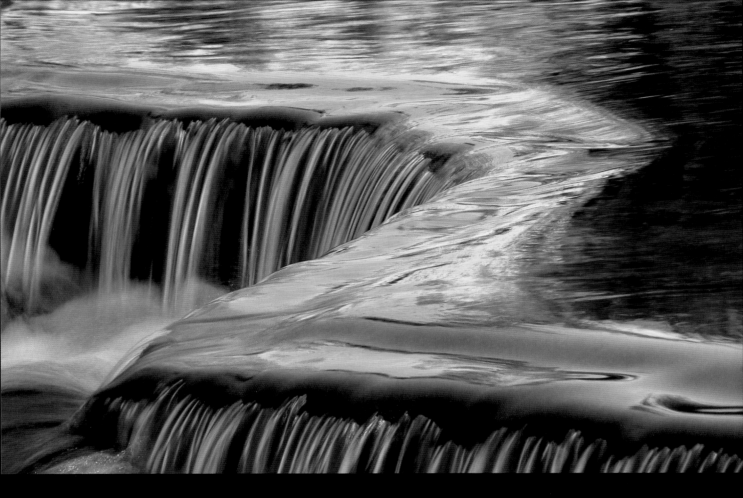

Autumn rainbow

Compositions of light on water
are a preoccupation of the
photographer, who has spent
many years searching for abstract
inspiration in nature. His
intention was to create a picture
using the painterly effect of

Reflections

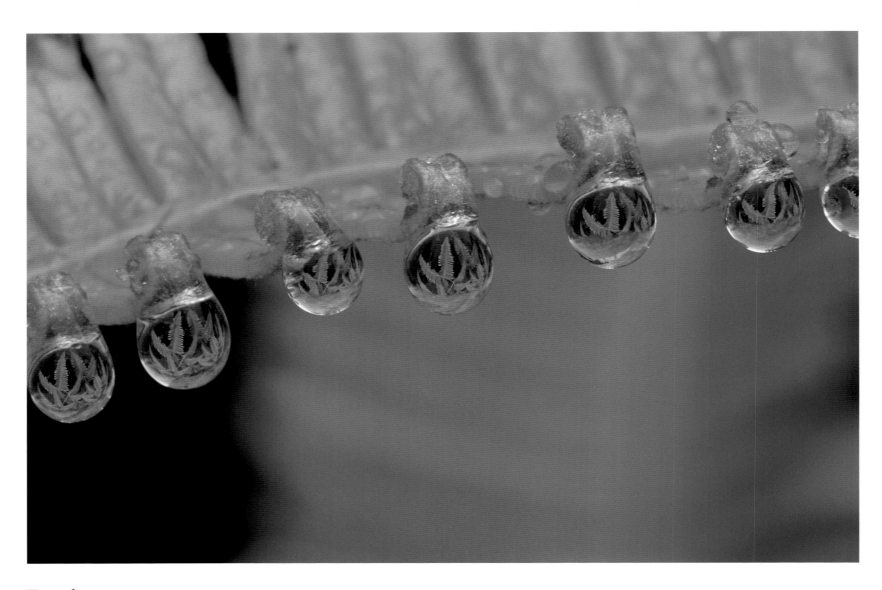

Fern drops

The photographer obviously had fun composing this natural puzzle of a picture. The series of gilded hooks are unfurling divisions of a fern leaf (the pinnae), from which hang raindrops, each with an image of the plant itself. But with the symmetry comes asymmetry: each pinna is curled in a slightly different way, each drop is a slightly different size and each picture is from a slightly different angle. And the apparent reflections are, in fact, refractions. Each raindrop has acted as a fisheye lens, focusing the light as it enters and, as it exits, converting it into an inverted image of the hanging fronds of the false staghorn behind it – a visual conundrum of a composition.

Whit Bronaugh *USA 1998*

Eye of the zebra

This is a haunting picture – a photographic record with a difference. The zebra is dead, shot by Western trophy hunters in the Okavango, Botswana. It was a licensed kill, justified on the basis that the bounty paid on the animal's head enters the local economy. The graphic pattern of stripes is striking, but it focuses attention on the strange eye. The black which surrounds it resembles make-up that appears to be running, as if the eye had been weeping. It highlights the green of what at first seems to be the pupil. But in place of a pupil is a reflection of the triumphant hunter with his gun, the photographer taking his shot and another figure, perhaps the tracker, standing back from the scene. Though the photographer makes no judgement, his image remains a disturbing statement.

Frans Lanting *USA 1991*

122

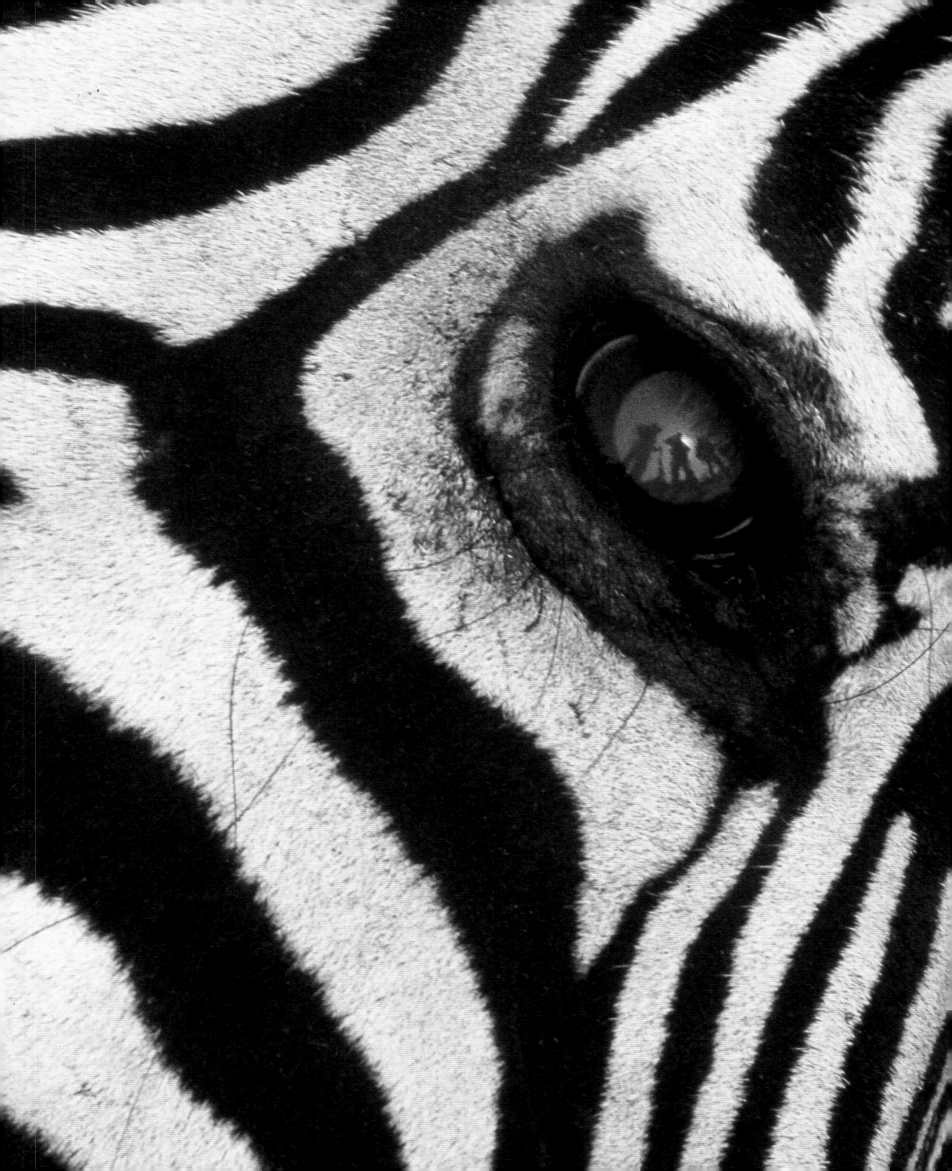

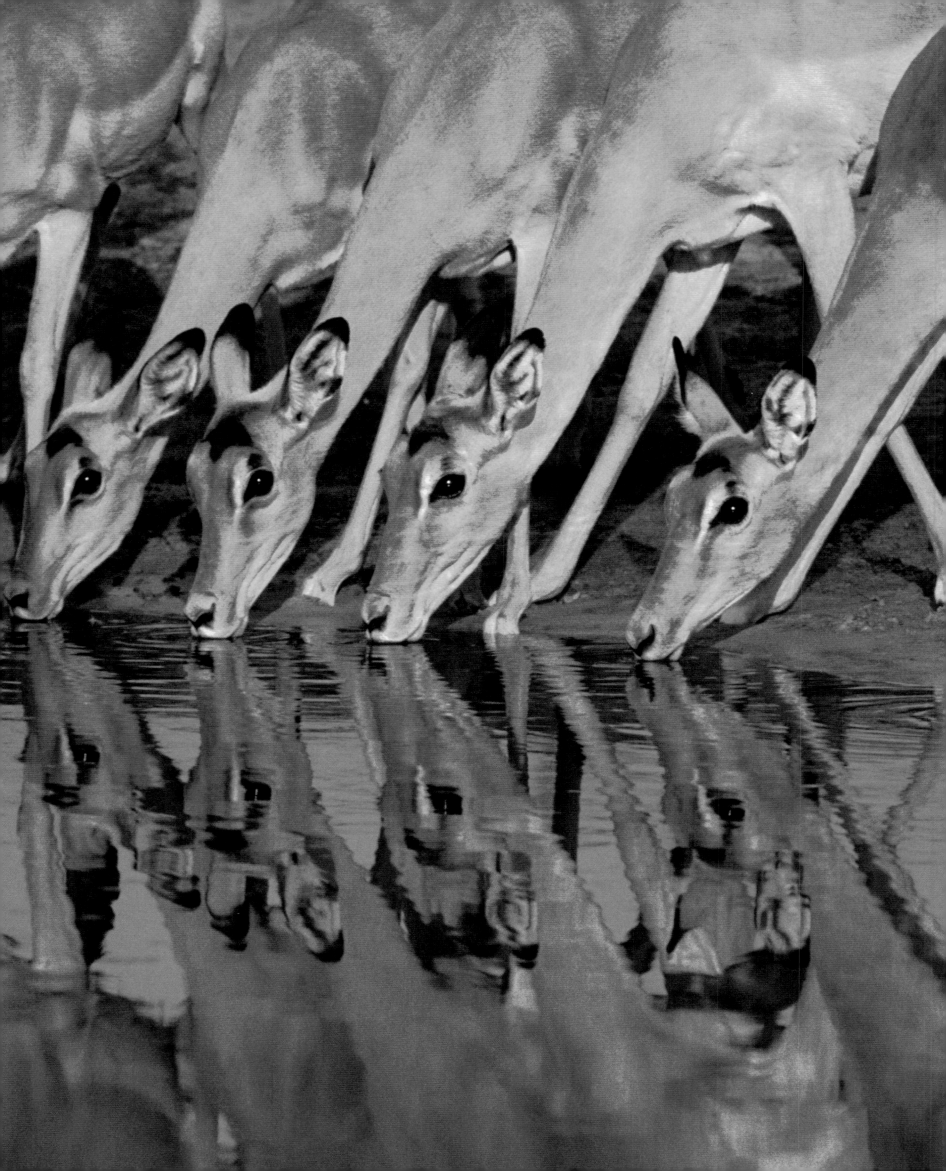

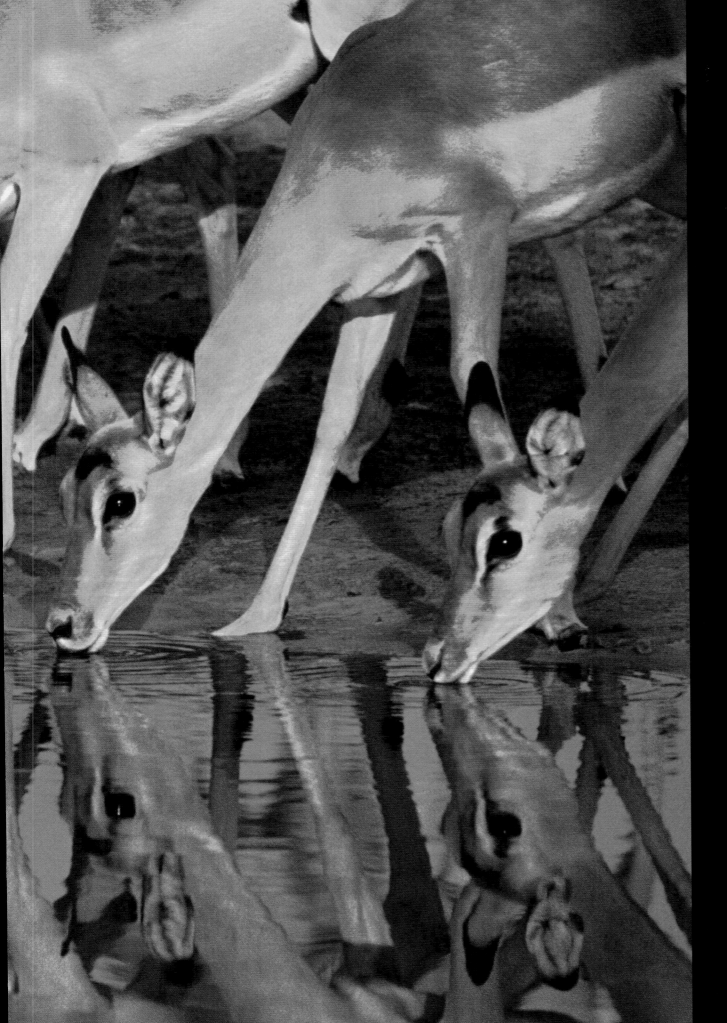

Impalas in unison

These beautiful antelope are very
much part of the African
landscape, though very often
overlooked. But for this
photographer, who prefers to
stay in one place, merging into
the landscape so the animals
ignore him, they are a source
of inspiration. The picture is
simple but conveys both their
togetherness and the gracefulness
of the animals as they delicately
drink from the waterhole.
There is also a natural symmetry,
not just because of the reflection
but in the way each animal's ears
are cocked, alert for danger,
and their legs positioned, one
forward, one bent. The low light
is perfect for the photographer's
purpose, casting a gentle glow
over the scene while flattening
it and so enhancing the pattern
of colour and form.

Green on gold

Colour changes in nature can be
gradual, as with the turning of
autumn leaves, or instant, as
shifting light brightens or dims.
And water can provide an ever-
changing mirror of the process.
Here the setting was a Turkish
woodland at last light on an
autumn day, and the mirror was
a lake full of floating pondweed.
The golden woodland reflections
are offset by the blue of sky
reflected off green and tinted
with shards of autumn hues.

Nusret N Eren *Turkey 2001*

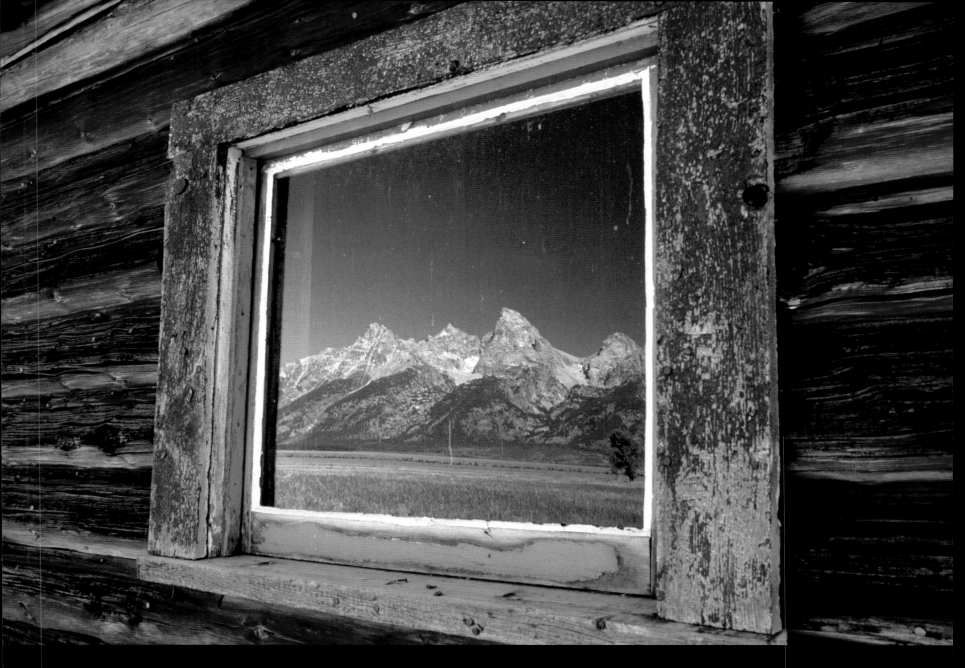

Mountain window

The icy peaks of the Grand Teton Mountains frame Wyoming's Jackson Hole valley, where the photographer discovered this window on an abandoned farm building. He fell in love with the colours – and then saw the picture. There is a play on pictures here: a beautiful landscape is framed for our admiration, but the angle chosen for the view of the window creates a feeling of looking out into and reflecting on the landscape.

Herb Eighmy *USA 2003*

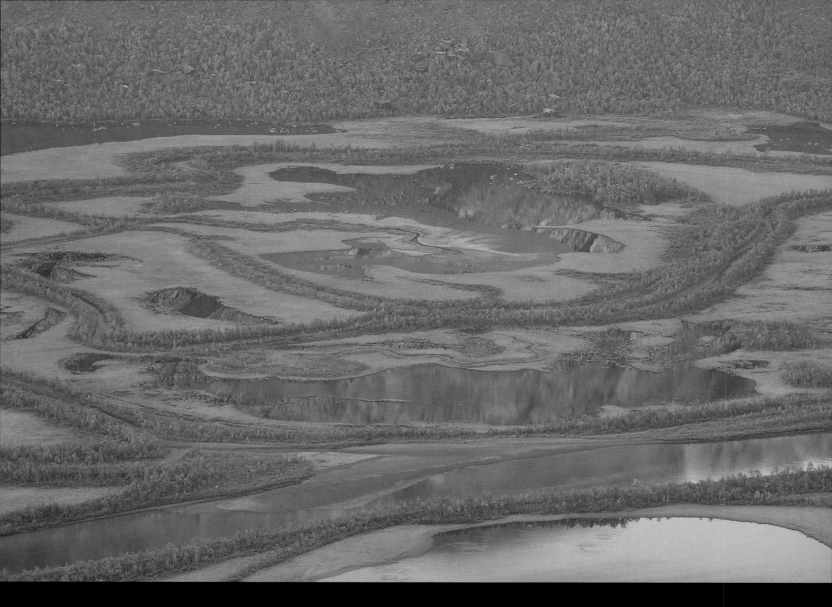

Delta reflection

Ice coloured steely-grey by the
early-morning light and rimmed
by frosted vegetation appears as
land, while the unfrozen sheets

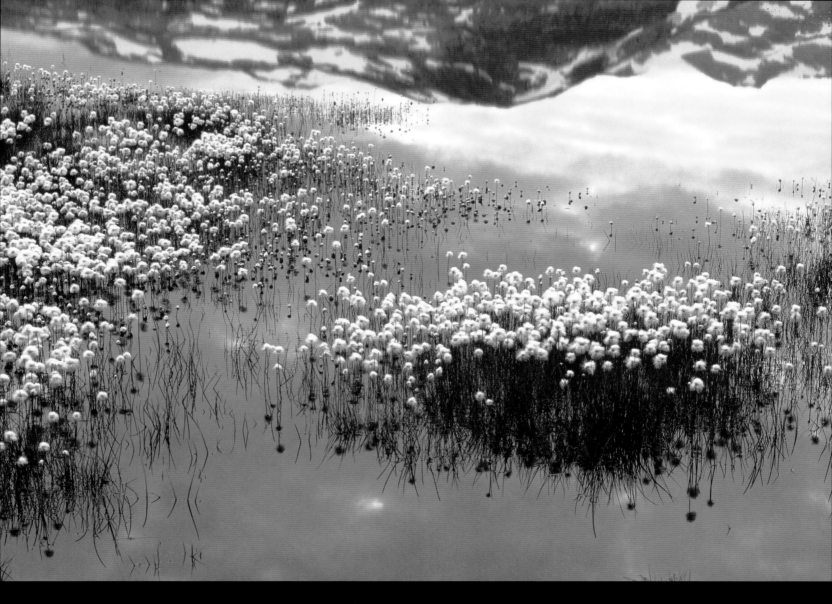

Cottongrass waterscape

A Norwegian meltwater scene is transformed by the framing and choice of light into an unknown landscape. Mountain-top reflections become mountain-bottom valleys, the sky becomes a snowscape and the seedheads of the cottongrass appear as floating islands of snowflowers.

Jan Töve *Sweden 2000*

Reeds on blue

Still water, blue sky and reeds –
simple, natural artistry.
The more you look, the more
you find: hieroglyphics, a fish,
the curve of a breast, a bird.
The photographer fell in love
with the lake in northern
Sweden and camped beside it
for a week, canoeing every day
and seeing new images every
day. But what captured his
imagination most were these
"messages from nature".

Jan-Peter Lahall
Sweden 1999

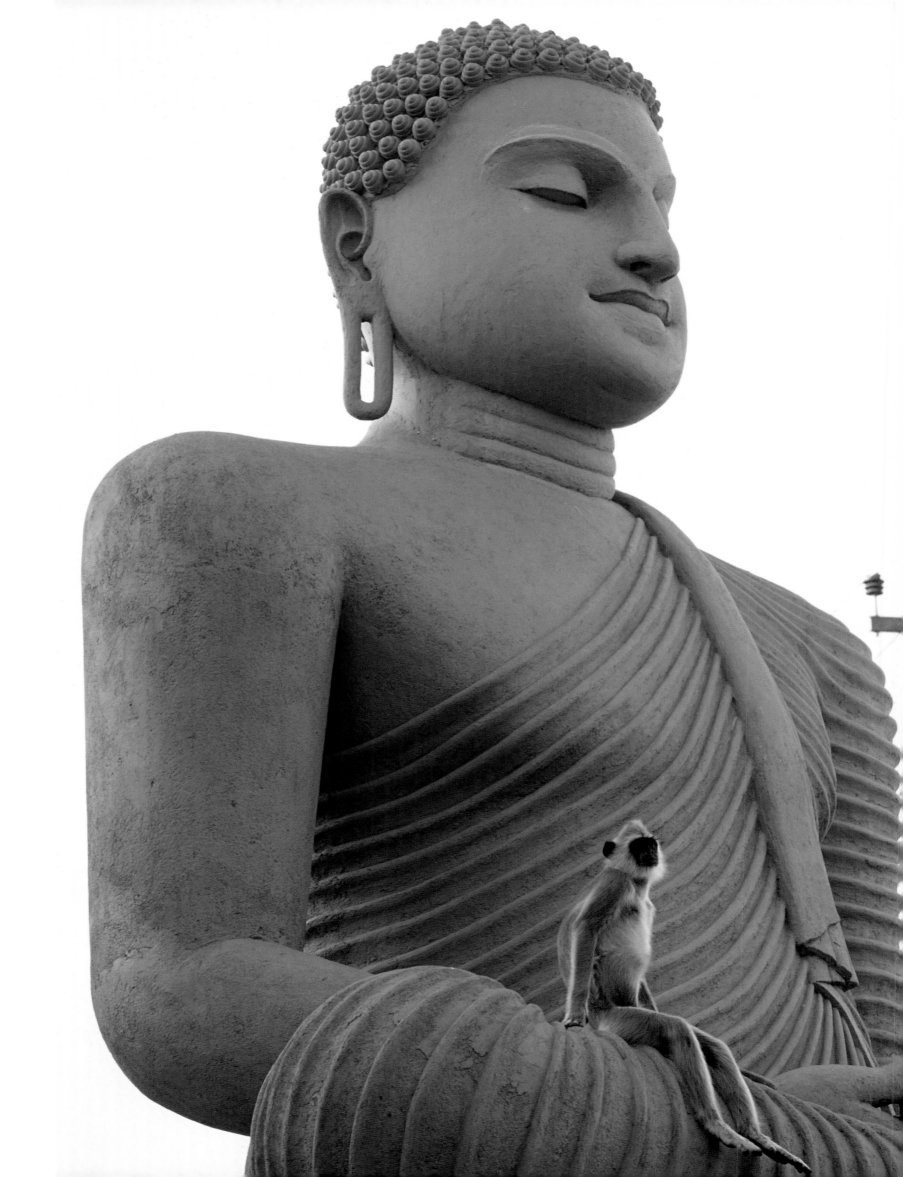

Connections

RAOUL SLATER

Once, while walking along a creek bed in the Australian desert, I was mugged by a flock of corellas. A corella is a small, pugnacious cockatoo. (It has been said that if a corella picks a fight with you in a pub, you need to have an emu watching your back.) On just about any day in the past hundred years, I could have made this walk undisturbed. Apart from the buzz of flies and the call of a far-off crow, there would have been silence. In the hush would have been an air of weary expectation . . .

Buddha and the monkey god

The photographer prayed for this picture. A group of Ceylon grey langurs (a type of Hanuman langur) passed by the Sri Lankan Buddha regularly, but it was only for one moment on one day that an individual chose such an auspicious resting place – an unforgettable symbolic pose, a representative of the Hindu monkey god Hanuman at ease on an icon of Buddhism.

Elio Della Ferrera *Italy 2001*

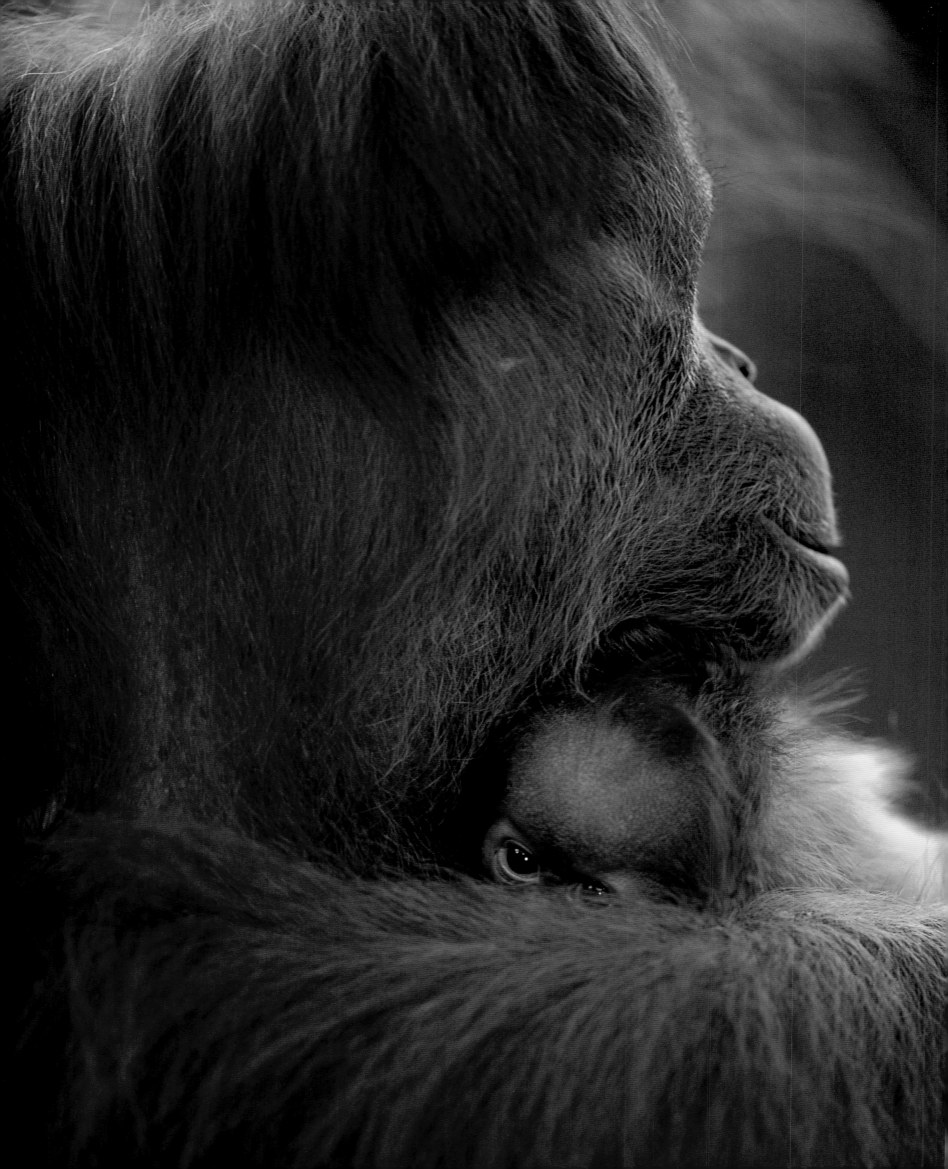

. . . Every dried-out, smudged and desperate living thing within sight would have been waiting for rain.

Once a century, the monsoon rains breach the coastal mountain ranges and the creek runs again, with one part water to two parts dust. It is worth watching the weather maps for inland rain and then booking a holiday for six weeks later. The Australian Outback, in August, six weeks after rain – where on Earth can compare! By then the creek will crunch underfoot with fractals of mud, and the silence will be gone. The calls of breeding birds will drown out even the flies: bellbirds, bowerbirds, robins, woodswallows, but most of all parrots.

Corellas follow the rains and nest in colonies along coolabah-lined desert watercourses. My walk along their creek brought them popping out of their nesting hollows in the branches above. They launched into a verbal attack.

A corella's call is a blend of fingernails on a blackboard, smashing glass and the cruellest of laughter. With hundreds overhead, the wall of sound was unbearable. First it seemed that my ears were bleeding, then it became difficult to think, and then my vision collapsed like a migraine. Some burglar alarms work in the same way by throwing up such a racket that it is impossible to think of anything except escape.

To preserve sanity, I ran out of range. The triumphant flock hung off twigs or puffed out their ridiculous, tiny crests. They were so pleased with themselves that I had to laugh.

In an instant the ruckus ceased. Their outstretched wings were like a salute. Instead of defeat, I felt exultant. Isn't this how Australians show that you've been accepted – by hanging upside down and yelling insults at you? Even at its most abrasive, nature had given me a gift.

At a later time on a different planet altogether, I walked along a Sydney street. All around were advertisements, hoardings, tv screens, t-shirts, newspapers and magazines: hundreds, thousands of photographs, each as shrill as a corella's cry.

This assault on our vision has been building since mass reproduction and distribution of the photographic image has become commercially viable. Even so, a walk along this King's Cross street would have been largely undisturbed for almost all of the past hundred years – apart from the buzz of neon and the far-off glimpse of a billboard. Just in these last few years has the presence of images become overpowering, appearing out of the ether on every available surface, each one clamouring for our attention.

Some days this can be too much. The images crowd in on you, the visual uproar becomes overwhelming. Taking in any

I wish that we could all stop just for a moment. Take a deep breath. Clear our minds of all the millions of artificial images we have seen. Return to what is real and important.

more is impossible. You feel like curling up somewhere safe, out of sight of technology.

That walk in King's Cross was different from the one in the creek bed because the experience felt artificial, without connection to the natural world. There was no way to step back. The crush of images just kept coming.

I wish that we could all stop just for a moment. Take a deep breath. Clear our minds of all the millions of artificial images we have seen. Return to what is real and important. Often in our lives it is birds that give us peace. With their song they silence the uproar. In their flight we see our own hearts. Even as they fly away from us, our bond with the Earth grows stronger.

Standing in a blaze of wildflowers and looking back at the eucalypts flagged white with corellas, I felt honoured to have been noticed. In my mind I hold an image of that moment, unrecorded yet indelible. Connected to a hundred crazy cockatoos in our home together.

Mother and child

This is a simple image but one with great poignancy. It's a pose the photographer has chosen with care and foresight. The strength of the mother's arm enveloping her tiny baby and her gaze out to an unknown future reflect tenderness and vulnerability. We share much in common with the orang-utan, genetically and behaviourally, but for the endangered ape, prospects are bleak. Despite international outcry, logging of its rainforest home in Borneo and Sumatra continues at speed.

Manoj Shah *UK 2000*

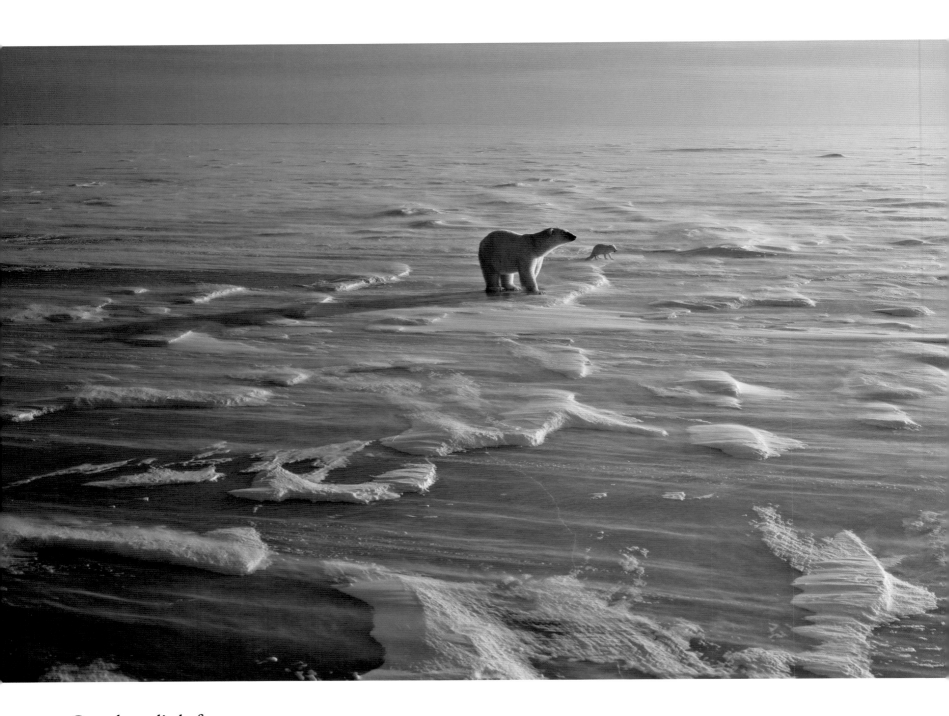

Great bear, little fox

This is a picture of immensity and intimacy. The two animals have paused together and are looking towards the setting sun, the great Hudson Bay sea ice rippling towards the horizon. Knowing that Arctic foxes often become attached to polar bears (relying on left-over seal meat for survival), the photographer set out to create exactly this panorama, illustrating both the harshness and the beauty of the vast ice wilderness.

Thomas D Mangelsen
USA 1994

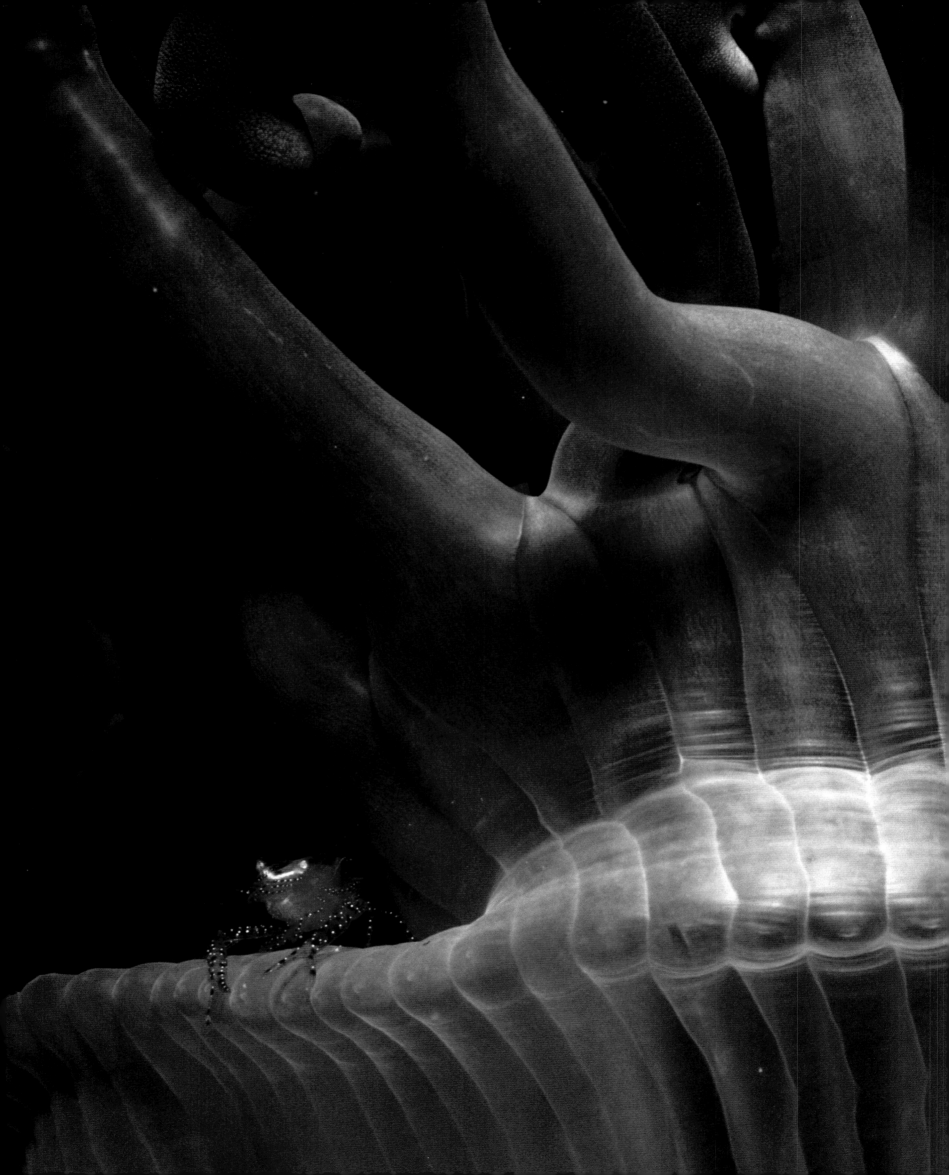

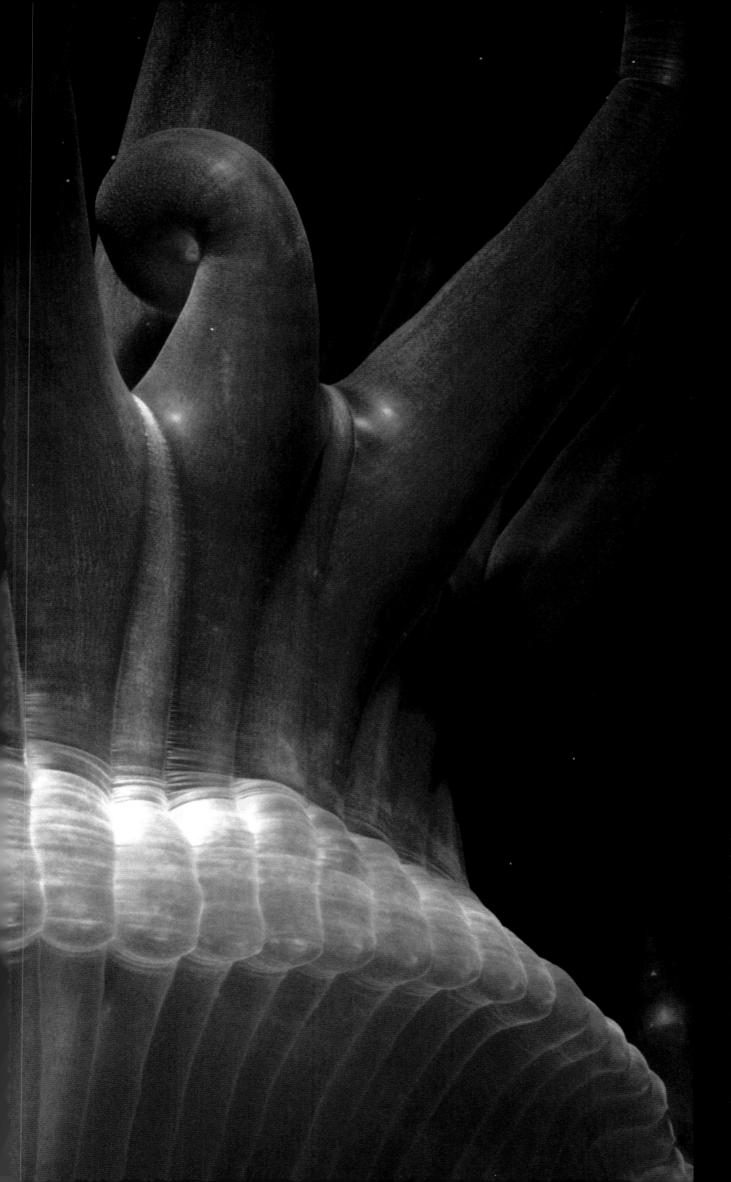

Shrimp

The usual way to portray the relationship between a cleaner shrimp and its anemone home is to show the scene in full colour, focusing on the shrimp. Here, though, the photographer has chosen to emphasise the sculptural vastness of the shrimp's great protector – provider of shelter and defence. The clever use of flash and reflector has put the anemone in deep shadow, highlighting just the foreground palisade and the head of the curious shrimp peeping out, ghostly in the gloom.

Jeff Rotman *USA 1991*

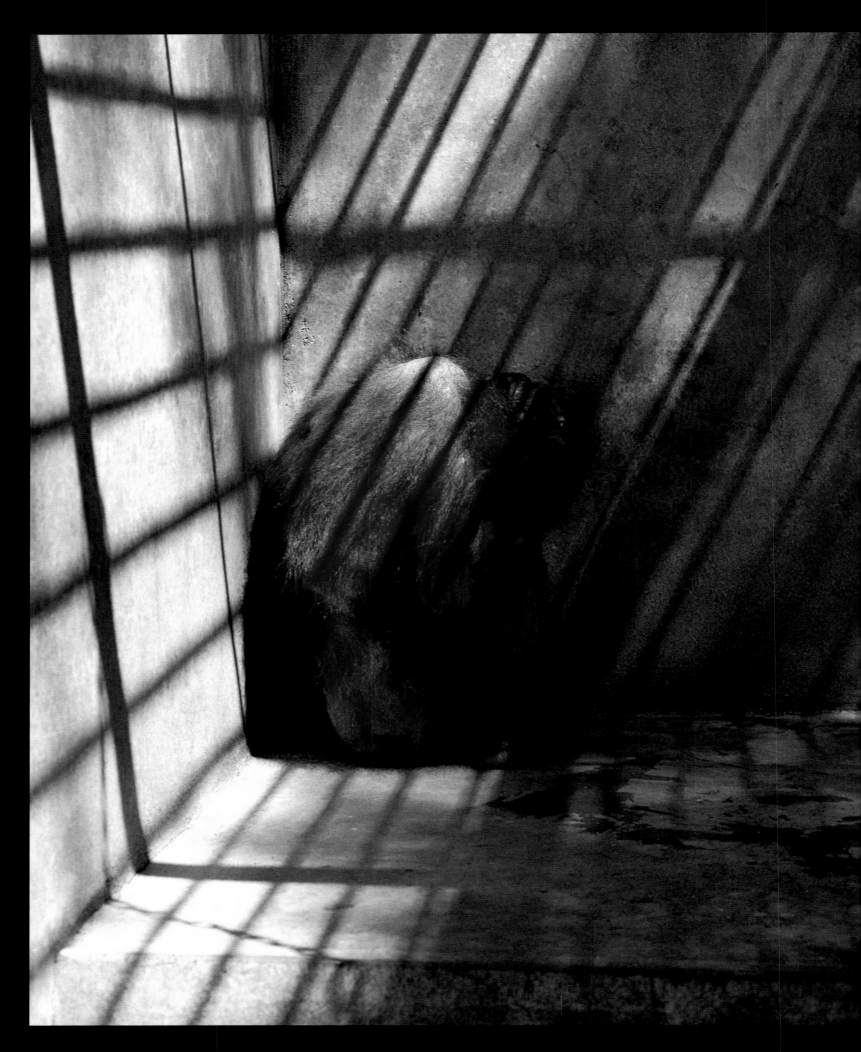

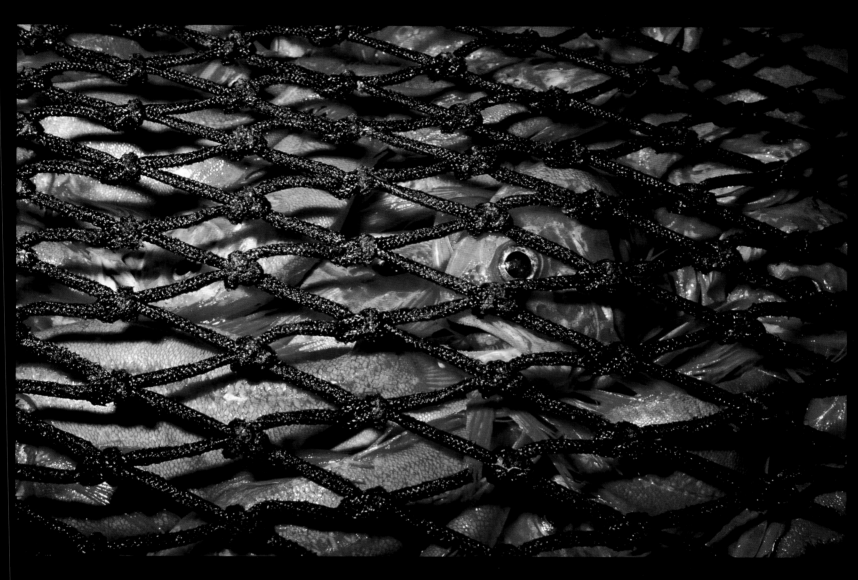

End of the line

Bars, shadows and a body hunched in a corner – symbols of despair.
It's a powerful picture, taken by a master of symbolic images who has
spent the past 15 years campaigning against the abuse of great apes.
The human attributes of apes make them a target of the pet trade.
In this case, the orang was confiscated after a government crackdown in
Taiwan but then dumped in a monkey park. More than a decade later,
the illegal export of baby orangs from Sumatra and Borneo continues,
involving countries such as Thailand and resulting in the death of
a thousand females a year, killed for their babies. At the heart of the
problem is the logging of the orang's rainforest home, especially in
Indonesia. But the countries responsible also include those that import
the timber – which to a great extent means Europe.

Karl Ammann *Switzerland 1993*

Net loss

A simple, graphic composition,
and one which makes a statement.
The photographer endured being
sick in rough seas off New
Zealand to take this image of
a haul of fish, focusing on the eye
of an individual taking its last
gasp. But there is a bigger story
here. These are orange roughy –
slow-breeding, long-lived deep-
sea fishes that congregate in great
shoals to spawn and so make easy
targets for commercial fisheries.
Fishing quotas have now been
enforced, but that has not
prevented the population
crashing because of overfishing.

Kim Westerskov
New Zealand 1993

Connections

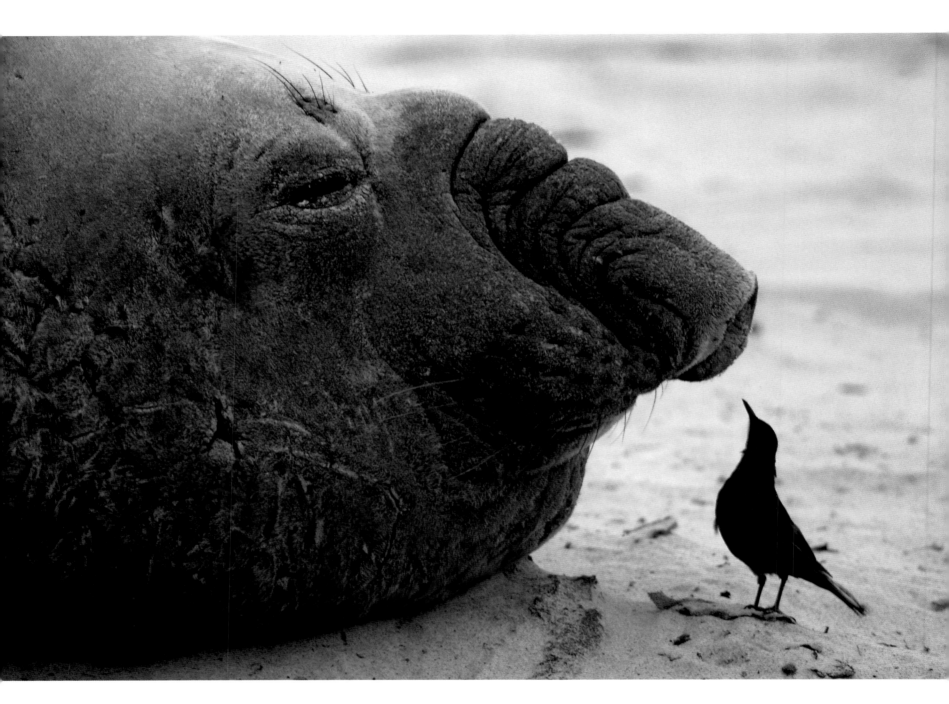

Attractive pickings

The interaction is not quite what it seems. Elephant seals, in this case the southern species, on one of the Falkland Islands, spend a lot of time lying around in the mating season, and flies are attracted to the wounds that result from skirmishes between males and the mucus that exudes from their huge noses. And flies are what this tussacbird is after. It's a portrait by a photographer with a sense of humour – a delightful juxtaposition of size and attitude.

Fritz Pölking *Germany 1991*

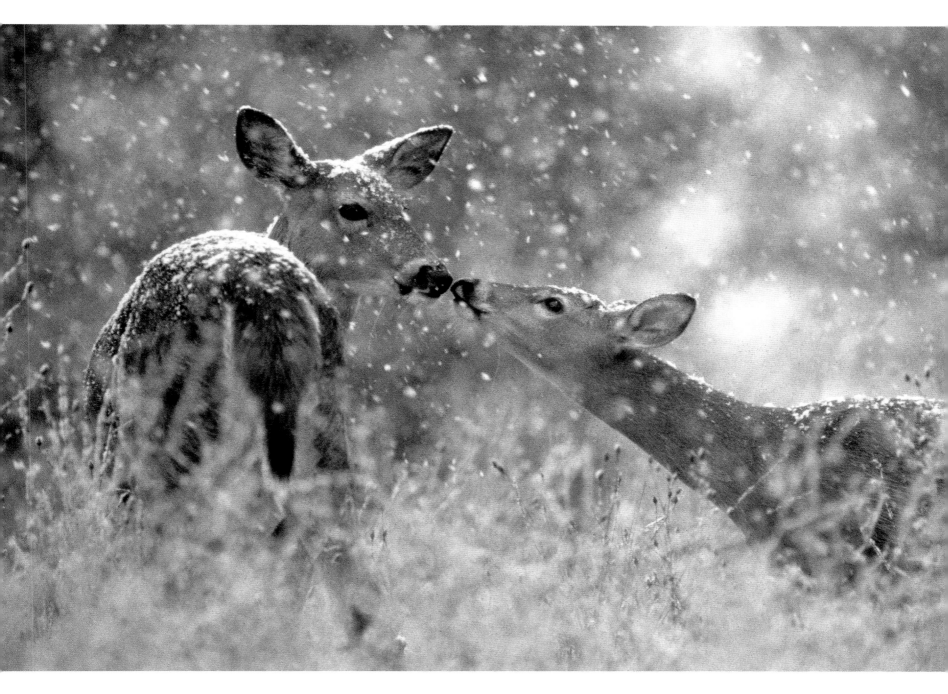

Touching noses

These two white-tailed deer were very familiar to the photographer, who had spent all year watching them in the woods around his home in Michigan. Here the fawn is seeking reassurance from his mother as the first snow of the year falls – a new experience for the young animal. The dull light and veil of snowflakes were perfect for the photographer's intention – to create a scene, just glimpsed, revealing the delicate intimacy between the two animals.

Carl Sams *USA 1994*

143

Connections

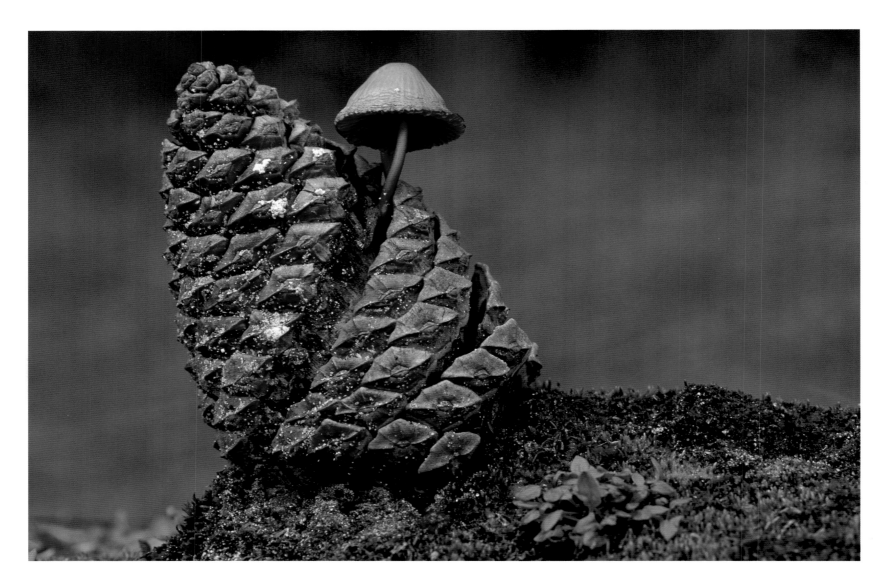

Still life

It often pays to look closely at natural objects, and beauty in miniature sometimes becomes apparent only when you are at its level. This tiny still life was observed close to the Belgian photographer's home on a heathland reserve, his favourite haunt. It's a study in colour and form, the cap of the tiny bleeding bonnet fungus echoing the shape and colour of the pinecone that its hidden parts are slowly decomposing. Algae, lichen and moss add extra colour to the picture, which the photographer chose to shoot in soft, overcast light to enhance their natural hues and give a subtle colour to the out-of-focus background.

Bernard Castelein *Belgium 1994*

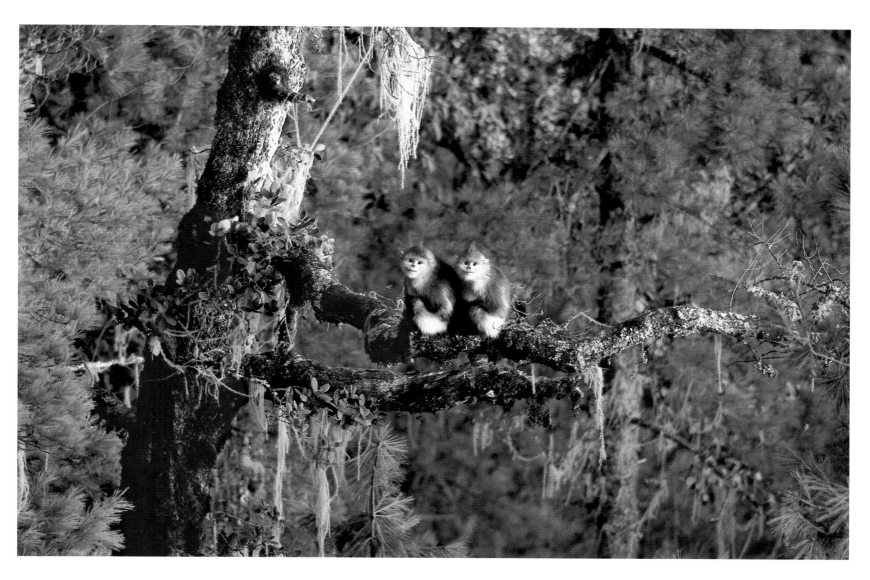

Survivors

Natural colours and textures are what make this composition, the monkey's fur blending with the ancient pine bark and its covering of lichens. But there is something strange about the scene. These are pines, festooned with cobwebs of lichen, suggesting a cold, wet, un-monkey-like environment. In fact, for half the year, the mountains are covered in snow. Yunnan snub-nosed monkeys are found only in this one region, feeding only on lichen, and are highly endangered. The photographer – a passionate advocate of wildlife in China – was the first to capture their pictures in the wild, and his campaigning has resulted in a ban on the logging of their ancient forest home.

Xi Zhinong *China 2001*

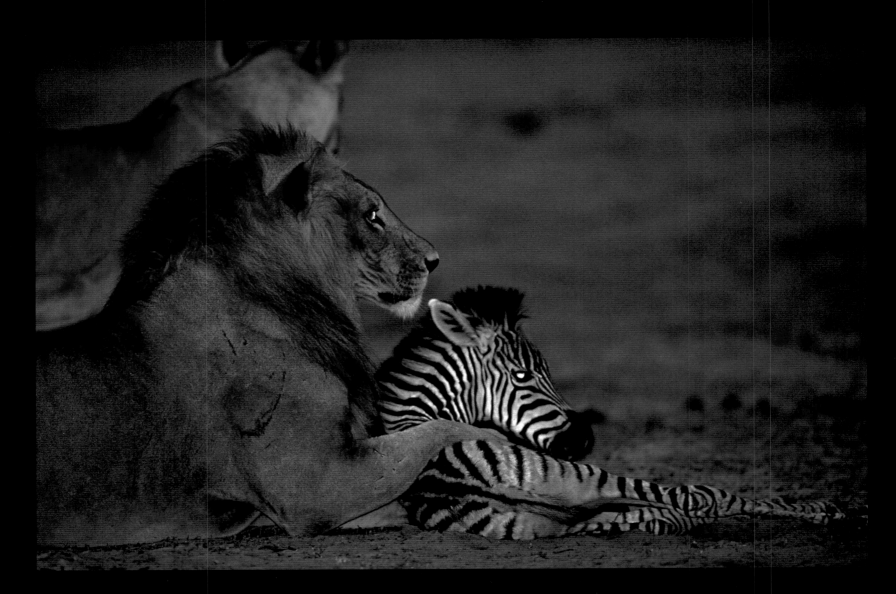

Lion and foal

Such a heraldic, almost caring
pose belies the lion's intent.
Though there are instances of
lions kidnapping and appearing
to adopt baby prey animals, this
capture ended in the foal's death.
The young zebra had become
separated from its family, which
was migrating south with
thousands of other zebras to new
grazing grounds in Botswana.
It was caught and held by the
male for a few minutes and then
released, only to be killed by
another lion in the pride.
The picture was taken before
dawn, adding a dream-like
quality to the unsettling scene.

Adrian Bailey
South Africa 2001

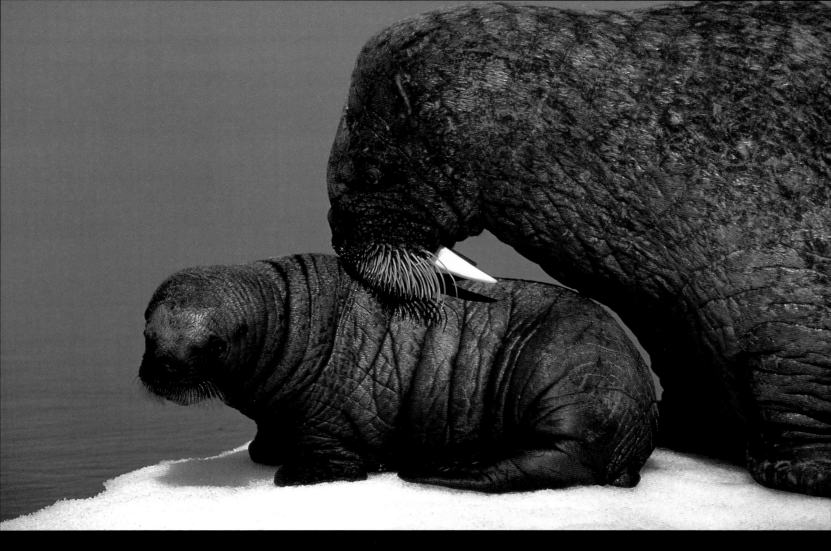

Mother and pup

There is an incongruity here between the roly-poly baby and the tusked, whiskered walrus, with its bloodshot eye and cracked skin. But the adult is a mother, tenderly guarding her newborn, and she will defend and suckle him till he is at least two years old. Though the sunlit scene seems almost tropical, the mother and baby are on drifting pack ice in the high Arctic, near northern Baffin Island, and the sun was a lucky break. The tender portrait, shot from a boat, was the result of several years'

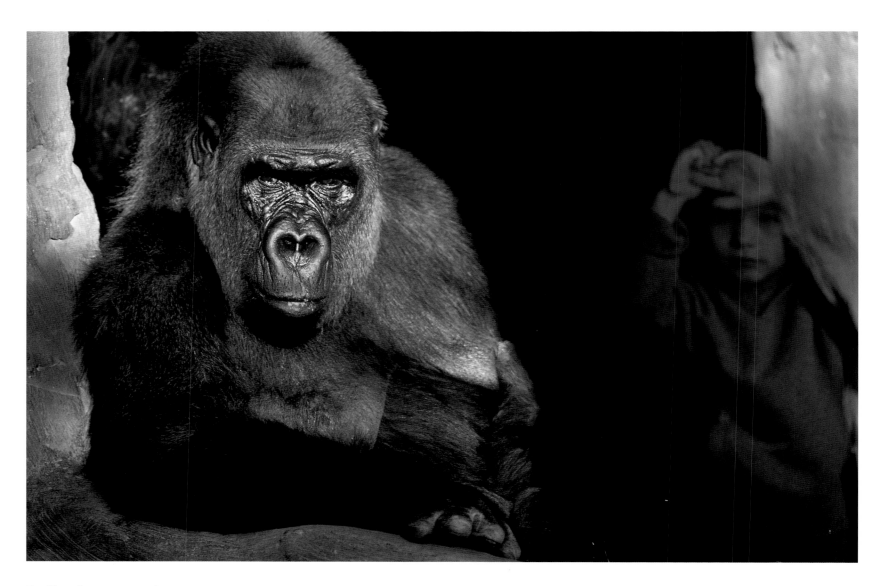

Reflections on primates

Here is a picture taken in a zoo. It's not a portrait purporting to be that of a wild animal, as so many are, but a considered and crafted composition with an aim: to make us think. Carefully framed is a juxtaposition of expressions and poses. The reflection of the boy, intent in contemplation of the huge lowland gorilla, is ghost-like in the shadows, creating a disturbing contrast between him and the adult male gorilla in full view, every detail of his expression highlighted and in a pose suggesting contemplation of his human viewers. It's the boy, though, who appears to be behind the glass – the imprisoned one of the two primates.

Gerhard Schulz *Germany 2003*

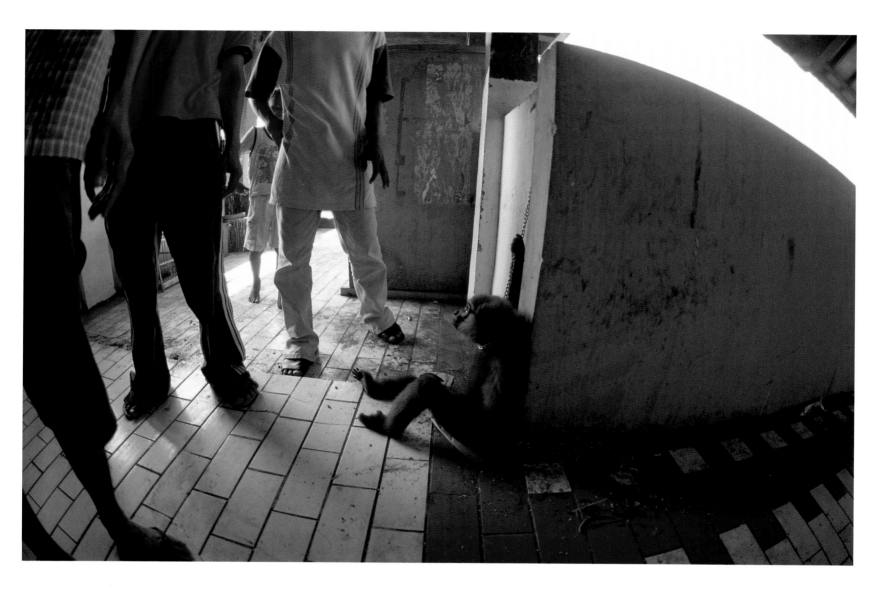

Viewpoint

This is true photo-reportage –
a picture shot from the hip, partly to
avoid confrontation with the sellers
but also to give a ground view of
the grime of the place and what it
must feel like to the wild animal to
have people so close. The gibbon's
vulnerability is emphasised by using
a horizontal format to show the
sweep of the path to its back,
leading to other, hidden atrocities.
This is the notorious Prambuka
Market in Jakarta, Java, supposedly a
bird market but a place where you
can always find endangered animals
for sale. The Indonesian authorities
occasionally raid the market but
effectively turn a blind eye.

Karl Ammann *Switzerland 2003*

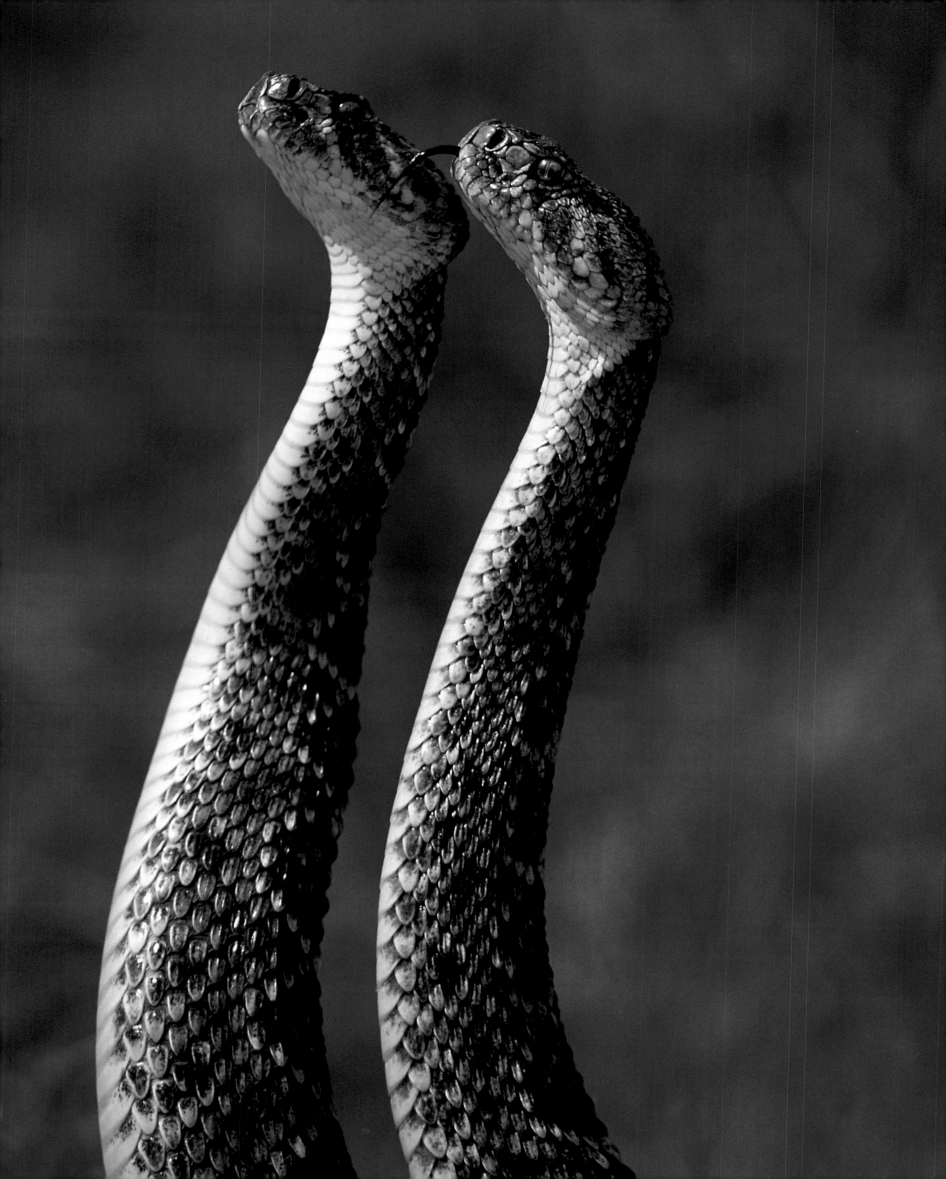

Reflective thoughts

To see your reflection for the first time must be a terrible shock. This Celebes black ape (a macaque monkey, found only on the island of Sulawesi) is transfixed by what he sees in the wing mirror, baring his teeth as a gesture of submission. The fact that he holds such a mirror should make us reflect on how he came to find it in a rainforest. A new road had been slashed through this part of the forest to bring in logging vehicles, at the same time giving access to hunters after bushmeat. The likelihood is that, today, the macaque and his group no longer exist.

Solvin Zankl *Germany 2003*

Combat dance

When male rattlesnakes compete for mating rights, they do so in a most graceful and ritualised way. The bigger, stronger snake usually wins the match without harm coming to either. It's an encounter rarely seen in the wild except by female rattlesnakes. The photographers witnessed these western diamondbacks in Texas in spring – mating time for rattlesnakes emerging from hibernation. They watched for more than half an hour as the males entwined around each other and then, with a third of their bodies raised, wrestled and pushed for several minutes before falling with a thud back to the ground to begin the ritual all over again.

Robert & Virginia Small *USA 1999*

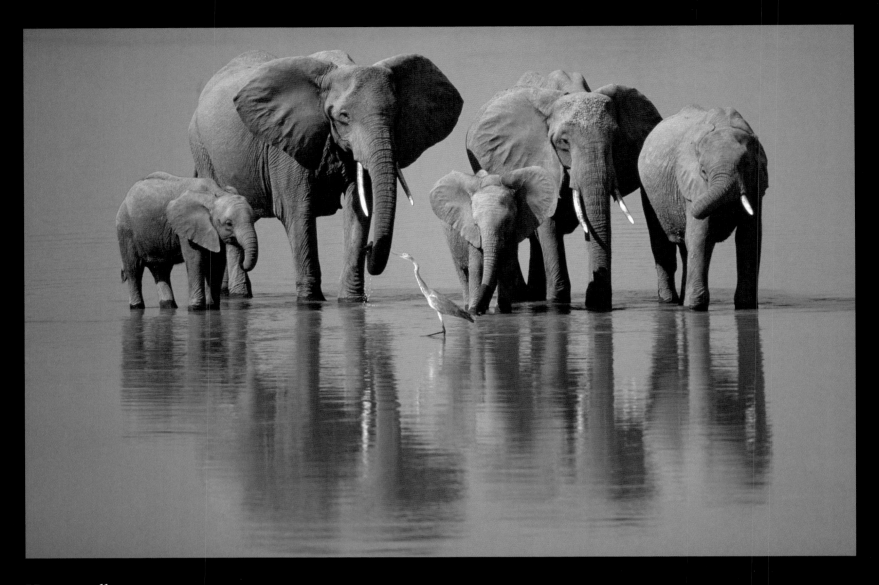

Heron walk-past

There is serenity about this
composition – the water
with hardly a ripple and the
family group relaxed, though
with ears forward, fascinated by
the heron sauntering past.
The photographer had spotted
this beautiful crossing point on
the Luangwa River, Zambia, and
returned early one morning,
positioning herself on the bank
to wait for the first elephants to
come down to drink. Perfection,
though, was created by the arrival
of the grey heron (watching for
fish stirred up by the elephants'
feet) and the momentary
entrancement of its observers.

Angie Scott *Kenya 2002*

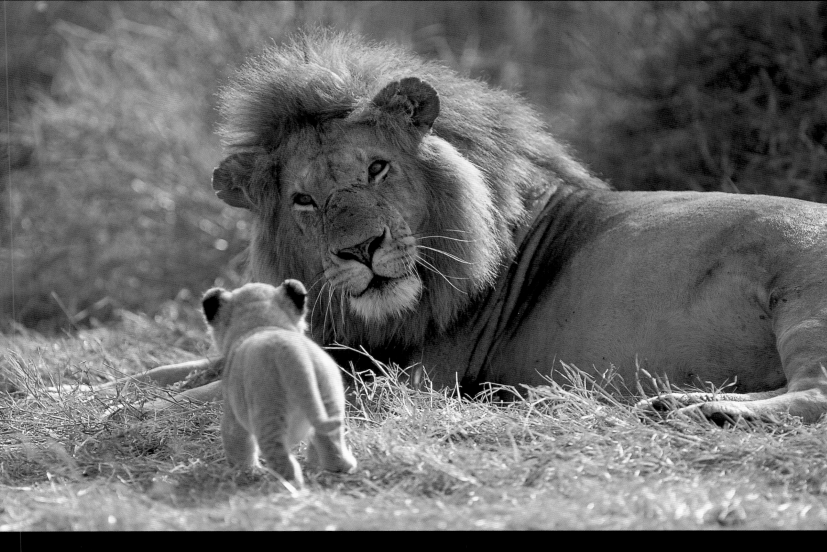

First encounter

The photographer has a special interest in the behaviour of young animals and interactions between them and their carers. Here, though, his focus is on the intense gaze of the pride male. Tension is created by the contrast in size and the frozen postures – the battle-scarred male, head at an angle, and the milk-fat cub teetering to one side (shot at near ground level for intimacy). And it *was* a tense moment. The cubs, born in safe seclusion, had just been introduced to the pride – a risky time – and the male has woken to the surprise of finding the boldest one at his side.

Anup Shah *UK 1999*

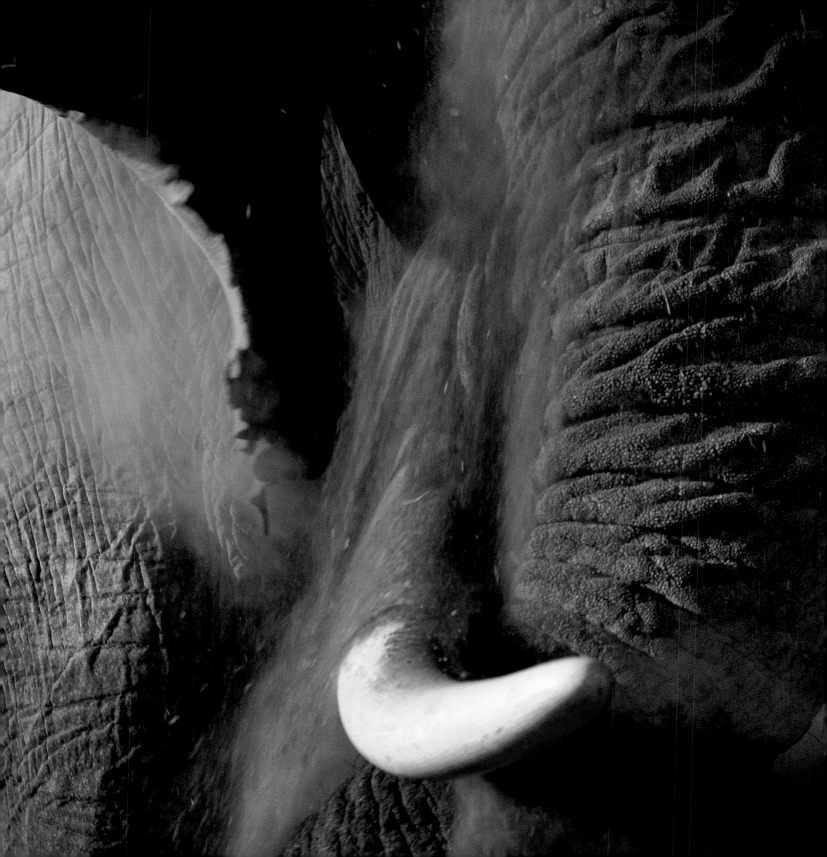

Compositions

Jim Brandenburg

It is a Sunday afternoon in a small flower garden. The greenhorn nature photographer is alone in a private world searching with camera in hand for that unique statement with a new and unfamiliar language. Exhilarated about the possibilities of creating a novel image and yet intimidated, if not frightened, by the mysterious and contradictory numbers etched on the knobs and dials of this newly invented magic box. The resulting monochrome prints finally arrive back, and a whole new discovery takes place once more . . .

Elephantine

Power and atmosphere – a bull elephant at dawn.
The low light has thrown his wrinkles into relief, contrasting against the golden glowing plume of dust that he's blown back over his body. Skilful framing by the photographer has juxtaposed the sweeping curves – of trunk, tusk and flapping ear. Not long after this picture was taken, the bull, from Kenya's famous population of elephants in Amboseli National Park and known as Sleepy by researchers, was shot by white hunters when he crossed the border into Tanzania.

Martyn Colbeck *UK 1993*

Compositions

. . . Surprise, wonderment, and the world will never appear the same. Years later the first attempts are rediscovered under old and yellowed papers in the bottom of a drawer. Powerful but good memories flash.

A shining, posh cruise ship arrives at the Antarctic ice edge. Au courant adventurers land to stroll among the tolerant king penguins. Laden with the hottest digital equipment, the intruders politely go about their business, their cameras hung like jewellry around their necks. They will with a bit of luck capture trophy images to amaze colleagues back home or display to the world on personal websites.

These two extreme accounts are bookends to a ritual that has played out countless times in the century that separates them. A career spent pursuing images from nature has allowed me to explore the motivation behind this curious endeavour. I have my own private agenda as a professional artist/journalist or otherwise. It is this 'otherwise' that has captured my imagination of late.

First, may we assume that nature photography is an art, even though it is still debated in some quarters? The use of a camera to express one's feelings, ideas or just record the scene at hand may at once be a simple instinctive act to remember the moment or a deep and complex inquiry into the very essence of what one believes.

Compared to learning the mechanics of oil painting or how to handle a violin, the camera is easy to master. Herein lies one of the obstacles in finding a 'voice' in photography. Both in the public perception (is photography really an art?) and in the serious pursuit of photography by the individual, the apparent ease of use of the camera clouds our judgement. Total accomplishment comes only with great effort and commitment in all art forms.

An unexpected close and intimate encounter with a wolf or bear is a good day for me. A strong memory of the moment will be burned into my psyche, and if I prepared well, I will also capture a powerful image that represents the supremacy and mystery that surrounds the animal. You might say it is a kind of 'prayer.'

An absorbing thought to me is the notion that capturing animals with a camera is an evolutionary extension of the painting of creatures on the walls of caves by my distant relatives a thousand generations ago. But theirs was a more beautiful and potent representation. Pablo Picasso visited Lascaux, one of the premier caves in France, and upon exiting remarked "We [artists of today] have invented nothing . . . none of us can paint like that."

On a recent speaking tour, I was asked to judge a nature photography contest. I surveyed the entries and made my selection. The top prize would go to a small, delicate impressionistic print of warm sunrays spilling through autumn foliage. You could almost feel the air.

There are times when the ancient need to capture nature's wonder comes roaring out. Skill with the instrument seems secondary during those exceptional times.

"Someone here has mastered the fine art of photography," I said to the audience. "Where is the photographer? A startled and dishevelled middle-aged man stepped forward and told his story. While raking leaves, he noticed "a real pretty scene." He ran to the house, found a cardboard throwaway camera, took the picture and then continued the yard work. Hearing about the photo contest, he decided to bring a couple of snaps he had grown fond of. A colour-copy machine was used to enlarge the drugstore print. No Stradivarius here, but the inspired performance was impeccable. I later learned the gentleman had just been released from a year in jail.

There are times when the ancient need to capture nature's wonder comes roaring out. Skill with the instrument seems secondary during those exceptional times. No matter what the level of experience, the same impulse drives us – the need to commune with and relate to nature. The camera, perhaps more than the paintbrush, combines the dynamics of the relationship between man and animal depicted in those sacred painting rites. A capture after the stalk – the camera as evolved 'weapon' is added to the aestheticism. We lived as hunters for a million years. The camera then is possibly just a replaced implement we use to be in attendance for the ceremony.

Green turtle on blue

The blue is the blue of the abyss surrounding the island of Sipadan, off Sabah, Borneo. The green is the filtered light from above. This has spotlit the green turtle at just the right angle as it has cast off from a ledge on the sheer wall of the island and is swimming up for air, highlighting in sky-blue the edges of its shell-plates and scales. At any other angle and depth, the effect would have been completely different – knowledge that comes only from experience.

Malcolm Hey *UK 1996*

Dune oryx

The best images are ones you never forget and never tire of looking at. This one has classic simplicity and yet is full of mystery and detail – from the footprints leading up the dune to the ripples of sand on the ridge. The gemsbok oryx has stopped, almost as if by command, its long shadow adding an otherworldly touch to the scene. The power of the picture comes both from the shadows and the perspective – looking down and along the sweep of dune. Add to that the subtle copper and bronze tinting of the sand by the early-morning sun, and you have an unforgettable portrait of the ancient Namib desert.

Jim Brandenburg *USA 1988*

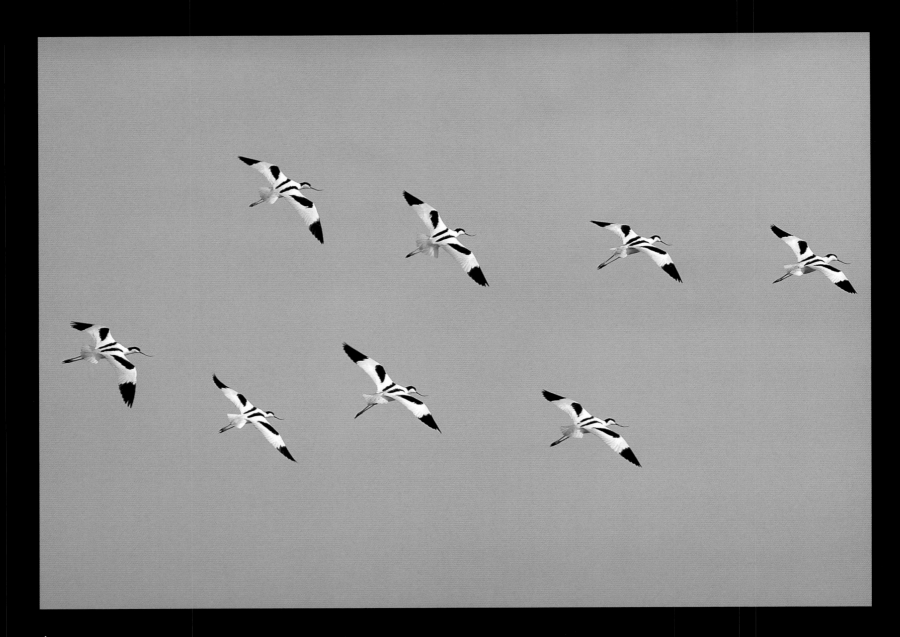

Avocet symmetry

There was no planning in this picture of perfect natural pattern. The photographer just stepped out of his hide in southern Spain, saw the circling flock of avocets and took the picture. Of course, he did have an intimate knowledge of bird behaviour and a tuned eye, and what he registered in an instant was the potential, proving that luck may also be judgement.

Mike Wilkes *UK 1992*

Silver birch
in golden snow

There is something very special
about the Scandinavian light
and seasons that inspire
photographic art. In this case,
the canvas is a winter woodland
in southern Sweden engulfed in
a snowstorm, and the subject a
row of spindly birch trees in the
foreground wrapped in swirling
flakes, with golden backlighting
provided by the low winter sun.

Jan Töve *Sweden 1997*

Zebra among the wildebeest

The incongruity is not just stripes against a mass of brown bodies but also the fact that the zebra stands still and that bit higher than the milling wildebeest. In search of just such a composition of pattern and movement, the photographer had been following the migrating wildebeest in the Masai Mara on the Kenyan leg of their journey. The Grant's zebra was in fact on a mound, looking for its family

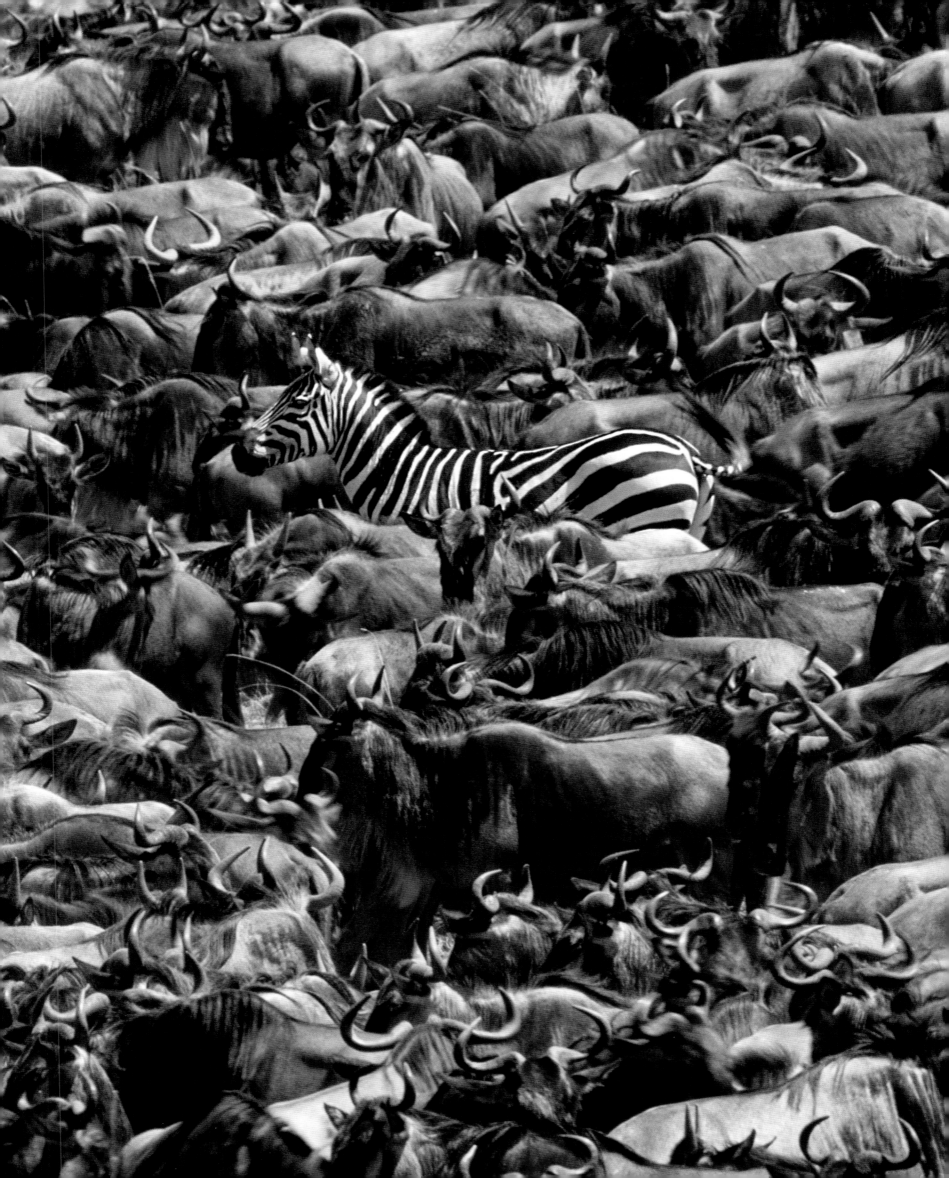

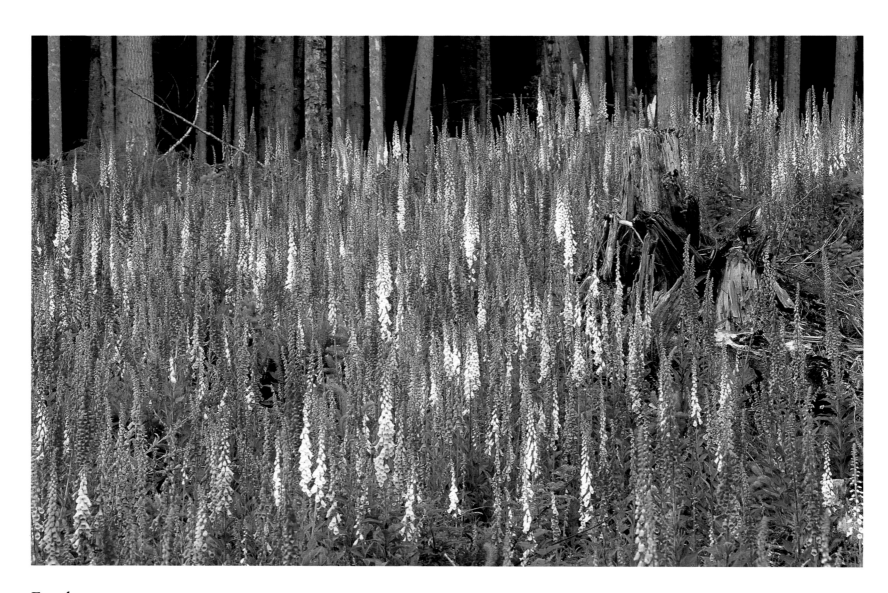

Foxglove tapestry

The swathe of wild foxgloves was an unexpected find. A forest clearing in the foothills of the Olympic Mountains, Washington, had allowed light and rain to stimulate buried seeds to germinate and flower en mass, producing a mosaic of colour, from shades of purple-pink to pale pink and white. The photographer has enhanced the pattern of colour and form by waiting until just before dusk to take the shot, when the soft light would lower the contrast and reduce shadows. A long exposure helped flatten the picture so that the trunks and stumps blend into an almost textural tapestry.

Olaf Broders *Germany 1999*

Snail on bamboo

This is a picture of simplicity and detail, structure and size. The moss-encrusted sections of bamboo trunk, photographed in sharp relief using a very slow shutter speed, become two dimensional against the unfocused trunks, which appear almost as reflections of the foreground. And the whorl of the shell of the perfectly positioned, algae-green snail complements the horizontal and vertical lines of the bamboo. The magical setting for this composition was an old grove of bamboo in the tropical El Yunque National Forest on the island of Puerto Rico.

Gerry Ellis *USA 1989*

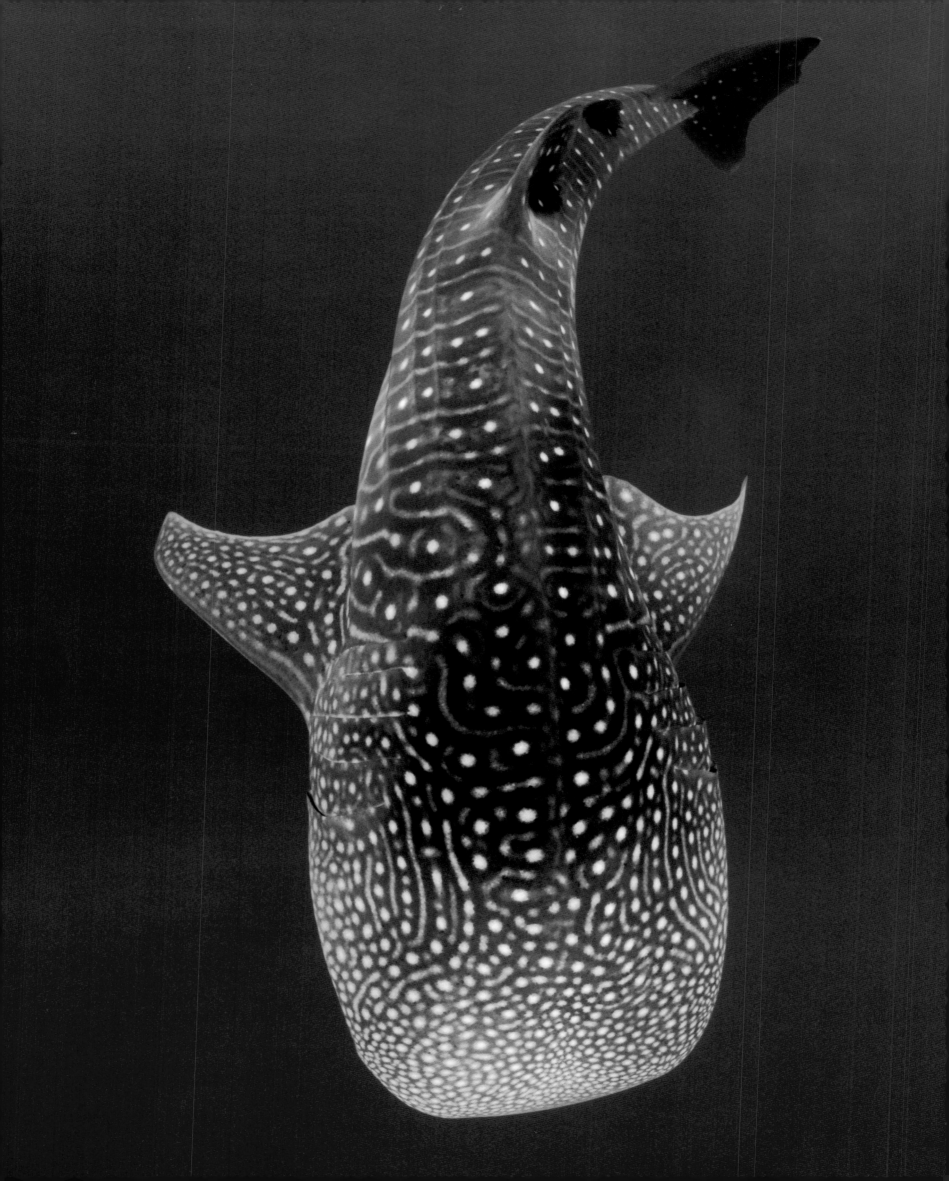

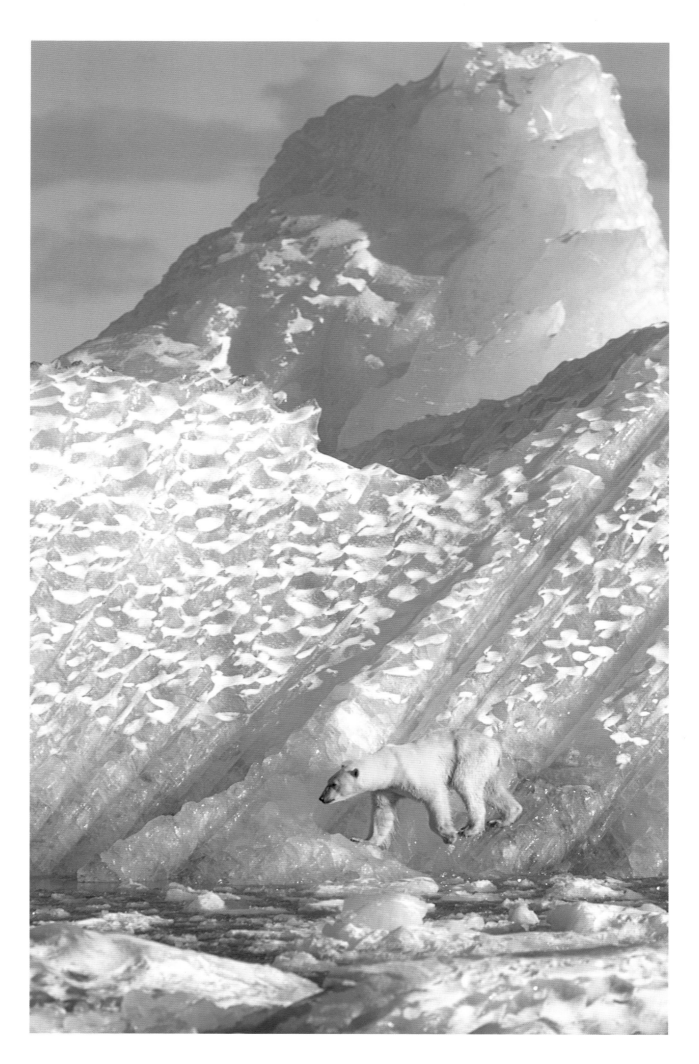

Whale shark spectre

Natural light filtering down has picked out the dappled checkerboard of white spots and scribbles of this giant whale shark as it hangs near the surface, gently moving its fins and tail while sucking in great volumes of plankton-rich water.
The hugeness of its broad head is emphasised by the angle of the composition, avoiding eyes or mouth or any background but the deep blue of the sea. The shark was oblivious of the photographer floating above it. The location was Christmas Island in the Indian Ocean, where whale sharks had gathered to take advantage of millions of planktonic Christmas Island crab larvae.

Jürgen Freund
Germany 1997

Glacial bear

For polar bears in the Scandinavian Arctic, life is a relentless search for food in an ever-moving sea of ice. Here, the young male, thin from a bad spring, the ice having melted much faster than normal, is searching the edge of a calving glacier. The great blocks of melting ice are crashing into the sea, making swimming hazardous for the bear and extremely dangerous for the photographer endeavouring to get as close as possible to the foot of the glacier. It took four years and four trips to Svalbard, in Norway, for the photographer to get such a shot, with a bear close enough, the light bright enough and a background of sculptural ice that could conjure up the sheer beauty of the place.

Jan-Peter Lahall
Sweden 2003

Compositions

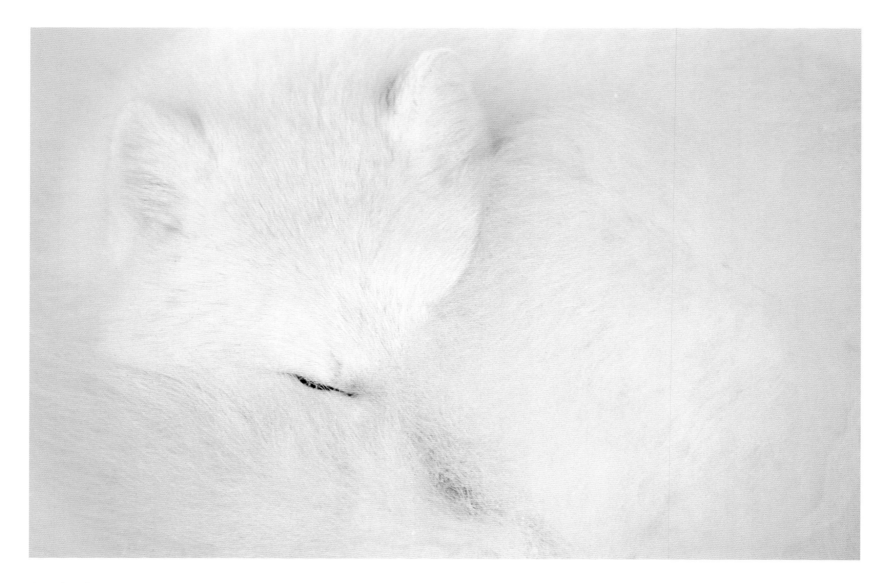

Arctic sleep

You can almost feel the softness
of the fox's fur, seen through
a delicate haze of wind-blown
snow, its body made visible by
a few subtle curves, accentuated
by the black slit of an eye.
The photographer spent nearly
an hour in the bitter wind of
the Canadian Arctic, creeping
close enough to the sleeping fox
to create this intimate picture, a
portrayal of what fur is really for.
Two hours later, the animal was
caught in a trap.

Norbert Rosing *Germany*
1993

Impressions

The colour of autumn leaves was what fascinated the photographer here.
He wanted to portray the impression rather than the actuality of a beech
woodland in Sweden and struggled for hours to find a composition
that worked for him. Creative focus and careful framing conjure up
the atmosphere of the damp October afternoon.

Jan Töve *Sweden 2001*

Gull on ice

Pristine ice on a lake close to the photographer's home is the stage for this minimalist vision of a black-headed gull in winter plumage. The bird has been positioned exactly, with just a few brush strokes of red, black and grey creating its simple but precise impression and elegant shadow.

Chris Packham *UK 1986*

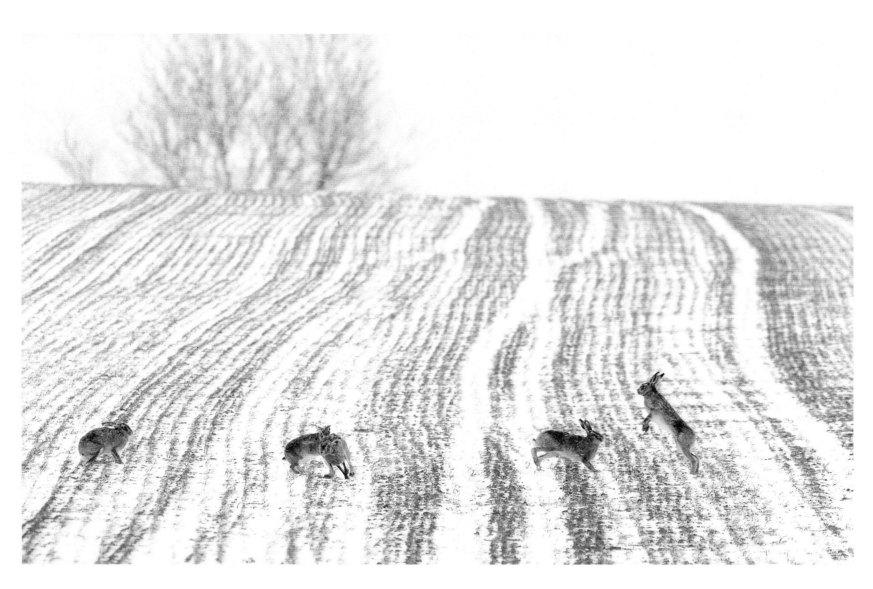

Cold courtship

The cold light of February was perfect for the execution of this composition. The photographer knew that the hares were already courting in this field, and when a sprinkling of snow fell overnight, enhancing the pattern of frosted furrows and providing a pale background to set off the delicate browns of their bodies, the time was right. The photograph – of a female rebuffing her suitors – was taken from a distance, mainly not to disturb the animals but also to enhance the grain of the picture.

Niall Benvie *UK 1993*

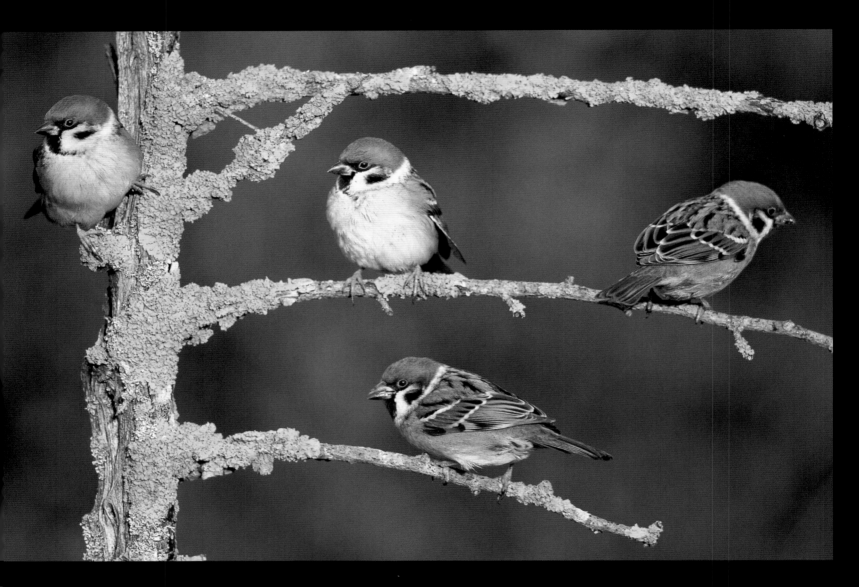

Tree sparrow pose

For 15 years, birds have been
gathering at a miniature sanctuary
and feeding station in a corner of
a field in Warwickshire, England,
created by the farmer and the
photographer. It's thick with
willows and wild flowers, and
seed is regularly provided for
the visitors, from sparrows and
goldfinches to doves and ducks.
The rewards for the photographer
are relaxed subjects, here tree
sparrows on their lichen-covered
'queuing perch', waiting to feed.

Mike Wilkes *UK 2002*

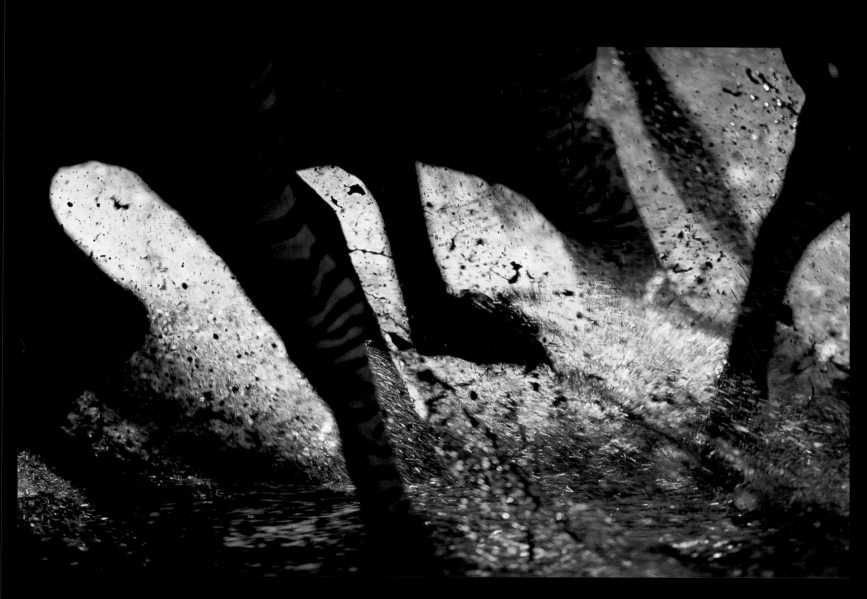

Shadow running

Shafts of early-morning light
filtering through open mopane
woodland in Botswana onto
a rainy-season pool, a group of
spooked Burchell's zebras and
a photographer with a vision
created this picture of light,
shadow and movement.
Zebras are among the most
photographed of animals, but
few people have captured
the energy and spirit of these
wild equids with such artistry.

Adrian Bailey
South Africa 1998

Compositions

Leopard dawn

Here the rising sun has been used to silhouette a juxtaposition of forms: the huge, gnarled tree, transformed into a heavenly catwalk for the lithe young leopard. The photographer had watched the leopard and her cub using the tree, in Tanzania's Tarangire National Park, as a feeding and resting place safe from lions and had seen the composition he wanted. He returned to the tree as the sun came up to wait for the female to rise and make her descent along the great branch, to drink or find a shady place for her and her cub to rest in the heat of the day.

Mike Mockler *UK 2000*

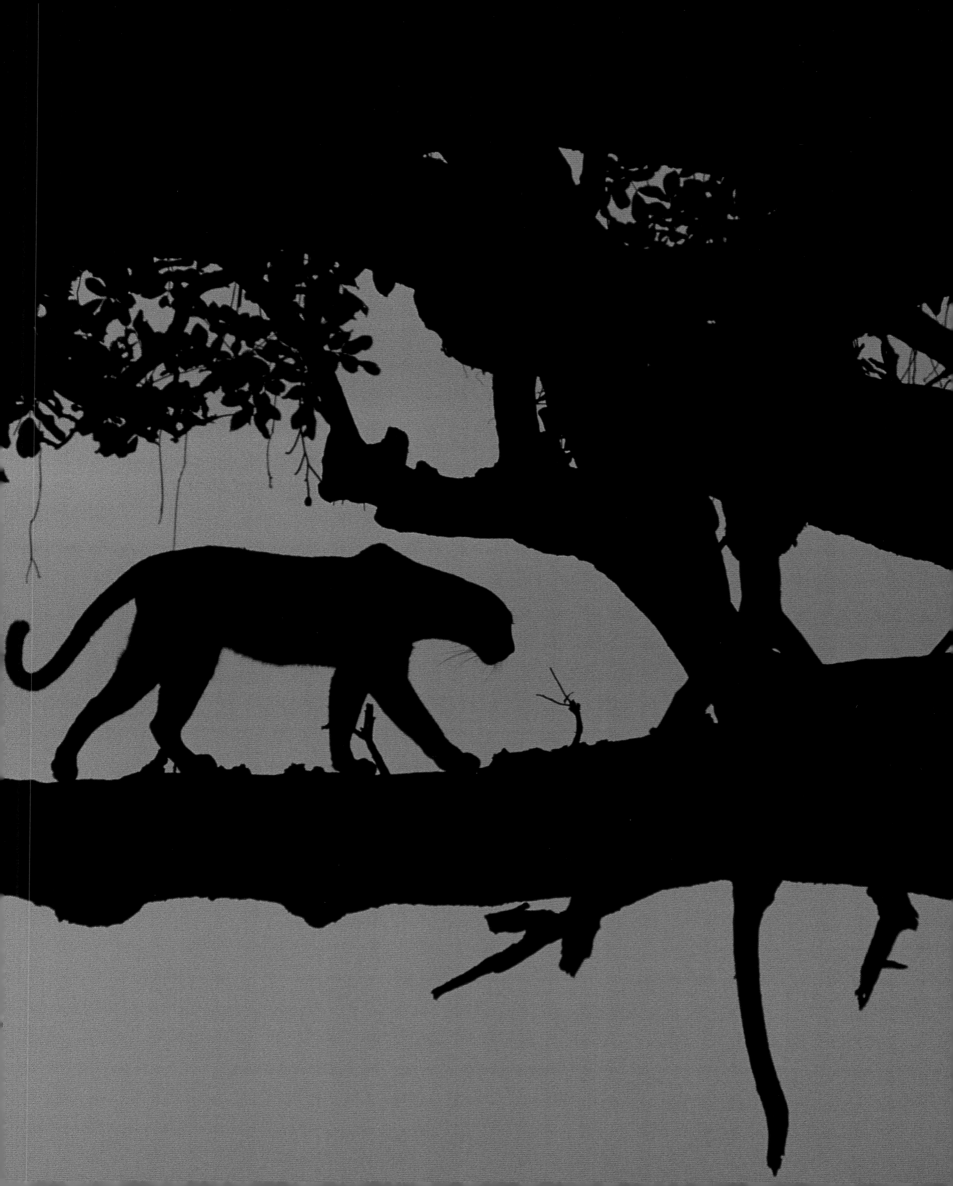

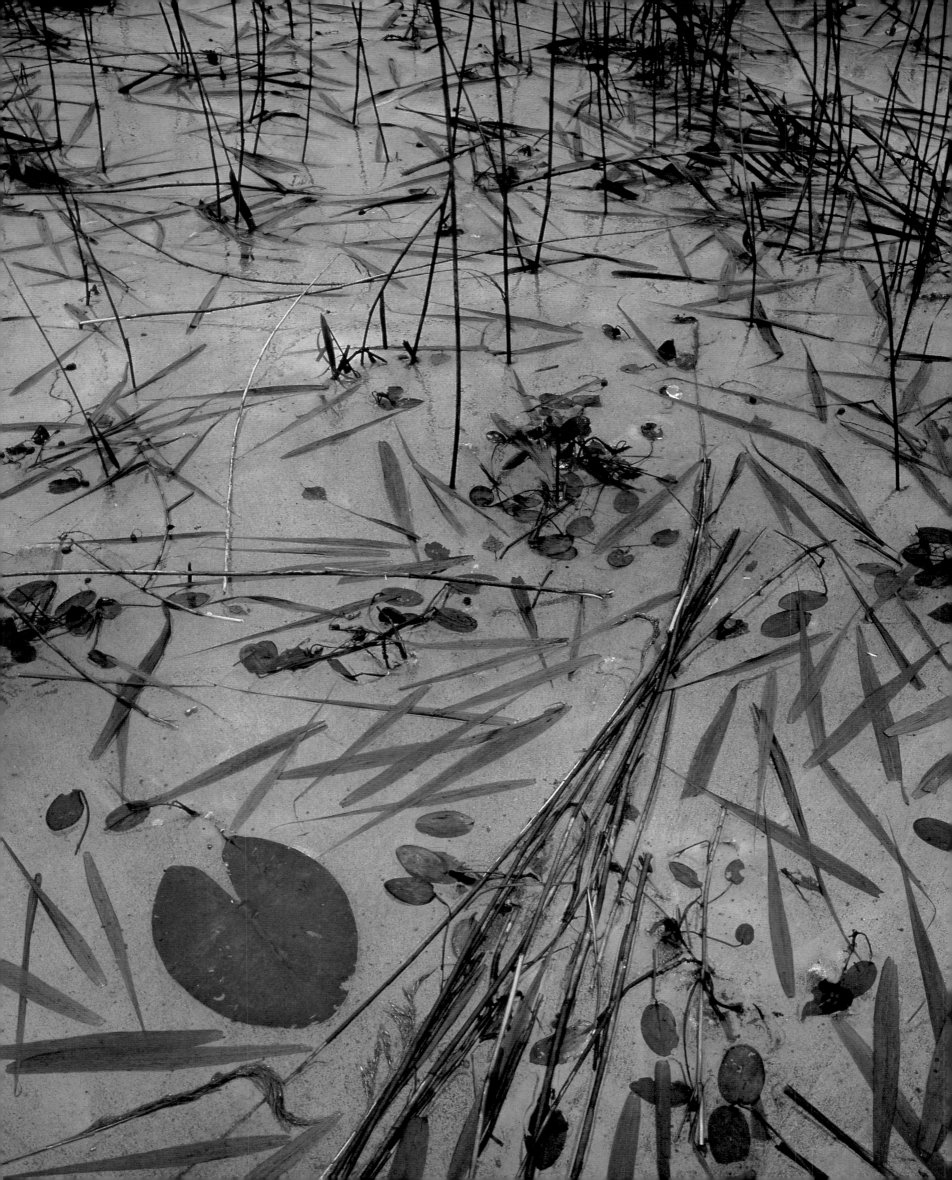

Japanese snow flight

Cranes are among the most
revered and auspicious of
animals in Japanese art –
symbolising, among other things,
purity. The photographer had
a dream of portraying their
graceful, balletic flight set against
the soft greyness of a snowfall.
It took a long, cold stakeout in
Akan National Park, on the
northern Japanese island of
Hokkaido, for the right
snowstorm to arrive. More than
40 centimetres (16 inches) fell
that day, and as the evening
drew in, producing the perfect
monochromatic lighting, a
family took flight, silhouetted
against the snowscape.

Vincent Munier *France 2002*

Ice collage

This is completely natural art. No leaf has been placed or moved.
All are frozen in position. But there is also art in the choice of
composition – seeing pattern and order in chaos and subtle colour in
the dead reeds and scattered leaves slowly being released by the melting ice.

Compositions

Shrine of lilies

The higanbana lily, which also
carries the Western names of
resurrection lily and hurricane
lily, is said to flower in the
Buddhist paradise. A sea of them
bloom in this ancient Japanese
plum orchard, for just a week, at
the autumn equinox – an
auspicious time for Buddhists.
They are native to Japan and
have been cultivated there for
centuries, for their beauty and
symbolism. The photographer
set out to create an icon of
rebirth from the scene, using
the dull light of early morning
and a long exposure to leave
the ancient trunks as dark forms
and saturate the picture with the
rich red of the flowers. The very
next day, a tornado swept
through the orchard, flattening
the lilies and leaving only the
gaunt plum trees standing.

Jun Ogawa *Japan 2001*

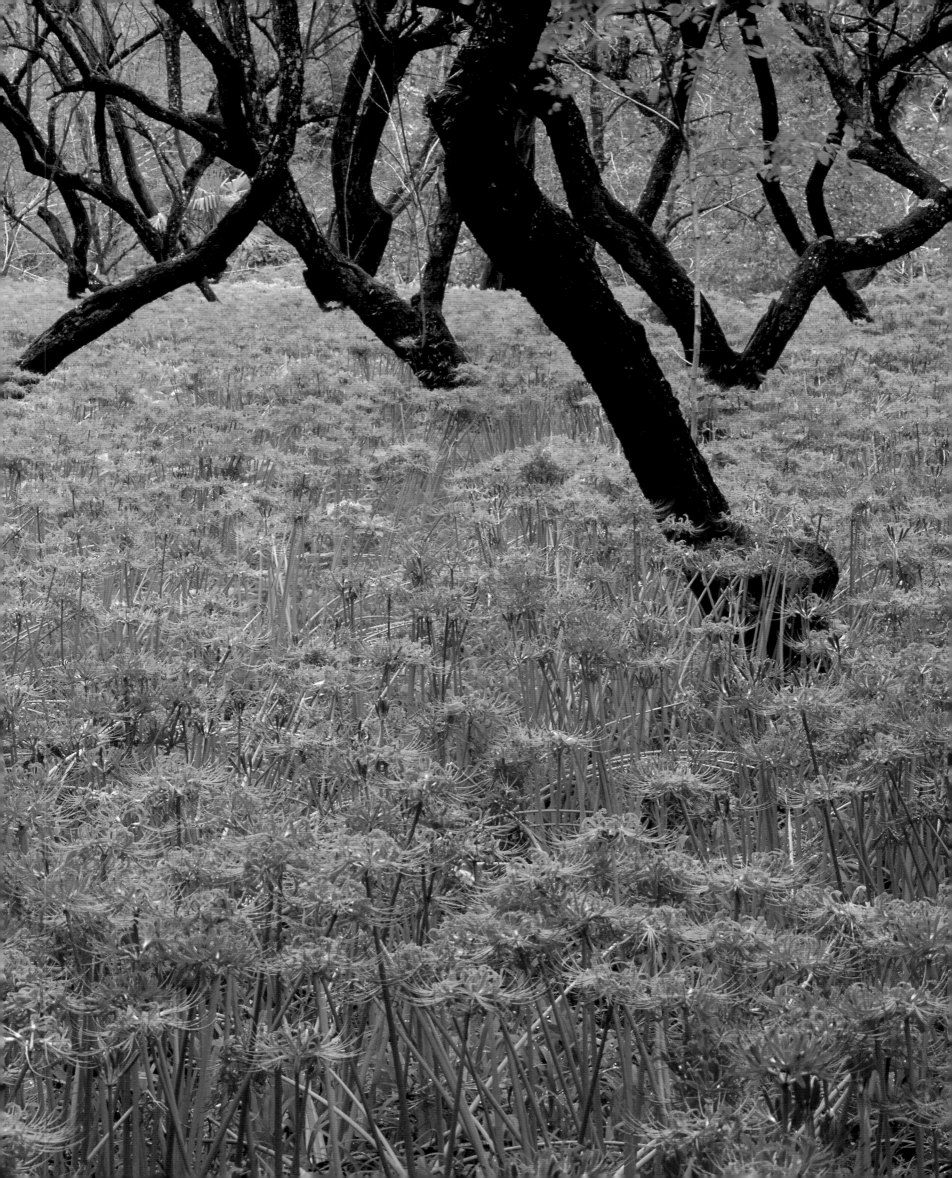

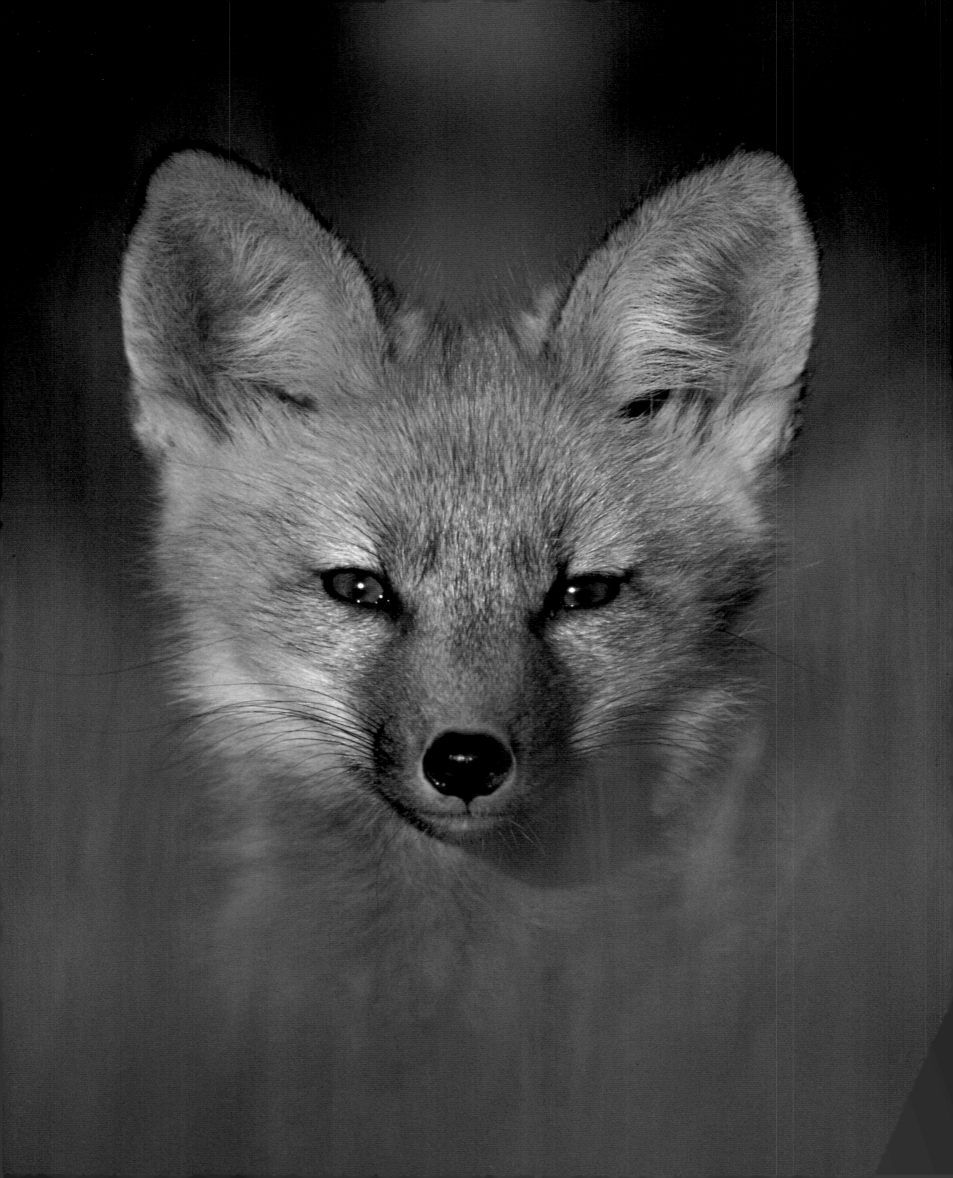

Portraits

KLAUS NIGGE

Should nature photography be a true reflection of the natural world?

Can photographs ever be truthful? Are all images merely illusions?

If they are, should nature photographers be free to create even greater

illusions of reality? With the advent of digital photography and the ease of

manipulation it allows, these are some of the questions that trouble nature

photographers who want their pictures to be seen as truthful reflections of

the natural world. But is there really anything to be concerned about? . . .

Fox in the sun

So often the simplest portraits are the best. The lighting (from a spotlight of afternoon sun), composition and focus are perfect, emphasising the eyes, nose and ears and putting into soft focus the surrounding long grass to create a frame of soft summer green. The result has nothing to do with luck: the photographer had been watching the young fox and its siblings for a number of days and knew where it was likely to be and exactly where to position herself to get the shot she wanted.

Wendy Shattil *USA 1990*

No matter what technology is used, photographers never do reflect pure truth, merely an interpretation of it. Simply by looking through the viewfinder, they decide which part of the scene to show – and more important, which parts not to show.

. . . Traditionally, photographers have worked in the darkroom to create prints that resemble as close as possible what they remember seeing in their viewfinders. They crop their images, work on contrast, brightness and colours and lighten up shade – just as digital photographers now do in Photoshop. Some photographers even use black and white technology to completely remove the colour. So, for many people, transparency film seems to be the only guarantee that a photograph is truthful.

But even when shooting slides, photographers influence how their images appear. They choose film that produces more (or less) saturated colour. They decide on more or less contrast or whether to underexpose or overexpose an image. They use polarising filters to create skies bluer than we ever see them or use graduated-grey or colour-density filters to compensate for the lack of contrast in a type of film or to create a mood more dramatic than it is. And with fill flash, they bring light where nature provided only dark shadow – just as digital photographers add light using Photoshop. There therefore seems little difference between the enhancement techniques of digital and film photography.

In fact, no matter what technology is used, photographers never do reflect pure truth, merely an interpretation of it. Simply by looking through the viewfinder, they decide which part of the scene to show – and more important, which parts not to show. In their passionate search to show paradise in our world, many nature photographers avoid including anything man-made that detracts from an impression of pristine nature, even though such artefacts may be part of an animal's environment – part of the truth.

Digital photography does, though, offer another means of altering the truth: the removal or addition of the elements of a picture. Is digital 'manipulation' something new and negative that we should worry about? Or is it, in fact, a positively creative tool?

It has always been possible to alter scanned slides and negatives, by combining different photos or using multiple exposures (exposing the same frame several times). The only difference between these traditional methods and Photoshop is that Photoshop makes it all much easier. Playing around with these techniques can also be fun. And what's wrong with someone getting a kick out of placing a polar bear with penguins? Painters can put their fantasies onto canvas. So why shouldn't photographers do the same on film? The problems arise when photographers are dishonest and pretend that their fantasies are real pictures of nature.

There are stories of photographers hoodwinking publishers – even the most famous of magazines – or cheating in competitions.

Such trickery, though, is not new or confined to digital manipulation. It includes presenting tame animals as wild, stuffed animals as alive and artificial arrangements as natural. The difference today is that digital manipulation makes cheating far easier. And the danger is not that some photographers may win competitions, become famous or earn big money – it's the loss of trust.

People trust wildlife photographs, and they trust wildlife photographers. And photographers bear a responsibility for such trust. "We are the eyes of the people," the respected wildlife photographer Frans Lanting once said. We show people what most will possibly never see with their own eyes. And they believe what they see. Without that trust, the value of nature photography will decrease. We will lose the direct access to hearts and emotions and therefore the chance to raise awareness of and interest in nature.

This is not a new state of affairs, but it is one made more worrying by the availability of better tools for manipulation. The onus is on us all – photographers, publishers and readers – to be alert to and police the situation our new digital tools have created.

Katydid surprise

When photographing animals, it's sometimes impossible to resist a humorous view that draws comparisons with human looks and behaviour. Here a skilled macro-photographer has chosen to represent a horned katydid not from the normal side-on view, appearing like a leaf, but full-frontal, revealing a katydid's-eye-view of its strange mouthparts, compound eyes and swivelling antennae.

Brian Kenney *USA 1994*

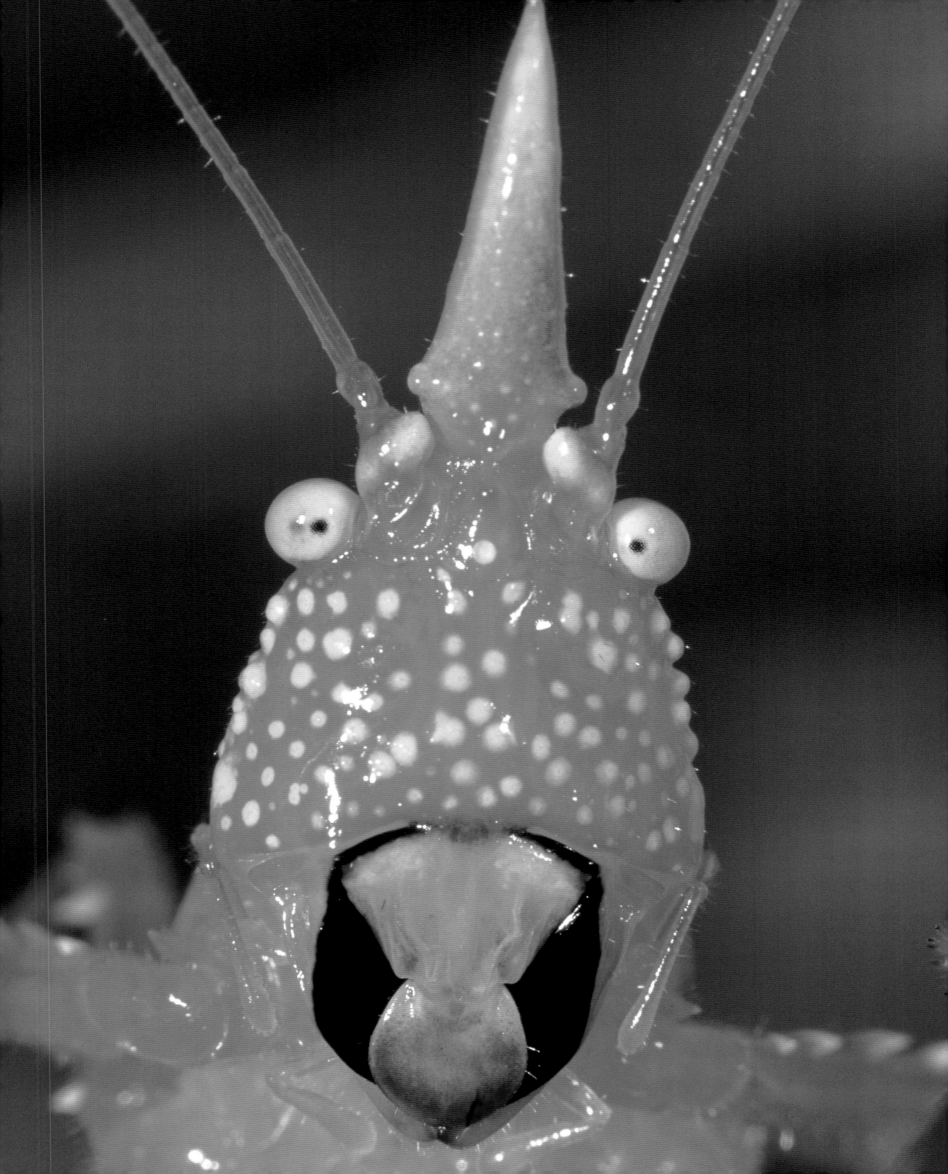

Portraits

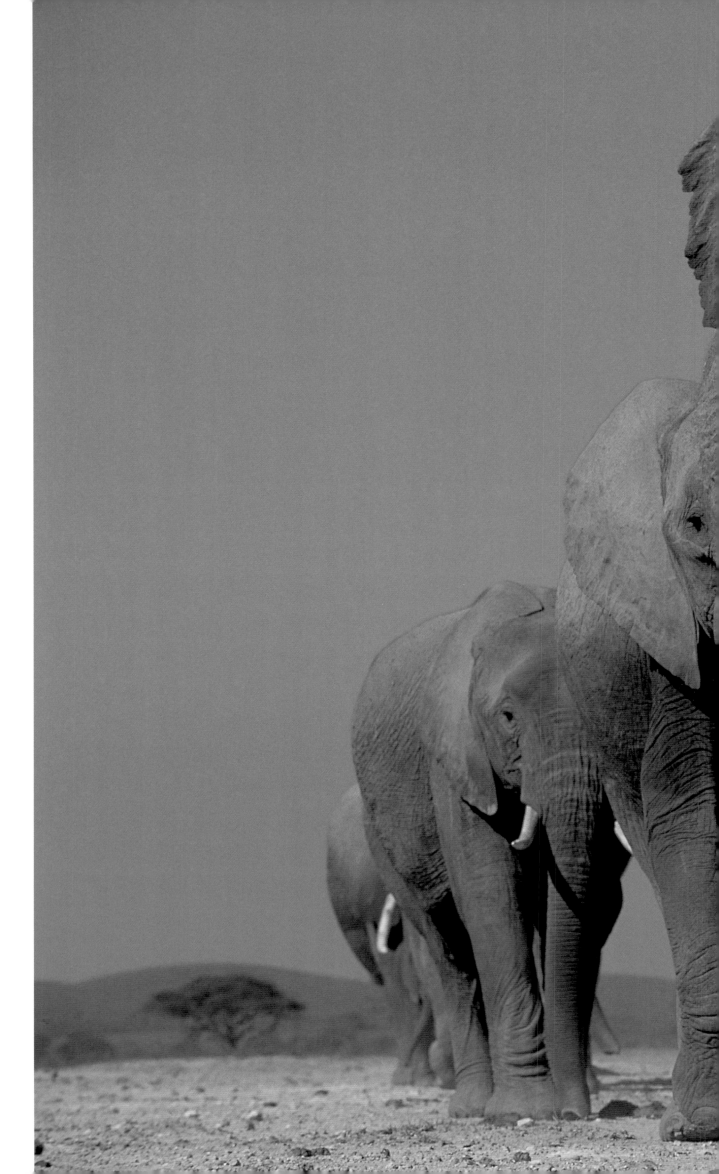

Procession

This is a portrait of
a remarkable elephant,
Jezebel, the oldest female in
her clan, leading the group
on their daily walk to
a swamp to drink and bathe.
The photographer knew her
well and the daily habits of
most of the elephants in this
part of Kenya's Amboseli
National Park, and he
stationed his vehicle where
he predicted the procession
would pass by. The key to
the success of the shot is the
angle – a ground-eye level
that places the animals one
behind the other, gives an
impression of the size of
the magnificent leader and
frames the group with the
vivid blue of the African sky.

Martyn Colbeck
UK 1993

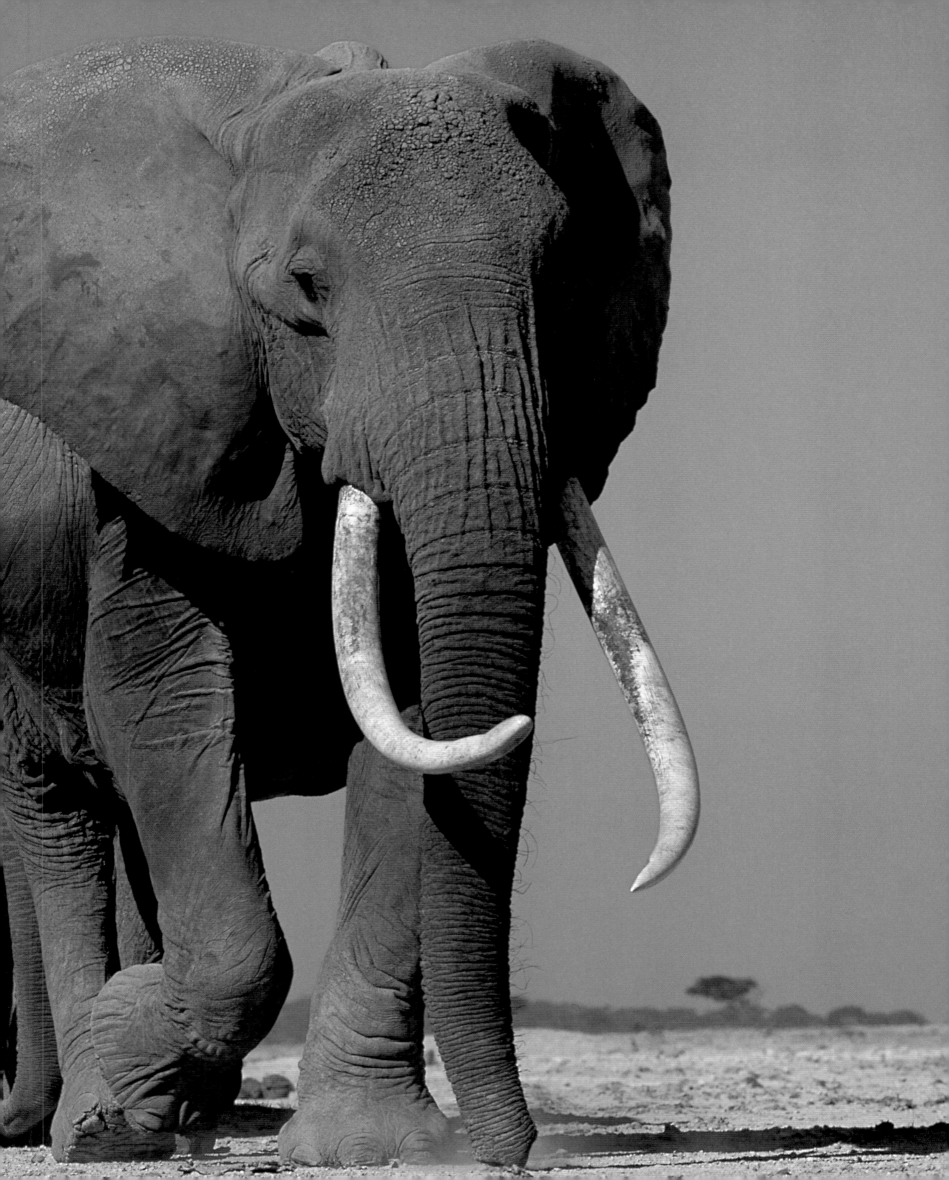

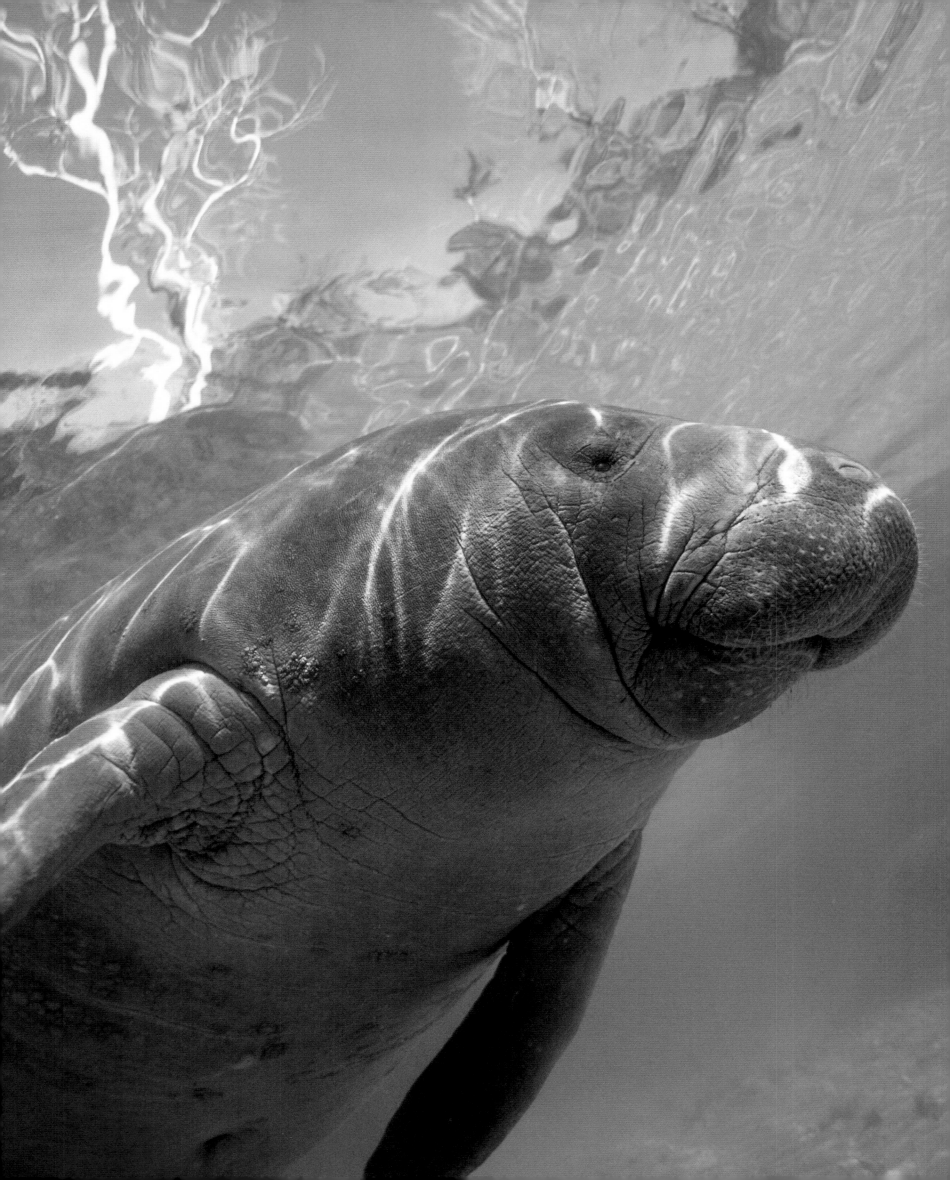

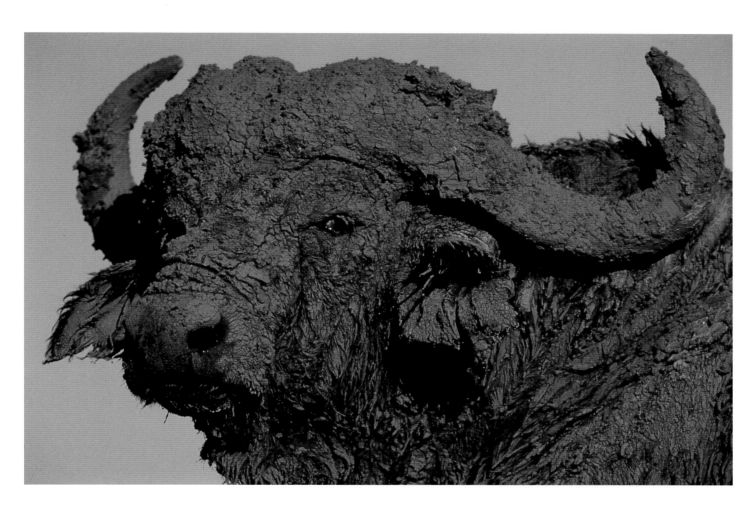

Mud buffalo

This powerful portrait is
the product of mud, sun and
the photographer's eye for
graphic composition. The bull,
spotlit in the late-afternoon sun,
has converted its chocolate-brown
coat to a striking Kenyan mud-
red after a session in a mudhole.
Wallowing is a way to cool down
during the heat of the day, but
mud also seems to have a social
use, as males in particular will
coat themselves in it, urinating
in the wallow and tossing the
mud around – and in this case
ending up with a spectacular and
aromatic head-dress.

Frank Krahmer
Germany 1995

Manatee in its element

The photographer describes manatees as the most co-operative of
subjects – slow, gentle and curious about humans swimming among
them. The warm water of Florida's Crystal River, where many
congregate in winter, is also as clear as its name. But the fact is that
many pictures taken of these strange mammals are unimaginative
record shots. Here the photographer has thought about both the angle,
which creates movement, and the frame – the turquoise algae-coloured
water, contrasting with the blue of the above-water scene.
Reflected squiggles of light on the manatee's back mirror the white
outlines of the winter trees above.

Brandon D Cole *USA 1995*

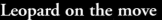

Portraits

Leopard on the move

Panning the camera while using a slow shutter speed is an established technique for creating a sense of movement, but it seldom works successfully. Here it has been used to perfection, creating the essence of determined leopardness as the lithe and powerful animal sets off for the evening's hunt, having spent the day asleep in a tree in woodland on the edge of the Serengeti. A skilled practitioner, the photographer has compensated for the low light of dusk and framed and focused the picture precisely, blurring the background and achieving the portrait he desired.

Konrad Wothe
Germany 1994

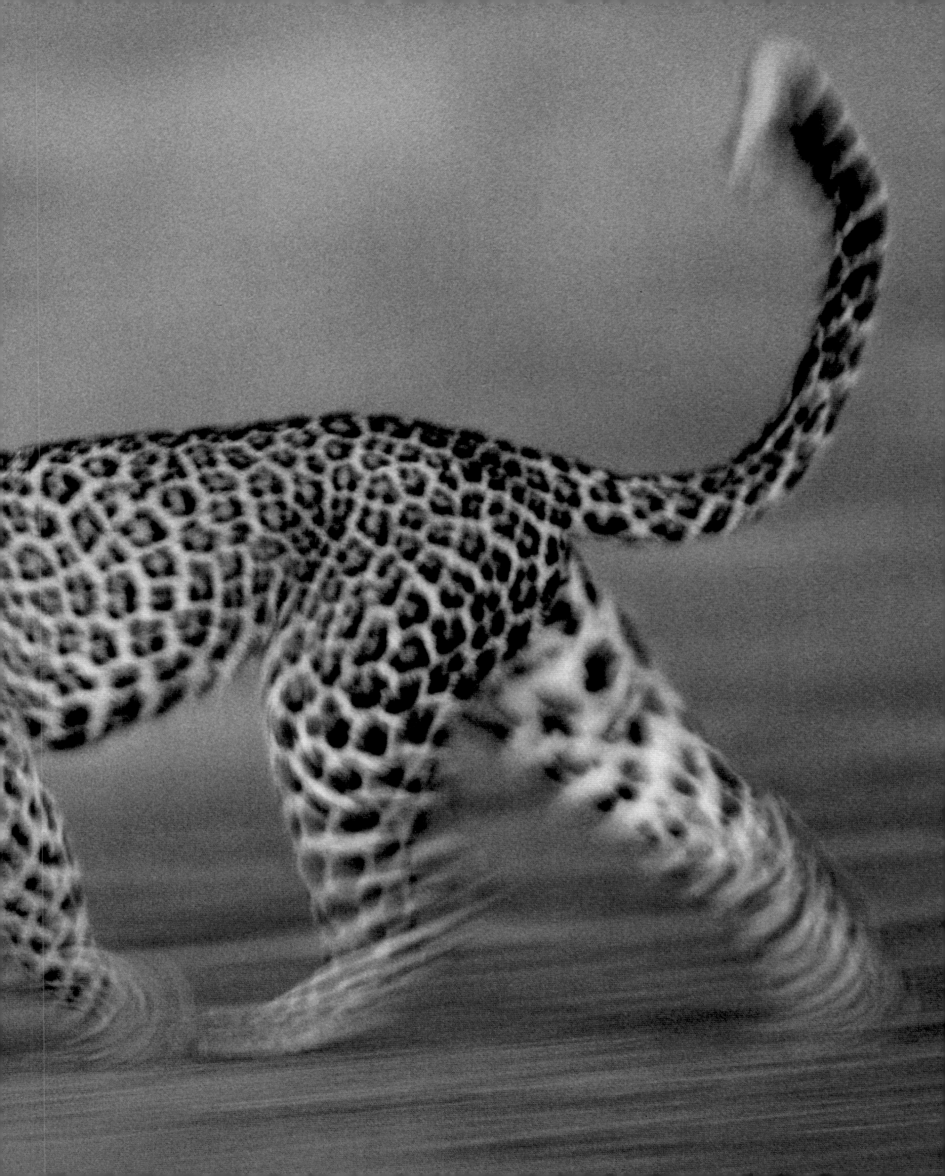

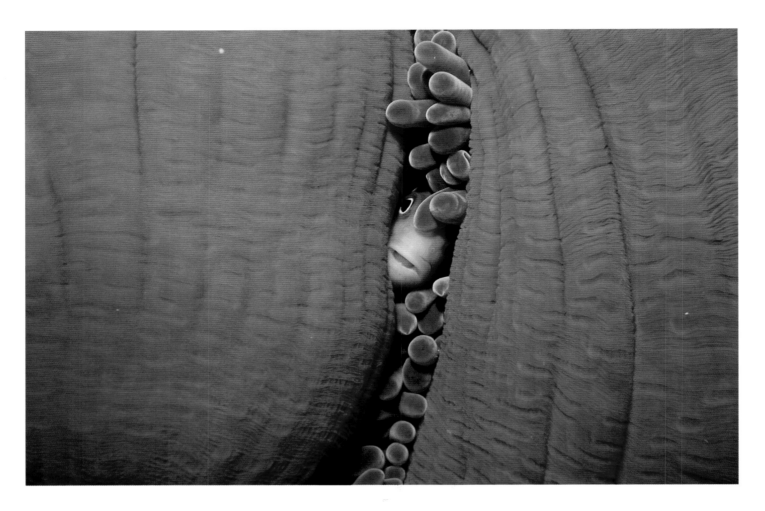

Peeping anemone fish

This is as much a portrait of the enveloping bosom of the anemone as it is of the anemone fish peeping out from the protection of its host's sting-covered tentacles. It's a clever view, not only humorous but also reflecting the relationship between the two. Using the same chemicals in its mucus covering as in the mucus that the anemone itself excretes to prevent being stung by its own tentacles, the fish is able to live safely in its home. In return, it provides defence against some of the fish that like a juicy bite of anemone. The stage curtain has been cleverly lit, too – to enhance the satin-and-velvet texture and colour of the anemone.

Michele Hall *USA 1992*

Snow monkey

What makes this portrait so compelling is that the macaque monkey is not looking at us but away into the distance, its face deliberately placed off centre and framed in folds of its thick fur coat. The lighting both brings out the detail and softens the image, so that the face blends with its surround, the snow-white chin matching the melting ice balls. The monkey is justifiably pensive, trying desperately to warm up in the steam from the famous Jigekudani hotsprings in Japan – the winter retreat for these most northerly of non-human primates.

Daniel J Cox *USA 1997*

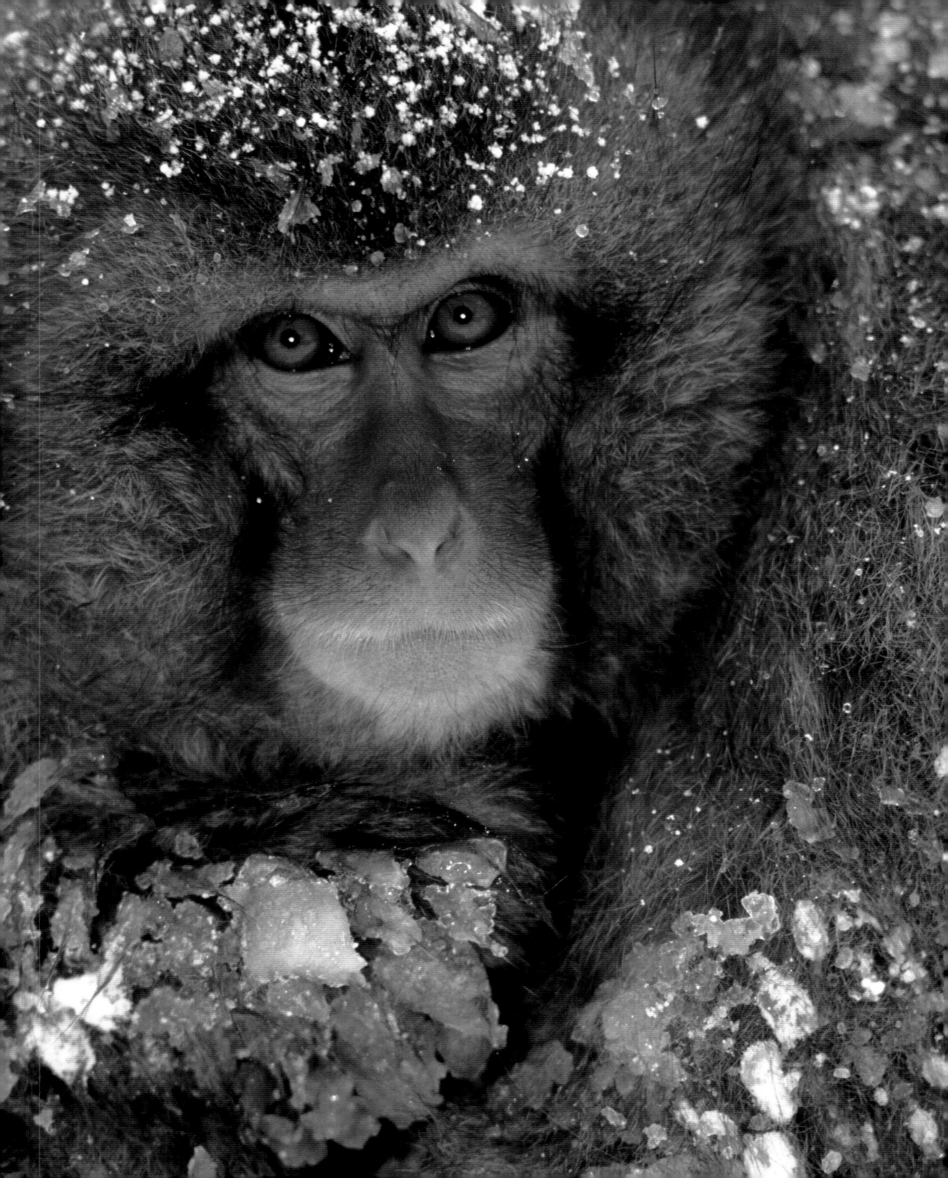

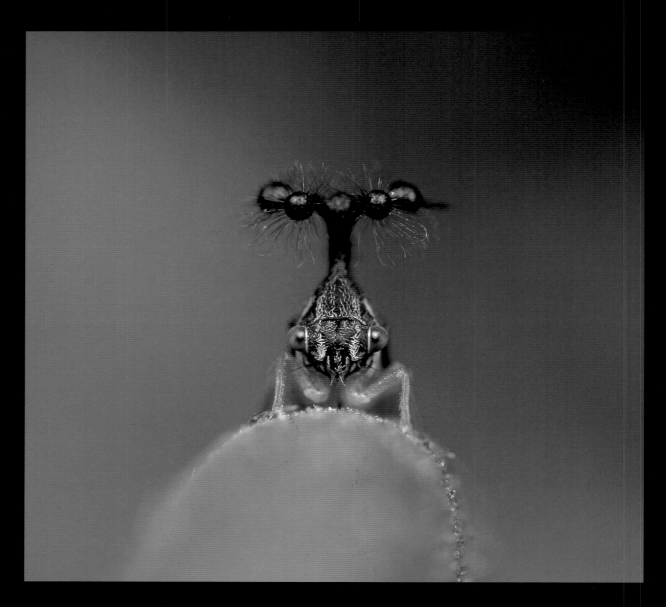

Four-humped treehopper

So small is this Brazilian bug that, to appreciate its strange appendages, you need both huge magnification and a treehopper's-eye view. It's also very wary, and so stealth was required for the photographer to manoeuvre into position. One sudden movement and this phenomenal jumper would have vanished. It spends its short life sucking sap, and the highly ornate projection may transform it into a fearsome-looking foe or an attractive mate – though no one knows for sure.

Mitsuhiko Imamori
Japan 1994

Fortress langur

Here the picture is all in the posture. It is undeniably a human one, made more so by the placing of the monkey against the ramparts of the ruins of a fort in Jaipur, India. In fact, the langur has not been directed but is warming herself in the early morning sun, oblivious to the photographer lying on the ground framing her portrait. The shades of brown and cream add the painterly quality to the composition.

Nick Garbutt *UK 1996*

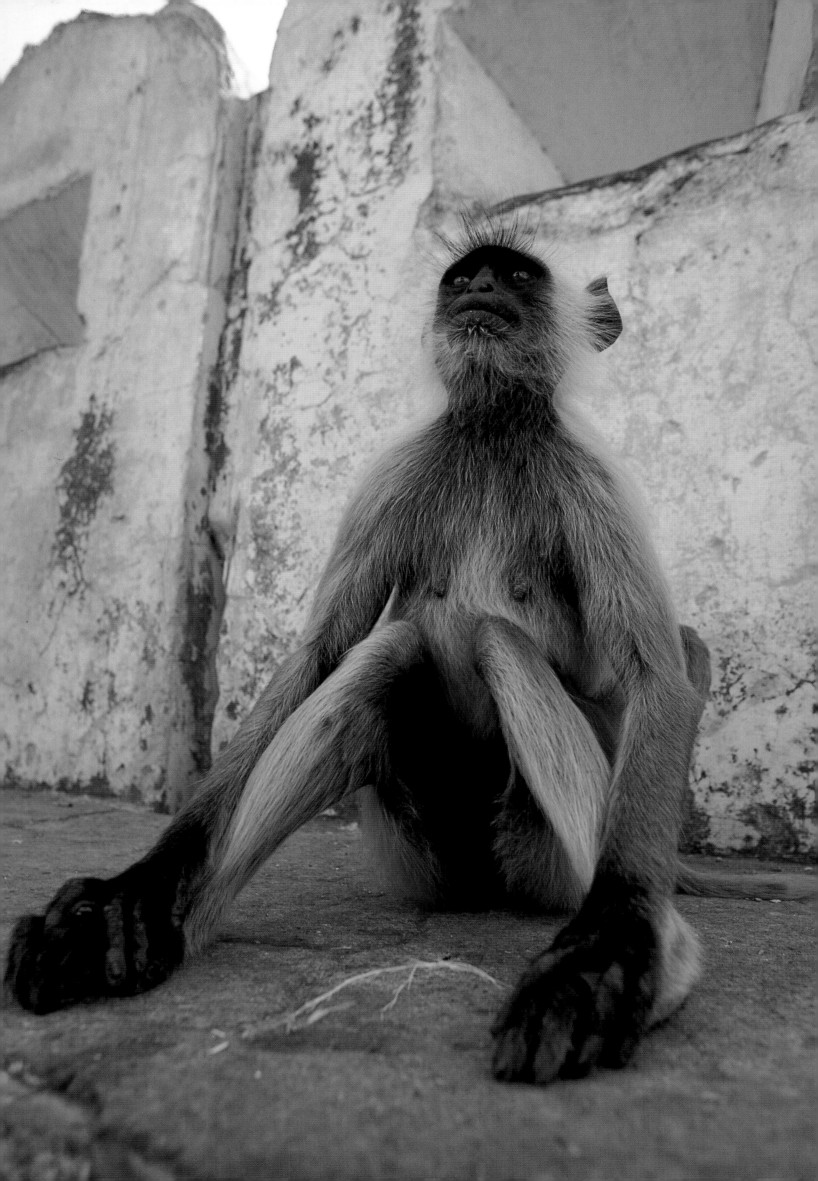

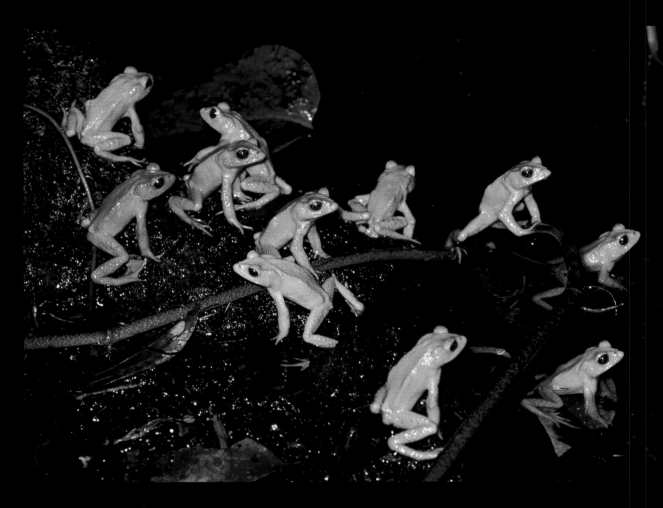

Last golden toads

This is one of the most poignant of nature portraits. The male golden toads are ready to mate and have gathered at a pool on an ancient tapir trail in the Monteverde Cloud Forest Reserve in Costa Rica to show off their colours to the females. It took five days to locate the males and a half day of being bitten by flies to get a near-perfect pose. But the truly unforgettable fact is that this is one of the last portraits of the toad, which hasn't been seen since 1989, when about 40 per cent of all the amphibians in Monteverde vanished. The cause? Most probably global warming.

Michael Fogden *UK 1984*

Dalmatian poise

Here is a subject transformed into a half-human, half-a the strange hair and great fan of feathers obscuring its The unforgettable eye is coldly determined – it's an an Of course it's just a Dalmatian pelican, waking up at f the Danube Delta to the shock of a photographer cam But it is also a classic example of how imagination can the ordinary – how a photographer with empathy for recreate its spirit and splendour.

Helmut Moik *Austria 2003*

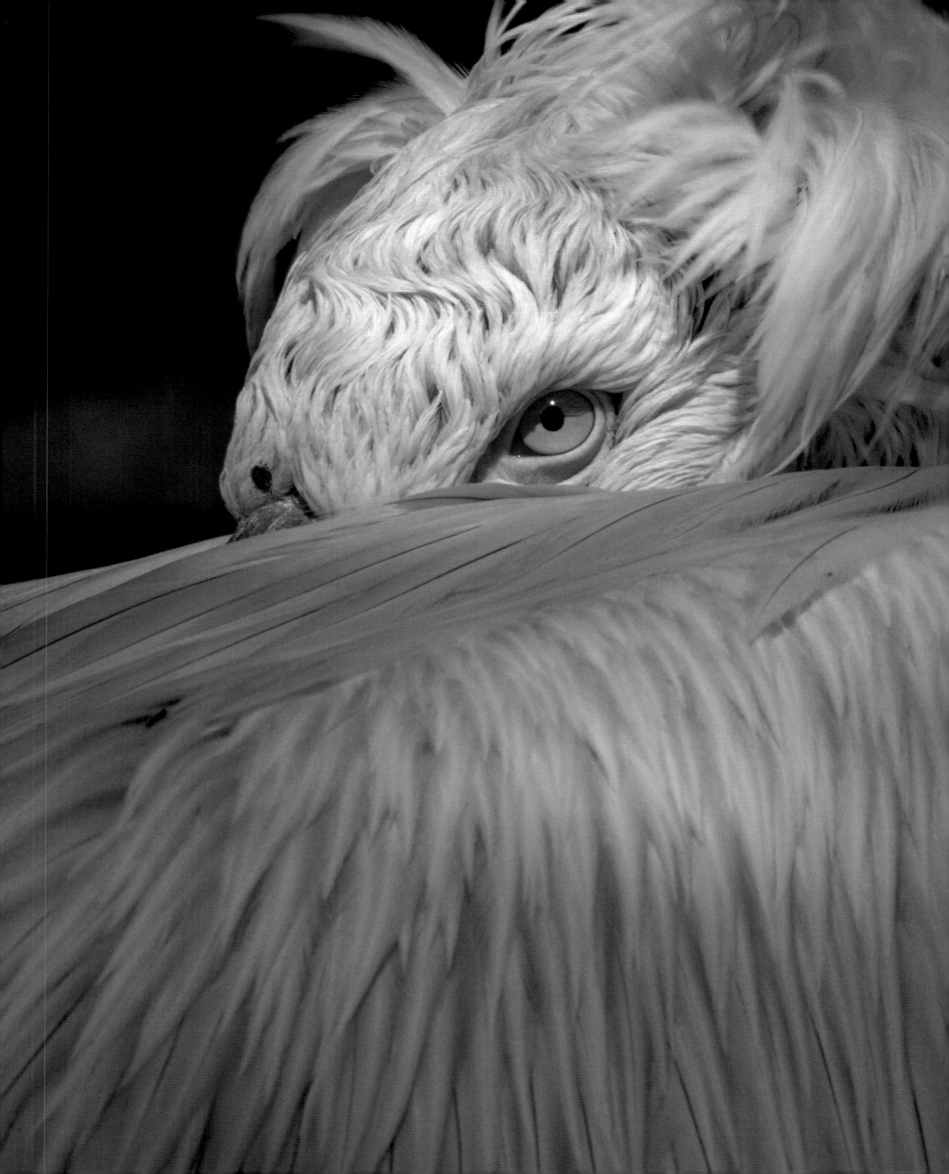

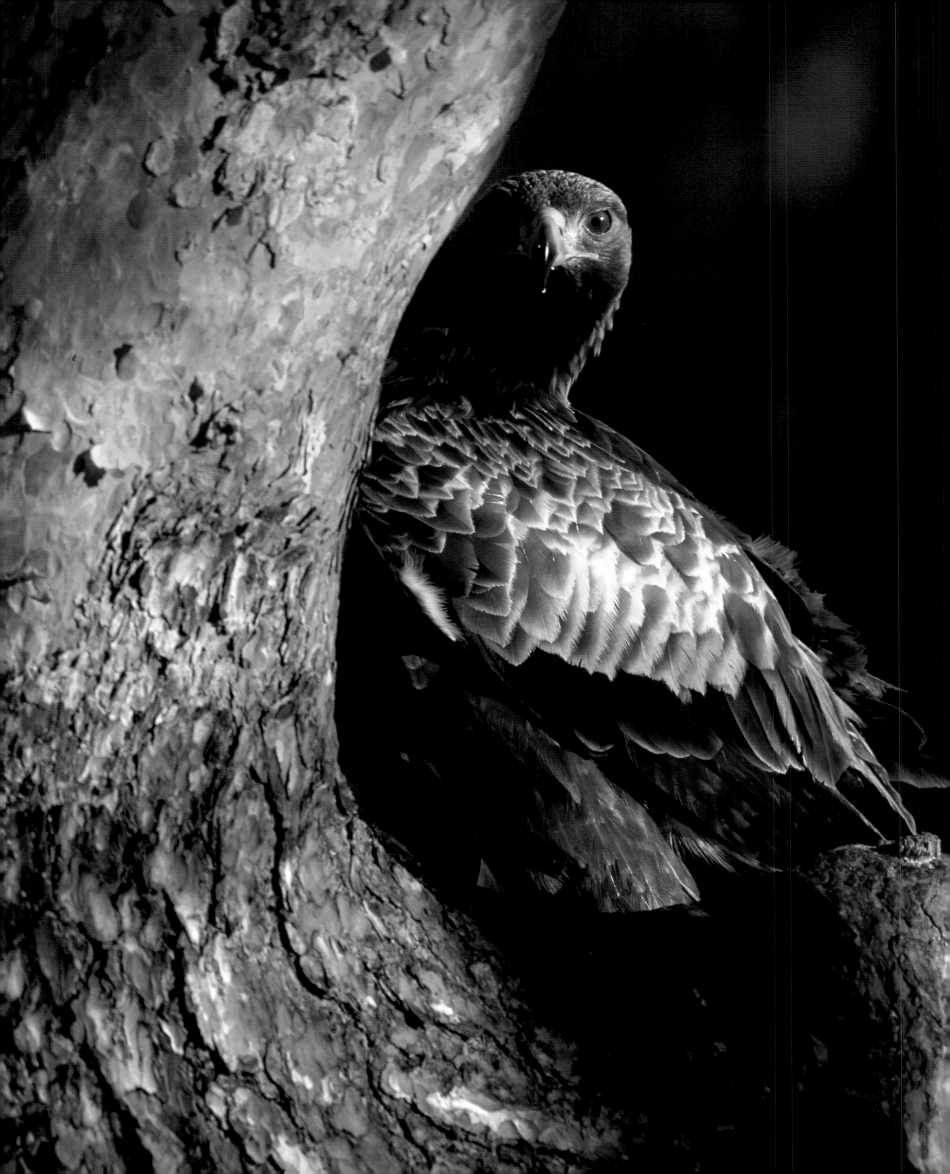

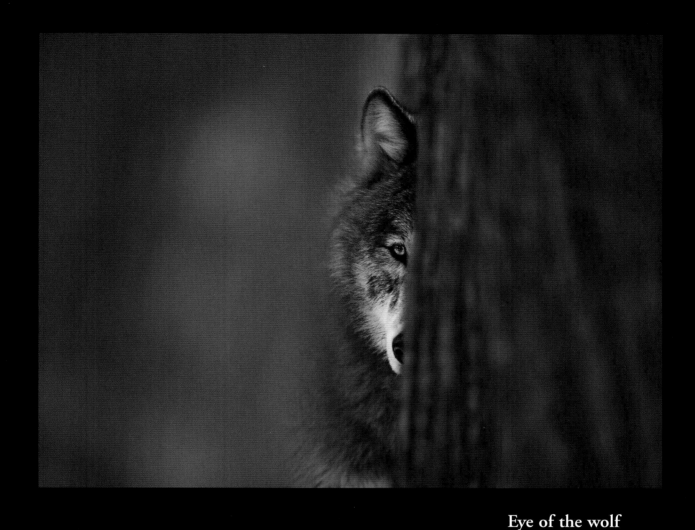

Eye of the wolf

In the years since it was taken, this subtle portrait has been much imitated . Its originality lies in the creation of an atmosphere of wildness – the wolf watching while remaining half hidden, merging into the forest surrounding the photographer's home in Minnesota. That its gaze is ahead but not meeting the viewer's makes the picture intimate, creating an impression of the wolf as timid, even hunted. Perhaps it's a reflection of the photographer's own feelings about wolves, having spent many years documenting their characters and behaviour.

Jim Brandenburg *USA 1988*

Golden pose

To get a portrait like this of a wild golden eagle requires perseverance, as these huge eagles are surprisingly shy. It also calls for a special understanding of an individual's behaviour. The photographer has, in fact, photographed almost nothing but golden eagles for the past 15 years, near his home in Sweden. This beautifully twisted Scots pine trunk was a favourite perch of the young eagle, but it took the photographer two months of visits to his hide before the ideal portrait presented itself, in early-morning light, with the bird seeming to look straight at the viewer, his eye perfectly lit and the pattern of his feathers mirrored in the pattern of the pine bark.

Conny Lundström *Sweden 1999*

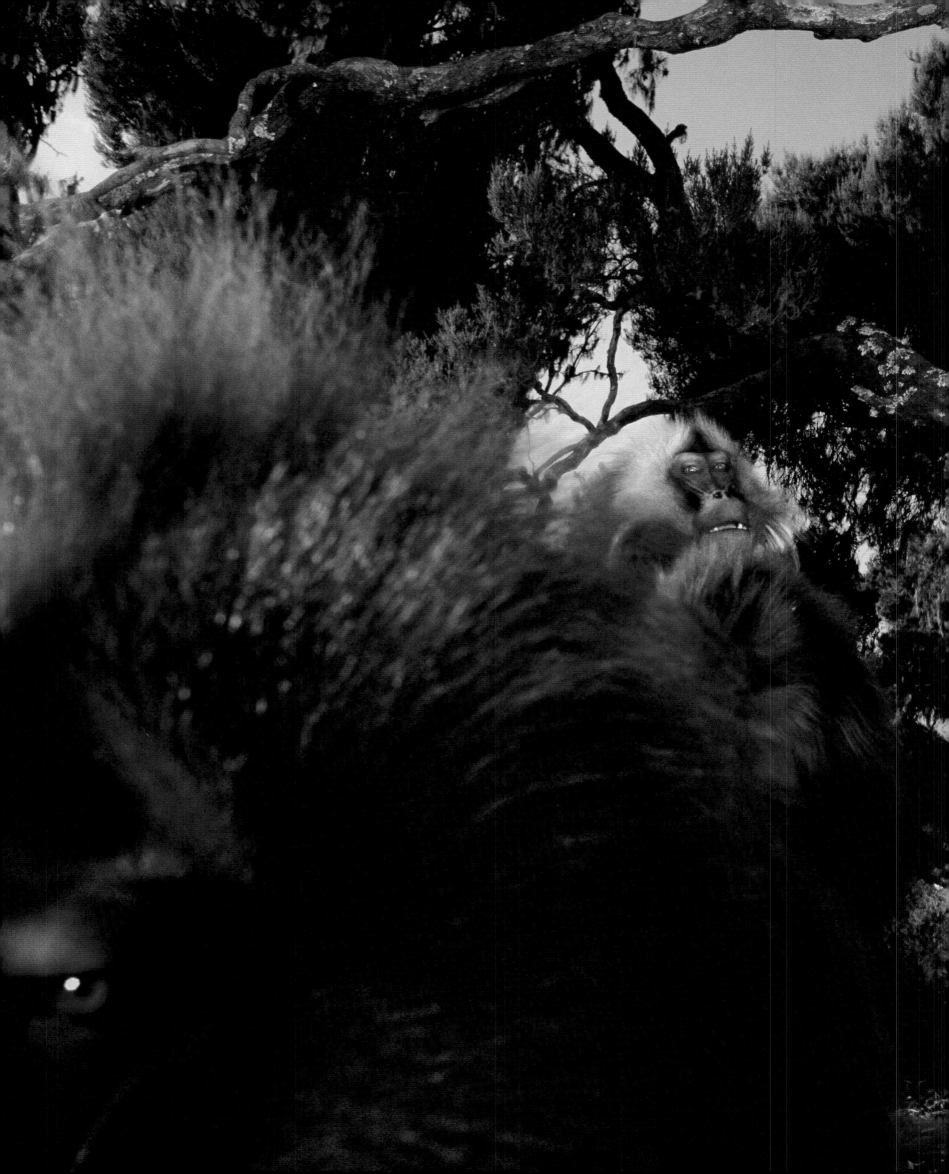

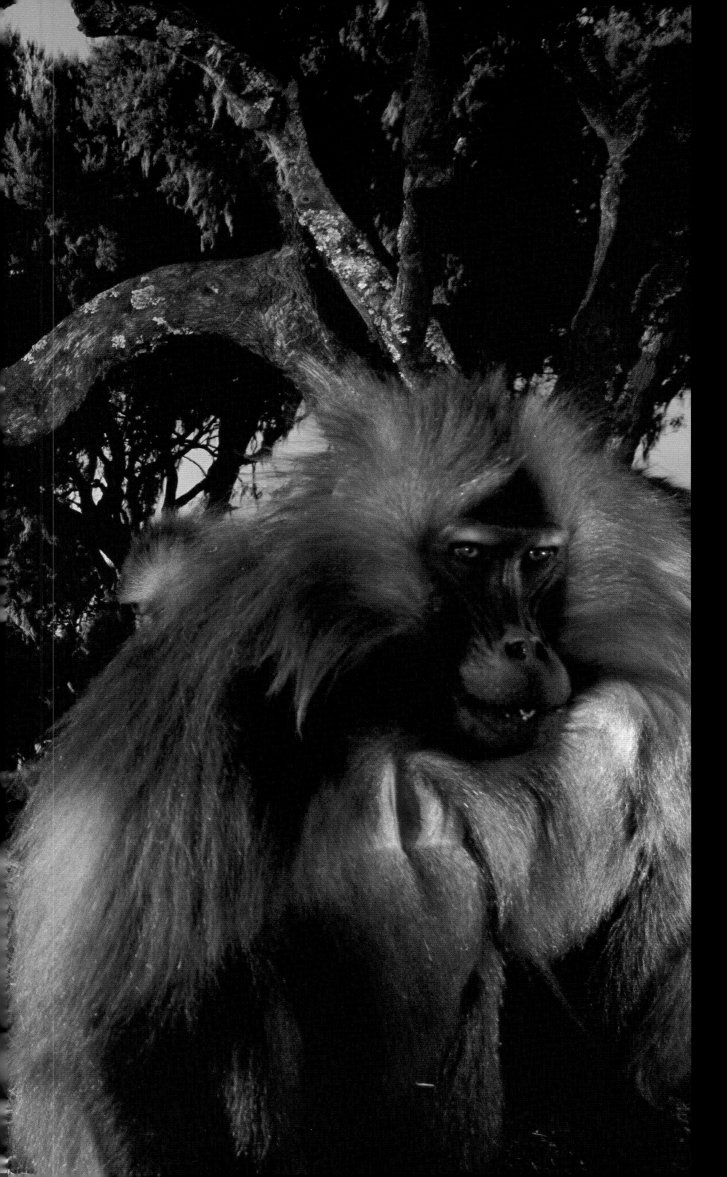

Gelada get-together

This is about as intimate
a portrait of a bachelor gathering
as you could get. A remotely
triggered camera places the
viewer in the heart of the group.
Each animal is a character in the
tableau, extravagant wind-blown
hairdos adding to the atmosphere
of brooding maleness, emphasised
by the single eye of the almost-
too-close male on the left, intent
on watching the females below.
It is a crafted composition,
illuminated by three carefully
placed strobe lights and
reflecting the unique nature of
these intelligent, social primates,
now relegated to shrinking
islands of alpine grassland in
the highlands of Ethiopia.

Michael Nichols *USA 2003*

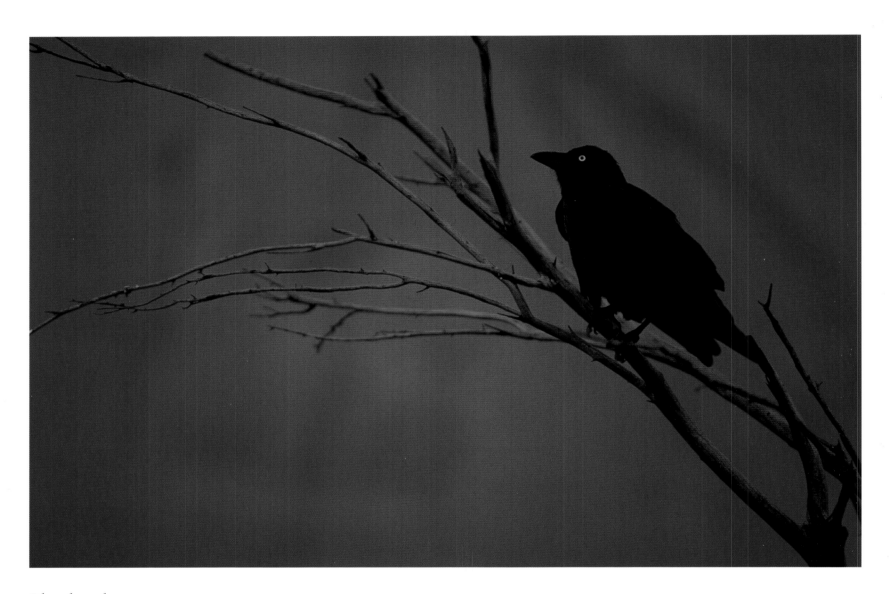

Blood-rock crow

The light in Australia can play strange tricks with the colour of rocks, and at sunset, Uluru (Ayers Rock) in the Northern Territory and the rock domes of Kata Tjuta to the west turn blood red. The photographer positioned himself to photograph a dead tree, black against one of the great domes lit up at sunset, but as he looked, a crow materialised on one of the branches. In Aboriginal dreamtime mythology, the crow represents the trickster – an apt symbol for a photographer who can change our perception of reality by showing us nature in a different light.

Theo Allofs *Germany 2003*

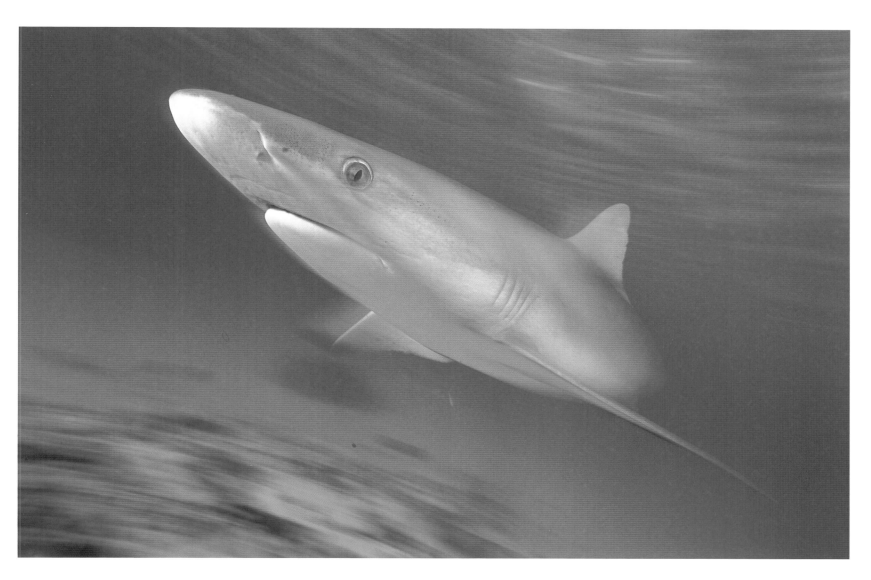

Shark turn

Here is a picture that conveys with great simplicity the streamlined swiftness of an animal attuned to its environment. The photographer never once felt threatened by this grey reef shark, whom he got to know over several days in a lagoon in the South Pacific. She was curious and obviously felt dominant, as she would often approach him, always performing a balletic turn at the last moment, eyeing him as she did so. The photographer planned his moment, preset his equipment, and as she swept by, panned the camera to create a sense of her perfect movement.

Tobias Bernhard
Germany 2001

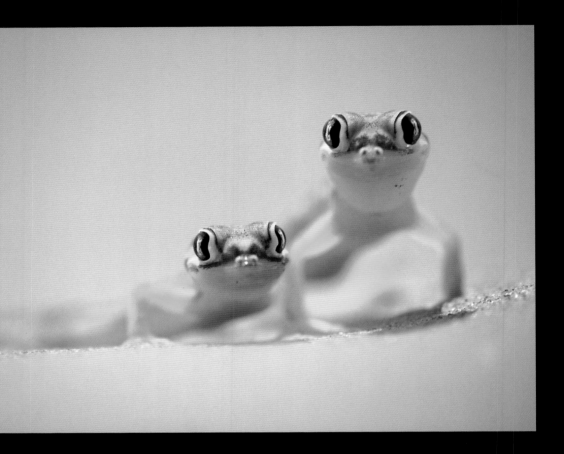

...tograph
...geckos in
...sun rises,
...ert where
...and they
...ey look
...hotographer
...g enough
...nd change
...could focus
...d their
...ronment.
...ow them to
...nout
...of many
...the dunes.

...X 1995

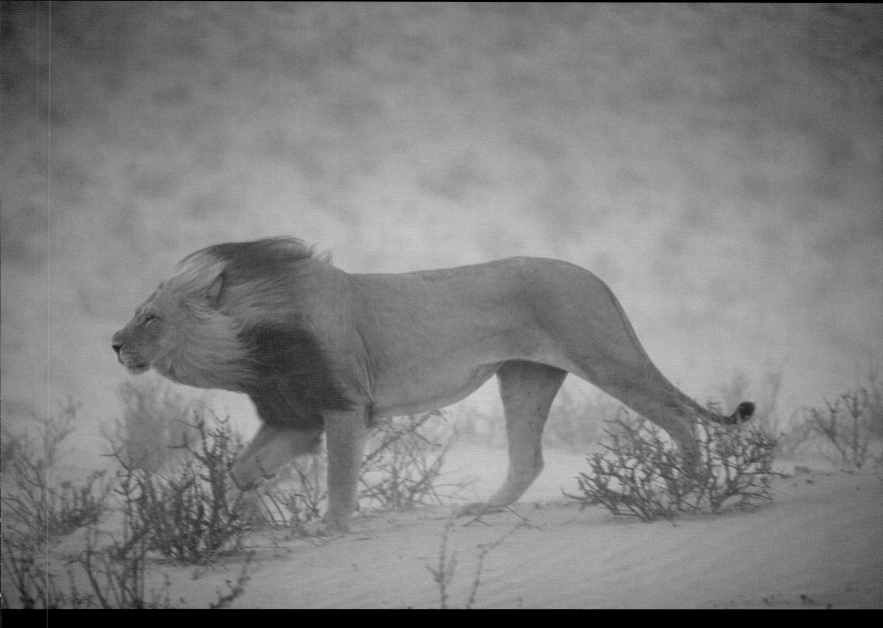

Lion in a sandstorm

The grainy nature of this picture is deliberate, as was the decision to depict the lion in some of the worst conditions for photography: low light, high wind and blowing sand (guaranteed to infiltrate the camera). The result is an unforgettable, highly original portrait. The lion's jutting muzzle and wind-blown mane and the sweep of his hind leg convey power and grace, and the way the subtle tones and grain of his coat blend into the riverbed portray him as part of the harsh, dry Kalahari environment.

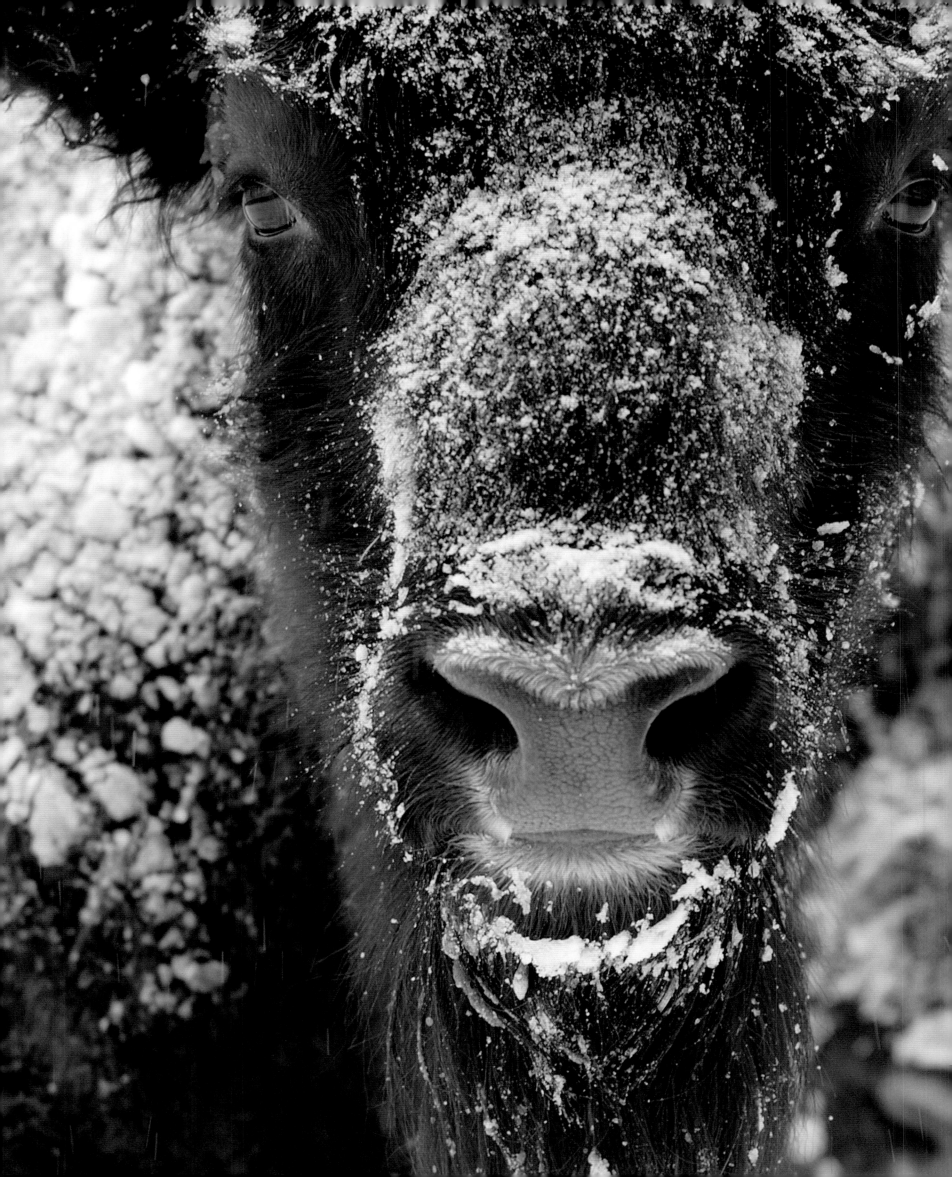

Bison morning

This is a portrait in which you can sense the animals, feel their breath and the light wetness of snow and hear the silence of the early-morning scene. The photographer prefers to use the subtle, often dull, everyday light that is normal for animals in a northern environment – in this case, the Bialowieza Forest of Poland. The forest is home to a population of European bison that originated from a handful of captive-bred animals, following the extinction of the species in the wild. The group has emerged into a clearing at first light after a night of heavy snow, and all are staring intently at the hide, unable to see the photographer but sensing the presence of something unusual.

Klaus Nigge *Germany 2004*

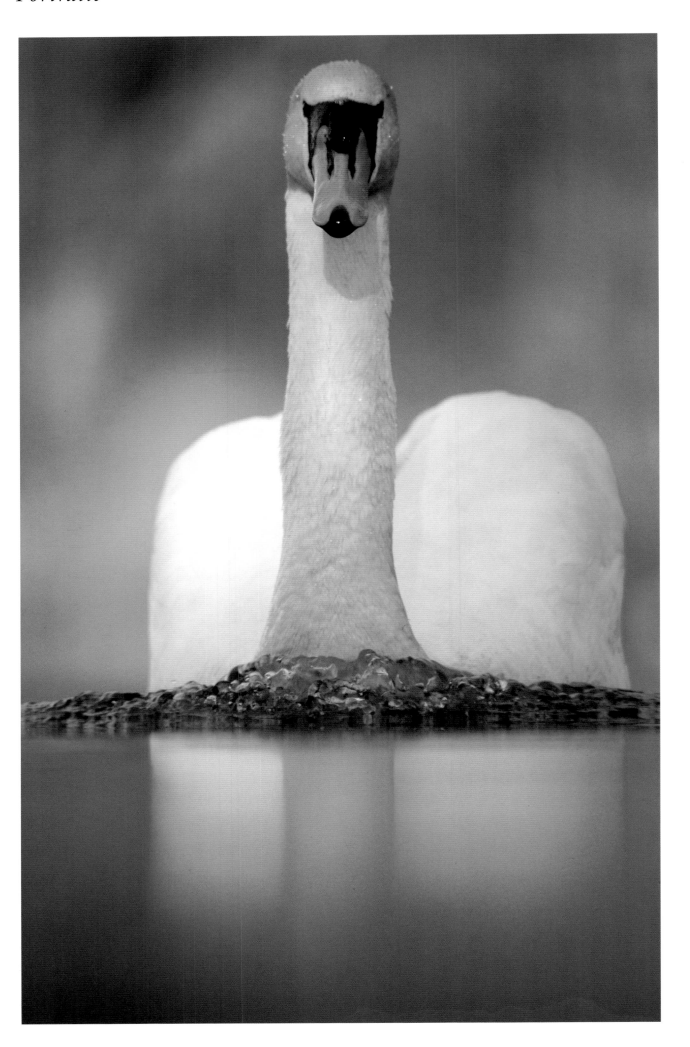

Swan display

Mute swans are often photographed but seldom as well as this. The picture was carefully planned, using the low, warm sun of a January day to provide a glow to the background and a low-as-possible perspective to bring power to the portrait and leave room for the reflection. The photographer positioned himself downstream from a waterfall in the lake and waited with the lens touching the water surface. Timing was crucial. The swan, of course, came to investigate, and the shot was taken just as it raised its wings at the start of a threat display. A fast shutter speed has frozen the surging bow-wave into a pedestal for the swan's magnificent head and neck, in sharp focus against a feather-soft surround.

Russell Hartwell *UK 1997*

Ice sleeper

The blue glow of the ice-light is what makes this underwater portrait of an Antarctic Weddell seal so unearthly. There is also a sensual nature to it, created by the voluptuous curves of the seal and the soft-focus ice above. The seal was discovered by the photographer napping in what must be, to a seal, a safe, warm place – an underwater ice cave. The animal's remarkable breath-holding abilities were demonstrated by the fact that, half an hour later, after the photographer had returned from a trip to the surface to change cameras and lenses, it was still there.

Norbert Wu *USA 2001*

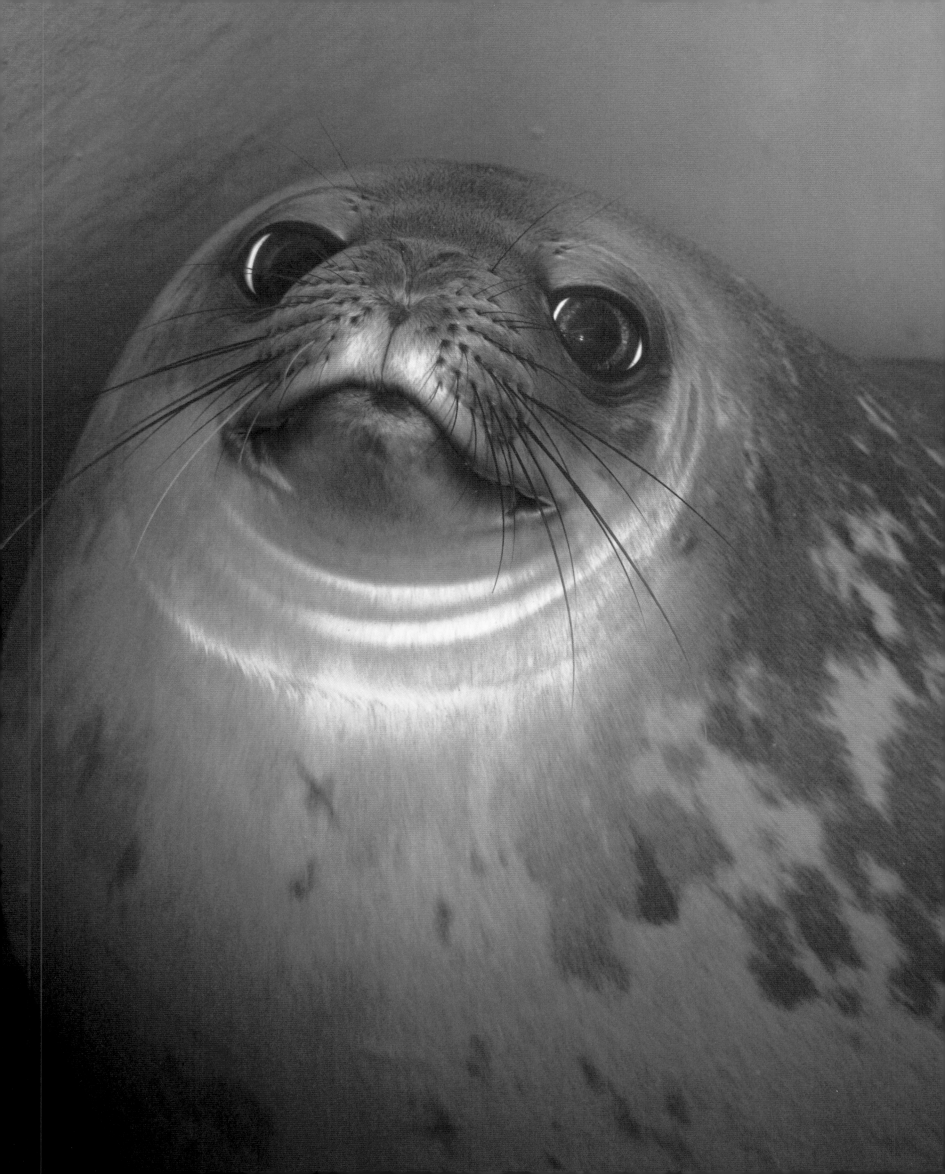

Family portrait

To photograph a group of
animals in the wild as you would
a family of people in a studio,
perfectly lit and all looking at
the camera, is virtually
impossible. Animals don't like
photographers – they move,
the light changes. This picture,
though, is not the result of pure
serendipity. The photographer
spent eight weeks with these
Hanuman langurs in India's
Thar Desert, allowing them time
to become accustomed to his
presence. He also got to know
when they would rise and where
they might sit to warm up.
The mystical early-morning
desert light was perfect for
illuminating the character of
these monkeys, named after
the Hindu god Hanuman, who
could change into any shape.

Ingo Arndt *Germany 2000*

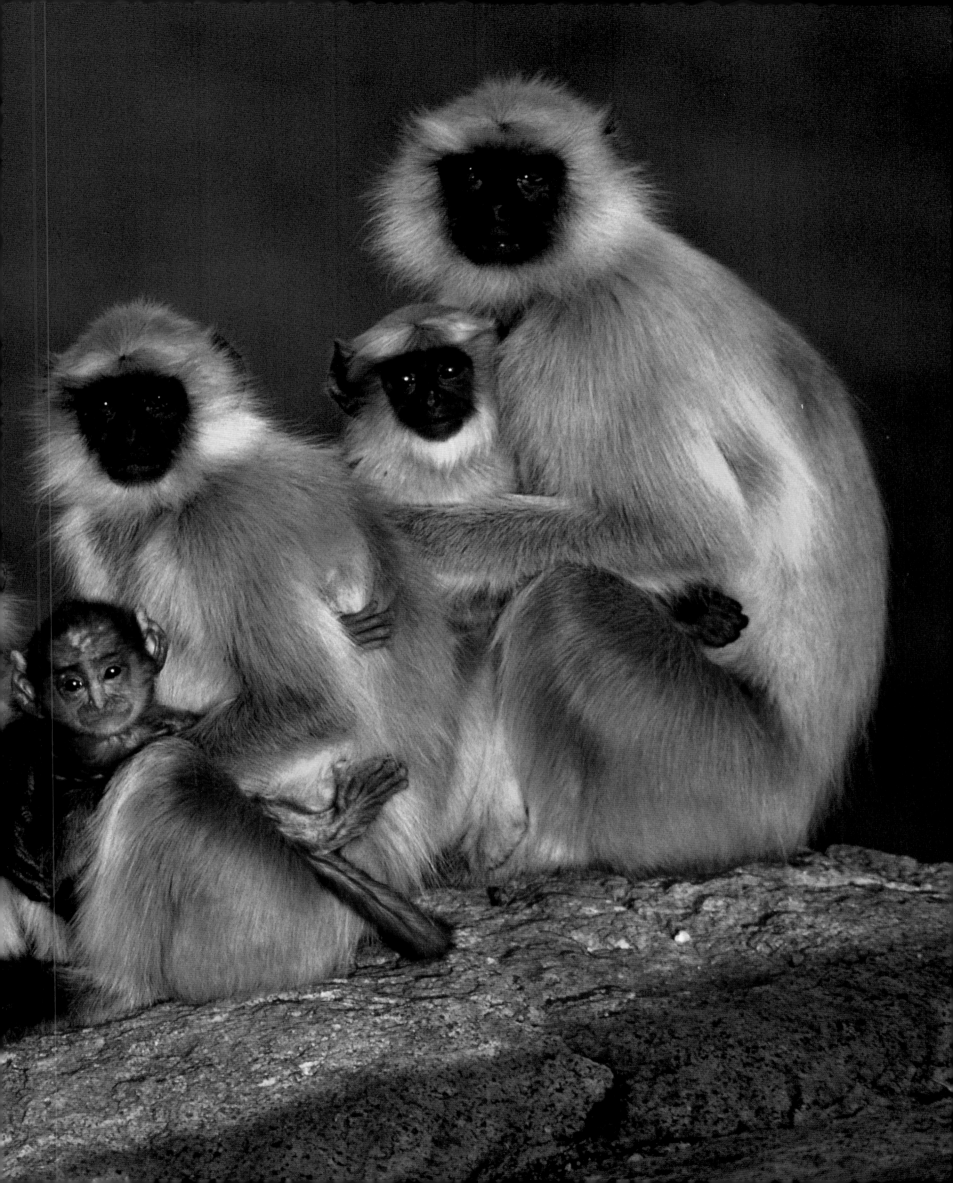

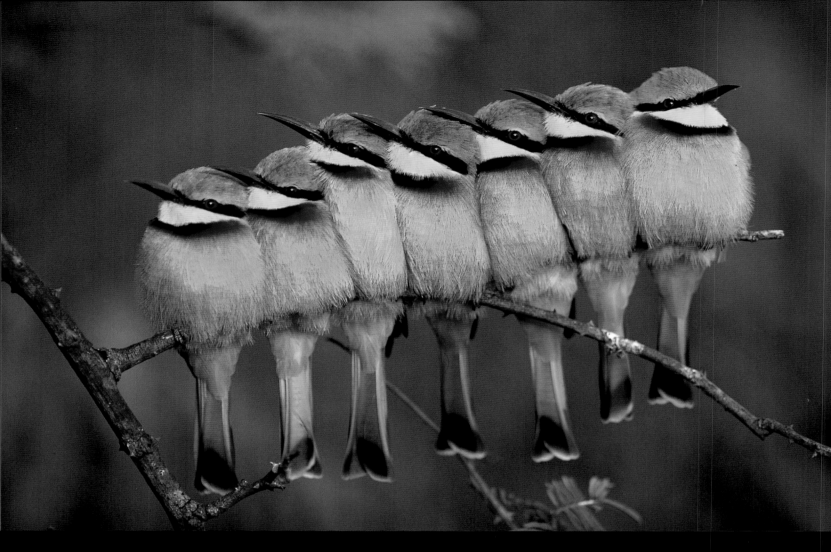

Seven little bee-eaters

Little bee-eaters have favourite perches to catch insects from, and when the temperature drops at night, a family group will often share one, huddling together for warmth. The photographer discovered this roost in a Kenyan wood. But it took a week of dawn vigils before he got the ideal eye-level view, with the sun low enough to light up their breasts, and the pose he wanted: a parallel arrangement of beaks. The final touch was when the last one turned away and presented a perfect end point to the line-up.

Peter Blackwell *Kenya 1997*

Ant shepherds with their aphid herd

This is a scene anyone could see close to home – ants tending aphids – though few people do and fewer still have the skill to take such a picture. The *Camponotus* ants are guarding a herd of oleander aphids feeding on the seedpod of a butterfly-weed plant (the ant at the top has just rescued one that has strayed from the group). The ant on the left is drinking honeydew that one of the aphids is excreting. Back at the ant nest, the fluid will be fed to the nurse ants tending the colony's grubs. In return for this food, the aphids are given day-long protection from predators – a partnership that is aeons old, encapsulatied in this vivid portrait.

Gerry Bishop *USA 1998*

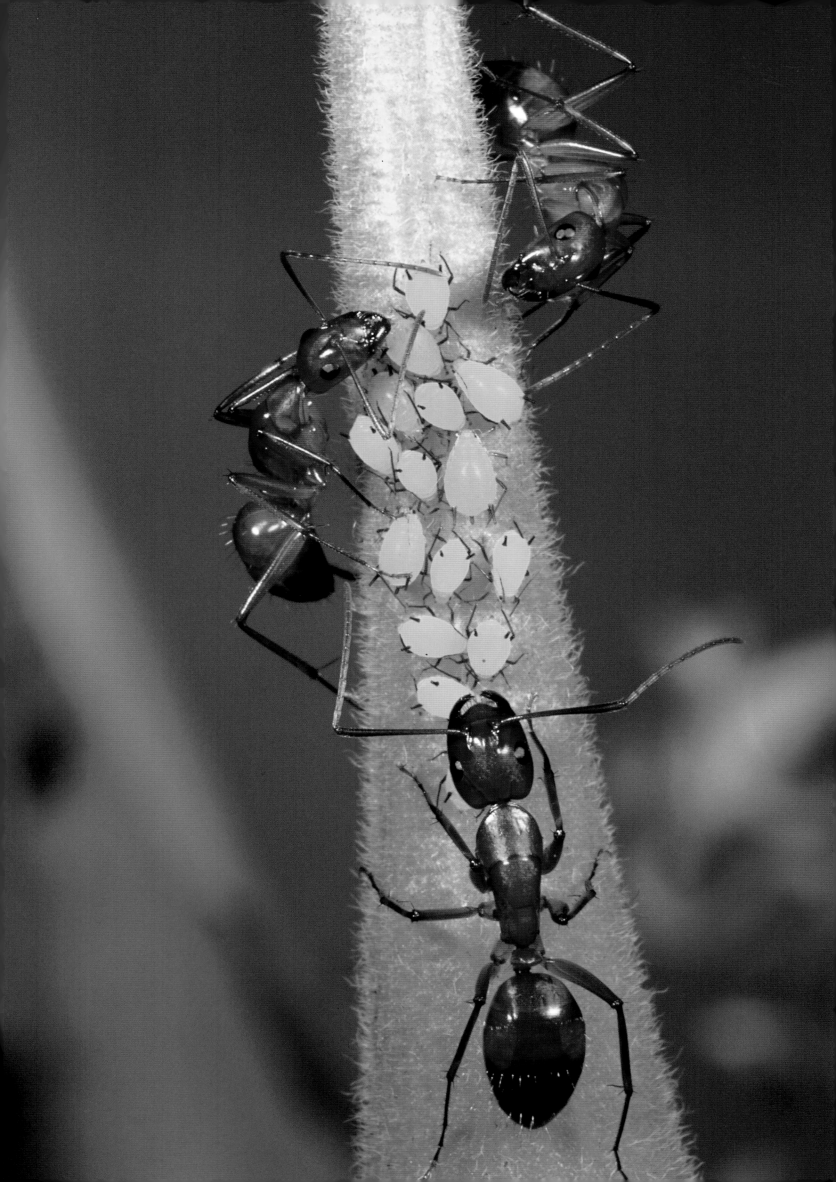

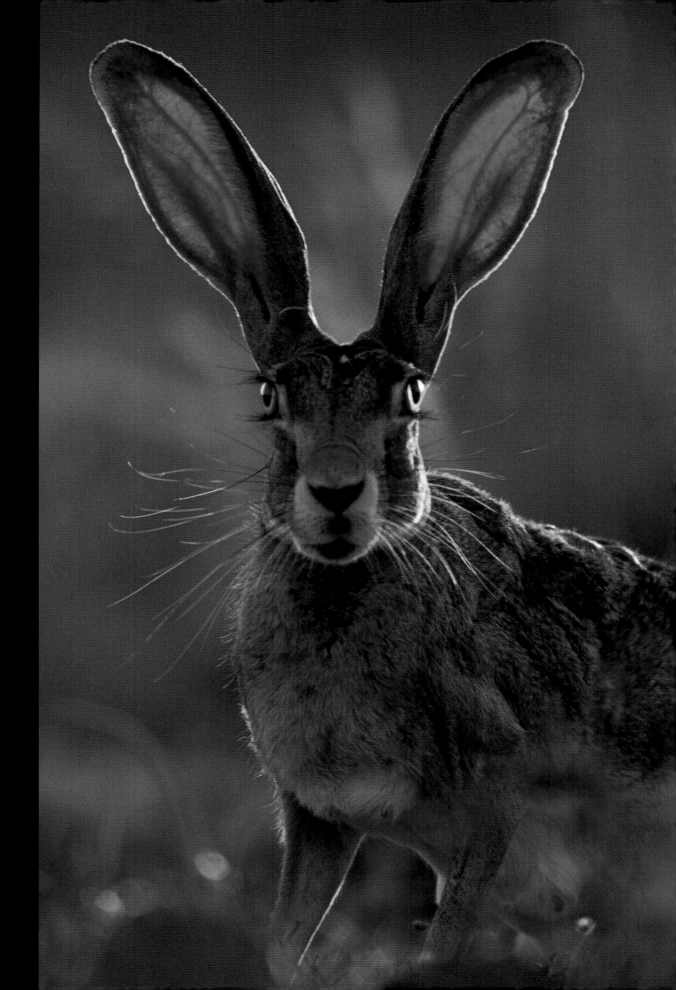

Australian flat wattle

Close-up is beautiful, when it comes to plants – each individual displaying this in a multitude of different ways. It's particularly true of Western Australia's rich flora, moulded by the hot, dry environment into strange, diverse forms. For many springs, when the rains came, the photographer searched the semi-desert for a branch of flat wattle (a sprawling, leafless acacia) bearing a display of each of its reproductive stages, from a golden globe fresh with pollen-bearing stamens through a flower ripe with rays of the female stigmas to the coiled pink seedpod. After five years, he finally found the colour creation he was looking for – an extravagant symbol of Australian floral uniqueness.

Andrew Davoll
Australia 2003

Texas jackrabbit

Jackrabbits, like all hares, are prey for almost every predator and in an almost permanent state of twitchiness. Even when they are dozing, their ears are tuned and their eyes alert to movement. This black-tailed jackrabbit was resting out the day under a mesquite tree, waiting for the safety of dusk to emerge and suckle her leverets. The photographer spotted her ears first, back-lit by the late-afternoon sun, and saw the potential for a beautiful portrait. Braving thorns, burrs and insects, he crawled as close as he dared and took the shot just as the jackrabbit's nose began to twitch.

Jeremy Woodhouse *UK 2003*

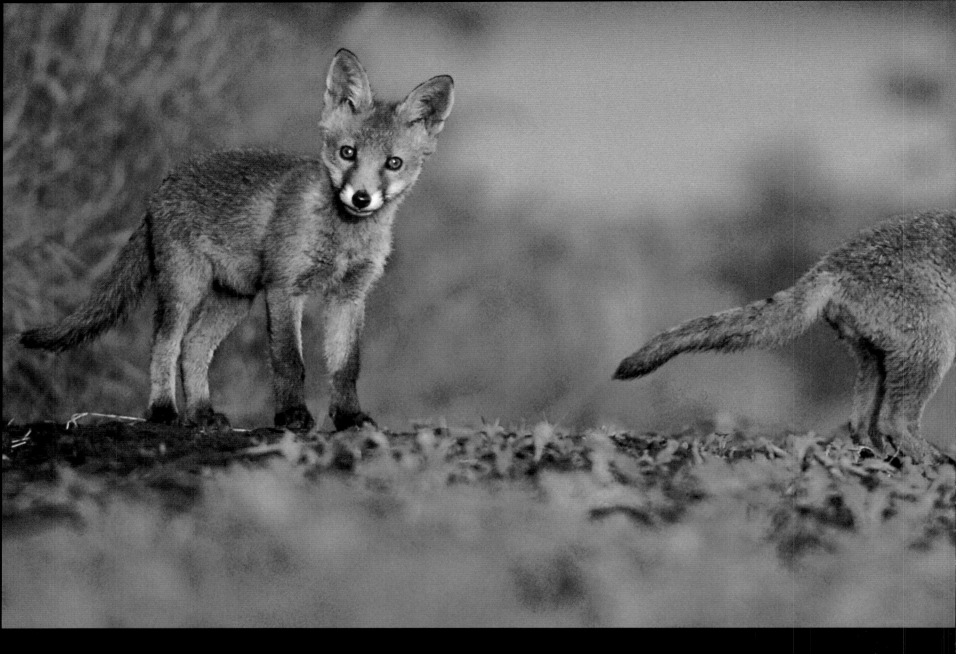

Foxes at sunrise

For many years the photographer has taken pictures of the foxes around his home, but only once has both light and pose been as perfect as this. It's the light of dawn, soft enough to allow a richness of colour but with a spotlight of the first rays of sun on the vixen. The photographer had entered his hide before dawn, as he had done for several weeks, and on cue, the cubs emerged from their den just as the vixen arrived back from hunting. The interaction was brief. The vixen suckled all three of the cubs together for a minute or so, regurgitated some food for them and then, before trotting off down the field, sat back for a few seconds to bask in the sun. At that instant, one cub turned to look at the hide, adding the final touch to this most delightful of family poses.

Mark Hamblin *UK 2002*

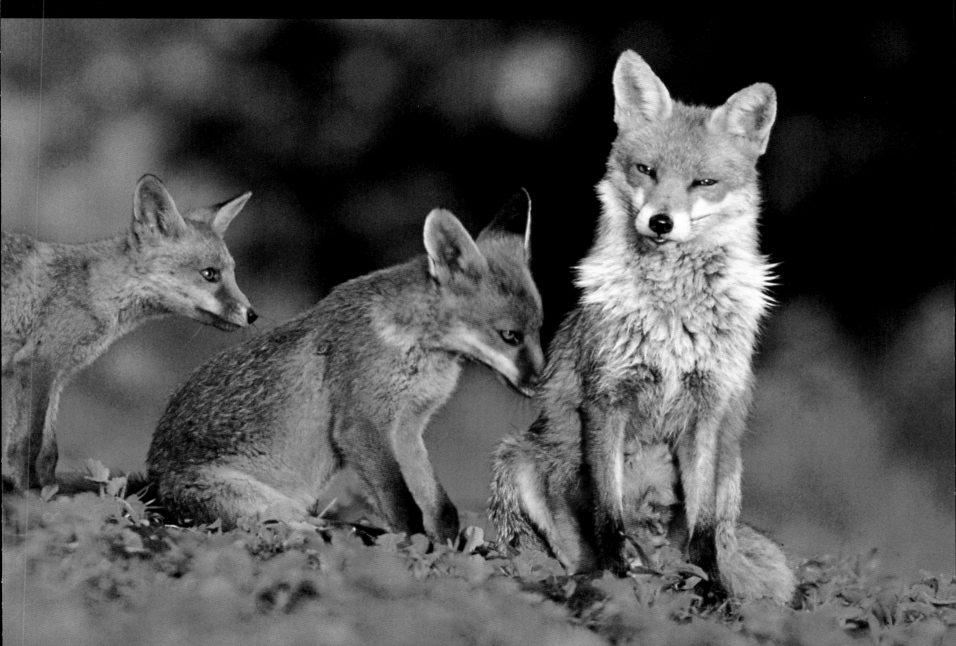

Photographers' details

9 Nikonos V with 15mm lens; 1/250 sec at f4.5; Kodachrome 64

Kelvin Aitken (Australia)
kelvin@kaphoto.com.au
0061 3 9480 4451
Agent: Marine Themes
info@marinethemes.com
www.marinethemes.com

14 Canon T90 with 80-200mm lens; Kodachrome 64

Cherry Alexander (UK)
Alexander@arcticphoto.co.uk
01258 473006
www.arcticphoto.co.uk

43 Nikonos V with 20mm lens; 1/125 sec at f5.6; Fujichrome Sensia 200

Doug Allan (UK)
dougallancamera@mac.com
0117 973 7579
www.dougallan.com
Agents: Nature Picture Library (UK) info@naturepl.com
www.naturepl.com
OSF (UK) enquiries@osf.co.uk
www.osf.co.uk

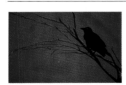

200 Canon EOS 1V with 300mm f2.8 lens; Fujichrome Velvia

Theo Allofs (Canada)
allofsphoto@northwestel.net
001 867 667 6000
www.theoallofs.com

140 Nikon F4 with 80-200mm zoom lens; Kodachrome 200

149 Nikon F100 with 20-35mm lens; Fujichrome Sensia 100

Karl Ammann (Kenya)
kamman@form-net.com
00254 62 32448
www.karlammann.com

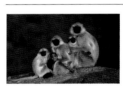

210 Minolta with 500mm lens; 1/250 sec at f5.6; Fujichrome Sensia; tripod

Ingo Arndt (Germany)
i.arndt-photo@t-online.de
0049 6105 1737
www.arndt-photo.de

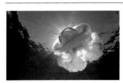

44 Subeye Reflex with 13mm R-UW AF Fisheye Nikkor lens; 1/125 sec at f11 1/16; Fujichrome Velvia; Ikelite substrobe 200

Pete Atkinson (UK)
yachtvigia@hotmail.com
www.peteatkinson.com
Agents: Getty Images (UK)
sales@gettyimages.com
www.gettyimages.com
NHPA (UK) nhpa@nhpa.co.uk
www.nhpa.co.uk

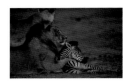

146

173

Adrian Bailey (South Africa)
aebailey@icon.co.za
0027 15 793 0772
www.baileyphotos.com
Agent: Aurora Photos (USA)
info@auroraphotos.com
www.auroraphotos.com

46 Nikon F4 with 400mm lens; 1/30 sec at f4; Fujichrome Velvia; tripod

André Bärtschi (Liechtenstein)
abc@wildtropix.com
00423 232 0338
www.wildtropix.com

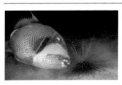

62 Nikon F4 with 20-35mm lens; underwater housing; 1/60 sec at f8; two strobes

Fred Bavendam (USA)
fabavendam@mac.com
001 941 953 7623
www.agpix.com/fredbavendam
Agent: Minden Pictures (USA)
info@mindenpictures.com
www.mindenpictures.com

19 Nikon FM with 80-200mm zoom lens; 1/250 sec at f4.5; Kodachrome 64

Rajesh Bedi (India)
bedifilms@touchtelindia.net
0091 11 2543 9939
www.bedibrothers.com

171 Nikon FAS with 300mm lens and x1.4 converter; 1/125 sec at f5.6; Kodachrome 200; beanbag

Niall Benvie (UK)
niall@niallbenvie.com
01356 626128
Agents: Images from the Edge
www.ImagesfromtheEdge.com
Nature Picture Library (UK)
info@naturepl.com
www.naturepl.com

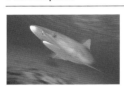

201 Nikon F90X with 18mm lens; 1/115 sec at f16; Fujichrome Velvia; two strobes

Tobias Bernhard (Germany)
wildimages@start.com.au
0049 80 4177 687
Agent: OSF (UK)
enquiries@osf.co.uk
www.osf.co.uk

213 Nikon 8008s with 90mm lens and extension; f22; Fujichrome Velvia; dual strobe with diffusers

Gerry Bishop (USA)
gbishop58@earthlink.net
001 703 255 5358

212 Nikon N90 with 500mm lens; 1/30 sec at f4; Fujichrome Velvia rated at 80; tripod

Peter Blackwell (Kenya)
blackash@africaonline.co.ke
00254 15 164032

101 Mamiya RZ 67 with 50mm lens; f16; Fujichrome Velvia; polarising filter; tripod

Melker Blomberg (Sweden)
melker@melkerblomberg.com
0046 70 2156 700
www.melkerblomberg.com

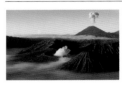

104 Canon EOS 1N with 28-70mm lens; 1/115 sec at f8; Fujichrome Provia; tripod

Dan Bool (Indonesia)
dan@eastimages.com
0062 8123 805 166 (mobile);
0062 361 733280
www.eastimages.com

87 Nikon 8008s with 105mm lens; 2 sec at f16; Fujichrome Velvia; tripod

Gary Braasch (USA)
gary@braaschphotography.com
001 503 699 6666
www.braaschphotography.com
Agent: Getty Images (UK)
sales@gettyimages.com
www.gettyimages.com

158 Nikon F3 with 80-200mm zoom lens; 1/125 sec at f8; Kodachrome 64

197 Nikon F3 with 300mm lens; 1/125 sec at f2.8; Kodachrome 64

Jim Brandenburg (USA)
info@jimbrandenburg.com
001 218 365 5105
www.jimbrandenburg.com
Agent: Minden Pictures (USA)
info@mindenpictures.com
www.mindenpictures.com

108 Canon EOS1V with 17-35mm f2.8 lens; 1/125 sec at f5.6; Fujichrome Provia

David W Breed (Kenya)
davidbreed@iconnect.co.ke
00254 20 890 455
Agent: OSF (UK)
enquiries@osf.co.uk
www.osf.co.uk
Agent: RSPCA Photolibrary (UK)
pictures@rspcaphotolibrary.com
www.rspcaphotolibrary.com

164 Nikon F90 with 80-200mm lens; 30 sec at f16; Fujichrome Velvia rated at 40; tripod

Olaf Broders (Germany)
obroders@web.de
0049 88 56 802 0533
www.broders-photo.de
Agent: OSF (UK)
enquiries@osf.co.uk
www.osf.co.uk

122 *Nikon F3 with 200mm lens with close-up lens and extension tube; 4 sec at f32; Fujichrome Velvia; tripod*

Whit Bronaugh *(USA)*
whit@whitphoto.com
001 541 683 3774
www.whitphoto.com

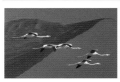

91 *Canon EOS 1N with 80-200mm zoom lens; 1/350 sec at f11; Fujichrome Sensia 100*

Marcello Calandrini *(Italy)*
m.calandrini@flashnet.it
0039 063 550 9212

6 *Nikon F4 with 500mm lens; 1/8 sec at f16; Fujichrome Velvia; tripod*

89 *Nikon F4 with 300mm lens and x2 converter; 1/500sec at f5.6; Kodachrome 200*

Laurie Campbell *(UK)*
laurie@lauriecampbell.com
01289 386736
www.lauriecampbell.com

144 *Nikon F3 with a 200mm f4 macro lens; 1/8 sec at f8; Fujichrome Velvia*

Bernard Castelein *(Belgium)*
bernard.castelein@vt4.net
0032 3 653 08 82
Agent: Nature Picture Library (UK) info@naturepl.com
www.naturepl.com

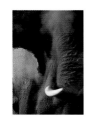

154 *Canon EOS1 with 300mm lens; Fujichrome Velvia*

184 *Canon EOS1 with 80-200mm zoom lens; Fujichrome Velvia*

Martyn Colbeck *(UK)*
martyncolbeck@compuserve.com
Agent: OSF (UK)
enquiries@osf.co.uk
www.osf.co.uk

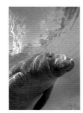

186 *Nikon 8008s with 20mm lens in underwater housing; 1/125 sec at f8; Fujichrome Sensia*

Brandon D Cole *(USA)*
brandoncole@msn.com
001 509 535 3489
www.brandoncole.com

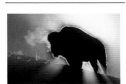

20 *Canon A2-EOS with Canon EF 300mm lens plus Canon 1.4 tele-extender attached for a focal length of 420mm; Fujichrome Velvia; tripod*

Mervin D Coleman *(USA)*
mcoleman@montana.net
001 406 446 1228
www.colemangallery.biz
Agents: Still Pictures (UK)
info@stillpictures.com
www.stillpictures.com
Woodfall Wild Images (UK)
wwimages@btinternet.com
www.woodfall.com

191 *Nikon F5 with 80-200mm lens; Fujichrome Provia; tripod*

Daniel J Cox *(USA)*
info@naturalexposures.com
001 406 556 8212
www.naturalexposures.com

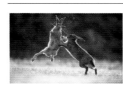

80 *Nikon F4 with 400mm lens; 1/1000 sec at f2.8; Fujichrome Sensia 100*

Manfred Danegger
(Germany)
tierfotodanegger@t-online.de
fax: 0049 7557 8970

84 *Minolta 9000 with 600mm lens; Kodachrome 64; tripod*

Bruce Davidson *(Kenya)*
Agent: Nature Picture Library (UK) info@naturepl.com
www.naturepl.com

214 *Nikon FE2 with 180mm Sigma macro lens; 2 sec at f16; Fujichrome Velvia*

Andrew Davoll *(Australia)*
davoll@arach.net.au
0061 8 9275 3280
Agents: Lochman Transparencies (Australia)
lochmantrannies@optusnet.com.au
www.lochmantransparencies.com
Alamy Limited (UK)
info@alamy.com
www.alamy.com

105 *Nikon F-801S with Sigma 70-210mm APO lens; 1/125 sec at f4; Fujichrome Provia; tripod*

José L Gómez de Francisco
(Spain)
jlgdefrancisco@hotmail.com
0034 941 262 398

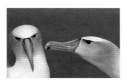

202 *Nikon F5 with 300mm lens; 1/250 sec at f2.8-f4.5; Fujichrome Provia; flash with fresnel lens*

Tui De Roy *(New Zealand)*
photos@rovingtortoise.co.nz
0064 3 5258370
Agent: Minden Pictures (USA)
info@mindenpictures.com
www.mindenpictures.com

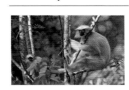

51 *Canon EOS 1N with 300mm lens and 1.4x extender; 1/125 sec at f4; Fujichrome Provia; tripod*

132 *Canon EOS 1N with 200mm lens; 1/115 sec at f11; Fujichrome Provia; tripod*

Elio Della Ferrera *(Italy)*
eliodellaferrera@iname.com
0039 0342 213 254
Agent: Nature Picture Library (UK) info@naturepl.com
www.naturepl.com

52 *Canon EOS 1NRS with 300mm lens; 1/500 sec at f4; Fujichrome Provia*

Michel Denis-Huot *(France)*
denishuot@aol.com
0033 2 3546 2970
www.denis-huot.com
Agents: Bios (France)
bios@biosphoto.com
www.biosphoto.com
Jacana/Hachette Photos (France)
apernecker@hachettephotos.com
www.hachettephotos.com

72 *Nikon RS with 13mm fisheye lens; 1/125 sec at f11; Kodak Elite II 100*

92 *Hasselblad xPan with 45mm lens; f16; Fujichrome Velvia; polarising filter and tripod*

Cornelia & Ramon Dörr
(Germany)
doerr-photo@t-online.de
www.doerr-naturbilder.de
Agency: age fotostock (Spain)
age@agefotostock.com
www.agefotostock.com

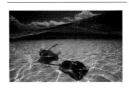

45 *Nikon F3 with Nikkor 18mm lens; split diopter; Kodachrome 64; Aquatic III housing*

David Doubilet *(USA)*
001 315 686 1209
www.daviddoubilet.com
www.nationalgeographic.com/photography/doubilet
Agent: National Geographic Image Collection (USA)
images@ngs.org ngsimages.com

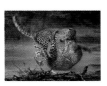

63 *300mm lens; 1/125 at f4; ISO 50 film; beanbag*

Richard du Toit *(South Africa)*
rdutoit@iafrica.com
0027 11 465 9919
Agent: Nature Picture Library (UK) info@naturepl.com
www.naturepl.com

16 *Nikon 801s with 16mm lens; underwater housing; 1/30 sec at f11; Fujichrome Velvia; two flashes*

Fredrik Ehrenström *(Sweden)*
aqua.media@telia.com
0046 31 943 792
and 0046 707 962 815
www.aquamedia
Agents: OSF (UK)
enquiries@osf.co.uk
www.osf.uk.com
Swedish Nature Photographers Association
info@naturfotograferna.se
www.naturfotograferna.se
Swedish Nature Photographers Association Picture Library
info@naturfotograferna-bildbyra.se
www.naturfotograferna-bildbyra.se

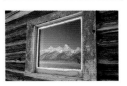

127 *Canon EOS 3 with 28-70mm lens; 1/4 sec at f16; Fujichrome Velvia; mirror lock-up and cable release; polariser*

Herb Eighmy *(USA)*
herbeighmy@aol.com
001 406 284 6380

165 *Nikon F2AS with 400mm f3.5 lens and extension tube; 1/2 sec at f8; Fujichrome 50D; A2 filter chamber*

Gerry Ellis/GLOBIO *(USA)*
gerry@globio.org
001 503 232 7067
www.globio.org

Photographers' details

126 Canon T90 with 100-
300mm zoom lens; 1/8 sec at
f22; Fujichrome Velvia; tripod

Nusret Nurdan Eren (*Turkey*)
yildizdemiriz@turk.net

49 Pentax 6x7 with 90mm lens;
16 sec at f22; Fujichrome Velvia;
soft filter

Per-Olov Eriksson (*Sweden*)
o.eriksson@mbox303.swipnet.se
0046 19 251 774
Agent: Woodfall Wild Images
(UK) wwimages@btinternet.com
www.woodfall.com

71 Canon EOS 3 with 500mm
lens and Canon teleconverter
1.4X; 1/500 sec at f8;
Fujichrome Provia RDP111

Tim Fitzharris (*USA*)
fitzharris@comcast.net
001 505 988 5530
www.timfitzharris.com

194

Michael Fogden (*Costa Rica*)
Fogden Wildlife Photographs
(UK) susan.fogden@virgin.net
01876 580245
http://fogdenphotos.com

166 Nikon F4 with 16mm
fisheye lens in underwater
housing; 1/60 sec at f8;
Fujichrome Sensia; strobe

Jürgen Freund (*Australia*)
scubayogi@compuserve.com
0061 7 4081 0363
www.scubayogi.de
Agent: Nature Picture Library
(UK) info@naturepl.com
www.naturepl.com

88 Nikon with 80-200mm lens;
Kodachrome 64

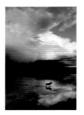

114 Nikon with 24mm 2.8 lens;
Kodachrome 64

Steven Fuller (*USA*)
stevefuller82190@yahoo.com
001 307 242 7279
www.stevenfuller.net
Agent: Peter Arnold (USA)
research@peterarnold.com
www.peterarnold.com

34 Pentax 645 with 120mm
lens; 1/8 sec at f22; Fujichrome
RDP III 100; warming polariser;
tripod

Howie Garber (*USA*)
howie@wanderlustimages.com
001 801 272 2134
www.wanderlustimages.com

67 Nikon F5 with 500mm F4
Nikkor lens; 1/125 sec at f4;
Fujichrome Provia; tripod

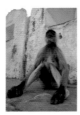

193 Nikon FE2 with 24mm
lens; Fujichrome Velvia

Nick Garbutt (*UK*)
nick@nickgarbutt.com
01931 716227
www.nickgarbutt.com
Agents: Nature Picture Library
(UK) info@naturepl.com
www.naturepl.com
NHPA (UK) nhpa@nhpa.co.uk
www.nhpa.co.uk

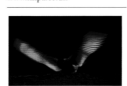

48 Canon F1 with 500mm lens;
1/15 sec at f4.5; Fujichrome
Velvia; tripod

Anders Geidemark (*Sweden*)
anders.geidemark@telia.com
0046 2202 0240
www.andersgeidemark.se
Agent: Getty Images (UK)
sales@gettyimages.com
www.gettyimages.com

107 Nikon F5 with 80-20mm
lens; Fujichrome Provia

Patricio Robles Gil/Sierra
Madre (*Mexico*)
patricio@terra.com.mx
0052 55 5611 0158
www.agrupacionsierramadre.com
.mx/default.htm
Agents: Nature Picture Library
(UK) info@naturepl.com
www.naturepl.com

94 Nikon F4 with 24mm lens;
1/500 sec at f4; Fujichrome Velvia

Lorne Gill (*UK*)
lorne@wolfhill.free-online.co.uk
01821 650455

24 Nikon F4E with 500mm
lens; beanbag; 1/60 sec at f4;
Fujichrome Velvia

Roy Glen (*UK*)
roy@royglen.co.uk
07970 577727
www.royglen.co.uk

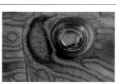

1 Nikon F4 with 105mm lens;
1/60 sec at f32; Fujichrome
Velvia; flash

Eye of the wrasse
The colours and patterns of fish
are irresistible subjects for
photographers, but this picture
has gone a stage further and
transformed the head of a little
European fish, the corkwing
wrasse, into something almost
cosmological, the encircling
colours focussing attention on
the otherworldly centre of its
extraordinary eye.
José Luis González (*Spain*)
marevision@terra.es
0034 986 201 162
www.mare-vision.com
Agent: AgeFotostock (Spain)
www.agefotostock.com

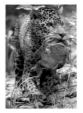

60 Nikon F4 with 80-200mm
zoom lens; 1/250 sec at f8;
Kodachrome 64

Nick Gordon (*UK*)
www.nickgordon.com
Agents: Ardea (UK)
ardea@ardea.co.uk
www.ardea.com
OSF (UK) enquiries@osf.co.uk
www.osf.co.uk
Nature Picture Library (UK)
info@naturepl.com
www.naturepl.com

99 Nikon F801 with 15-35mm
f2.8 lens; 1/8 sec at f16;
Fujichrome Velvia rated at 40;
tripod; grey gradual filter.

Olivier Grunewald (*France*)
bernadette.gilbertas@wanadoo.fr
0033 1 4254 3043 and
0033 1 4806 5747

100 Hasselblad 205 FCC with
250mm lens; 1 sec at f16;
Fujichrome Velvia; tripod

Tore Hagman (*Sweden*)
t.hagman@spray.se
0046 322 623 236

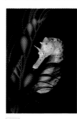

25 Nikonos RS with 50mm
macro lens; 1/125 sec at f11;
Fujichrome Velvia; 2 strobes

David Hall (*USA*)
david@seaphotos.com
001 845 679 6138
www.seaphotos.com

190 Nikonos IV with 35mm lens
and extension tube; 1/60 sec at
f22; Kodachrome 64; strobe

Michele Hall (*USA*)
Howard Hall Productions
hhp@howardhall.com
001 858 259 8989
www.howardhall.com

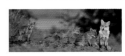

216 Canon EOS1n with 500mm
f4 lens; 1/125 sec at f5.6;
Kodak VS100

Mark Hamblin (*UK*)
mark@markhamblin.com
01479 841547
www.markhamblin.com
Agent: Getty Images (UK)
sales@gettyimages.com
www.gettyimages.com

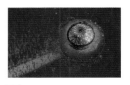

17 Nikon F4 with 105mm
micro lens; 1/2 sec at f22;
Fujichrome Velvia

Paavo Hamunen (*Finland*)
paavo.hamunen@pp.inet.fi
00358 400 191 269
http://personal.inet.fi/private/pa
avo.hamunen
http://homepage.mac.com/kuusa
mophotos
Agent: http://www.leuku.fi

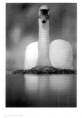

208 Nikon F4 with 500mm
lens; 1/500 sec at f5.6;
Fujichrome Provia rated at 200

Russell Hartwell (*UK*)
russell.hartwell@meuk.mee.com
01628 527996

220

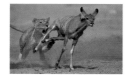

82 Canon EOS 1n with Canon 600mm lens; 1/500 sec; Fujichrome Velvia; beanbag

Martin Harvey *(South Africa)*
martinharvey@wildimages.co.za
0027 12 664 4789
www.wildimagesonline.com

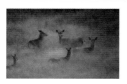

42 Nikon F4s with 600mm lens; 1/8 sec at f4; Fujichrome 1600

176 Nikon F4s with 35mm lens; 4 sec at f22; Fujichrome Velvia

Pål Hermansen *(Norway)*
Paal.hermansen@c2i.net
0047 6486 5515
www.palhermansen.com
Agents: Getty Images (UK)
sales@gettyimages.com
www.gettyimages.com
NHPA (UK) nhpa@nhpa.co.uk
www.nhpa.co.uk

157 Nikon F801 with 24-50mm lens in underwater housing; 1/60 sec at f8; Fujichrome Velvia; flash

Malcolm Hey *(UK)*
mdh@malcolmhey.co.uk
01845 577864;
www.malcolmhey.co.uk

92 Fuji GX617 with 90mm lens; 1 sec at f16; Fujichrome Velvia; tripod

Mike Hill *(UK)*
mike@mikehillimages.com
01805 622 035;
www.mikehillimages.com
Agents: Getty Images (UK)
sales@gettyimages.com
www.gettyimages.com
Agents: OSF (UK)
enquiries@osf.co.uk
www.osf.co.uk
Alamy (UK) sales@alamy.com
www.alamy.com
flowerphotos.com:
info@flowerphotos.com
www.flowerphotos.com
age fotostock america inc:
agenyc@agefotostock.com
www.agefotostock.com

192 Pentax 6x7 with 50mm lens; bellows; 1/30 sec at f16; Fujichrome Velvia; flash; tripod

Mitsuhiko Imamori/
Nature Production *(Japan)*
mail@nature-pro.co.jp
0081 3 3461 7695
www.nature-pro.co.jp

205 Nikon; Fujichrome Provia

Chris Johns/National
Geographic Image
Collection *(USA)*
images@ngs.org
http://ngsimages.com

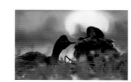

38 Nikon F4s with 500mm f4 lens; 1/125 sec at f4; Fujichrome Provia; floating hide; beanbag

78 Nikon F4s with 500mm f4 lens; 1/15 sec at f4; Fujichrome Provia; floating hide; beanbag

Rob Jordan *(UK)*
rob@robjordan.co.uk
01670 512761
www.robjordan.co.uk

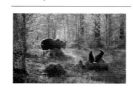

22 Nikon F4 with 80-20mm lens; 1/60 sec at f5.6; Fujichrome 100

Eero Kemilä *(Finland)*
eero.kemila@leuku.fi
00358 8 536 1370
mobile 00358 40 515 8010
Agent: www.leuku.fi (Finland)

65 Nikon FE with 50mm lens; 1/125 sec at f8; Kodachrome 50; two flash guns; tripod

Richard & Julia Kemp *(UK)*
sales@augurfilms.co.uk
01603 872498
website.lineone.net/~richardkemp
www.dryforest.co.uk
Agent: OSF (UK)
enquiries@osf.co.uk
www.osf.co.uk

183 Nikon 8008s with 105mm macro lens and extension tubes; two flashguns; 1/250 sec at f16; Fujichrome Velvia rated at 40

Brian Kenney *(USA)*
briankenney@netzero.net
001 941 426 9585
www.agpix.com/briankenney
Agents: Animals Animals/Earth
Scenes (USA)
info@animalsanimals.com
www.animalsanimals.com
OSF (UK) enquiries@osf.co.uk
www.osf.co.uk
Wildlife GmbH (Germany)
wildlife@t-online.de
www.wildlifebild.com

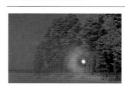

4 Canon EOS with 28-90mm lens; 45 sec; Kodak Elite Extra colour 100; tripod

Hannu Kivelä *(Finland)*
kivelahannu@luukku.com
www.juorkuva.net

59 Canon EOS1 with 80-200mm lens; 1/125 sec at f4; Fujichrome 100

Jean-Louis Klein &
Marie-Luce Hubert *(France)*
klein-hubert@wanadoo.fr
00 33 3 8871 9429
(mobile) 33 6 0876 6784
www.klein-hubert-photo.com
Agent: BIOS (Paris)
bios@biosphoto.com
0033 1 4356 6363
www.biosphoto.com

37 Minolta 9 with 300mm lens and 2x teleconverter; 1/20 sec at f27; Kodak Ektachrome 100VS; tripod

Claudio Contreras Koob
(Mexico)
asalazar@miranda.ecologia.unam
.mx 0052 55 5595 1034

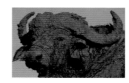

187 Canon EOS 1 with 500mm lens; 1/180 sec at f4.5; Fujichrome Velvia; beanbag

Frank Krahmer *(USA)*
frank@frankkrahmer.de
0049 89 612 2974
www.frankkrahmer.de

128 Pentax 6x7 with 300mm lens; 1 sec at f16; Fujichrome Velvia

130 Pentax 6x7 with 300mm lens; 1/5 sec at f22; Fujichrome Velvia

167 Canon EOS 3 with 70-200mm f2.8 lens; 1/250 sec at f8; Fujichrome Velvia

Jan-Peter Lahall *(Sweden)*
J-P Lahall Photography
info@lahall.com
0046 19 121312
www.lahall.com
Agents: Auscape (Australia)
auscape@auscape.com.au
www.auscape.com.au
IFA-Bilderteam (Germany)
info@ifa-bilderteam.de
www.ifa-bilderteam.de
Peter Arnold (USA)
research@peterarnold.com
www.peterarnold.com
PPS - Pacific Press Service
(Japan) ppsadmin@ppsjp.com
www.ppsimages.com

2 Canon EOS 1N RS with 35-350mm lens at f22; Provia 400F

Midsummer dawn
The challenge that the photographer sets himself is always to find artistic form in nature. This picture is a view of his favourite lake, using the patterns of reeds and water lily leaves but adding a pinch of magic by photographing the scene on midsummer's day, just as the sun rose.

Johannes Lahti *(Finland)*
Johannes.lahti@pp.inet.fi
00358 40 583 3890

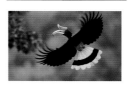

75 Canon EOS-1V with 600mm lens; 1/250 sec at f4; Fujichrome Provia; tripod; hide

77 Canon EOS 1nRS with 70-200mm lens plus 1.4x extender; flash exposure at 1/250 sec; Fujichrome Provia rated at 200

Tim Laman *(USA)*
tim@timlaman.com
001 781 676 2952
www.timlaman.com
Agent: National Geographic
Image Collection (USA)
images@ngs.org
http://ngsimages.com

Photographers' details

23 *Nikon N90 with 300mm lens; Fujichrome*

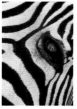

123

124

Frans Lanting *(USA)*
Frans Lanting Photography
photo@lanting.com
001 408 429 1331;
www.franslanting.com

58 *Canon A1 with 100mm lens; 1/250 sec; Fujichrome 400*

Antti Leinonen *(Finland)*
aleinonen@netti.fi
00358 8 6551 775

39 *Pentax 645 with 600mm lens; 1/45 sec at f5.6; Fujichrome Velvia; tripod*

Peter Lilja *(Sweden)*
peter@peterlilja.com
0046 910 770 029
www.peterlilja.com
Agent: Getty Images (UK)
sales@gettyimages.com
www.gettyimages.com

196 *Canon F1 with 300mm lens and x2 extender; Fujichrome Provia; tripod*

Conny Lundström *(Sweden)*
lundstrom_conny@hotmail.com
0046 9103 9278
www.connylundstrom.com

18 *Canon EOS 50 with 300m lens; 1/60 sec at f4; Fujichrome Sensia 100; tripod*

Daniel Magnin *(France)*
d.magnin@libertysurf.fr
0033 3 8580 2652
danielmagnin.free.fr

136 *Fuji 617 Panoramic camera with 105mm f8 lens; bean bag; 1/125 sec at f11; Fujichrome Velvia*

Thomas D Mangelsen/
Images of Nature *(USA)*
photo@imagesofnaturestock.com
001 307 733 6179
www.imagesofnaturewebstore.com

204 *Canon T90 with 200mm macro lens; f4; Fujichrome Velvia*

Chris Mattison *(UK)*
Chris.Mattison@btinternet.com
0114 236 4433
chrismattison.co.uk
Agents: FLPA (UK)
pictures@flpa-images.co.uk
www.flpa-images.co.uk
NHPA (UK) nhpa@nhpa.co.uk
www.nhpa.co.uk

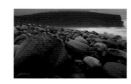

106 *Nikon F4S with 24mm lens; f2.8; Kodachrome 25; tripod*

Mark Mattock *(UK)*
markmattock@mac.com
0777 854 4051

36 *Nikon F5 with 80-200mm f2.8 lens; 2 sec at f11; Fujichrome Velvia; warming filter*

121 *Nikon F4 with 300mm lens; tripod; Fujichrome Velvia*

Lawrence A Michael *(USA)*
larry@brehmeragency.com
001 414 581 3714
www.larrymichael.com
Agent: Nature Picture Library
(UK) www.naturepl.com

174 *Nikon F5 with Nikkor 75-300mm lens; Fujichrome Sensia; beanbag*

Mike Mockler *(UK)*
mikemockler@lineone.net
01425 478103

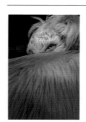

195 *Nikon F5 with 300mm f2.8 lens and x2 teleconverter; 1/30 sec at f5.6; Fujichrome Sensia; tripod*

Helmut Moik *(Austria)*
Wildlifefoto.moik@aon.at
0043 3114 2759
www.helmutmoik.com
Agents: NHPA (UK)
nhpa@nhpa.co.uk
www.nhpa.co.uk
Bigshot (Austria)
www.bigshot.at

35 *Canon EOS 1N with EF600mm lens; evaluative metering + 2/3 stops; 1/320 sec at f5.6; Fujichrome Velvia*

Arthur Morris *(USA)*
birdsasart@att.net
001 863 692 0906
www.birdsasart.com

13 *Nikon F5 with 600mm lens; 1/500 sec at f4; Fujichrome Velvia; tripod*

177 *Nikon F5 with 600mm lens; 1/250 sec at f4; Fujichrome Provia; tripod*

Vincent Munier *(France)*
photo@vincentmunier.com
0033 6 0712 0097
www.vincentmunier.com
Nature Picture Library (UK)
info@naturepl.com
www.naturepl.com

70 *Canon EOS 1N with 75-300mm lens; 1/1000 sec at f5.6; Fujichrome Provia*

Duncan Murrell *(UK)*
Dunks45@hotmail.com
www.duncanmurrell.com

74 *Nikon F4 with 300mm lens; 1/250 sec at f2.8; Fujichrome 100 rated at 200*

198 *Nikon n90 with 24mm Nikkor lens; 1/125 sec at f8; Kodak 100 SW; radio trigger and three strobelights*

Michael Nichols *(USA)*
www.michaelnicknichols.com
Agent: National Geographic
Image Collection (USA)
images@ngs.org ngsimages.com

147 *Canon EOS 1N with 70-100mm lens; 1/500 sec at f9.5; Kodak 100VS*

Paul Nicklen *(Canada)*
nicklen@northwestel.net
001 867 456 2737
www.paulnicklen.com

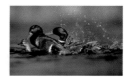

81 *Nikon F4 with 300mm lens; tripod; Kodachrome 64*

Scott Nielsen *(USA)*
Edge of Wilderness Gallery
scotlu@webtv.net
001 715 399 0412
Agent: DRK Photo (USA)
info@drkphoto.com
www.drkphoto.com

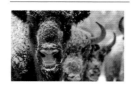

206 *Nikon D100 with 80-200mm lens; 1/90 sec at f4; digital 200 ISO*

Klaus Nigge *(Germany)*
klaus.nigge@t-online.de
0049 2306 51720
Agent: National Geographic
Image Collection (USA)
images@ngs.org ngsimages.com

178 *Pentax 645 with 80-160mm lens; 1 sec at f22; Fujichrome Velvia rated at 40; tripod*

Jun Ogawa *(Japan)*
shasin-j@qb4.so-net.ne.jp
0081 489 272 213
Agent: Nature Production
(Japan) mail@nature-pro.co.jp

170 *Canon F1 with 500mm lens; 1/30 at f8; Kodachrome 64*

Chris Packham *(UK)*
sexbeatles@aol.com

68 *Canon EOS D60 with Sigma 14mm f2.8 lens; 1/800 sec at f5.6; digital IOS 200; Canon 550EX strobe; UK-Germany underwater housing*

Doug Perrine *(USA)*
SeaPics.com info@seapics.com
001 808 329 4253
www.seapics.com

142 *Nikon F4 with 300mm lens; f4; Kodachrome 64; tripod*

Fritz Pölking *(Germany)*
fritz@poelking.com
0049 2571 52115
www.poelking.com

66 *Canon EOS10 with 300mm lens; Fujichrome Provia*

Benjam Pöntinen *(Finland)*
benjam.pontinen@netikka.fi
00358 64 4146 136

222

28 Canon EOS 1NRS with 300mm lens; 1/1000 sec at f4.5; Fujichrome Provia rated at 200

Tapani Räsänen (Finland)
tapani.rasanen@pp.inet.fi
00358 5 453 4929
Agents: Woodfall Wild Images
(UK) wwimages@btinternet.com
www.woodfall.com
Naturbild (Sweden)
www.naturbild.se
Luontokuvat (Finland)
www.luontokuvat.fi

168 Leica R6.2 with 400mm lens; Fujichrome Velvia

Norbert Rosing (Germany)
rosingbear@aol.com
www.rosing.de
Agent: National Geographic
Image Collection (USA)
images@ngs.org ngsimages.com

138 Nikonos II with 28mm lens and 2:1 extension tube; f22; flash and reflector; Kodachrome 64

Jeff Rotman (USA)
contact@jeffrotman.com
www.jeffrotman.com
Agents: Corbis (UK)
info@corbis.com
www.corbis.com
Getty Images (UK)
sales@gettyimages.com
www.gettyimages.com
Nature Picture Library (UK)
info@naturepl.com
www.naturepl.com

76 Canon EOS 5 with 17-35mm fisheye lens; 1/125 sec at f11; Fujichrome Velvia rated at 40

Andy Rouse/ARWP (UK)
sales@andyrouse.co.uk
07768 586288
www.andyrouse.co.uk

110 Nikon FM-2 with 50mm f2 AIS lens; 6 min at f2.8; Fujichrome Velvia; flash fired 5 times; teleflash

José B Ruiz (Spain)
jbruizl@hotmail.com
0034 96 596 1330;
www.josebruiz.com
Agent: Nature Picture Library
(UK) info@naturepl.com
www.naturepl.com

117 Nikon FM with Leitz 560mm f6.8 lens and Novoflex rapid-follow-focus grip; 1/30 sec at f6.8; Kodachrome 64; tripod

Jouni Ruuskanen (Finland)
ruuskanen.jouni@dnainternet.net
00358 400 287 686

143 Nikon F4 with 300mm lens; 1/250 sec at f2.8; Fujichrome 100 rated at 200

Carl Sams (USA)
carlsams@ameritech.net
001 800 552 1867
www.carlsII.aol.com

40 Nikon F5 with Nikon 80-200mm AF lens; 1/250 sec at f2.8; Fujichrome Provia

Joel Sartore (USA)
sartore@inebraska.com
001 402 474 1006
www.joelsartore.com
Agent: National Geographic
Image Collection (USA)
images@ngs.org ngsimages.com

33 Nikon F100 with 60mm macro lens; 1/80 sec at f11; Fujichrome Velvia

Kevin Schafer (USA)
Kevin@kevinschafer.com
001 206 933 1668
www.kevinschafer.com
Agents: ImageState (UK)
www.imagestate.com
NHPA (UK) nhpa@nhpa.co.uk
www.nhpa.co.uk

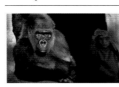

148 Canon EOS 1V with 600mm f4 lens; 1/250 sec at f8; Fujichrome Sensia 100; tripod

Gerhard Schulz (Germany)
schulz-naturphoto@t-online.de
0049 40 656 4217
www.schulz-naturphoto.com
Agent: Arco Digital Images
(Germany)
info@arco-digital-images.de
www.arco-digital-images.de

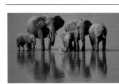

152 Canon EOS-1V with 500mm lens; 1/250 sec at f4.5; Fujichrome Velvia; image stabiliser; polarising filter; tripod

Angie Scott (Kenya)
jpscott@swiftkenya.com
00254 2 891 162
www.jonathanangelascott.com
Agents: Getty Images (UK)
sales@gettyimages.com
www.gettyimages.com
NHPA (UK) nhpa@nhpa.co.uk
www.nhpa.co.uk

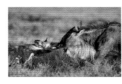

64 Canon F1 with 500mm lens; 1/60 sec at f4.5; Kodachrome 64 rated at 80

Jonathan Scott (Kenya)
jpscott@swiftkenya.com
00254 2 891 162
www.jonathanangelascott.com
Agents: Getty Images (UK)
sales@gettyimages.com
www.gettyimages.com
NHPA (UK) nhpa@nhpa.co.uk
www.nhpa.co.uk

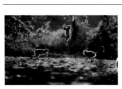

61 Canon EOS 600 with 200mm lens; 1/500 sec at f4; Kodachrome

83 Canon EOS 1V with 600mm lens; Fujichrome Provia

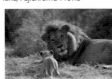

112 Canon EOS 1V with 35mm lens; Fujichrome Provia

153 Canon EOS1N with 500mm lens; Fujichrome Sensia

Anup Shah (UK)
sneh_shah_uk@yahoo.com
020 8950 8705
Agent: Nature Picture Library
(UK) info@naturepl.com
www.naturepl.com

134 Canon EOS 1N with 300mm lens; 1/30 sec at f4; Fujichrome Velvia; monopod

Manoj Shah (UK)
sneh_shah_uk@yahoo.com
020 8950 8705

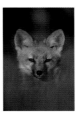

180 Canon T90 with 800mm lens; f6.7 at 1/125 sec; Fujichrome Velvia

Wendy Shattil (USA)
wendy@dancingpelican.com
001 303 721 1991
www.dancingpelican.com

120 Canon OS A2 with 75-300mm lens; 1/30 sec at f5.6; Fujichrome Velvia

Raoul Slater (Australia)
wilddog@spiderweb.com.au
0061 7 5485 0918
Agent: Woodfall Wild Images
(UK) wwimages@btinternet.com
www.woodfall.com

150 Canon EOS 1NRS with 600mm lens; Fujichrome Velvia rated at 100; tripod

Robert & Virginia Small
(USA)
Agent: Rick Poley Photography
(USA) rkpphoto@aol.com
001 352 567 7500

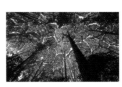

93 Linhof Technicandan with Schneider Super-Angulon XL 47; 6 sec at f22; Fujichrome Velvia; tripod

96 Hasselblad 203FE with CF 100mm lens; 1/1500 sec at f4; Kodak E100VS 160 (pushed 2/3 stops)

Hans Strand (Sweden)
strandphoto@telia.com
0046 8 186 568
www.hansstrand.com

26 Nikon F90x with 300mm lens; 1/30 sec at f4; Ektachrome E200; beanbag and spotlight

Jamie Thom (South Africa)
jamiet@netactive.co.za
0027 11 646 7978
mobile 0027 82 338 0380
www.leopard-moon.com

118 *Pentax 645 with 120mm macro lens; 1/4 sec at f32; Fujichrome Velvia; tripod*

129 *Pentax 645N with 200mm lens; 1/25 sec at 32; Fujichrome Velvia*

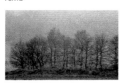

161 *Pentax 645 with 600mm lens; 1/60 sec at f6.7; Fujichrome Velvia; tripod*

169 *Pentax 67 with 300mm lens; 1/125 sec at f4; Fujichrome Velvia; tripod*

Jan Töve *(Sweden)*
jan.tove@telia.com
0046 33 274 028

90 *Canon EOS 3 with 28-135mm EF IS lens; Fujichrome Velvia*

Andy Townsend *(Australia)*
andy@imagesofantarctica.com
0061 3 6239 1878
www.imagesofantarctica.com
www.ozimages.com.au/Portfolio.asp?MemberID=857
www.ozimages.com.au/portfolio/atownsend.asp

97 *Canon EOS 5 with 35-70mm lens and extension tubes; 3 sec at f22; Fujichrome Sensia; tripod*

Adriano Turcatti *(Italy)*
eliodellaferrera@iname.com
0039 342 510 644

50 *Nikon F5 with 300mm lens; 1/160 sec at f5.6; Fujichrome Provia*

Stefano Unterthiner *(Italy)*
info@stefanounterthiner.com
0039 347 695 1159
www.stefanounterthiner.com

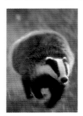

10 *Nikon F90 with 70-210mm lens; 1/60 sec at f5.6; Fujichrome Provia*

Jason Venus *(UK)*
jason@wildlife-photography.com
07767 895955
http://www.wildlife-photography.com

32 *Canon 10D with 500mm lens and 1.4x extender; 1/500 sec at f8; digital IOS 400; beanbag*

Jan Vermeer *(The Netherlands)*
Janvermeer.foto@planet.nl
0031 55 3555 803
www.janvermeer.nl
Foto Natura
info@fotonatura.com;
www.fotonatura.com

29 *Nikonos III with 35mm lens and 1:1 extension tube; 1/60 sec at f11; Fujichrome 100; dual strobe*

Dan Welsh-Bon *(USA)*
welshbon@prodigy.net
001 303 651 1626

141 *Canon F-1N with 28mm lens; Ektachrome 100 rated at 200; flash*

Kim Westerskov
(New Zealand)
kim.westerskov@clear.net.nz
00 64 7 578 5138
Agencies: Alamy (UK)
sales@alamy.com
www.alamy.com
Getty Images (UK)
sales@gettyimages.com
www.gettyimages.com
Hedgehog House (NZ)
Hedgehog.house@netaccess.co.nz
www.hedgehoghouse.com

113 *Nikon F5 with 300mm f2.8 lens; 1/250 sec at f4; Fujichrome Velvia*

Staffan Widstrand *(Sweden)*
photo@staffanwidstrand.se
0046 8 5835 1831
(mobile) 0046 70 657 3324
www.staffanwidstrand.se
Agents: Corbis (UK)
info@corbis.com
www.corbis.com
Nature Picture Library (UK)
info@naturepl.com
www.naturepl.com
Naturbild (Sweden)
info@naturbild.se
www.naturbild.se

160 *Canon EOS 1 with 300mm lens; 1/1000 sec at f4; Ektachrome 100*

172 *Canon EOS 3 with 500mm lens; 1/250 sec at f5.6; Fujichrome Sensia 100; beanbag*

Mike Wilkes *(UK)*
wilkes@photoshot.com
01527 550686

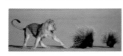

56 *Canon EOS1 with 600mm lens; 1/2000 sec at f4; Ektachrome EPZ 100*

Barrie Wilkins *(South Africa)*
bwilkins@iafrica.com
0027 41 581 1214

162 *Nikon N90S with Nikkor 600mm lens; 1/30 sec at f16; Fujichrome Velvia*

Art Wolfe *(USA)*
Wolfe, Art info@artwolfe.com
00 1 206 332 0993
www.artwolfe.com
www.artwolfestock.com

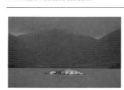

98 *Mamyia 6 x 4.5 with a 210 mm lens; 1/15 sec at f4; Fujichrome 50; tripod*

David Woodfall *(UK)*
Woodfall Wild Images
wwimages@btinternet.com
www.woodfall.com

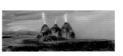

102 *Fuji 617 with 105mm lens; 1/4 sec at f4.5; Fujichrome Velvia rated at 40; polarising filter*

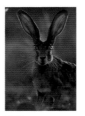

215 *Canon EOS 1v with 500mm f4L IS lens and 1.4x teleconverter; 1/8 sec at f5.6; Kodak E100VS rated at 200; beanbag*

Jeremy Woodhouse *(USA)*
jeremy@pixelchrome.com
001 214 544 3169
www.jeremywoodhouse.com
Agent: Masterfile Corporation
(Canada) info@masterfile.com
www.masterfile.com

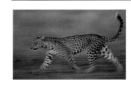

188 *Canon EOS1 with 600mm lens; 1/15 sec at f4; Kodachrome 200; car mount*

Konrad Wothe *(Germany)*
k.wothe@t-online.de
0049 8856 804 446
www.konrad-wothe.de
Agents: Minden Pictures (USA)
info@mindenpictures.com
www.mindenpictures.com
LOOK GmbH (Germany)
info@look-foto.de www.look-foto.de

30 *Nikonos V amphibious camera with UW Nikkor 15mm lens; 1/125 sec at f11; Fujichrome Velvia (RVP) rated at 100*

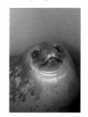

209 *Nikon N90 with 24mm lens; Sea & Sea housing; 1/30 sec at f2.8; Fujichrome Sensia 100; flash*

Norbert Wu *(USA)*
office@norbertwu.com
001 831 375 4448
www.norbertwu.com

151 *Nikon F5 with 300mm lens; 1/125 sec at f2.8; Ektachrome E100VS; tripod*

Solvin Zankl *(Germany)*
szankl@aol.com
0049 431 311 581
www.solvinzankl.com
Agent: Nature Picture Library
(UK) info@naturepl.com
www.naturepl.com

145 *Canon EOS 1N with 400mm lens and Canon 2x extender; 1/500 sec at f5.6; Fujichrome Provia III rated at 400*

Xi Zhinong/Wild China Film *(China)*
wildchina@163.net
0086 10 6839 0595
Agent: Nature Picture Library
(UK) info@naturepl.com
www.naturepl.com

55 *Canon EOS 1V with 100mm f2.8 macro lens; 1/100 sec; Fujichrome Velvia; flashes*

Christian Ziegler *(Germany)*
zieglerphoto@yahoo.com
(Panama) 00507 212 8934
www.naturphoto.de

111 *Nikon F801, with 20mm lens; Fujichrome Velvia*

Jean-Pierre Zwaenepoel
(Belgium)
jp.zwaenepoel@pandora.be
0032 5040 5024